ITALY'S RENAISSANCE IN BUILDINGS AND GARDENS

ITALY'S RENAISSANCE IN BUILDINGS AND GARDENS

A Personal Journey

FREDERICK KIEFER

 FIRST HILL BOOKS

FIRST HILL BOOKS
An imprint of Wimbledon Publishing Company Limited (WPC)

This edition first published in UK and USA 2025
by FIRST HILL BOOKS
75–76 Blackfriars Road, London SE1 8HA, UK
or PO Box 9779, London SW19 7ZG, UK
and
244 Madison Ave #116, New York, NY 10016, USA

British Library Cataloguing-in-Publication Data
A catalogue record for this book is available from the British Library.

Library of Congress Cataloging-in-Publication Data
A catalog record for this book has been requested.
2024938247

ISBN-13: 978-1-83999-279-7 (Hbk)
ISBN-10: 1-83999-279-4 (Hbk)
ISBN-13: 978-1-83999-280-3 (Pbk)
ISBN-10: 1-83999-280-8 (Pbk)

Cover credit: Frederick Kiefer

This title is also available as an e-book.

For my friend Fernando Chavez.

Architecture is the very mirror of life. You only have to cast your eyes on buildings to feel the presence of the past, the spirit of a place; they are the reflection of society.

I. M. Pei

CONTENTS

LIST OF FIGURES

ACKNOWLEDGMENTS

Learning Latin in high school opened my eyes to the wonders of the ancient world. When I had the opportunity to travel to Europe, I gained first-hand experience of what I had previously known only through reading. Later as a teacher, I would explore with students the impact of antiquity on Italy and points north after the Middle Ages. In my seminars on Renaissance Design, we traced enthusiasm for the remote past in contemporary arts. Those undergraduate classes provided the genesis of this work. In conceiving and writing about the topic, I have been particularly assisted by my colleagues Carl T. Berkhout and Fenton Johnson. Sidney Homan has also helped with valuable counsel.

PREFACE

Palaces, villas, and churches. These were the highlights of my first visit to Italy. I took a lot of photos and looked forward to sharing them with friends and family. Back home in Arizona, though, I found that I didn't recall much about the places that had impressed me. Although I had the benefit of half-day guides in Rome, Florence, and Venice, I sometimes had difficulty hearing what was said on crowded streets and busy interiors. The guides were capable but had only enough time to mention a few major features of each locale. Of course, I had access to other sources of information. In advance of my trip, I had purchased a few books about Italy, but they offered only the most basic information: maps, opening times, restaurants, hotels, and the like. As a rule, they skimped on actually describing buildings, which intrigued me. And so they were not especially helpful in providing the insights I wanted. Upon my return, I found myself wondering: Where had the architects actually found their ideas? What did they want to accomplish? And what do their choices tell us about their time? My initial sojourn in Italy would have been more satisfying if I had come away with a deeper appreciation of what I had seen. What I most needed was context.

What you have in your hands is a series of brief essays about the most innovative buildings and gardens of the Italian Renaissance, roughly 1400–1600. Join me as we explore what's distinctive about the sites, how they came to be constructed, and what connects them to their world. I wrote these essays for one reason: to enhance your enjoyment. This is the book I wish had existed when I first visited Italy.

At the outset, I should say what you will not find here. I don't visit other countries to shop. I'm not interested in fashionable clothes, fine jewelry, or shiny souvenirs. And when virtually everything is available for purchase online, do we really need to travel several thousand miles to snag glassware in Venice or scarves in Milan? Nor am I drawn to sunny beaches, overpriced drinks, or

lively clubs. For recommendations of such fare, you will need to look elsewhere. The tourist offices of cities you visit will be helpful. The locals are the people who know what their towns offer for nightlife and pleasant diversions.

Today many, if not most, Americans experience Italy by joining tours. These groups make the practicalities of travel far easier. A frequent disadvantage, however, is that guides are eager to hurry their charges on to the next destination. Years ago, I watched my fellow countrymen visiting the chief art museum of Antwerp: they entered the building, the guide tarried in front of a painting, made a vulgar remark about anatomy, and led them outside. They had just "done" the museum, one of the finest in Europe. Some travelers believe they don't need a guidebook as long as they have an electronic device. Internet resources, of course, make nearly everything easier. They usually skimp, however, on explaining what makes a site unique and what a visitor feels while exploring it.

I'm not opposed to tours per se. In fact, I joined a student tour on my first visit to Italy. Many years later, my wife and I took a tour on our honeymoon in Turkey, where both of us had long wanted to see the Greek ruins. And we felt lucky in our guide, who specialized in tracing the roots of Christianity. But we prepared by arriving in Istanbul a few days early so that we had plenty of time to enjoy at our own pace the early church frescoes. We both thought that getting to know a work of art or architecture from an earlier era entails an investment of time, but one that pays dividends. I hope that these essays, presented in roughly the venues' chronological order, will enrich your experience.

In Italy, you may find yourself distracted by fatigue and the practical challenges of travel. It is not unusual to visit a museum that has closed some of its rooms for lack of staff, especially in the summer months when employees take their vacations. Public restrooms are few and far between. Many churches and museums shut down for two hours in the middle of the day. Expect to find air conditioning scarce. Ice for drinks is treated as a precious commodity; you will be lucky to get a sliver. And you usually won't find family restaurants of the kind we know in America. On top of everything else, some ATMs will seize your card when you try to withdraw cash. Such are routine tribulations. You can, though, save yourself the hassles simply by reading these essays. (Yes, I'm being facetious.)

One last thing. If you travel a long way and spend a lot of money to enjoy the culture of another country, you will be wise to savor the experience. Take your time. Let the architecture and art speak to you. You will be glad you listened.

INTRODUCTION

In the early 1400s, Italy was superbly suited to welcome a transformation. Thanks to its location at the center of the Mediterranean, with access to Egypt, the Holy Land, Arabia, and Constantinople, Italy profited from international trade, its city-states accruing wealth on a scale unknown to the Middle Ages. And more than in most other countries in Europe, where people and power were dispersed in landed estates, much of Italy's populace was concentrated in urban centers: Florence, Rome, Milan, Genoa, Bologna, Siena, and Naples. Venice, the crossroads of the Mediterranean, the richest city in Europe and perhaps the largest as well, imported all sorts of merchandise, practical and exotic, for both Italy and points north. Along with the flood of material goods came new ideas, new styles, and new sophistication. Venice and Italy in general became ever more cosmopolitan.

If Italians had full pockets, they also experienced a certain disquiet, especially in the creative arts. The energy that once fueled everything from prose style to wall painting to building construction was flagging. Forms of expression hardened into convention. Dynamism was in short supply. Without consciously realizing it, society was on the brink of a secular revelation that would prove a conduit for creativity. Italians found that inspiration beneath their very feet. They rediscovered the materials of classical antiquity in the form of derelict theaters, baths, aqueducts, palaces and temples. For a millennium no one had examined them systematically or discovered how the ancients actually made them. By excavating the ruins, Italians found a portal into the world of Greece and Rome. They opened their minds to the past and found treasure.

What accompanied this discovery were written accounts that survived the Middle Ages. Many books from antiquity—tablets, scrolls, or parchment codices—had, of course, simply disappeared over the centuries. Those that remained were seldom seen, often stored in monasteries where access was difficult, if not impossible. In the early 1400s, however, students of the past

1

began to seek out ancient manuscripts, to learn what they contained, and to share their findings. Within a short span of time, artisans learned to capitalize on a newly found appetite for ancient precedent.

Through manuscripts and, later, printed books, Italians had access to the ideas and accomplishments of their ancestors. For a millennium, monasteries all over Europe had preserved ancient texts. Monks laboriously copied them by hand, giving new life to records of a civilization that would otherwise have been lost. Now wealthy Italians began to collect those manuscripts, ensuring their availability to future readers. Princes discovered that owning a personal library became a status symbol. Their collections acted as rescuers of the written and printed word. In the summer of 1414, Poggio Bracciolini, famous for prowling monastic libraries throughout northern Europe, visited the Swiss monastery of Saint Gall with two friends. They were appalled to discover in the church tower "countless books [...] kept like captives and the library neglected and infested with dust, worms, soot, and all the things associated with the destruction of books." Filled with dismay, he wrote in a letter, "we all burst into tears."[1]

This reaction reveals an empathetic, not just intellectual, connection with the remains of antiquity. Men and women of the 1400s and 1500s felt a powerful link with ancient writers once their works became accessible. A disconsolate Niccolò Machiavelli, having been dismissed by the Medici family in Florence, reports that at the end of the day, he found sanctuary in his personal library, where he communed with Roman authors: "I am not ashamed to speak with them and to ask them the reason for their actions; and they in their kindness answer me; and for four hours of time I do not feel boredom, I forget every trouble, I do not dread poverty, I am not frightened by death; entirely I give myself over to them."[2]

Hunting for ancient manuscripts, the indefatigable Bracciolini discovered a number of lost works, none more important than a study by Vitruvius, *On Architecture*, discovered at St. Gall. Although this Roman author (first century BCE) was not himself a distinguished architect, although his writing was often muddled, and although the manuscript no longer contained its original (eleven) illustrations, his was the only commentary on architecture to survive Rome's fall. This good fortune gave his work—both a practical manual and a declaration of principles—extraordinary prestige. In contrast to other fragmentary and textually corrupt copies of Vitruvius, this one from St. Gall was both reasonably complete and reliable. Bracciolini shared it with Filippo Brunelleschi and Leon Battista Alberti, the two most talented architects of the Early Renaissance.

The discovery proved electrifying. While Vitruvius's work, written *c.* 25–14 BCE, was becoming required reading for anyone interested in building,

contemporary architects emulated his example by writing their own treatises. For the first time in more than a thousand years, a spirited discussion of what constituted good architecture gathered momentum. Alberti's *On the Art of Building*, the first architectural treatise of the Renaissance, was modeled on Vitruvius, describing ancient construction but also setting forth directions for future architects. "It is a paradox of history that for a Renaissance reader, Alberti and Vitruvius were effectively contemporary texts: both were published in 1486, one in Florence and the other in Rome."[3] Written in Latin and completed *c.* 1452, Alberti's work would prompt other architects to contribute their own findings. No previous era produced so many books devoted to architectural theory and practice.[4] Collectively, they reveal the lively, informed, ongoing conversation about principles of design that characterized the 1400s and 1500s. Architects tuned in to their cultural moment. They knew one another, competed with one another, and learned from one another. They were all, in effect, members of a club. The password for admission was "Vitruvius."

Contemplation of antiquity and the exchange of views among architects released a surge of intellectual energy not seen for a millennium, a development that would never have happened so quickly were it not for Johannes Gutenberg's invention of printing with movable type in the 1450s. Through woodcuts and, later, metal engravings and etchings, the press allowed for the distribution of architectural images, thus publicizing innovation.

This development, in turn, led to architects' heightened self-awareness of their collective enterprise. They read what their fellow architects wrote and thereby gained in sophistication. They were no longer merely masons. They became architects in the modern sense. They signed contracts for the work they undertook so we know their names and what they built. They took pride in their achievements and shared a conviction that the visual culture they created was far superior to that of the previous thousand years.

The embrace of classical civilization had a visceral urgency. Rome, after all, was a culture with a storied past, peopled by larger-than-life figures. Roman accomplishments in every field from law to engineering commanded attention. What fostered this reception was the conviction that, while society changed, human nature did not. To learn what the ancients had created in word or stone, therefore, could supply a shortcut to wisdom. And emulating the ancients would provide new models of aesthetic excellence. This endeavor became known as the Renaissance.[5] The term originated in language that Giorgio Vasari used in his 1550 *Lives of the Most Excellent Artists, Sculptors, and Architects* (revised 1568). Vasari spoke of *rinascità*, "rebirth." Its French translation—*renaissance*—came into wide use in the nineteenth century thanks to the historian Jules Michelet,

whose *Histoire de France* was published in 1855. Jacob Burckhardt, the Swiss historian, gave the name his imprimatur when he published his influential *The Civilization of the Renaissance in Italy* (1860).[6]

Perhaps more than anyone else, Pope Nicholas V exemplified a simultaneous enthusiasm for writing and building. Before he assumed the papacy in 1447, he was already a collector of manuscripts; in fact, he had assembled 824 Latin manuscripts and an additional 352 in Greek. He established the basis of what would become the Vatican Library, his own collection joining that already owned by the Church. His death in 1455 prevented the timely realization of his dream, achieved by his successor, Sixtus IV, twenty years later. But Nicholas managed to acquire precious Greek manuscripts that became available when Muslims sacked Constantinople in 1453. And he hired translators to render them in Latin, the language of most educated men and women in the West. He also oversaw the editing and copying of manuscripts he owned. In time, Rome's papal library would become a magnet for both manuscripts and, later, printed books.

Nicholas was simultaneously concerned with reshaping Rome's urban landscape. He found the city impoverished and nearly desolate, especially after the papacy's fourteenth-century sojourn in Avignon. He declared 1450 a Jubilee Year, thereby attracting a surge of pilgrims and a windfall of cash. And he began restoring a number of basilicas. He even contemplated the reconstruction of a dilapidated St. Peter's. His pontificate became a turning point in regaining the former glory of his Church and his city. Some contemporaries criticized him for spending money on construction projects. But Leon Battista Alberti, author of the first Italian treatise on architecture, praised the pope for encouraging the art of building. In fact, he gave a copy of his book to Nicholas *c.* 1452.

As he lay dying, Nicholas stressed that Christian faith could be strengthened by the very buildings that housed worshipers:

> The mass of the population is ignorant of literary matters and lacking in any culture. It still needs to be struck by grandiose spectacles because otherwise its faith, supported as it is on weak and unstable foundations, will end in due time by declining to nothing. With magnificent buildings, on the other hand, monuments in some sense perpetual that appear almost to testify to the hand of God himself, the popular conviction may be strengthened and confirmed in the same way as it is in the affirmations of the learned.[7]

What kind of buildings constituted "magnificence"? By the time Nicholas spoke these words in 1455, religious structures had begun to adopt features owing

inspiration to antiquity. Architects found ways to apply ancient principles in churches, chapels, and sacristies. Christian buildings began to resemble Roman temples.

* * *

All along, however, a certain tension existed between Christianity and the materials of the classical past. At the dawn of the Renaissance, Francis Petrarch (1304–74) wrestled with the conflict. Powerfully attracted to Roman culture, especially its language and literature, this poet sought to read every ancient text he could find; a tireless traveler and scholar, he discovered previously unknown personal letters by Cicero at a library in Verona. And he assembled one of the largest collections of classical manuscripts in existence. His admiration of the ancients led him to recognize that much of Roman philosophy was consistent with his own values. Ancient ideals like self-knowledge and personal responsibility were consistent with Christian belief. Similarly, the Cardinal Virtues of antiquity—Justice, Temperance, Fortitude, and Prudence—remained principles to be practiced in everyday life. Ancient writings, then, were a source of practical wisdom and could supplement Scripture. Their study fostered the formation of a moral compass.

Petrarch's allegiance to the ancients took shape at his home in Vaucluse, a district of Provence, near Avignon, where he was raised; in 1305, the papacy had relocated to this French city. There he could enjoy a contemplative life, reading in solitude the works of Virgil, Seneca, Horace, and others. Of his modest estate, he wrote, "Here in my mind I build my Rome, my Athens, here my homeland." In a "Letter to Posterity," he said that, "Though I was interested in many subjects, I devoted myself especially to the study of antiquity."[8] He referred to his home as a "transalpine Helicon," site of springs sacred to the Muses in Greece. Even his gardens drew inspiration from ancient Rome. "The one garden is very shady, suitable only for study and sacred to our Apollo [...]. The other garden, near the house, appears more cultivated, and is a delight to Bacchus."[9] When Petrarch was named Poet Laureate in 1341, he arranged to have his crowning with laurel take place on Rome's Capitoline Hill, once the center of the empire he so admired.

At the same time, Petrarch realized as a Christian that the Revelation of the New Testament came *after* the founding of Roman civilization. What the ancients wrote, therefore, however profound and elegant, had a liability: it could not offer a path to salvation. Faith in Jesus was indispensable to Christian belief. Petrarch found a convergence in the career of St. Augustine. Born in a Roman

colony in North Africa, he studied at Carthage and then at Rome. He admired much of what the Romans had achieved, particularly the excellence of what they wrote. So distinguished were his intellectual gifts that he became a professor of rhetoric in Milan and seemed destined for a career in that field. His interest was not merely aesthetic, for his upbringing sensitized him to moral issues. His mother was Christian, and his father was pagan, not subscribing to Christian beliefs. In his formative years, Augustine must have heard his parents discuss spiritual matters at home. In 386, he pleased his mother by converting to her religion. Returning to Africa, he was ordained a priest and became bishop of Hippo, in modern Algeria.

A key to understanding the fusion of pagan and Christian lies in the intrinsic importance of words as an essential source of moral value. What the Romans wrote with unsurpassed brilliance was infused with guidance that complemented Christianity. Similarly, the New Testament accorded supreme importance to *the word*, even identifying the term with divinity. St. John's Gospel begins: "In the beginning was the Word, and the Word was with God, and the Word was God."[10] So important was Scripture to the new faith that it led to the invention of modern books. In antiquity, texts had typically been written on papyrus scrolls made from reeds that grew along the Nile. Christians found it convenient to gather rectangular sheets of this material or vellum (made from animal skins) and sew them together, creating a codex, the ancestor of books today.[11] Because such books could be foliated (numbering the leaves of a book) or, in the era of print, paginated, the faithful were able to move conveniently from one biblical passage to another. The codex had another advantage too: it was easily portable.

Petrarch's trek up Mont Ventoux on April 26, 1336, near his French home, epitomized his allegiance to the written word. Upon reaching the summit, this Latin scholar found himself surrounded by spectacular scenery. He savored the experience, of course, but proceeded to take out of his garment a manuscript and began reading. It was Augustine's *Confessions*, a spiritual autobiography written by a man whose personal life had embraced pagan learning but whose allegiance to Christianity culminated in his book *The City of God against the Pagans*, extolling the city of God rather than man. He says, "I closed the book, angry with myself for continuing to admire the things of this world when I should have learned a long time ago from the pagan philosophers themselves that nothing is admirable but the soul beside whose greatness nothing can be as great."[12] This incident became a turning point in his life.

Despite his enthusiasm for Augustine, Petrarch never surrendered his appreciation of ancient culture, and he exhorted others to follow his lead. Through his reading, Petrarch developed a historical consciousness unusual in

his era. That is, he had a feeling for the pastness of the past. He knew how different was his own time from that of antiquity. And he felt frustrated that he did not possess all the tools that would allow him to bridge that gap. He would sit with a copy of Homer's poetry in his hands while tears streamed down his face. He could not read Greek. Few contemporaries did.

Some fervent Christians took offense at the survival of ancient artifacts and sought to obliterate them as if they represented a threat. Bracciolini, champion of classical culture and skilled Latinist, was appalled to witness workmen in Rome reducing ancient statuary to gravel. In 1416 he wrote, "if anyone asks these men why they are led to destroy marble statues, they answer that they abominate the images of false gods. Oh voice of savages, who flee from one error to another! For it is not contrary to our religion if we contemplate a statue of Venus or of Hercules made with the greatest skill and admire the almost divine art of the ancient sculptors."[13] A century later Raphael lamented to Pope Leo X the indifference of the Church to widespread destruction: "Why are we complaining about the Goths, Vandals and other perfidious enemies of the Latin name when the very men who, as fathers and guardians, should have defended Rome's wretched remains did in fact spend a great deal of time and energy trying to destroy those relics and to expunge their memory?"[14] And in the preface to *Lives of the Artists*, Giorgio Vasari complained of the wreckage wrought by adherents of the faith. Having annihilated the religion of the pagans, Christianity "applied itself to removing and eradicating on every side the slightest thing from which sin might arise; and not only did it ruin or cast to the ground all the marvelous statues, sculptures, paintings, mosaics, and ornaments of the pagan gods, but it also did away with the memorials and testimonials to an infinite number of illustrious people, in whose honour statues and other memorials had been constructed in public places by the genius of antiquity."[15]

Even the greatest of ancient buildings were not immune. Leon Battista Alberti became an eyewitness to senseless destruction: "Examples of ancient temples and theaters have survived that may teach us as much as any professor, but I see—not without sorrow—these very buildings being despoiled more each day" (6:154).[16] Alexander VI, the Borgia pope, leased Rome's Colosseum as a quarry, pocketing a handsome profit. In 1540, Paul III authorized builders of St. Peter's Basilica to raid the Roman Forum for stone.

* * *

The tension between Christian and classical never disappeared. And with the Protestant Reformation, it intensified. On October 31, 1517, Martin

Luther, a provincial theologian in northern Germany, posted his 95 Theses at the castle church in Wittenberg. Critical of Christianity as then practiced, they were intended as challenges to popular thinking and points for public disputation. In addition to opposing certain religious doctrines, he questioned such widespread practices as seeking the intercession of saints, the veneration of relics, the cult of Mary, the value of pilgrimage, and the requirement of celibacy for priests—all of which were anathema to reformers. Luther also deplored the Vatican's handling of money and the very buildings in which the faithful worshiped. Few Italians could have foreseen the implications of Luther's act, which triggered a wholesale revolution in European culture. Thanks to the printing press, his views circulated widely. Within a few months, they attracted attention everywhere.

Reformers objected to those who found inspiration in a society that executed Jesus Christ and made martyrs of his followers. Even more important, Lutherans believed that the Church neglected the Bible and its path to salvation. The wealth and energy devoted to building and furnishing ecclesiastical structures was money misspent. Furthermore, reformers fretted that the faithful might confuse material images with spiritual reality. Although Pope Leo X excommunicated Martin Luther in 1521, the monk's arguments could not be refuted so easily. What began as a desire for spiritual reform in Germany became a religious, political, and military tsunami. Leo, however, seemed unable to understand the threat to his Church.

The consequences for architecture and the other arts were profound. Although Luther had visited Rome (having been sent to the city in 1511 to heal a rift within his Augustinian order), he was scandalized by the air of decadence he witnessed there; and he was indifferent to the artistic creations of the previous century. Ironically, it was precisely the splendor of Italian craftsmanship that offended him. Luther and other reformers identified religious art with the "graven" images forbidden in Exodus 20:4.[17] Hence in northern Europe, especially, the interiors of churches would be despoiled of statues and altarpieces and paintings by those claiming that such artifacts impeded a personal relationship with Christ. The reformers identified decoration with pointless ostentation. They trashed the artifacts that had accumulated over centuries. Spending money on religious sculpture, painting, and buildings, they believed, was irrelevant to spiritual progress. And so the construction of new ecclesiastical edifices came to a halt in nations of the north that adopted Lutheran attitudes. Reformers preferred to adapt existing medieval churches, once stripped of their ornamental contents. The cost of remaking St. Peter's Basilica, already enormous, seemed a particular affront.

At the very time that Italian construction was moving from one brilliant success to another, religious reform would change the trajectory of architecture in Italy and the rest of Europe. Luther brought to issue a quandary: how exactly was Christianity to be reconciled with the pagan past, if at all? Could one source of inspiration be sustained without compromising the other? Since the early 1400s, Italians had been experimenting with a new cultural model for their cities, one that found its chief inspiration in antiquity rather than in the medieval past. In the early 1500s, they confronted an additional challenge: religious reform questioned the aesthetic achievements of the previous hundred years. The story of Renaissance architecture represents the effort to find an accommodation.

NOTES

1 Poggio Bracciolini, "Letter I," in *Two Renaissance Book Hunters: The Letters of Poggius Bracciolini to Nicolaus de Niccolis*, trans. Phyllis Walter Goodhart Gordan (New York: Columbia University Press, 1991), 188–89.

2 "Letter to Francesco Vettori [1513]," in *Machiavelli, The Chief Works and Others*, trans. Allan Gilbert, 3 vols. (Durham, NC, and London: Duke University Press, 1989), 2:929.

3 Alina A. Payne, *The Architectural Treatise in the Italian Renaissance* (Cambridge: Cambridge University Press, 1999), 70. The work by Vitruvius was first published by two Germans from Mainz—Conrad Sweynheym and Arnold Pannartz—who settled in Subiaco, a Benedictine abbey fifty miles east of Rome, and set up a printing press. It's unclear why they chose this particular location for their new venture.

4 For an account, see Vaughan Hart and Peter Hicks, ed., *Paper Palaces: The Rise of the Renaissance Architectural Treatise* (New Haven and London: Yale University Press, 1998).

5 "The Renaissance was the first period in history to be aware of its own existence and to coin a label for itself." See H. W. Janson, *History of Art*, revised and expanded by Anthony F. Janson, 4th ed. (New York: Harry N. Abrams; Englewood Cliffs, NJ: Prentice Hall, 1991), 419.

6 Jacob Burckhardt, *The Architecture of the Italian Renaissance*, ed. Peter Murray, trans. James Palmes (Chicago: University of Chicago Press, 1985).

7 Cited by James S. Ackerman, "The Planning of Renaissance Rome, 1450–1580," in *Rome in the Renaissance: The City and the Myth*, ed. P. A. Ramsey, Medieval & Renaissance Texts & Studies 18 (Binghamton, NY: Center for Medieval & Early Renaissance Studies, 1982), 7.

8 Petrarch, "Letter to Posterity," in *The Italian Renaissance Reader*, ed. Julia Conaway Bondanella and Mark Musa (New York: Penguin, 1987), 16.

9 Cited by William Tronzo, *Petrarch's Two Gardens: Landscape and the Image of Movement* (New York: Italica Press, 2014), 4.

10 *The Holy Bible: King James Version* (Cleveland and New York: Meridian Books, n.d.), 82.

11 Vellum was "calfskin soaked in lime, then smoothed by knife and pumice stone, or parchment, made from the scraped skin of sheep or goats. Vellum was a luxury material, extremely durable, and was used throughout the Middle Ages for the finest manuscripts." See Paul Johnson, *The Renaissance* (London: Weidenfeld and Nicolson, 2000), 14.

12 "The Ascent of Mount Ventoux," in *The Italian Renaissance Reader*, ed. Bondanella and Musa, 19.

13 "Letter I," in *Two Renaissance Book Hunters*, 190.

14 Cited by Claudia La Malfa, *Raphael and the Antique* (London: Reaktion Books, 2020), 249.

15 Giorgio Vasari, *The Lives of the Artists*, trans. Julia Conaway Bondanella and Peter Bondanella, Oxford World's Classics (1991; repr. Oxford: Oxford University Press, 2008), 5.

16 Leon Battista Alberti, *On the Art of Building in Ten Books*, trans. Joseph Rykwert, Neil Leach, and Robert Tavernor (1988; repr. Cambridge, MA, and London: MIT Press, 1997).

17 Exod. 20:4 reads, "Thou shalt not make unto thee any graven image, or any likeness of anything that is in heaven above, or that is in the earth beneath, or that is in the water under the earth."

PART I

FLORENCE

CHAPTER 1

THE FOUNDLING HOSPITAL, FLORENCE

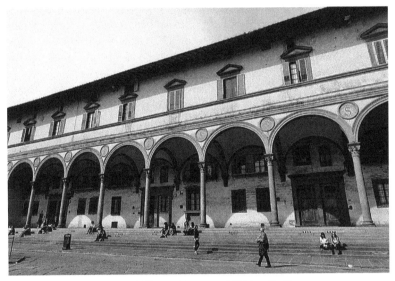

FIGURE 1 *Foundling Hospital, Florence.* Courtesy of Wikimedia Commons.

This is widely regarded as the first true Renaissance building, a new departure from the style adopted universally in the Middle Ages. Designed by Filippo Brunelleschi, it drew inspiration from the architects of classical Rome.

Chances are you've never seen the Foundling Hospital in Florence, known in Italian as *Ospedale degli Innocenti*. The city has so much to offer, from the Duomo to the Medici Palace to the museums, that this orphanage simply can't compete for attention. I must have walked across the piazza where it's located

a dozen times before I even noticed it. Yet, this building marks a fundamental turn away from the past. It represents nothing less than the beginning of the Renaissance.

To appreciate what it meant when it was built, we need to put aside our twenty-first-century vision and see anew. For a resident of Florence in the early 1400s, the Hospital would have looked unusual. The prevailing style was *Gothic*, epitomized throughout Europe in buildings, especially churches, featuring pointed arches, stained glass, elaborate sculptural detail, and structural lines that drew the eye skyward. The Foundling Hospital turned its back on all this.

When I first saw the Hospital, what struck me was the façade's stark simplicity: a row of nine semicircular arches rising from slender columns. The arches are twenty-six feet high, creating a sense of spaciousness. Between the colonnade and the front wall lies a loggia (roofed arcade) open to the street. It's a waiting room that says in effect: Welcome! This feature suited the building's purpose: a home for children who had been abandoned because their parents were dead, unmarried, too poor to care for them, or simply unwilling to acknowledge them. The size of the facility hints at its need. A wheel protruding from a side wall allowed infants to be deposited; a bell would be rung, the wheel turned and the child received inside. In time, the children, mostly female, would receive some education and vocational training. This orphanage was the first of its kind in Europe.

Why does it look different from contemporary buildings? Because architects, like artists and sculptors, had begun to find prevailing styles unsatisfactory. The term "German" (Gothic) conveyed disdain for those structures created everywhere since the style originated in France *c.* 1140. (Goths were Germanic tribes whose invasion of Italy helped doom the Roman Empire.) For several hundred years, the most imposing buildings in Europe were cathedrals, which rose ever larger and higher, their arches more pointed, their vertical lines more pronounced. At their best, they induced a sense of exhilaration that can still be felt today. Italy, however, never embraced the Gothic style in the way northern Europe had. As a practical matter, Italy's sunny climate had less need for walls of glass than did cloudy northern locales. And steeply raked roofs, necessary to shed the weight of winter snow, had little appeal in Italy's warm, dry weather.

By the early 1400s, a new spirit was in the air, inspired by the rediscovery of ancient culture. People came to feel that the summit of aesthetic achievement had been reached during the Roman Empire. After its fall, Europe retreated from greatness. Governments collapsed, as did commerce and the rule of law. The culture of antiquity largely disappeared. Descendants of the early Romans

plundered ancient buildings for their materials. Were it not for medieval monks who painstakingly copied classical texts, Roman literature, history and philosophy would likely have disappeared as well.

The elegance of ancient buildings had been forgotten, too, as medieval structures—monasteries, palaces, churches—took on a defensive character with thick walls, small windows and a stolid appearance. This style, called Romanesque,[1] prevailed about 800–1200 and would eventually be overtaken by Gothic, which replaced masonry with walls of glass often shored up by external supports called flying buttresses. By the early 1400s, both Romanesque and Gothic came to be regarded as symptoms of a decline that had lasted for a millennium.

Giorgio Vasari, a practicing painter and architect who wrote *Lives of the Artists*, captured the contempt for medieval forebears when he described the career of Filippo Brunelleschi, designer of the Foundling Hospital's façade: "[his] genius was so lofty that it may well be said that he had been sent to us by Heaven to give a new form of architecture which had been going astray for hundreds of years; the men of those times had spent many fortunes badly, constructing buildings with no sense of order, bad methods, poor design, bizarre inventions, a shameful lack of grace, and the worst kinds of decoration" (110).[2] Vasari, whose book contained 175 minibiographies, believed that the new style manifested itself first in architecture.[3] Florence and, in time, all of Italy had a fresh agenda: to banish the medieval past by reviving the best of ancient culture, especially its physical appearance. Their view may best be summarized as "Back to the future!"

* * *

What set Brunelleschi on a search for ideal architectural form was, ironically, his failure to win a contest in Florence. In 1401, the authorities decided to install a new set of Baptistery doors in gratitude for God's hand in sparing Florence from plague, known as the Black Death, which struck the city in 1348–50. The Baptistery, which stands immediately opposite the cathedral, occupied a special place in the life of the city: all Florentine children were christened there. To secure the very best of contemporary sculpture, the authorities held a competition. (The building has three entrances, one of which had previously been designed by Andrea Pisano, who depicted the life of John the Baptist, patron saint of the city.) Sculptors were invited to submit gilded bronze panels depicting the sacrifice of Isaac by his father Abraham (Gen. 22:2–13). The narrative represents a test of the father's faith, rewarded when an angel sent

by God stays Abraham's hand at the last moment. Abraham then slays a lamb instead of his son. The field of thirty-four contestants narrowed to seven finalists, including Brunelleschi and Lorenzo Ghiberti. Their two submissions survive in the Bargello Museum, the finest sculpture collection in Florence.

Brunelleschi, trained as a goldsmith and, already a sculptor of some repute, submitted a design showing Abraham with a knife at his son's throat. An angel rushing from heaven grasps the father's wrist to avert catastrophe. Despite the merit of his work, the twenty-three-year-old Brunelleschi lost to another Florentine, Ghiberti, a younger and even greater sculptor, who had also trained as a goldsmith.[4] Ghiberti later said, "I was permitted to execute the commission in whatever way I believed would result in the greatest perfection, the most ornamentation, and the greatest richness."[5]

Today Ghiberti's term *ornamentation* may have a slightly negative connotation: that is, something merely fancy or decorative, as in the hood ornament of a car or a bulb on a Christmas tree. For Ghiberti and his contemporaries, by contrast, the word had an altogether favorable meaning—something that contributed grace and harmony. This definition suggests its importance: "Ornamentation is the decorative embellishment of an object, adding beauty, meaning, and emphasis. It may enhance the structural elements of architecture, for it can transmit meaning and culture and can convey a narrative or instill curiosity and delight."[6]

According to Vasari, Ghiberti's submission was perfect in every detail: "the entire work possessed a sense of design and was beautifully composed; the figures in his style were lively and gracefully executed in the most beautiful poses; and the work was finished with such care that it seemed not cast and polished with iron tools but, rather, created by a breath" ("Ghiberti" 88). The word "lively" captures the sense of motion that animates Ghiberti's work. No wonder Michelangelo Buonarotti later praised Ghiberti's second set of Baptistery doors: "They are so beautiful that they would do nicely at the entrance to Paradise" (98). In no time, Florentines acclaimed them masterpieces.

The focus of Ghiberti's submission is the kneeling Isaac, who has been called the first male nude of the Renaissance, inspired by the sculpture of antiquity. The authorities preferred Ghiberti's submission, but, recognizing Brunelleschi's talent, especially his previous work on a silver altar in the cathedral of nearby Pistoia, they invited him to collaborate with his rival. Brunelleschi declined. Instead, he abandoned the city for Rome in 1402, inviting the seventeen-year-old Donatello to accompany him. Leaving the life of a sculptor behind, Brunelleschi would spend much of the next dozen years in Rome studying the architectural secrets of the ancients. (Florence lacked important antique structures.) Living in

the heart of what was once their empire, Romans were, of course, surrounded by visual remnants of that culture—the Colosseum, the Pantheon, the Arch of Constantine, the Forum, and so much more. Now Brunelleschi would begin to investigate those remains. He would learn building methods not from the guild of masons at home but from personal study in Rome. (Guilds controlled trades in a city, as modern unions do.)

Examining the traces of antiquity, Brunelleschi found something quite different from what Vasari called "the barbarous German [Gothic] style" ("Brunelleschi" 117). In temples, aqueducts, baths, and amphitheaters, Brunelleschi discovered that the Romans had used round—not pointed—arches everywhere. He also found the widespread use of columns topped with sculptural capitals (from the Latin *caput*, "head"). The ancients called them Doric (the simplest), Ionic (scrolled volutes, the capital looking like an opened scroll upside down), and Corinthian (adorned with a double row of stylized acanthus leaves). These forms, described by Vitruvius, are known collectively as the classical "Orders." Each usually consists of a base, shaft, and capital. The Greeks invented them, and the Romans added two more: the Tuscan, a stockier version of Doric, lacking vertical grooves and resting on a flat base; and the Composite, which fuses the Corinthian acanthus with abbreviated Ionic volutes above. Although Vitruvius did not mention the Composite (sometimes called the Italic) Order, it was in fact occasionally used for public buildings in antiquity. It is "the most ornate and finely carved of all the Orders."[7]

Doric was the plainest and shortest; Vitruvius associated it with a male body and with temples dedicated to the gods Mars, Hercules, and Minerva (4:216).[8] The slimmer Ionic, with twenty-four flutes (shallow vertical grooves), was identified with the female body and with temples dedicated to Juno, Diana, and Bacchus. The elegant Corinthian column, a favorite of the Romans, became identified with the slender figure of a maiden and temples dedicated to Venus, Flora, and the Muses. Typically, a multistory building like the Colosseum organizes the wall by employing Doric on the lowest level, Ionic on the middle, and Corinthian above; the fourth level uses tall Composite pilasters, which are basically flattened columns that protrude slightly from the wall surface. Frequently decorative in fifteenth-century buildings, they provide vertical support. Sebastiano Serlio codified the Orders in his treatise published in parts between 1537 and 1551.[9] It was his "book of antique architecture [that] was the first ever to present plans, sections, and elevations of the major buildings of ancient Rome."[10] The Orders, while a form of decoration, are anything but superfluous: "Visually, they dominate and control the buildings to which they are attached."[11]

Brunelleschi never tired of analyzing and recording antique works. Vasari tells us that the architect assimilated what he learned so thoroughly that he was able to see Rome as it existed in its glory: "his studies were so intense that his mind was capable of imagining how Rome once appeared even before the city fell into ruins" (118). What he discovered became the inspiration for his own creations. He would be guided not by existing structures but rather by what the ancient Romans had perfected and by his own judgment. He decided, above all, that buildings should be rigorously symmetrical in contrast to much medieval construction that seemed to grow piecemeal. The individual parts of a building, he believed, should be subordinated to an overriding plan. By observing this principle, the architect would find the harmony achieved by the ancients. Brunelleschi also came to believe that façades should be relatively plain so as not to detract from the overall design. Accordingly, he banished dense, fussy sculptural decoration that had long adorned buildings.

* * *

Brunelleschi had an opportunity to apply what he discovered when, in 1419, he was hired to design the façade of the Foundling Hospital. In this, his first public commission, he applied principles he had learned in Rome. The new building, commissioned by the Silk Weavers' Guild, appears eminently simple. Looking from ground to roof, we see, above a podium of nine steps, two stories. On the first, smooth columns, surmounted by Corinthian capitals, support nine semicircular arches. The wall itself is white, and so contrasts with the local gray limestone, a sedimentary rock called *pietra serena*. On the extreme right and left sides of the colonnade (a row of connected columns) are additional arches—not part of Brunelleschi's original design—flanked by fluted pilasters. These too have Corinthian capitals. Within the loggia each *bay*, a subdivision defined by columns and arches, has the shape of a cube topped by a hemisphere called a sail vault, an arched ceiling made of stone or brick. Doorways into the building itself are topped with flat lintels rather than pointed arches. Columns support a horizontal superstructure above the arches—the entablature, which consists of the architrave (from the Latin for a beam), frieze and projecting cornice. A row of rectangular windows stretches across the second level, each one rising directly over the center of an arch below. Little pediments, the triangular forms that appear atop virtually all classical temple fronts, surmount the windows. Brunelleschi intended that fluted pilasters separate those windows, but for some reason, they were never added.

The architect's creation initiated another innovation as well. It contributed to the reorganization of urban space. Florence was a densely populated city. The home of Brunelleschi and Donatello retained virtually no relic of an ancient Roman gridwork. Streets wandered willy-nilly. Brunelleschi realized that, for his Foundling Hospital design to be appreciated, an open space before it was necessary for viewing. Accordingly, that piazza became "one of the most significant urban set pieces, the first formally designed public square of the modern era."[12]

The decoration of the façade identifies the nature of this building: between the arches are a row of fourteen glazed terracotta (baked earth) reliefs in roundels; each depicts, against a blue background, an infant in swaddling clothes, a clue to the building's purpose. The reliefs (carved or molded work) were fashioned by Andrea della Robbia, whose family was supremely skilled at making religious images out of baked and painted clay. They were added in 1487, decades after the façade's construction. Originally, the concave circular frames were empty.

Brunelleschi's Foundling Hospital established principles that would increasingly find expression in the following years: symmetry and uniformity. The architectural vocabulary of Italy would henceforth consist of fluted pilasters, round arches, windows topped with pediments, classical columns surmounted by capitals and, above all, strong horizontal lines. Although this architect's contribution to the project was limited to the façade, the loggia and the visible part of the second story, he helped doom Gothic principles with his design. The orphanage "is generally regarded to be the earliest monumental expression of the new style."[13] It's no exaggeration to say that, at the threshold of his career, Brunelleschi jump-started the Renaissance.

NOTES

1 Peter Burke, in *The European Renaissance: Centres and Peripheries*, The Making of Europe (Oxford: Blackwell, 1998), comments, "Pre-Gothic art and architecture is known today as 'Romanesque' precisely because of its debt to that of the Romans" (22).

2 Giorgio Vasari, *The Lives of the Artists*, trans. Julia Conaway Bondanella and Peter Bondanella, Oxford World's Classics (1991; repr. Oxford: Oxford University Press, 2008).

3 In 1568, a revision of Vasari's work was published; it contained 250 minibiographies. (Modern translations omit many of the author's accounts.) The original title, *Lives of the Most Excellent Architects, Painters and Sculptors*, changed in time to *Lives of the Most Excellent Painters, Sculptors and Architects*. The new title reflected Vasari's growing interest in painting.

4 Bertrand Jestaz observes that "Brunelleschi and Michelozzo, the founding fathers of Florentine architecture, were both goldsmiths by trade: this might seem incomprehensible if we did not know that, at the end of the Middle Ages, the goldsmith's trade was considered a major art form that required not only mastery of drawing and ability to make sculpture, but also a knowledge of architectural forms (if not of architecture itself)." See his *Architecture of the Renaissance: From Brunelleschi to Palladio*, trans. Caroline Beamish (New York: Harry N. Abrams, 1996), 113.

5 Cited by Stephen J. Campbell and Michael W. Cole, *A New History of Italian Renaissance Art* (London: Thames and Hudson, 2012), 93.

6 *Architectura: Elements of Architectural Style*, gen. ed. Miles Lewis (Lane Cove, Australia: Global Book Publishing, 2008), 320.

7 Vaughan Hart and Peter Hicks, introduction to Sebastiano Serlio, *On Architecture* (New Haven and London: Yale University Press, 1996), xxiii.

8 Vitruvius, *Ten Books on Architecture*, trans. Ingrid D. Rowland, ed. Rowland and Thomas Noble Howe (1999; repr. Cambridge: Cambridge University Press, 2001).

9 For the tortuous printing history of Serlio's *On Architecture*, published in installments over a long period, see the translation by Hart and Hicks, 470–71. The publication of individual books in random order complicates the narrative.

10 Fil Hearn, *Ideas That Shaped Buildings* (Cambridge, MA: MIT Press, 2003), 54.

11 John Summerson, *The Classical Language of Architecture* (1963; repr. London: Thames and Hudson, 1980), 20.

12 Richard Goy, *Florence: The City and Its Architecture* (London: Phaidon, 2002), 178.

13 Marvin Trachtenberg and Isabelle Hyman, *Architecture, from Prehistory to Postmodernity*, 2nd ed. (New York: Prentice-Hall and Harry N. Abrams, 2002), 279.

CHAPTER 2

SAN LORENZO, FLORENCE

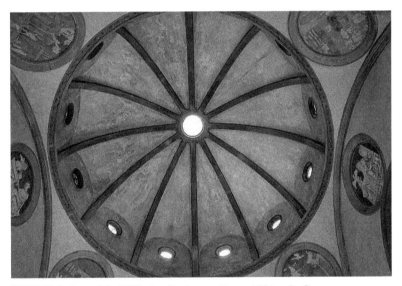

FIGURE 2 *Dome of the Old Sacristy, San Lorenzo, Florence.* Wikimedia Commons.

When Brunelleschi lost a competition to design new doors for the Baptistery, he moved to Rome, where he studied the ruins of ancient buildings. When he returned to Florence, he brought with him what he had learned. This church turned its back on the Gothic style by substituting round Roman arches for the pointed arches of the medieval era and by conceiving the church interior as blocks of space.

Two years after he planned the façade for the Foundling Hospital, Brunelleschi had an opportunity to design a church. Built on the site of an ancient religious building consecrated in 393 (and once the cathedral of Florence), San Lorenzo looks forlorn today. Money grew scarce during construction, and even when the Medici family contributed funds to continue work on their parish church, the

building was never faced with attractive stone. Because it remains unfinished, the façade—three plain doorways and a blocked arch above—promises little. Raw brickwork rather than marble confronts the visitor. Long after Brunelleschi's death, the Medici commissioned Michelangelo to design a façade. His all-marble scheme, however, was never built; the Medici canceled his commission. So after six hundred years, San Lorenzo awaits completion. The drab exterior gives no hint of what lies within. When I first stood in front of the rough, mud-colored structure, I asked myself: Have I misread my map? Can this possibly be the church I've heard so much about? Was this building in its earliest form really Florence's first cathedral? With low expectations, I entered.

Once inside, I saw a continuum of mostly uninterrupted space. Originally there were no bulky wooden pews of the kind common in America; most worshipers occupied empty space, though chairs were available for the infirm. The broad *nave* (central section of a church, from the Latin word for ship) stretches ahead and culminates in an altar. Tall columns separate the central space from adjacent aisles. This architectural model had its origins in the ancient Roman meeting hall, or basilica, a roofed secular structure in the shape of an elongated rectangle flanked by narrower, lower rectangles on both sides. Basilicas were typically used for legal proceedings and commercial exchange. Architects in the Christian era readily adopted the design because it furnished a way of accommodating large numbers of people, not a goal of classical temples, which were not sites of regular worship. The lower rectangles culminated in a semicircular apse (a recess usually at the end of a chapel).

I imagine that many visitors, arriving at San Lorenzo, may ask themselves: Why does my guidebook recommend a stop here? I asked the same question myself when, as a student, I first came to Florence. Perhaps I should have asked a different question: What would Brunelleschi's contemporaries have thought? None of us can recapture the feelings of people who attended Mass in San Lorenzo when it was new. Their reaction, though, would likely have been very different from ours. I suggest it may have been one of surprise. After all, they were steeped in Gothic style at least as it was practiced in Italy. Naves of medieval churches were often cluttered with tombs, statuary, and commemorative monuments. By contrast, this church seems comparatively spartan. As I made my way slowly toward the altar, I wondered if maybe I had judged too quickly. Was it possible, even likely, that what I initially considered emptiness was a deliberate choice? If so, I wondered, what would this feature accomplish? One possibility occurred to me. With distractions removed, the experience of prayer, meditation, and ritual would likely be more focused and thus profound.

The interior is well-lit, unlike many earlier churches. Circular windows in the walls and located directly above each alcove illuminate the edifice, as do elongated windows topped with arches in the clerestory, the upper walls over the nave. Medieval church interiors, by contrast, were often dim, especially those built when the Romanesque style prevailed. People would immediately have noticed something else as well. The ceiling here, unlike those of most churches in the late Middle Ages, is flat, resembling what Romans saw in their basilicas. Our eyes are not drawn upward by pointed arches that soar toward heaven and disappear, as they do in medieval buildings. Instead, this ceiling seems to say: Focus on the here and now.

Almost all large medieval churches were constructed over a long period of time. And so as tastes changed, different architectural features might be juxtaposed, sometimes dramatically, often awkwardly. The interior of San Lorenzo was completed relatively quickly. As a result, there's a stylistic consistency that Florentines would have appreciated. In other words, the various parts of the church look as though they belong together.

Typically, medieval churches feature a series of chapels projecting from the interior walls. Each contains an altar, a painting, and, sometimes, sculptural decoration meant to memorialize a wealthy or prominent resident. Because Gothic churches were built slowly over time, they invariably reflected changes in prevailing taste, and this was true of side chapels as well. Walking along an aisle in a medieval church, many of us sense dissonance, for each little chapel is unique and so fails to harmonize with the others. Indeed, the families who paid for such memorials must have competed with one another to create the most striking commemoration for their loved ones. Brunelleschi found this disparity distracting. And so chapels seem not to have been part of his original plan. They were, however, added in a later phase of construction either by Brunelleschi himself or by Michelozzo di Bartolomeo, who assisted Lorenzo Ghiberti with the new Baptistery doors. In any event, each chapel is confined within an alcove surmounted by a semicircular arch. By subordinating the chapels to a larger design, Brunelleschi avoided a clash of styles. And, diminishing the prominence of the chapels even further, the architect framed each alcove with classical pilasters.

Medieval churches often feature wall paintings of biblical stories. Brunelleschi, however, departed from precedent. He wanted no mural art that would draw the eye away from the architectural ensemble. For his part, Leon Battista Alberti would later write, "Within the temple [church] I favor detached painted panels rather than pictures applied directly to the walls [frescoes]" (7:220).[1] Here white plastered walls present a backdrop for *pietra serena*, the gray limestone of arches and columns, emphasizing their elegant curves.

The sedimentary stone has the advantage of being fairly soft and thus easily carved; over time it becomes harder. The interior of San Lorenzo is mostly plain, though the arches above the columns have incised designs. And each column is topped with a Composite capital. Above the capitals are impost blocks on which the arches rest; these feature subtle and detailed carving, something a hurried visitor may well miss.[2]

Everywhere I looked, I noticed semicircular Roman arches. They appear above the chapels and their alcoves; they connect the cylindrical columns along the nave. Smaller sail, or domical, vaults top each bay of the side aisles. And arches appear above those points where the nave intersects the transepts (arms at right angles to the nave). A *cupola* (dome), built long after Brunelleschi's death, rises above the crossing, where nave, transepts, and choir meet. (A *choir*, located at the east end of a Christian church, usually includes an altar and provides a space reserved for clergy.) The consistent use of the semicircular arch ensures the coherence of the church's various parts.

The strict use of a geometric form—the square—distinguishes San Lorenzo from medieval precedent. The architect conceived the interior as blocks of space, the larger multiples of the smaller. For example, the nave consists of a series of four square units laid next to one another in a row. Smaller units, one-quarter the size of the larger squares, make up the aisles. Even the flat ceiling consists of squares, and it is *coffered*, meaning that every panel is symmetrically recessed, a feature of ancient structures. The marble inlay of the floor reinforces the pattern. A broad stone stripe leads from the entrance directly to the altar while a series of smaller stripes intersects it at right angles. The resulting gridwork marks repeated spatial units, creating a pattern that the eye and mind find inherently pleasing.

Looking toward the center of the church from the entrance, I noticed that the parallel lines on the floor and the rows of columns on either side of the nave seem to converge as they approach the altar. Brunelleschi must have been acutely conscious of this effect, for he is credited with developing linear perspective, a term derived from two Latin words meaning "look through." The word, which can apply equally to art and architecture, chiefly designates a way of representing three-dimensional objects on a flat surface by projecting a system of parallel lines that converge at a vanishing point on the horizon, as train tracks do. Through mathematical calculation, size and distance determine the relationship of disparate objects. Those closest to the viewer will appear larger, those farther away smaller. By observing this principle, the architect/ artist organizes space schematically, projecting a pictorial world that shapes what the eye sees. Painters accentuated this effect by their handling of color:

that is, more intense colors dominate foregrounds, subdued colors backgrounds. In short, the artist creates an illusion of volume or space. He prizes what we call realism. Brunelleschi may have hit upon this discovery through his painstaking drawing of Roman ruins. Vasari wrote that Brunelleschi "paid great attention to perspective, then very badly employed as a result of the many errors made in using it" ("Brunelleschi" 113).[3] Another architect, Leon Battista Alberti, would formulate the principle in his influential treatise *On Painting*, completed *c.* 1435. (His book, in Latin, was translated into Italian the following year; Alberti dedicated it to Brunelleschi.) With the discoveries of Brunelleschi and Alberti, the notion of artistry fundamentally changed. As Joan Gadol has observed, "Painter's perspective opened not merely a new phase in the practice and theory of the visual arts but a new age in which reality came to be viewed and understood in mathematical terms."[4]

Churches typically contain a room for the storage of consecrated hosts, holy oil, relics, and vestments. We tend not to think much about such places because they are not usually accessible. The area designated for this purpose in San Lorenzo is known as the Old Sacristy (begun *c.* 1421, finished 1428). Designed by Brunelleschi, it adjoins the left transept of the T-shaped church and was actually built first. In fact, the self-contained space is structurally independent of the church proper though attached to it. This room performs two functions. In addition to storing materials needed for worship and furnishing a place where the priest prepares for a service, it's a memorial chapel for the Medici family. Before construction was complete, Giovanni di Bicci de' Medici, founder of the Medici bank, who had helped pay for the Foundling Hospital as well as the Sacristy and who commissioned the rebuilding of San Lorenzo, died. His son Cosimo supervised the completion of the chamber that houses his father's remains beneath what looks like a marble altar.

Like the church itself, the Sacristy proclaims its debt to geometry. The space may be described as a cube topped by a dome with twelve ribs and twelve circular windows around its base, an allusion to Christ's twelve apostles. A small extension on one side of the room, in the form of a smaller cube, houses an altar. Italians call this secondary space a *scarsella* (literally, a "pocket").[5] Where the dome meets the walls, the corners are rounded off by a form called a pendentive, a concave, curved triangle that marks a transition between a square-shaped space below and the round dome above. Brunelleschi rediscovered this form, used earlier in Rome and Byzantium. It bridges the primary shapes of the Sacristy with symbolic implications of the secular and the sacred. The square below, made by human hands, alludes to the things of this world; the hemisphere above, summoning the heavenly firmament, evokes the spiritual.

My journal records a first impression: "The dome, while not especially large, is the most beautiful I have ever seen."

The wall surfaces of white *stucco* (Italian for coarse plaster, a durable mixture of lime, water, sand, and, occasionally, powdered marble) have less ornamentation than most earlier churches do, a feature that may well have surprised contemporaries accustomed to a denser kind of decoration. Most Gothic churches were adorned with *frescoes*, paintings on wet plaster. The word derives from the Italian *affresco* meaning "fresh": pigments, ground in water, became part of the wall when brushed on. Ideally, paint needed to be applied within two hours of plastering; warm weather provided the best conditions. Brunelleschi preferred painted panels instead: pigments were applied to specially prepared wood surfaces that were movable.

There are, however, painted terracotta reliefs within the pendentives under the dome; these large medallions, depicting the life of John the Baptist, were made by Donatello *c.* 1434–43, apparently at the direction of Cosimo de' Medici. And so were the smaller *tondi* (circular pictures depicting the Four Evangelists—Matthew, Mark, Luke, and John) beneath the chief arches on the walls. Donatello also made two bronze doors for the Sacristy and probably the archlike reliefs above them. Finally, the sculptor, who is buried in the church crypt, made two bronze pulpits for the nave shortly before his death. Although they depict the life of Christ, each looks like an ancient Roman sarcophagus, awkwardly held aloft by four Ionic columns, which were not added until the sixteenth century. I admired some of the carvings, but the dark pulpits struck me as unattractive, at least partly because it's difficult to see details unless you are standing right next to them. Even with several spotlights now trained on the stone, the carving is obscure. And the density is at odds with the simplicity of San Lorenzo: Donatello's decoration detracts from the clean lines of Brunelleschi's design. His biographer, Antonio Manetti, reveals that the architect never approved the sculptor's additions. Whatever his reservations, the Sacristy became immensely popular because it represented, at least in part, a "reaction against the luxuriant detail of late Gothic."[6] According to Manetti, who completed the church after Brunelleschi's death and wrote his biography, the Sacristy "aroused the marvel, for its new and beautiful style, of everyone in the city and of the strangers who chanced to see it."[7]

* * *

If the design of the Old Sacristy was a turning point for the people of Florence, it had a personal meaning for me as well. On previous trips to Europe, I had

been particularly drawn to the medieval cathedrals of the north and their wealth of artifacts. Now I found something to rival those masterworks. Contemplating San Lorenzo, especially the Old Sacristy, I realized how profoundly different it was from every religious structure I had ever seen. The devotion to geometry, a combination of shapes, balance of design, and sheer simplicity—these combined to lift me out of my everyday world.

As I stood in the Sacristy, quietude enfolded me. Ensconced in Brunelleschi's disciplined space, I had a feeling of calm and security, enjoying not only a refuge from the hurly-burly of the city outside but also from my own mood, a mixture of fatigue and restlessness. Despite finding myself in an unfamiliar place, I felt comfortable. My mind floated free, receptive to thoughts that often elude me in the everyday world. This, I later concluded, was made possible by the architect's elaborately contrived design, which made architecture out of the raw material of numbers. When I visited the Sacristy, I was not thinking about mathematics, of course. Instead, what I experienced was the emotional effect that Brunelleschi invited.

When we speak of Renaissance buildings, we use terms like "proportion," "ratio," "perspective" and the like. My experience at the Sacristy alerted me to something I had not thought much about: architecture is much more than the sum of its technical features. At its best, a structure creates an immediate emotional effect, intended by its maker. No matter how clever the architect, no matter how impressive the materials, and no matter how imposing the design, a building that fails to move us will seem inert, indifferent and cold. By such features, it announces that it does not care whether we are there or not.

For all his skill as an engineer, Brunelleschi realized that his chief goal was to attract our eyes and thereby to move our spirit. The evening I visited San Lorenzo for the first time, I wrote in my journal: "I've finally moved beyond my preoccupation with the Middle Ages. No longer do I see medieval design as the summit of artistic achievement. What I saw today has made me a convert to the Renaissance."

NOTES

1 Leon Battista Alberti, *On the Art of Building in Ten Books*, trans. Joseph Rykwert, Neil Leach, and Robert Tavernor (1988; repr. Cambridge, MA, and London: MIT Press, 1997). Citations within parentheses designate book and page numbers.

2 An *impost* may be defined as "a masonry unit or course, often distinctively profiled, which receives and distributes the thrust at each end of an arch." See Cyril M. Harris, ed., *Illustrated Dictionary of Historic Architecture* (1977; repr. New York: Dover Publications, 1983), 295.

3 Giorgio Vasari, *The Lives of the Artists*, trans. Julia Conaway Bondanella and Peter Bondanella, Oxford World's Classics (1991; repr. Oxford: Oxford University Press, 2008).

4 *Leon Battista Alberti: Universal Man of the Early Renaissance* (Chicago and London: University of Chicago Press, 1969), 22.

5 The smaller dome over the *scarcella* depicts the night sky on July 4, 1442, when the project was completed.

6 Peter Burke, *The European Renaissance: Centres and Peripheries* (Oxford: Blackwell, 1998), 34.

7 *The Life of Brunelleschi*, ed. Howard Saalman, trans. Catherine Enggass (University Park and London: Pennsylvania State University Press, 1970), 106.

CHAPTER 3

SANTO SPIRITO, FLORENCE

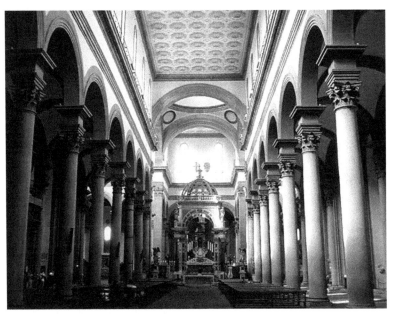

FIGURE 3 *Interior of Santo Spirito, Florence.* Wikimedia Commons.

This church has a pared-down look. It has the shape of a classical basilica with a broad nave and side aisles separated by columns. Tall windows supply abundant lighting. Mathematics defines the interior space. The harmonious proportions are exacting. In his *Lives of the Artists*, Giorgio Vasari called this "more charming and better proportioned than any other church."

As early as 1428, Filippo Brunelleschi contemplated a new and larger church for the Augustinian monks in Florence, whose original settlement was founded in 1250 and whose buildings were Gothic. He envisioned a church facing the Arno, where travelers on the river could look up and admire the façade. This intention would require reversing the orientation of the existing medieval church. But some landowners refused to sell their property, frustrating the architect; the new façade had to face away from the Arno. The church of Santo Spirito (Holy Spirit), begun in 1446, today looks out on a broad piazza. If the situation of the church does not represent the architect's original intention, neither does the unadorned façade. When I first saw the plain plastered wall, I could make little sense of it. Later, I learned that it was not completed until 1792. In other words, it is not entirely the product of Brunelleschi's thinking. Other features of the façade, similarly, did not originate with the architect. Brunelleschi apparently wanted four entrances into the church, but the present façade has three. The prominent volutes (spiral scrolls) on either side of the façade and the gable (triangular form at the end of a pitched roof) atop the rose window (round in shape, a Gothic feature) were not added until the eighteenth century. So what we see from the piazza fails to capture Brunelleschi's intention. The traditional practice of building a façade at the latest stage of construction accounts for the absence of the architect's original design. What does survive intact, fortunately, is the interior, though it remained unfinished till 1482, long after Brunelleschi's death.

When I walk into a Florentine church, I form an impression fairly quickly. I note a number of features more or less simultaneously. For convenience, I'll cast them in the form of questions: *What does the size of the structure tell me? Does the space by its sheer extent mean to overwhelm me? Or is the building more modest, intending to make me feel comfortable? What design guides the handling of stone and stucco? Is the prevailing style captive to that of the previous several hundred years? Or is it receptive to more recent innovation? Does the building find its conceptual roots in the medieval era or in the incipient Renaissance? Has anything been added after the building reached completion?* To judge the original effect of the church, I need to subtract mentally the "add-ons." Donatello's pulpits in San Lorenzo and his contributions to the Old Sacristy, for example, were not approved by the architect. Antonio Manetti wrote of them, "His works in the sacristy, individually and collectively, never had the blessing of Filippo."[1] They add nothing. Finally, I ask myself this: *Will I look forward to returning here?*

Having visited and enjoyed Brunelleschi's earlier church, I was prepared for a similar experience. I saw at once points of resemblance between San Lorenzo and Santo Spirito. Brunelleschi's two buildings have the same pared-down look. His earlier church having established the prototype, Santo Spirito has the shape of a

classical basilica, with a broad nave and a narrow aisle on either side. I noticed other similarities as well: columns and pilasters topped with Corinthian capitals, separating the nave from aisles; impost blocks; semicircular arches supporting the entablature; and a flat coffered ceiling painted with rosettes (rose-shaped ornaments). Tall windows in the clerestory provide ample lighting.

Here mathematics defines the interior space. Having visited San Lorenzo only that morning, I was sensitized to the use of repeated modules—namely, squares. The principal unit, which represents the point where the transepts meet, contains the altar, with a hemispheric cupola above, divided into twelve segments, each with a round window at its base. Brunelleschi may not have designed this dome; we don't know who did, though it is one of the most beautiful in Florence. Each arm of the Latin cross occupies another square so that, were it not for the elongated nave, the church would have the shape of a Greek cross, that is, a structure with four equal arms. The mathematically harmonious proportions are exacting. Although I had no way of measuring the dimensions, I later learned that the height of the arches in the crossing is double their span; the height of the arcade (a row of arches resting on columns or piers) equals the width of the nave, where the rectangular space consists of four squares laid end to end.

If you spend a little time looking around the nave, you may notice that the interior entablature is taller than that at San Lorenzo, and the columns closer together. *Pietra serena*, limestone with a blue or gray tint, outlines the curves of the arches, the columns and the cornice (projecting molding atop a wall); it has more prominence in Santo Spirito than in the earlier San Lorenzo. This elaboration also applies to the arches, pilasters and blind windows (without apertures) of the octagonal Sacristy later erected by Giuliano da Sangallo and Simone del Pollaiuolo. The stonework, which gives a more sculptural quality to Santo Spirito, creates a unified ensemble: "the columns are matched by half-columns separating semi-circular side chapels which are more obviously part of the same space as the aisles and the nave."[2] No frescoes distract our attention from the overall design. Conservators working in Renaissance buildings have discovered that Brunelleschi's contemporaries largely eschewed dazzling colors on interior walls. White or beige was favored in churches, and shades of blue, rust, or yellow in private homes.

When his career began, Brunelleschi had mixed feelings about side chapels, though he knew that well-to-do families wanted them as memorials. (The Duomo in Florence could house tombs only by permission of the Wool Guild.) At Santo Spirito, he conceived of niches rather than chapels along the walls. He intended them to cover the perimeter of the church, including the interior of the façade (though these were not built). The forty semicircular niches, each of

which features an altar and a painting, originally bulged from the exterior walls, creating a series of convex shapes. In the 1470s, after Brunelleschi's death, the recesses were filled in. Today the visitor confronts an unadorned flat exterior wall. The coats of arms over the windows belonged to families who paid for the niches inside. When Brunelleschi died, the dome had not yet taken shape. Salvi d'Andrea, guided in part by the architect's plan (no longer extant), designed the dome constructed in 1479–82.

In *Lives of the Artists* Giorgio Vasari called Santo Spirito "more charming and better proportioned than any other" church ("Brunelleschi," 145).[3] What was it about the building that attracted such praise? Perhaps the spare simplicity of the structure accounts for much of its appeal. It has basically the same look as the earlier San Lorenzo, but the later church is more austere. The arches along the nave lack the decoration at San Lorenzo. And the plain impost blocks do not feature the carving they have at his earlier building. The arches between the columns, moreover, lack the fine sculptural detail that they have at San Lorenzo. The casual visitor may not notice such differences. But Vasari and his compatriots missed nothing.

* * *

Why did this particular church win widespread approval? I believe Santo Spirito appealed to people beset with uncertainty and needing reassurance. Imagine everyday life. Streets of most European cities were scenes of squalor. Detritus was everywhere and hygiene was primitive. Beggars, thieves, pimps and scavenging dogs were rife. Passageways tended to be narrow, and overhanging structures diminished light at street level. Interiors could be dark and cold, especially in winter. Periodically, the Arno flooded Florence, destroying bridges, homes and shops; at one point parts of the city were covered in seventeen feet of mud and water. Sanitation, medical treatment and scientific knowledge were primitive. Tuberculosis, pneumonia and a cabal of other infectious diseases were always ready to pounce. Syphilis would prove highly contagious and have no effective cure. In the late Middle Ages, the Black Death had killed a third of Europe's people. The specter of the plague's return was ever-present; people did not even understand how it was transmitted. In the absence of a reliable police force, moreover, unexpected violence could flare at any moment. Class antagonism poisoned the body politic. Lacking longstanding political institutions, the populace could never know with confidence what faction might rule them next. In 1478, the Pazzi family of Florence tried to wipe out the popular Medici clan by assassination. The Medici were overthrown in 1494 and then restored sixteen

years later. External threats were more or less constant. Italy was a patchwork of city states, not a modern nation; it would not achieve unity until the nineteenth century. For hundreds of years potential attack by a rival principality haunted Italians. Social and political stability remained an aspiration more than a reality.

Walking into Santo Spirito in the 1440s, the visitor entered another world: orderly, secure, restful, restorative and attractive. The experience of the city outside dropped away. A spirit of serenity and good feeling informs the interior. I can best convey this phenomenon by recounting my visit to Liège many years ago. I had been traveling through Germany and found myself in Aachen. The map told me that I was not far from Liège in an area of French-speaking Belgium, which I had never visited. I drove across the border and found myself in a huge metropolis. My first impression was not entirely reassuring. Approaching the city, I had noticed rusting guard rails and debris along the roadway; rest stops overflowed with trash. After parking my car, I set out to gain a sense of the place and soon felt a beleaguered atmosphere. The legacy of history has something to do with what I saw. In World War II, Nazi Germany occupied this area of Belgium, leaving a nasty residue. Later, the coal and steel industries faltered. The city slowly exhaled and never quite caught its breath again. Despite a population of nearly 800,000, the energy of Liège drained away.

A little dispirited and in need of respite, I selected a restaurant at random. As soon as I entered it, I found myself occupying a very different world. The interior was sparkling clean, bright and elegant. Every detail of the décor was stylish. The attentive staff took pride in their faultless service. The meal was impeccable. A commitment to excellence animated the establishment. Like every city, Liège has its share of the unemployed and poor. The population, however, clearly prizes its cuisine. Whatever might be happening outside the restaurant, whatever problems diners bring with them, the restaurant stands apart, instilling a feeling of well-being for the price of a meal. Is it a stretch to compare my experience in Liège with that of parishioners arriving at Santo Spirito?

* * *

Despite the appeal of Brunelleschi's church interior, one oddity detracts from the overall effect: the *baldacchino*, which had its origins in cloth canopies held aloft over sacred spaces or powerful people. The permanent canopy here, housing the principal altar and built *c.* 1599–1607, is too large and flamboyant for its setting. As I stared at it, the word *grandiloquent* came to mind. Enormous, its decoration includes huge candelabra, silver lamps, colored marble, statues atop columns, a

Roman arch surmounted by a pediment, a balustrade (short posts supporting a railing) near the top, and, finally, an octagonal dome. The American entertainer Liberace would have loved it. The Augustinian monks, who valued simplicity, could not have found the baldacchino congenial. Brunelleschi would have deemed this complicated mélange out of keeping with the rest of his church. It does not belong to his world or, for that matter, to Vasari's. This architectural/ sculptural fantasia belongs to the Baroque style, a new aesthetic, a vivid confection of confidence, color, exuberance and complexity intended to dazzle the senses. It did not come to prominence until the seventeenth century. To my eye, the baldacchino violates a basic principle of Brunelleschi's—simplicity.

* * *

Santo Spirito, where Martin Luther once preached, became involved in a conflict that would electrify Florence in the 1490s. Girolamo Savonarola, an ascetic Dominican friar famous for urging Christian renewal and suppressing art and literature deemed secular, sought to advance Church reform through preaching. Trained in Ferrara and Bologna, this Dominican scold in 1481 arrived in Florence, where his strident views conflicted with those of Mariano da Genazzano, a learned Augustinian, who preached at Santo Spirito, a center of theological sophistication. The contretemps between the two preachers came to be known as "the battle of the pulpits." Lorenzo de' Medici, visiting Fra Mariano to discuss theology, was drawn into the dispute and suggested that his favorite preacher point out the error of the zealot's thinking. Fra Mariano, a highly accomplished speaker, took up the challenge in a sermon on May 12, 1491, claiming that his adversary was a false prophet. Carried away by his own eloquence, Fra Mariano damaged his reputation by launching so vitriolic an attack that he alienated his supporters. Soon afterward he left the city. A few days after Fra Mariano's sermon, the fanatical friar preached a sermon in the Duomo refuting the charges against him. Savonarola, who experienced visions and claimed to predict the future, had scored at least a temporary victory. In July his fellow friars at San Marco elected him prior.

In the following years, Savonarola continued to attract huge numbers of people to his sermons. Some listeners were so affected that they found themselves on the verge of hysteria. The monk represented himself as the voice of God. He took advantage of carnival festivities to stage a spectacular Bonfire of the Vanities in 1497, consigning to the flames images of the ancient gods, cosmetics, perfume, clothing, jewelry, wigs, dolls, tapestries, musical instruments, chessboards, playing cards, dice, sculpture and art that did not conform to his

severe notion of purity. Boys dressed in white and called "blessed innocents" roamed Florence to seize additional "vanities" that were added to the ninety-foot pile stacked up in the Piazza della Signoria. Singing hymns and bearing crosses, they snatched and set ablaze writings by Ovid, Boccaccio and Petrarch. Also put to the torch were "pagan books" by Plato and Aristotle; the monk rejected the whole panoply of ancient philosophy.

Although Savonarola's puritanical leanings and attack on corruption appealed to many Florentines, sentiment began to shift when he trained his hostility on the papacy. In 1495, Pope Alexander VI had ordered him to stop preaching, but the monk merely paused and then resumed. Next, he refused a papal summons, calling him to Rome. Fra Mariano, who once preached against Savonarola from his pulpit in Santo Spirito, had become head of the Augustinian order and wielded his influence against the monk, who continued to gain followers through the sheer power of his sermons. As many as 10,000 people crowded into the Duomo to hear him speak. Mariano may have lost the battle of the pulpits, but eventually he found himself on the winning side.

Florentines gradually wearied of Savonarola's political ambitions and his insistent alarms of the Apocalypse. When he launched a personal attack on Alexander, advocating a council to depose the pope, Savonarola's days were numbered. In 1497, the pope excommunicated him. On May 23, 1498, the Dominican monk was hanged and burned in the Piazza della Signoria, ostensibly for heresy. This charismatic figure had finally reached the end of a spectacular career and found himself in the same place that had earlier witnessed his Bonfire of the Vanities. His enemies dumped what was left of his body into the Arno.

With Savonarola's demise, the secular life of the city swept back. Religious ranting had run its course. The threat to expunge the pagan past had failed. Even the Roman gods had carte blanche to reclaim their prominence and strut their stuff. If Brunelleschi had lived to see this turnabout, he would surely have cheered.

NOTES

1 *The Life of Brunelleschi*, ed. Howard Saalman, trans. Catherine Enggass (University Park: Pennsylvania State University Press, 1970), 108.

2 George Holmes, *The Florentine Enlightenment, 1400–1450* (1969, repr. with corrections; Oxford: Clarendon Press, 1992), 201.

3 Giorgio Vasari, *Lives of the Artists*, trans. Julia Conaway Bondanella and Peter Bondanella, Oxford World's Classics (1991; repr. Oxford: Oxford University Press, 2008).

CHAPTER 4

THE PAZZI CHAPEL, FLORENCE

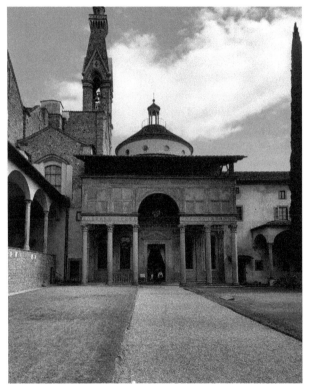

FIGURE 4 *Pazzi Chapel, Florence.* Author's photo.

Andrea de' Pazzi was a formidable figure in the commercial life of Florence. In a city where economic and political status found expression through architecture, this wealthy banker determined to leave his mark by creating a chapel that would link the family name with a structure of stunning beauty.

Andrea de' Pazzi, a formidable figure in the commercial life of Florence, was patron of the Franciscan monastery of Santa Croce, a Gothic structure begun in 1294. In a city where economic and political status found expression through architecture, this wealthy banker was determined to leave his mark by financing a new chapter house adjacent to the church. It would serve at least four purposes: furnish a site where monks could conduct business, provide a repository for the tombs of the Pazzi clan, demonstrate the builder's piety, and, most of all, link the family name with a structure of stunning beauty. He was mindful of creating an edifice comparable to the Old Sacristy at San Lorenzo, financed by the Medici. Rivalry was the rule in Florence, and aesthetic brilliance publicized power. Who better to take on the challenge than Filippo Brunelleschi, now at the height of his career? In 1429, Pazzi selected the architect to design the chapter house that would double as a chapel, though for various reasons, major construction was delayed and did not reach completion for forty years.

When I approached the Cappella dei Pazzi, I saw a façade with a high semicircular arch (inspired by a Roman triumphal arch, the kind erected to honor victorious generals). This arch is the central feature of an open porch that runs the width of the building. The wall and the vestibule behind it are called a narthex (entryway). On both sides of the arch, three Corinthian columns support the frieze, a horizontal decorative strip, that features a row of winged cherub heads. Above it, pairs of very small Corinthian pilasters divide the upper story into four squares, two on either side of the arch. Each larger square is subdivided into four.

Because the upper level appears to belong to a different building, this façade struck me as completely unsatisfactory the first time I saw it, and time has not diminished my reservations. Admittedly, symmetry characterizes both stories. But the columns below have no obvious connection with the squares above, except that the little pilasters feebly extend the vertical lines. The exterior of the Pazzi Chapel puzzles more than it pleases. When I stood before it, I could make little sense of what I was seeing, namely, a conglomeration of disparate elements: the wall of the narthex itself with its Corinthian columns; part of a cantilevered roof projecting downward from above, resembling an awning; a windowed drum (cylindrical support for the cupola); a singularly unattractive dome; and, furnishing interior light, a strangely tall lantern (windowed turret) that does not relate visually to anything beneath it. Considered together, these features failed my test of coherence.

We do not know whether Brunelleschi himself designed the portico (an open colonnade at the front of a building) that dominates the façade and screens the chapel from view. My strong hunch is that he did not. He died in 1446. The porch,

not completed until 1461, may well have been designed by someone else, perhaps Giuliano da Maiano or Michelozzo di Bartolomeo. No one has solved the mystery. In any event, the façade of the porch, evoking the Foundling Hospital, simply does not belong to the interior. Behind the façade of the narthex, a *barrel vault* (arched masonry ceiling, semicircular in shape, also called a tunnel vault) surmounts the porch; it has glazed ceramic decoration from the della Robbia family. A shallow saucer-dome rises at the center, and an additional small dome covers the *scarsella*, a little square room on the opposite side of the chapel housing an altar.

The chapel itself, the main reason to visit this site, is rectangular, perhaps because the number of monks could not be accommodated in a smaller (square) space, which the architect probably would have preferred. Bertrand Jestaz calls the plan "a variant" of San Lorenzo's square sacristy.[1] A low bench along the walls provided seating for the monks when they transacted business. The existing walls of the monastery limited Brunelleschi's options; the chapel had to fit in a corner of the church's transept. The interior may be described as a domed square with two secondary arms (each half the size of the square) that complete a rectangle. The very short barrel-vaulted extensions seem to buttress the rib-vaulted dome (inspired by Gothic precedent), divided into twelve segments, each of which contains an oculus, or circular window. These windows represent the twelve apostles, who, for Christians, brought the light of revelation into the world.

If for the moment we discount the spaces flanking the center of the chapel, we see that what Brunelleschi has created is essentially a cube topped with a shallow dome. The pendentives are decorated with Pazzi's coat of arms (a pair of gold dolphins, back to back on a dark blue field, along with five crosses) as well as majolica medallions of the Four Evangelists, seen against blue backgrounds. Luca della Robbia made these images, perhaps working from Brunelleschi's designs. An innovation by Luca allowed new possibilities for baked clay: "In the 1430s he invented a tin-based glaze for terracotta, one of the great artistic discoveries of the period, indeed of all time."[2] His colors were vivid, though the roundels, not installed until about 1460, seem slightly too large for the pendentives in which they are mounted.

Fluted Corinthian pilasters support triumphal arches and divide the walls into tall rectangular compartments. Within each, we see the outline of a smaller round-headed rectangle outlined in dark gray *pietra serena*. Directly above it appears a small, glazed terracotta *tondo* (circular panel) with the image of an apostle. (We don't know whether the architect intended to fill the circular frames or preferred them to remain empty.) The molding above the pilasters, with decorations including pairs of winged angel heads alternating with lambs,

executed in gold, divides the chapel into upper and lower zones. The *pietra serena* outlining the rectangles, arches and circles, provides a pleasing contrast with the creamy white walls. Like other buildings in Florence, the interior, not the exterior, is the chief reason for a visit.

Since the same architect designed both the Pazzi Chapel and the Old Sacristy at San Lorenzo, and since both structures shared much the same purpose, it is hardly surprising that they resemble one another. Both have the basic shape of a square topped with a dome. If the interior of the Pazzi Chapel seems more attractive, it is chiefly because the decoration is restrained. The large medallions on the walls and ceiling of San Lorenzo's Old Sacristy, as well as Donatello's bronze doors leading into adjoining service rooms, the colored stucco plaques above these doors, and the repetition of the Medici coat of arms—all of these apparently sought by Cosimo de' Medici—distract from Brunelleschi's master plan at San Lorenzo. Antonio Manetti, Brunelleschi's biographer, tells us that the architect never approved of Donatello's additions to the earlier church. Pazzi's chapel, by contrast, creates a feeling of cool, understated elegance that would not fall victim to superfluous embellishment.

* * *

Ironically, the Pazzi family did not enjoy indefinitely the chapel they financed, for they later joined a plot to assassinate leaders of the Medici clan. The conspirators had an ally in Pope Sixtus IV, annoyed over Lorenzo de' Medici's refusal to extend a loan. Bristling with irritation, the pope turned to another Florentine family, the Pazzi, who answered his request for money and became the new papal bankers. Having secured the tacit support of a corrupt pope, the Pazzi clan initiated a daring plan to wipe out the Medici. Francesco de' Pazzi, manager of the family bank in Rome, and Jacopo de' Pazzi, who had become head of the Florentine family in 1464, along with other conspirators (including the pope's favorite nephew, Girolamo Riario), and Francesco Salviati, archbishop of Pisa, plotted an attack on Lorenzo de' Medici and his younger brother Giuliano. It took place during High Mass at the Duomo on April 26, 1478. The signal to strike was the raising of the consecrated Host. Two priests hovering near the intended victims suddenly pulled out hidden daggers and began the assault. Together with Francesco de' Pazzi, they managed to wound Lorenzo, who fled to the sacristy, locked the heavy bronze doors, and succeeded in escaping. His younger brother was not so lucky. Stabbed nineteen times, Giuliano quickly bled to death. The Pazzi assumption that the people of Florence would turn against the Medici proved a catastrophic delusion.[3]

Revenge followed swiftly. Although the pope himself was untouchable, most members of the conspiracy were soon apprehended. The two priests were captured, stripped, and castrated before they were hanged. Some eighty persons would eventually be implicated in the plot and executed. Francesco was pulled out of bed in the Palazzo Pazzi, dragged naked to the Palazzo della Signoria, and hanged. Jacopo initially fled but was hunted down, carried back to Florence in an ox cart, tortured, and executed. He was buried in the family crypt at Santa Croce but was then exhumed and reburied in unconsecrated ground. After this second burial, a group of boys dug up the body, mutilated it, dragged it through the streets, and dumped it into the Arno. Riario was assassinated in 1488, probably with the complicity of Lorenzo. The archbishop of Pisa, appointed by Pope Sixtus, was thrown from a window of the Palazzo del Popolo, a rope around his neck.

The disgraced family was banished and their property confiscated. They had to forsake the Pazzi name, and their coat of arms was suppressed. Dolphins in the family crest were chiseled from buildings. Members of the family were forbidden to hold office. The people of Florence had spoken. In the future, the head of the Medici family would dominate the city. Indeed, he became known as Lorenzo the Magnificent.[4] His first decision was telling: he hired Sandro Botticelli to paint eight of the conspirators with nooses around their necks on the wall of the Palazzo della Signoria, now the Palazzo Vecchio; only a sketch of the images survives. The relentless Lorenzo even tracked down the assassin who had fled to Constantinople. The murderer was apprehended, dragged in chains back to Florence, and thrown from a window, a rope around his neck. Leonardo da Vinci sketched the assassin's body dangling from that rope.

NOTES

1 *Architecture of the Renaissance: From Brunelleschi to Palladio*, trans. Caroline Beamish (New York: Harry N. Abrams, 1996), 66.

2 Paul Johnson, *The Renaissance* (London: Weidenfeld and Nicholson, 2000), 62.

3 For a first-hand account of the attack and its aftermath, see Angelo Poliziano, "The Pazzi Conspiracy," trans. Elizabeth B. Welles, in *The Earthly Republic: Italian Humanists on Government and Society*, ed. Benjamin G. Kohl and Ronald G. Witt (Philadelphia: University of Pennsylvania Press, 1978), 305–22.

4 "History has dubbed Lorenzo 'the Magnificent' and he was, in his day, addressed as *magnifico*. This was a general title of respect accorded to powerful men who were not of noble birth. Lorenzo undoubtedly cultivated the magnificence attached to his name, for it had important implications." Patricia Lee Rubin and Alison Wright, *Renaissance Florence: The Art of the 1470s* (London: National Gallery Publications, 1999), 47.

CHAPTER 5

THE CATHEDRAL DOME

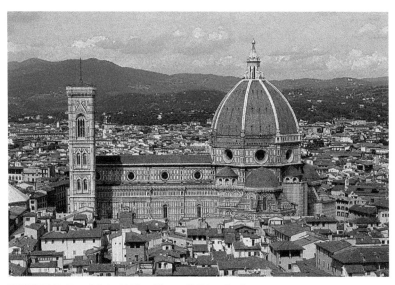

FIGURE 5 *Santa Maria del Fiore, Florence.* Wikimedia Commons.

This medieval cathedral was unfinished for a long time. No one had the knowledge to build a huge dome worthy of the church below. Then Brunelleschi came along with a stunning plan: build a permanent covering by designing two domes, one inside the other. The interior provided structural support while the exterior offered protection from the elements and an attractive silhouette for residents of Florence.

Although Florence is known as the home of the Italian Renaissance, its cathedral—the emblem of the city—is actually Gothic, displaying the pointed arches, stained glass windows, massive pillars, and rose window of the medieval world. Despite these features, its design is markedly different from cathedrals in Cologne and Kutná Hora, Amiens and Chartres, Lincoln and York, where

flying buttresses support thin glass walls, pinnacles stretch ever higher and vaulting becomes more sharply pointed. The interior of Florence's cathedral may best be called half-hearted Gothic. It lacks both the majesty and ornament that northern churches provide. The supernatural does not dwell here. Perhaps this explains why so many tourists in Santa Maria del Fiore wander about with vacant expressions instead of finding transport to a spiritual plane. What makes this cathedral unique, however, and what accounts for its fame is the dome. Its shape had religious significance. Architects believed that the circle was the most perfect geometric form. After all, every point of a circle is equidistant from the center. A circle has no beginning and no end. A dome represents half of that form, an arch rotated around its center. It also had the prestige of the Roman Pantheon, the largest surviving domed temple from the ancient world (143 feet in height and diameter). The Florentine church is known by the word *Duomo*, as are Italian cathedrals generally.

Brunelleschi's involvement came about because the nearly completed church, begun in 1294, lacked a permanent covering over its central crossing, where the nave, transepts and choir ("head" of the cross) intersect. A tiled wooden frame kept the rain out. No one had been able to solve the engineering problem: how to cover a massive space, nearly as wide as that of the Pantheon in Rome. When finished, the top of the dome (and lantern) would achieve a height of 300 feet. This area was so high and wide that the traditional building method—creating temporary wooden scaffolding called "centering"—would not work. A forest of trees would have been required. What's more, the walls of the cathedral were judged inadequate to support a huge dome made of heavy masonry. Unlike northern churches, the Duomo lacked flying buttresses.

Why should the medieval architects have designed a building whose dome could not be built with their know-how? Because cathedrals not only accommodated a great many worshipers but also, by sheer size, expressed civic pride and fostered a sense of community. We accomplish these goals today with athletic stadiums, concert halls, museums and theaters, shifting from religion to entertainment. No matter how splendid such modern buildings may be, however, they appeal to disparate members of the populace. Today someone who routinely visits a stadium to enjoy football is unlikely to be the same person who frequents a concert hall. A cathedral in the time of Brunelleschi, by contrast, welcomed everyone, required no fee for admission, and sought both to delight and to instruct simultaneously. In this sense, the cathedral served as a unifier, drawing together people of different backgrounds and interests. As they departed, they enjoyed the fellowship of friends and family.

Because the original architects of the Duomo intended that their building extol the leading city of Italy, they designed one of the largest churches in Christendom. Because their ambition exceeded their expertise, however, the cathedral, known as Santa Maria del Fiore, or Holy Mary of the Flower— the city's symbol is the lily—had been left unfinished for a very long time. (The façade we see today, called "Gothic Revival," was not finished till 1887.) Since the unbuilt dome had become an embarrassment, the cathedral's Board of Works in 1418 decided to hold a competition for a plan that would allow for the building's completion. Brunelleschi urged that advice be sought from every nation. Eleven applicants submitted proposals. Supremely self-confident, he figured that no one was likely to come up with a better solution than his own. Meanwhile, he returned to Rome to pursue his studies. Eventually, he went back to Florence and met with the assembled architects as they presented their plans.

What follows is Giorgio Vasari's account of what happened next. Whether entirely accurate or not, it captures the competitive artistic climate of the time and the importance of personalities in arriving at aesthetic decisions. To the surprise of the judges, Brunelleschi declared that he could build the dome without the wooden centering that had always been used for constructing domes and large arches. His brilliantly original plan called for a double dome (one inside the other) to reduce the total weight. The interior shell would carry most of the burden; the outer would offer protection from the weather and present an appealing profile. He proposed a self-supporting masonry technique, setting bricks in an interlocking herringbone pattern to distribute weight to the vertical ribs. The bricks were laid in concentric rings from the bottom to the top of the dome and, in effect, supported themselves by creating horizontal arches. This technique, pioneered by the Romans, allowed for the construction of a dome without traditional scaffolding.

Far from embracing the scheme, the authorities treated the truculent Brunelleschi brusquely. The trustees "mocked him and laughed at him."[1] Although they thought him a little mad, they nevertheless recognized his brilliance and eventually called him back. They asked him to provide detailed explanations in writing of what he proposed and to furnish a wooden model. Because he feared that his ideas would be stolen, the secretive architect demurred. He in turn suggested that whoever could balance an egg on a marble slab should be awarded the commission. When no one succeeded, Brunelleschi cracked the bottom of an egg on the stone and made it stand upright. His exasperated competitors said they could have done the same thing. He replied that "they would also have learned how to vault the dome if they had seen his model and his plans." Although not altogether convinced, the authorities were

nevertheless intrigued and invited him to describe specifically how he intended to build the dome. He finally agreed, and, in the absence of a superior plan from other architects, they entrusted him, albeit reluctantly, with the commission. But they insisted that he collaborate with Lorenzo Ghiberti, his rival in the contest for the Baptistery doors.

The story does not end here. Ghiberti had a following, who sought to assign him a major role in construction. The popular sculptor fancied himself capable of executing the dome without anyone's assistance, though he lacked a track record as an architect or engineer. The disappointed Brunelleschi devised a plan to rid himself of his would-be partner. While work proceeded, Brunelleschi elected to stay home. Pleading illness, he took to his bed with a bandage around his head. Meanwhile, the workers awaited instructions that Ghiberti was unable to provide. With the project at a standstill, the authorities prevailed upon Brunelleschi to return to the cathedral. But when he discovered that Ghiberti would continue to be paid without doing anything, Brunelleschi proposed that his rival make a wood and iron chain connected with bolts to the masonry in order to stabilize the ribs; it functioned like a barrel hoop. When Ghiberti failed to accomplish the task, the authorities met in August 1423 and decided to let Brunelleschi supervise the project alone.

Because the octagonal drum on which the dome would sit had already been finished and because it did not have attached buttresses to support the immense weight from above, the dome could not be a shallow hemisphere of the kind built by Emperor Hadrian (CE 118–28) for the Pantheon. Brunelleschi used a different technique. Needing a pointed dome to better distribute the downward pressure of the masonry, he created a series of angular arches, common in Gothic construction, and stood them on end, thereby forming a series of vertical supports. Eight major ribs (along with sixteen others concealed between the shells) provide the structural frame. Made of white marble, the main supports visible on the exterior contrast with the russet tiles of the roof. Although an ingenious solution, those ribs, tapered near the top, created a problem of their own: they would naturally tend to tilt outward at the point where they met. "As gravity pulls down on the unsupported centre of a dome, the weight of all that curving stonework pushes the sides outwards. They bulge, like a cushion when someone sits on it."[2] As a result a heavy cap, called a lantern, functioning like the keystone in an arch, was later built to hold the ribs in place and illuminate the dome's interior, 144 feet wide at its base. The top of the dome, consecrated in August 1436, measures 270 feet from the ground to the base of the lantern.

This lantern looks a little like a miniature temple of octagonal shape with eight curved buttresses continuing the vertical pattern of the visible ribs below. If you

have time, you may visit the original wooden model that Brunelleschi designed for the lantern. It's in the nearby Museum of the Works of the Cathedral. With this, his last design, the architect introduced to Italian architecture volutes, the spiral scrolls that both support and ornament the lantern near its base. Beneath them, shell niches top the round arches. Fluted Corinthian columns separate the taller arches containing the eight windows that light the interior. An entablature surmounts the arched windows and supports the conical top.

In short, Brunelleschi capped off an essentially Gothic church with an architectural vocabulary belonging to ancient Rome. Although the architect made a model of the proposed lantern, he did not live to see its construction; that task fell to Bernardo Rossellino. The gilded copper sphere atop the lantern was made by Andrea del Verrocchio, goldsmith, sculptor, painter and teacher of Leonardo da Vinci.

Although the dome, with its four million bricks, is not the perfect hemisphere that most Renaissance architects would have preferred, it marks a triumph of engineering and so celebrates the brilliance of this architect and those who would follow him. Neither medieval nor classical builders had devised a double dome. This was an unprecedented creation by Brunelleschi, who also invented hoisting machinery that allowed heavy stone to be raised from ground level to the work site aloft, and who devised a new kind of vessel to transport marble from Pisa to Florence on the treacherous Arno. "Renaissance man," a term not yet coined in Brunelleschi's lifetime, aptly describes this goldsmith turned sculptor turned architect turned engineer. Leon Battista Alberti, in his treatise *On Painting* (*c.* 1435), saluted Brunelleschi as "equaling or exceeding" the accomplishments of the ancients.

NOTES

1 Giorgio Vasari, *Lives of the Artists*, trans. Julia Conaway Bondanella and Peter Bondanella, Oxford World's Classics (1991; repr. Oxford: Oxford University Press, 2008), 122.
2 Alistair Moffat, *Tuscany: A History* (Edinburgh: Birlinn, 2009), 127.

CHAPTER 6

THE MEDICI PALACE, FLORENCE

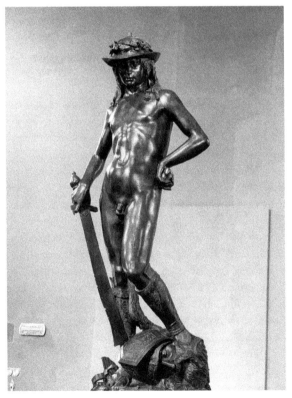

FIGURE 6 *Statue of David created for the Medici Palace, Florence.* Author's photo.

The Medici family managed one of the largest banks in Europe and sought a home worthy of their status. They hired Michelozzo di Bartolomeo to design a formidable redoubt while also providing a comfortable and fashionable home. Today this remains the most impressive domestic building in the city.

The Medici family of Florence, who managed one of the largest banks in Europe, epitomized the conjunction of wealth and culture in the Italian Renaissance. Lorenzo de' Medici, the generous patron of the arts, used his money to assemble a community of talented men, who learned from and competed with one another. Previously, most commissions originated with the Church. Now a private individual offered patronage. Lorenzo opened his doors to Brunelleschi, Alberti, Donatello, Leonardo da Vinci and Michelangelo, as well as to the philosophers Pico della Mirandola and Marsilio Ficino. Together they became the epicenter of the Renaissance. Thanks to banking and the trade in wool and silk, Florence became a financial behemoth. And because of Lorenzo's enlightened leadership, it emerged as an intellectual dynamo as well.

Families seeking to build homes worthy of their status needed to contend with the threat of civil disruption. Foreign intervention was always a possibility as, for example, the French occupation of Milan in 1494 and 1499. Individual cities lacked a police force to ensure stability. Political rivalries within cities had the potential for fomenting unrest. (Think of the Montagues and Capulets in *Romeo and Juliet*.) For protection, a substantial residence had to appear formidable. Windows, especially near the street, were a liability, formidable entrances a necessity. Wooden gates were studded with iron to strengthen them. The successful structure projected power discouraging incursion.

There is, of course, nothing especially appealing about a fortified house. How, then, to protect a family, along with its business, and, at the same time, to incorporate the most innovative architectural style? This question confronted Cosimo de' Medici, the richest banker in Florence, who wanted a substantial home for his extended family. He turned to Filippo Brunelleschi, already at work on San Lorenzo. Putting his church project aside in favor of the prestigious commission, the architect eagerly prepared a large model of his proposed building, which apparently resembled a substantial palace. Although Cosimo very much admired him, the last thing he wanted was a showplace that would suggest ambition and attract envy. According to Vasari's *Lives of the Artists*, "Filippo's virtuosity was so clearly displayed in this model that it seemed too luxurious and grand to Cosimo, and, more to avoid envy than the expense, he gave up the idea of using Filippo's plan" ("Brunelleschi," 140).[1] Perhaps the architect had suggested the use of a triumphal arch or even a temple façade. This kind of embellishment is just what Cosimo wanted to avoid lest such forms be deemed too grand for a domestic dwelling. Rebuffed, the disappointed Brunelleschi "angrily broke his model into a thousand pieces," according to Vasari. Cosimo next turned to Michelozzo di Bartolomeo, who had begun his career as a goldsmith and sculptor and assisted Ghiberti on the Baptistery doors.

He went on to make a name for himself as a designer of building ornaments and became Cosimo's favorite architect.

* * *

Begun in 1444, the palace divides the façade into three horizontal bands. The masonry of each differs from the others. On the lowest level (*piano terreno*), reserved for commercial activity, as well as for storage and kitchens, Michelozzo used rusticated stones, and large rough-hewn blocks, separated by exaggerated joints that evoked medieval fortifications. Small barred windows, high above the street, preserved security. A narrow horizontal molding, called a stringcourse, marks the dividing line between floors. (What Americans call the first floor Europeans call the ground floor.) On the second level, which Italians term the *piano nobile* (the noble, or main, floor) and which contains the principal spaces for a family as well as for receptions and entertainment, the stones look different. Called ashlar, they have beveled edges and a smooth surface. On the third level, accommodating servants and staff, still smoother stones have joints almost invisible from the ground. The wall, then, presents three distinct textures.

Topping off the façade, a carefully sculpted cornice, the ornamental molding along the top of a building, projects outward from the wall and gives the impression of massive weight. "The style and magnitude of the cornice are unprecedented in secular architecture after Imperial Rome; it was the product of Michelozzo's special affinity for the powerful, weighty forms of antique architecture."[2] By sheer size, by the use of rusticated stone, and by a lower wall higher than the levels above, the overall structure radiates strength. But despite its imposing design, the palace is not threatening. It bespeaks fortitude rather than menace.

When the Riccardi family acquired the palace in 1659, they extended its size still further, adding two more arches. Alas, they also destroyed all the splendid interiors, except one: a 1459 fresco of the *Journey of the Magi to Bethlehem* by Benozzo Gozzoli. The painting includes images of Cosimo de' Medici, Sigismondo Malatesta, Galeazzo Maria Sforza, and even Gozzoli himself! Today the painting often shows up on Christmas cards.

The consistent use of the semicircular Roman arch imposes unity on the three divisions of the exterior. The ground floor arches are huge. Although two at a corner were originally open, they were later walled up; seventy-five years after the palace was built Michelangelo added pedimented windows, which are now blind. The façade's middle level has much smaller semicircular arches.

I noticed within each of these a pair of narrow windows, called biforate because they have two vertical openings separated by a column. A circle bearing the Medici coat of arms rests above each pair. The basic design dates from the Gothic era, but the architect updated it by using slender Corinthian colonnettes (little columns) to divide the windows and by topping them with semicircular arches. The third floor has much the same arrangement though the semicircular arches above the pairs of windows are less obviously separate from the rest of the wall.

The principal arch on the ground floor opens onto the square *cortile* or courtyard, a twelve-columned loggia with Composite capitals. The combination of columns and arches in the courtyard looks much like Brunelleschi's arcade of the Foundling Hospital, but here the elements are deployed as an interior square rather than an external façade. All four sides feature columns connected with semicircular arches. Above the ground floor, a broad frieze is decorated with the Medici coat of arms, often six or seven *palle*, or roundels, on a gold ground, though the color has been lost. (The spheres may identify the family's business of banking and pawnbroking, though the blazon may represent "pills or cupping glasses," a reference to the family name meaning "of the doctors."[3]) The arms appear on carved shields throughout the building. Sculpted garlands and ribbons connect eight medallions in the courtyard frieze, most of them copied from ancient cameos and medals belonging to the Medici family. Pairs of narrow, arched windows resembling those on the exterior façade characterize the courtyard's second level. The third floor originally had an open loggia, subsequently glazed. Small columns on this top-level support the entablature. The design of this open, cubic space has a practical purpose. The colonnaded courtyard and abundant windows allow for much greater illumination of interior rooms than in medieval buildings.

In its heyday, the palace courtyard and the walled garden behind it must have been crowded with colorfully dressed power brokers, courtiers seeking favor, and entrepreneurs looking for a stake. Visitors to Florence, as well as residents simply hoping to experience the scent of money and influence, were drawn here. Artists and artisans of all kinds shared the same space as well. After all, Lorenzo, who lived from 1449 to 1492, had a gift for attracting his most gifted contemporaries. Some were businessmen, of course, some painters and architects; others were philosophers. The mixture ensured sophisticated conversation and the diffusion of ideas. In fact, it was precisely the juxtaposition of so many talents in the same place and at the same time that enabled Florence to flourish. Perhaps no more intellectually stimulating and emotionally engaging atmosphere existed in the whole of Italy. At the center, the most celebrated

figure of his day presided. He held no official political post, but he radiated authority, dignity and good humor. Only in our imaginations can we begin to recapture the exhilaration of those assemblies.

In contrast to the rugged, external façade, the interior courtyard creates a graceful ensemble. Donatello's life-size bronze *David with the Head of Goliath*, the first statue of a freestanding male nude since ancient times (*c.* 1450), once stood on a marble plinth in the center. Despite the biblical inspiration of the figure who slew Goliath, the androgynous David is emphatically secular and so evokes Roman precedent. (David is not described as naked in the Old Testament account.) In fact, the slender figure, who wears nothing but knee-high leather boots and a floppy hat adorned with laurel leaves, exerts an undeniable erotic charge. The statue has been called "one of the most sexually suggestive works of art ever made."[4] Giorgio Vasari wrote, "This statue is so natural in its vitality [*vivacità*] and delicacy that other artisans find it impossible to believe that the work is not moulded around a living body" ("Donatello" 152). David has tousled hair resting on his shoulders and a relaxed posture. One foot rests upon Goliath's severed head while a phallic feather from the dead giant's helmet creeps up David's inner thigh. It can be no accident that Donatello includes on the helmet a cameo from antiquity depicting Cupid in his chariot. In contrast to most classical statuary, this adolescent David exudes neither masculinity nor heroism, though he holds a sword in his right hand and a small projectile in his left for use with a sling. Instead, he casts a downward glance, perhaps a recognition of God's role in his victory. Vincent Cronin calls the statue nothing less than "a landmark in the history of civilization. With consummate artistry, Donatello shows the body to be the ally, not the prison, of the spirit."[5]

If you visit the courtyard today, you won't see the statue. When the Medici were expelled from Florence in 1495, David was removed from their residence and placed in the Palazzo della Signoria, the center of Florentine political life. Later it joined the sculpture collection at the Bargello Museum, the chief repository of sculpture in the city. A copy of Michelangelo's later marble statue of the biblical David now stands in the main piazza.

Having no exact medieval precedent, Michelozzo's building, completed in 1460, must have intrigued contemporaries. He managed to create a redoubt that simultaneously incorporated elements of contemporary design: a strong horizontal emphasis, rigorous symmetry, a pleasing combination of variety and continuity, and the use of the semicircular arch throughout. "The Palazzo Medici marks the rebirth of civil architecture. Here at last was a private house that was also a work of art, as beautiful in its way as many a church and meant to be admired."[6] While the exterior conveyed dignity, interior rooms were filled

with opulent decoration in the form of furniture, tapestries, carved wood, painting and metalwork. All of this fostered an image of magnificence befitting a businessman possessed of both immense wealth and good taste. When he saw the palace in 1459, Pope Pius II deemed it worthy of a king. Another contemporary, the archaeologist and historian Flavio Biondo, who wrote books called *Rome Triumphant* and *Rome Restored*, judged the palace comparable to the work of the Roman Emperors.

NOTES

1 Giorgio Vasari, *The Lives of the Artists*, trans. Julia Conaway Bondanella and Peter Bondanella, Oxford World's Classics (1991; repr. Oxford: Oxford University Press, 2008).
2 Marvin Trachtenberg and Isabelle Hyman, *Architecture from Prehistory to Post-Modernism: The Western Tradition* (New York: Harry N. Abrams, 1986), 285.
3 Vincent Cronin, *The Florentine Renaissance* (New York: E. P. Dutton, 1967), 59.
4 Alistair Moffat, *Tuscany: A History* (Edinburgh: Birlinn, 2009), 133.
5 Cronin, *The Florentine Renaissance*, 176.
6 Cronin, *The Florentine Renaissance*, 183.

CHAPTER 7

SANTA MARIA NOVELLA, FLORENCE

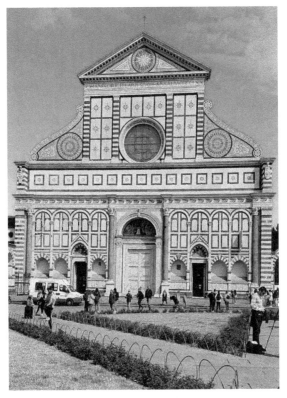

FIGURE 7 *Santa Maria Novella, Florence.* Author's photo.

European cities were filled with Gothic churches. How could such structures be made to look like buildings belonging to a new age and still retain their contents? Alberti came up with an ingenious solution: he created a new façade for a medieval building. It consists of an array of different geometrical forms that somehow seem to belong together.

55

In the era of Brunelleschi and Alberti, European cities were filled with Gothic churches containing elaborate tombs, sculptures and frescoes. To raze an existing church would therefore entail destroying valuable artistry. (Much later, when Donato Bramante expanded St. Peter's in Rome, he demolished wall paintings, mosaics, altars and relics, generating an epithet, "the wrecker.") So how could a Gothic structure be made to look like a building belonging to the new age and still retain its contents?

Leon Battista Alberti came up with a solution for the Dominican church of Santa Maria Novella in Florence, whose façade had been left unfinished a hundred years earlier. Giovanni Rucellai, who commissioned a new façade, offered to finance the project with the proviso that his name be prominently inscribed on the façade, which reads, "I, GIOVANNI RUCELLAI, SON OF PAOLO, MADE THIS IN THE YEAR 1470." With that matter settled, Alberti set about creating a wall with an array of geometrical forms outlined in white and gray-green marble. And he reached back to Rome for inspiration when he assembled these elements. The finest creator of church façades in his time, he popularized Roman pilasters and engaged columns (attached to a wall). When I arrived in Florence as a student, this was the first church I saw as I walked from the train station. I was immediately intrigued and delighted.

What inspired Alberti was the façade of the Baptistery, opposite the Duomo, widely thought to be an ancient temple dedicated to Mars though it was no such thing. (Although Florentines believed that Romans had built the structure to celebrate a victory over the Etruscans, it was actually an eleventh-century redesign of a sixth-century edifice.) Alberti must also have had in mind the small but perfect San Miniato al Monte, an eleventh-century church on a hill that overlooks Florence. A row of five round arches dominates that façade, which appears as an ominous setting in Brian De Palma's 1976 film *Obsession*. Perched above the entablature is what looks like a Roman temple front. Multicolored marble outlines a series of geometric forms: rectangles, squares, circles, and triangles. If this Romanesque façade was his primary inspiration, Alberti vastly complicated it by his interplay of vertical and horizontal lines.

On the lowest level of Santa Maria Novella, we see two sets of triple Gothic arches that do not belong to this architect's world. Part of the original church, their purpose was to house sarcophagi, a practice of the Middle Ages. The donors a century earlier had stipulated that they were not to be altered. So the arches represent a medieval survival in a Renaissance façade. Alberti incorporated them into the new wall by surmounting them with a blind arcade: a row of tall semicircular arches attached to the wall for decoration. The original Gothic arches are banded (made of alternating colors), and Alberti

repeated that banding on the tall piers (rectangular vertical supports) that frame both sides of the façade. He also used four massive engaged columns to support the cornice. Looking upward, I noticed that each level presents something different. The vertical emphasis of the columns is balanced by a horizontal row of billowing sails, the Rucellai emblem recalling the sail of personified Fortune, an apt symbol for a merchant whose business was subject to the whim of wind and wave. Just above, a row of squares that stretch across the façade divides the wall in two. A flattened, narrow classical temple front stands above, framed by four pilasters that repeat the alternating colors of the banded arches and piers below. Between the pilasters a series of rectangles stands on end; each contains a decoration. Complementing the play of vertical and horizontal forms, Alberti uses eight principal circles in the upper half of the façade. The largest of these is the rose window in the existing Gothic wall; the stained glass portrays the coronation of the Virgin. (The stringcourse on which the window rests marks the vertical midpoint of the façade). Other circles appear within the volutes that Alberti adds on either side of the temple front to disguise the lean-to roofs above the aisles of the Gothic building behind the façade, a highly innovative feature, sometimes called a scroll buttress, that also helps draw the lower and upper halves together. (Brunelleschi had earlier pioneered the use of volutes with the lantern he designed for the Duomo, and they must have been Alberti's inspiration here.) In addition to the large circle contained in each one, the volutes have smaller circles at the base and top of the spirals and even smaller circles between them. Finally, yet another circular form appears in the center of the tympanum (triangular space in a pediment), within it a radiant sun.

Described in these terms, the façade may seem impossibly complicated and therefore off-putting. But such was Alberti's genius that, when I stood in front of the church, the various forms seemed to belong together. There's a harmonic unity of parts to the whole. It is as though the architect, having unlocked a treasure chest of shapes, selected those he considered apposite and arranged them in patterns ensuring coherence. Although intricate, the careful arrangement of features achieves consistency by the principle of repetition. For instance, each of the squares separating the upper and lower halves of the façade is outlined in a dark border. White marble inlay appears within; and in the middle of each square, we see a dark disk with a stylized white star at its center. Each star is unique. The pattern pleases by its combination of variety and continuity.

* * *

Alberti's adherence to mathematics derived, in part, from his reading of the ancient treatise by Vitruvius, who explored the proportions of the human figure and its correspondence with architecture: "No temple can have any compositional system without symmetry and proportion, unless, as it were, it has an exact system of correspondence to the likeness of a well-formed human being." He demonstrated that a man with extended arms and legs fits into the figures of both a circle and a square: "if a person is imagined lying back with outstretched arms and feet within a circle whose center is at the navel, the fingers and toes will trace the circumference of this circle as they move about. But to whatever extent a circular scheme may be present in the body, a square design may also be discerned there."[1]

Leonardo da Vinci would later make an anatomical ink drawing of Vitruvian man (*c.* 1492), a naked figure with legs and arms outstretched and inscribed within both a circle and a square. The application for architects is clear: the idealized human body, with its constituent parts, provides the basis for architectural forms. In a cruciform church, for instance, the head corresponds to the chancel[2]; the arms, the transepts; and the torso, the nave. The body, created by God, finds a counterpart in the creations of humankind. Understanding the one provides the basis for achieving the other. In short, the architecture of the body is a paradigm for assembling materials of stone and wood and stucco. Mathematics, then, becomes a route to understanding the relationship between human and divine, for God built mathematical principles into the universe, and architecture makes visible the underlying order of God's creation: "Proportion, whether in the human body or in a sacred building, came to be considered the distinctive mark of beauty, and reflection of God's cosmic order."[3] In Vitruvian man, "the world of man and the world of geometry find a point of contact."[4]

Alberti, too, subscribed to the anthropomorphic principle of Vitruvius. He believed that a sense of proportion is rooted in nature. The key to achieving aesthetic excellence is to discover the principles of animating nature. Alberti, who used the words Nature and God as virtual synonyms, wrote that his ancestors "not without reason [...] declared that Nature, as the perfect generator of forms, should be their model. And so, with the utmost industry, they searched out the rules that she employed in producing things, and translated them into methods of building" (9:303).[5] In short, the pathway to realizing harmony and beauty lies in discerning the divinely designed contours beneath the often untidy surfaces of the world. Convinced of an analogy between living being and structural design, Alberti advocated that individual parts of a building should be inextricably related to one another. This, in turn, would ensure fidelity to nature.

What Vitruvius argued in antiquity found an enthusiastic reception among Italian architects of the 1400s. The façade of Santa Maria Novella constitutes a detailed, thoughtful *composition*, a term originating in the Latin words for "put together." This design demonstrates a principle that Alberti set forth in his own treatise *On the Art of Building* (written in the 1450s, published *c.* 1486), itself inspired by Vitruvius: "Beauty is that reasoned harmony of all the parts within a body, so that nothing may be added, taken away, or altered, but for the worse" (6:156). And nothing was more important than achieving that quality: "For Alberti, beauty was the overriding criterion of excellence in a building."[6] Out of shapes and colors, Alberti created a pleasing equilibrium. Everything relates to everything else. This principle served the architect's conviction that "With sacred works, especially public ones, every art and industry must be employed to render them as ornate as possible: sacred works must be furnished for the gods [...]." (8:244).

NOTES

1 *Ten Books on Architecture*, trans. Ingrid D. Rowland, ed. Thomas Noble Howe (Cambridge: Cambridge University Press, 1999), 47.

2 A *chancel* "contains the sanctuary and altar, and often embraces the choir, especially in larger churches where the chancel is part of the main body of the building east of the crossing." See James Stevens Curl, *A Dictionary of Architecture and Landscape Architecture*, 2nd ed. (Oxford: Oxford University Press, 2006), 165.

3 Vincent Cronin, *The Florentine Renaissance* (New York: Dutton, 1967), 180.

4 Michele Furnari, *Formal Design in Renaissance Architecture from Brunelleschi to Palladio* (New York: Rizzoli, 1995), 183.

5 Leon Battista Alberti, *On the Art of Building in Ten Books*, trans. Joseph Rykwert, Neil Leach, and Robert Tavernor (1988; repr. Cambridge, MA, and London: MIT Press, 1997). Citations designate book and page numbers.

6 Fil Hearn, *Ideas That Shaped Buildings* (Cambridge, MA: MIT Press, 2003), 41.

CHAPTER 8

THE MEDICI LIBRARY, FLORENCE

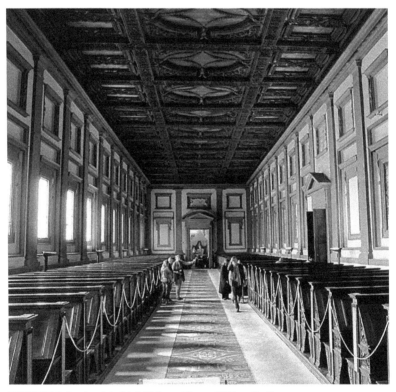

FIGURE 8 *Interior of the Medici Library, Florence.* Wikimedia Commons.

The Medici family wanted a library to house its collection of rare manuscripts and hired Michelangelo to supervise the project. What he created manifests both self-conscious stylization and a departure from traditional design. It defies convention but uses the materials of antiquity to imagine something entirely new. It delights because of its novelty.

Michelangelo may have had mixed feelings about the death of Pope Julius in 1513. The pope had been a valuable if meddlesome patron, who commissioned the sculptor to design his enormous tomb, a project that would have consumed years. Although Michelangelo had long been preoccupied with the monument, he would have been responsible for no fewer than forty statues. The sculptor/ architect/painter was now available to take on other commissions. In 1518, Pope Leo X, born Giovanni de' Medici and son of Lorenzo the Magnificent, asked Michelangelo to design a façade for the family church of San Lorenzo, Florence, which had been standing unfinished since the interior was built nearly a century earlier. The architect produced several designs that survive on paper along with a wooden model; he anticipated a façade of white marble and even visited quarries to find the best stone. He also had a workshop constructed for his use. The plans, however, never reached fruition. In March 1520, the authorities cancelled his contract, much to Michelangelo's dismay. Scavengers plundered the marble he had so carefully selected.

Michelangelo was deflected by, among other tasks, work on the New Sacristy of San Lorenzo, known as the Chapel of the Princes, which combined memorials for the Medici family and some of his finest marble sculptures. In fact, the Sacristy would become as well known for its personifications of *Day* and *Night*, *Dawn* and *Dusk*, as for other achievements, including a coffered dome. Two members of the Medici family, Giuliano, Duke of Nemours, and his nephew Lorenzo, Duke of Urbino—both in Roman military garb—sit atop their separate tombs. Some observers questioned the rendering of Giuliano, judging it as a poor likeness. Michelangelo replied: "A thousand years from now, who will care whether these were his real features?" (The tombs of Lorenzo the Magnificent and his slain brother Giuliano, originally contemplated, were never completed.)

In 1523, Clement VII, the new pope (Giulio de' Medici), commissioned Michelangelo to build a library at San Lorenzo to house manuscripts and printed books owned by his clan; actually, the library had been anticipated a century earlier when the Old Sacristy was conceived. Manuscript hunting had become a mania, and for princes, a personal library had become a status symbol. Their collections served to rescue the written and printed word because books were, as they still are, susceptible to damage or destruction from war, water, fire, rodents, insects, neglect and censorship, the refuge of scoundrels. (The greatest library of the ancient world, located in Alexandria, was destroyed by fire.) Although the assemblage is named for Lorenzo de' Medici, its patron, many of the books had earlier been acquired by Niccolò Niccoli, a scholar with a passion for archaeology, classical artifacts and ancient writing. Poggio Bracciolini said of him, "his house was always full of learned and important

men who attended upon him every day. No-one with any knowledge visited Florence without giving priority to seeing Niccoli and his books."[1] At his death, he may have owned as many as 800 manuscripts. Work began on the library in 1524, but Michelangelo departed Florence in 1534, leaving the project unfinished. Niccolò Tribolo, Giorgio Vasari and Bartolomeo Ammannati later brought it to completion.

Michelangelo was constrained by the dimensions of the site, already occupied by a building next to the Medici family church and providing living quarters for the monks. Because the new library would be situated atop an extant structure, the foundations were strengthened with stone buttresses. The library's location on the new story had a singular advantage, protecting its materials from the damp and possible flooding of the River Arno. (The devastating flood of 1966 destroyed many treasures of Florence.)

* * *

Built largely of brick and plaster, the library contains something strikingly new. Its most unusual aspect is the vestibule, *ricetto* in Italian, rising from the ground level to the building's upper floor. Although forty-four feet high, it takes up relatively little floor space. This entrance hall, much taller than wide (thirty feet square), must have struck contemporaries as peculiar. The interior, which resembles an exterior façade, defies expectations. In contrast to precedent, large Tuscan columns are paired and recessed *into* the walls of the vestibule instead of standing before them. "Michelangelo's design alters the classical role of columns, which seem to be independent from the architecture, like statues in niches."[2] Although large consoles (brackets in the shape of volutes) appear beneath the columns and seem to support them, in reality, they support nothing. On the walls we find blind windows; these deeply set rectangular spaces are blank—the faux apertures admit no light. Oddly, the frames of the tabernacle "windows," projecting slightly from the wall surface, taper downward. Surmounting them are alternating segmented and triangular pediments that project from the white stucco surface. Above the pediments are additional vacant niches, square in shape. This collection of atypical forms highlights an architectural agenda at odds with customary practice. Although the architectural vocabulary is classical, its application defies precedent.

The single most striking feature of the library's anteroom is the disproportionately large staircase. Made of gray *pietra serena*, the stairs are mostly bow-shaped and seem to grow wider and deeper as they near the bottom. With some justice, they have been compared to lava flowing from

the floor of the library downward and outward. Both sides of individual steps culminate in stone curlicues, and a low balustrade borders the stairs, left and right. Parallel to the balustrade on both sides is yet another row of (shorter) steps, conventionally straight rather than curved. The central staircase, then, is flanked by two others. Michelangelo apparently claimed that they were meant for servants, accompanying their masters, who may have needed assistance. This suggestion seems a little dubious in the sense that all the "extra" parallel steps stop about halfway to the reading room. In any event, who would have witnessed the stately parade? In strictly practical terms, the flanking steps are unnecessary. Precedents were few.

Nothing could be more unconventional than the *ricetto*. In fact, James Ackerman has written, "The restricted width and expanded height of the vestibule made an interior of a strange, irrational quality, unique in the Renaissance."[3] What fascinates me is that, when Giorgio Vasari saw it, he responded enthusiastically, delighting in the novelty: "Never before had there been seen such resolute grace in the whole as well as in the parts, as in the corbels, tabernacles, and cornices, nor was there ever a more commodious staircase: in it, he executed so many unusual breaks in the steps and departed so far from the usual custom in other details that everyone was astonished by it" ("Michelangelo," 454).[4] Despite his veneration of antiquity, Vasari was sufficiently flexible to appreciate the new direction in which Michelangelo was moving. Upon my most recent visit to Florence, I discovered to my dismay that the *ricetto* and the library itself were barred to visitors, a great shame.

Like Giulio Romano's Palazzo Te, the Medici Library manifests both self-conscious stylization and departure from traditional design. In its defiance of convention, it approaches the style that has come to be known as Mannerism, a term derived from Giorgio Vasari's *maniera* and signaling both technical skill and delight in peculiar effects. (See my chapter on Giulio Romano's palace in Mantua.) Michelangelo clearly meant to break with precedent, not to follow the lead of Brunelleschi, Bramante or anyone else. Referring to both the Library and the New Sacristy at San Lorenzo, Vasari said that Michelangelo rejected customary architectural features "because he did not wish to repeat them" (454). As a result, artists owe a debt to Michelangelo "since he broke the bonds and chains that made them all continue to follow a common path."

The vestibule is dimly lit. At the top of the stairs, however, we pass through a classical doorway topped with a triangular pediment and enter a light-filled reading room so different from the stairway that it seems almost to belong to a different building. In contrast to the *ricetto*, a horizontal rather than a vertical line dominates here. One hundred and fifty-two feet long, the room has a coffered

wooden ceiling beneath a timber roof. A wide aisle with decorated terracotta flooring divides the rectangle in two. Vertical supports align with ceiling beams to create bays accommodating two desks each, perpendicular to the walls. Windows separated by Doric pilasters ensure ample light for readers. The savvy pope requested that desks be fashioned from the wood of walnut trees, known for toughness and thus resistant to damage from those who feel the need to record their presence.

Michelangelo meant to finish the project with a triangular maze of desks for rare books at one end. The surviving plan originated in the pope's desire for a "secret library" to hold the most precious materials. This would have ensured closure for the elongated room, but Michelangelo left the project unfinished when he departed Florence. Although the reading room was largely complete, the staircase was not. He corresponded with the architects who took over construction and sent them sketches along with a wax model, though when he left Florence, forty-seven years would pass before the library finally opened. Work stopped in 1526. The Sack of Rome followed the next year, delaying completion still further. (Bartolomeo Ammannati and Vasari finished the project.)

The Medici Library, also known as the Laurentian Library, named for Lorenzo the Magnificent, did not officially open until 1571 when books stored in the Medici Palace finally made their way to the new site. Readers would now have access to 11,000 rare manuscripts. Although many of them were originally produced by pagan culture, they rest companionably above the Christian monastery below.

NOTES

1 Poggio's letter, cited by George Holmes, *The Florentine Enlightenment* (Oxford: Clarendon Press, 1992), 93.
2 James S. Ackerman, *The Architecture of Michelangelo* (1961; repr. Chicago: University of Chicago Press, 1986), 109.
3 Ackerman, *The Architecture of Michelangelo*, 108.
4 Giorgio Vasari, *The Lives of the Artists*, trans. Julia Conaway Bondanella and Peter Bondanella, Oxford World's Classics (1991; repr. Oxford: Oxford University Press, 2008).

PART II

ROME

CHAPTER 9

THE TEMPIETTO, ROME

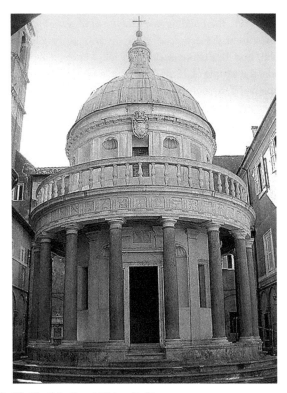

FIGURE 9 *The Tempietto, Rome.* Wikimedia Commons.

The building marks the site of St. Peter's crucifixion. It is cylindrical in shape, with a dome on top. It's not large but it came to be regarded as a précis of ancient architecture, evocative of a round Roman temple. A contemporary architect called it "a model of balance and harmony." With this structure, the designer, Donato Bramante, would mark a pivot from the Early to the High Renaissance.

Donato Bramante, raised in Urbino, worked for nearly twenty years in Milan. When the French toppled his patron Ludovico Sforza in 1499, the architect, in his fifties, moved to Rome and never left. He brought with him the expertise he had been compiling in central and northern Italy and his interest in central-plan construction. His most famous architectural design marked the place of St. Peter's crucifixion. The Tempietto is situated in the monastery complex of San Pietro in Montorio, founded by champions of the new learning, Ferdinand and Isabella of Spain in 1480, during the papacy of Alexander VI, a Spanish pope. Not long after Bramante's arrival, he built this "little temple." With Bramante's construction, the energy of the Renaissance would pivot from Florence to Rome.

Designed in 1502, the building takes the form of a *martyrium*, a Latin term designating the site of a martyr's sacrifice. In antiquity, such structures were usually circular, and Bramante decided to follow precedent. Specifically, he took as a model the temple of Hercules Victor, a round structure. He intended that the Tempietto be surrounded by a circular courtyard, which in turn would consist of a second ring of columns. The colonnaded portico was to have been set within a rectangle, with a little chapel at each of the four corners. Unfortunately, Bramante's work today lacks that courtyard, which would have echoed the shape of the round building. As a result the present setting, a confined space with right angles, seems claustrophobic. The large structures of the monastery looming over the Tempietto detract from the effect Bramante must have sought. A large iron gate, moreover, blocks access and redoubles the awkwardness of the site.

Bramante's plan unmistakably evokes the ancient world. The Tempietto is essentially a cylinder rising upon a base of three curving steps. The ground floor consists of a *cella* (enclosed room of a Roman temple, with a divine image inside), surrounded by a *peristyle*, a circular colonnade of sixteen smooth columns taken from ancient buildings. (Vitruvius favored this number.) To the gray shafts, Bramante added capitals and bases of white marble. In keeping with the assumption that Peter, fisherman by trade, was a plain man, those granite columns are a simplified Roman variant of Doric, the Tuscan, and they support a Doric entablature decorated with a frieze wherein classical *triglyphs* (literally "three [vertical] slits" formed by two grooves) alternate with *metopes* (carved square panels between triglyphs) in the manner of ancient temples, the first time since antiquity that these designs were used in a Doric frieze. Here, however, the carvings represent liturgical objects: chalice and paten, the keys given to St. Peter, an incense "boat," and papal umbrella. Tuscan pilasters, part of the cella wall, stand behind the columns. Above the frieze the architect

constructed a balustrade that has an aesthetic rather than a practical purpose; no one would likely walk around the structure on that level and risk falling off. The balustrade does, however, mark a graceful transition from entablature to drum, whereon rectangular spaces alternate with niches topped with shells, symbolic of baptism and rebirth. The niches not only ensure a pleasing combination of light and shadow but also "reveal the mass and density of the wall."[1] The high drum has the effect of elevating and thus emphasizing the cupola, a single-shell, ribbed, hemisphere made of cemented masonry. Bramante did not design the oversized finial/lantern, added later. A stairway behind the structure leads to an underground crypt. Despite the Tempietto's "classical look," neither the drum nor the balustrade belongs to antiquity. Renaissance architects, though indebted to the past, felt free to experiment.

Blue paint and gold stars cover the dome's interior, which has a diameter of fifteen feet. The white stone below has little adornment except for the seated figure of Peter in a niche above the altar; he holds the keys to the kingdom in one hand and a book in the other. A carved plaque beneath the statue depicts the martyr's crucifixion. Doric pilasters flank the statue and its enclosure. Sculpted images of the seated Evangelists appear in niches above the windows. Although the Tempietto has been called a miniature church, the interior is not really suited for a religious service. There is room only for the altar (opposite the entrance), a priest, and a server or two. Accordingly, Bramante's structure may accurately be called a chapel rather than a conventional church. In fact, it is anomalous: it looks like a cross between a giant sculpture and a tiny building. Nevertheless, it proved to be one of the most influential structures of the entire Renaissance.

* * *

In the eyes of Bramante's contemporaries, the Tempietto epitomized the essence of Roman architecture, which prized an exacting symmetry and sense of proportion. Sebastiano Serlio would later call the Tempietto "a model of balance and harmony, without a superfluous detail. The circle of the ground plan, the height of the drum, and the radius of the dome are in exact ratio to one another."[2] Bramante also evoked the past by situating the smooth columns on the exterior of his building, where the Romans would have placed them. Raphael's tapestry, *St. Paul Preaching in Athens*, devotes nearly half its space to an ancient temple inspired by the Tempietto. In his *Four Books on Architecture* (1570) Palladio included an account of Peter's mausoleum in his treatment of ancient buildings, the only contemporary structure so honored

(and implicitly a compliment to Spain). Palladio saw in it the realization of a classical ideal: "Since Bramante was the first to make known that good and beautiful architecture which had been hidden from the time of the ancients till now, I thought it reasonable that his work should be placed amongst those of the ancients" (4:276).[3] Accordingly, the Tempietto found a place in Palladio's treatise. In essence, Bramante deployed the principles of pagan architecture in service of the Christian deity. With the studiously geometric Tempietto, Bramante signaled the arrival of the High Renaissance, identified chiefly with Leonardo, Raphael and Michelangelo. In fact, Bramante has been called "the preeminent architect of the High Renaissance."[4]

For all its acclaim at the time of construction, the Tempietto exerts nothing like the same appeal today. When first built, Bramante's work contrasted with most structures in a city filled with dilapidated buildings. The aqueducts that previously brought fresh water to the populace no longer worked. The city of Caesar and Augustus had become a site of decay, which made it seem to many the symbol of a Church in disarray.

Bramante's austere design drew admiration because it synthesized the constituent parts of classical building and made it look as though what resulted was the logical culmination of architectural thinking over the past hundred years. No wonder Vasari exclaimed over its success: "nothing [is] more shapely or better conceived, whether in proportion, design, variety, or grace."[5] Without some familiarity with precedent, it's difficult to appreciate the novelty of Bramante's design. A little context allows us to see with new eyes.

The Tempietto's small size and the reluctance of authorities to allow entry to the interior limit its appeal. Every time I have visited, access was forbidden. What I know of the interior, then, is entirely dependent on photographs taken by others. As a result, I cannot say anything about how a visitor actually feels within this space, a major disadvantage, for, if I cannot enter a building and explore it, I can't get a true sense of the place. I want to savor the color and texture of the stone and stucco. I want to admire the inside of the dome and look closely at the carvings. Without this opportunity, my experience is necessarily incomplete. There is, after all, something visceral about understanding architecture. It speaks to the body as well as the mind.

Perhaps the greatest obstacle in coming to terms with Bramante's building is its situation. The architect's original intention was for the structure to be surrounded by a courtyard. The tall, undistinguished, box-like structures that surround the Tempietto keep it in shadow for at least part of every day. By their size, they seem about to encroach on Bramante's creation and snuff out its vitality. Today a location in the open—whether a clearing or a main

piazza—would make for a more enjoyable visit. Alberti observed that a temple "should address a large, noble square and be surrounded by spacious streets, or, better still, dignified squares, so that it is perfectly visible from every direction" (7:195).[6]

NOTES

1 James S. Ackerman, *The Architecture of Michelangelo* (Chicago: University of Chicago Press, 1986), 27.

2 Cited by R. A. Scotti, *Basilica, The Splendor and the Scandal: Building St. Peter's* (New York: Viking, 2006), 49.

3 *Andrea Palladio: The Four Books on Architecture*, trans. Robert Tavernor and Richard Schofield (Cambridge, MA: MIT Press, 1997). Citations designate book and page numbers.

4 Scotti, *Basilica*, 61.

5 Life of Bramante," in *Lives of the Most Eminent Painters, Sculptors, and Architects* [1568 edition], trans. Gaston DuC. de Vere, 10 vols. (London: Philip Lee Warner for the Medici Society, 1912–14), 4:143. This minibiography is not included in the translation by Julia and Peter Bondanella, used elsewhere in this book.

6 Leon Battista Alberti, *On the Art of Building in Ten Books*, trans. Joseph Rykwert, Neil Leach, and Robert Tavernor (1988; repr. Cambridge, MA, and London: MIT Press, 1997).

CHAPTER 10

VILLA CHIGI/FARNESINA, ROME

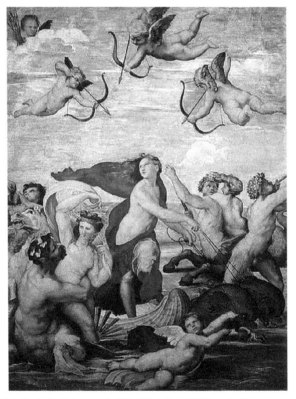

FIGURE 10 *Raphael's Galatea, at the Villa Chigi, Rome.* Wikimedia Commons.

The wealthy banker Agostino Chigi hired Baldassare Peruzzi to design a riverside home and garden. He sought an apt setting for intellectuals to visit and discuss books, listen to music, and see theatrical performances in the courtyard. He also recruited Raphael and other talented artists to decorate the interiors of his villa. The paintings remain virtually intact today.

In 1487, the banker Agostino Chigi moved from Siena to Rome, where opportunities beckoned. He founded a bank there in 1502 and became financial advisor to Popes Julius II and Leo X. As a sign of his new status, he sought a riverside home, designed, and built between 1506 and 1511 by Baldassare Peruzzi. Reputed to be the wealthiest man of his day, Agostino encouraged servants to toss the gold and silver dishes of banquet guests into the Tiber. (The canny banker hid nets on the river bottom to salvage the valuable dinner service.) Envisioned neither as a primary residence nor as an agricultural estate, this was the first suburban villa built in Rome—outside the city walls. The chief purpose of this country retreat was to entertain the rich and powerful as well as to celebrate the owner's aesthetic taste. Originally known as the Villa Chigi, the palatial structure assumed the name Farnesina in 1579 when acquired by Cardinal Alessandro Farnese. (The *ina* suffix distinguishes the villa from the Palazzo Farnese located on the other side of the Tiber.)

What looks from one side like a two-story rectangle has lateral wings on the original entrance. They project into the garden, creating an abbreviated U shape. An arcaded loggia opens onto the courtyard, which serves as a site for open-air entertainment. Between the wings, Agostino sought a temporary raised platform for entertainment, and Peruzzi, famous as a designer of stage sets in gardens and courtyards, built it. The architect would later help construct a temporary theater on the Campidoglio celebrating with extravagant spectacle the bestowal of honorary Roman citizenship on Leo X's brother, Giuliano, Duke of Nemours, and nephew, Lorenzo de' Medici, Duke of Urbino.

An entablature, with architrave, frieze, and cornice, separates the villa's two levels. Between the projecting wings on the side overlooking the garden, Tuscan pilasters flank five window bays on the ground floor. Decoration is minimal, but a terracotta frieze consisting largely of garlands held by putti tops the second floor. And quoins, alternating white and dark stone, mark the corners of the building. The flat walls are not relieved by projections such as pediments. And time has dulled the exterior. Originally adorned with monochrome paintings depicting plants, *caryatids* (draped female figures serving as columns), and *telamons* (male counterparts), the wall decoration must have softened the now austere look. Vasari reports that the outside was decorated with paintings, and we know that Peruzzi gained a reputation for the quality of such art. Virtually none of it survives.

* * *

The banker Agostino enjoyed inviting intellectuals to discuss books, listen to music or see theatrical performances in the courtyard. A reader of Greek, Agostino even set up a printing press to publish classical texts. Among them were works by Pindar, the lyric poet, and Theocritus, credited with pioneering the pastoral genre. The interior must have housed an array of splendid furniture and objets d'art. But Charles V's mercenary troops, chiefly German Lutherans and Spaniards, plundered everything during the 1527 Sack of Rome, the first time in a thousand years that the city experienced such widespread devastation. Today, the plain exterior gives no sign of the once extraordinary decoration within.

Villa Chigi's fame rests chiefly on paintings, and the single most famous is *The Triumph of Galatea* by Raphael, a fresco made in thirteen days *c*. 1511–12. Based in part on a poem by Angelo Poliziano,[1] who lived for a time in the Florentine home of Lorenzo de' Medici, the painting is located in the five-arched loggia on the ground floor. The subject belongs to Greek myth, which recounts the story of the sea nymph Galatea, pursued by the one-eyed Polyphemus, who appears in a companion fresco by Sebastiano del Piombo; the bulky cyclops has a flute in his hand used to woo the nymph. It seems that when she fell in love with a mortal man (a shepherd named Acis), the jealous Polyphemus killed him in a rage. Galatea, whose name means "milk white," changed his blood into the water of a river that now bears his name. In her flight, the golden-haired Galatea, nude but partially covered by a scarlet robe, rides in a paddlewheel seashell[2] drawn by two dolphins while three putti in the sky aim arrows below. Their targets are hybrids: powerfully built tritons (half men, half fish) pursue nereids (sea nymphs). Swirling around Galatea amid waves and wind, the creatures create a feeling of ceaseless motion: one triton clasps the body of a nereid while another blows a shell trumpet. Yet, a sense of balance informs the watery scene. Although her body describes a twisting spiral—she evidently turns backward upon hearing the music of Polyphemus—the serene Galatea, whose head occupies the exact center of the composition, grasps the reins of her conveyance. She focuses her gaze heavenward on a putto who clutches arrows but does not shoot them, an evocation of Neo-Platonic love. One of Galatea's dolphins devours an octopus, a symbol of lust.

Lunettes, hexagons, and triangular supports for the vaults cover the upper walls of this room, most of it painted by Sebastiano del Piombo. Mythological figures fill the compartments. Festoons of fruit, flowers, and foliage by Giovanni da Udine separate individual paintings on the ground floor. They evoke the interior of a pergola, a covered walkway made of light wood and covered with leafy vines, and thereby connect this room with the garden. Because the loggia opens onto greenery, the paintings ease the demarcation

between outside and inside. Originally, the arches were open. They have been glassed in to protect the frescoes.

Some of the paintings in this room are credited to Giulio Romano, some to Raphael. In panels around the upper border of the room of the first-floor loggia, Raphael and his assistants painted the story of Psyche. In *The Golden Ass*, Apuleius narrates an account of Cupid's love for Psyche and the impediments that jealous Juno used to block their union. Fifteen paintings depict the tale against a blue background, suggesting the realm of the gods. According to myth, Jupiter eventually ordered Juno to desist, and the wedding could at last take place. In the Loggia of Psyche, two large frescoes that simulate tapestries cover the ceiling. One depicts Cupid before a council of the gods, beseeching Jupiter to intercede with Venus and admit Psyche to their company; the other depicts the marriage. The two paintings may have been inspired by the forthcoming marriage of Agostino to his Venetian mistress Francesca Ordeaschi, mother of their four children. Pope Leo X officiated at the ceremony in August 1519. At the wedding banquet, Agostino gave each guest a silver plate inscribed with his coat of arms.

Concerned about the slow pace in completing the interiors, Agostino looked for a way to prod Raphael to hasten his work. The banker knew that his painter delighted in the company of women, and this distraction led to a successful ploy. According to Vasari's *Lives of the Artists*, "Raphael could not really put his mind to his work because of his love for one of his mistresses; Agostino became so desperate over this that [...] he finally managed to bring this woman of Raphael's to come and stay with him on a constant basis in the section of the house where Raphael was working, and that was the reason why the work came to be finished" ("Raphael" 328).[3]

The architect himself made the most remarkable painting in the villa *c.* 1517. We walk upstairs to the *piano nobile* and find a splendid space called variously the Sala delle Prospettive (Room of the Views/Perspectives) or the Sala delle Colonne (Room of the Columns), which served for receptions. A frieze painted against a dark background fills the top of the walls all around the room; many of the stories depicted find their inspiration in Ovid's *Metamorphoses*, a collection of mythological stories written during the reign of Emperor Augustus. Colored marble surrounds the doorways and covers the floor in a pattern of squares. The shorter walls of the rectangular room appear to open onto loggias. Twin pairs of Tuscan columns with gilded capitals and bases attract the eye. Beyond a low stone balustrade and terrace lie the countryside and buildings of Rome. A contemporary would recognize landmarks: the church of St. Augustine and Santo Spirito Hospital. Surprisingly, the colonnaded loggia is actually made

of paint, not masonry, as are the fields and buildings, a stunning trompe l'oeil display. In a triumph of perspective painting, the artist has created an illusionistic view. Peruzzi the artist merges with Peruzzi the architect. Figures on the wall painted in monochrome look like statues in niches, completing the deception. No wonder this painter's contemporaries admired his work so highly. Sebastiano Serlio celebrated Peruzzi as "very gifted at perspective" and explained how that expertise was acquired: "When wishing to record measurements of columns and other ancient things in order to be able to draw them in perspective, he was so fired by these proportions and measurements that he dedicated himself entirely to architecture and progressed so far that he was second to no one" (37).[4] Vasari reported that Peruzzi's designs at the Villa Chigi were "executed with such beautiful grace that it seems not to have been built, but rather to have sprung into life."[5]

* * *

What the various paintings of the Villa Farnesina have in common is their classical inspiration. Collectively, they breathe life into the creations of ancient civilizations. None of them depicts a specifically Christian personage. Agostino imagined his home as the modern counterpart of Roman dwellings, a place for feasting and entertainment and conversation. It supplied an opportunity to admire mythological stories painted on ceilings and walls, stroll through gardens, and listen to music. Designed above all to afford pleasure, the villa represents the powerful attraction of pagan antiquity. Rome was becoming a city of palaces taking inspiration from the ancient world.

During his busy life as artist and architect, Baldassare Peruzzi also took part in the rebuilding of St. Peter's. When Raphael died in 1520, Peruzzi was named assistant to Antonio da Sangallo the Younger, then chief architect, and Peruzzi worked in this capacity during the 1520s. His projects, then, encompassed both pagan and Christian realms.

Despite his renown, he suffered grievously during the 1527 Sack of Rome. He was taken prisoner by German troops, and, in order to prove that he was an artist, not a rich prelate, he had to draw a picture of the Duke of Bourbon, the formidable military commander killed in the initial assault on the city. Peruzzi was released but robbed of all his possessions. When he fled to Siena, his birthplace, he was victimized again en route, arriving home broke. He soon found work, however, designing palaces and improvements in that city's fortifications. In the 1530s, he divided his time between Siena and Rome. When his life ended in 1536, Peruzzi was buried near Raphael in the Pantheon, a mark

of his stature. According to Vasari's account, he died destitute. He had not been paid for all his work at St. Peter's. Two years went by before his widow managed to secure the outstanding pay her husband had earned.

In spite of the riches of the Villa Chigi, it must be one of the least visited buildings in Rome. I had trouble finding the site on a summer day and wandered for some time. Finally, I spotted two police officers and asked if they could help with directions. They looked nonplussed, but, with the assistance of a map, eventually figured out the location. I shared the villa with only two other people.

NOTES

1 In antiquity, Ovid told the story of Galatea in his *Metamorphoses*.
2 Ingrid D. Rowland, in *Culture of the High Renaissance, Ancients and Moderns in Sixteenth-Century Rome* (Cambridge: Cambridge University Press, 1998), calls the paddle wheel "incongruous" (243), for the shell is drawn by dolphins.
3 Giorgio Vasari, *The Lives of the Artists*, trans. Julia Conaway Bondanella and Peter Bondanella, Oxford World's Classics (1991; repr. Oxford: Oxford University Press, 2008).
4 Sebastiano Serlio, *On Architecture*, trans. Vaughan Hart and Peter Hicks, 2 vols. (New Haven and London: Yale University Press, 1996). Citations designate page numbers in the first volume.
5 "Baldassare Peruzzi," in *Lives of the Most Eminent Painters, Sculptors, and Artists*, trans. Gaston DuC. de Vere, 10 vols. (London: Philip Lee Warner for the Medici Society, 1912-14), 5:65. (This minibiography is not included in the translation by Bondanella and Bondanella, used elsewhere in this book.) Vasari adds that Peruzzi "gave attention to perspective, and became such a master of that science, that we have seen few in our own times who have worked in it as well as he."

CHAPTER 11

VILLA MADAMA, ROME

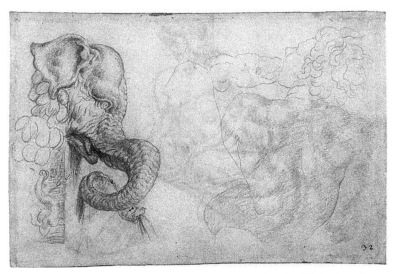

FIGURE 11 *Sketch by Maarten van Heemskerck of the elephant fountain, Villa Madama, Rome.* Wikimedia Commons.

The future Pope Clement VII hired Raphael to design a sumptuous secular building on the outskirts of Rome. It exceeded in size that of any similar building in Rome. The scope of the project was unprecedented, for Raphael sought to include an array of architectural features popular in antiquity. And the villa was adapted to its topography and thus reconceived the relationship between artistically crafted construction and natural setting. In effect, the villa reached out and incorporated its surroundings.

In 1508, the young Raphael, having spent four years in Florence, arrived in Rome and remained there until his death twelve years later. He found a patron in Pope Julius II and quickly achieved renown for his murals in the Vatican. The most spectacular of them decorates the pope's Stanza della

Segnatura (room of the signature). Leo X, who succeeded Julius, converted his predecessor's library to a place where he signed and sealed documents, hence the name. Here classical and Christian cultures converge. One wall depicts *The Debate over the Holy Sacrament*, another *The Cardinal and Theological Virtues*; and a third shows *Mount Parnassus*, sacred to the god Apollo and home of the Muses.[1] The fourth has come to be known as *The School of Athens* (*c.* 1508–12), a twenty-five-feet fresco depicting the most eminent thinkers of the Greek world. At the center stand two figures, each with book in hand, representing schools of ancient philosophy. (In antiquity, of course, the books would have had the form of tablets or scrolls).

An implied vertical axis divides the fresco in half. On one side Plato, concerned with ideal forms, holds his *Timaeus* and points toward the sky, the realm of ideal forms; on the other, Aristotle, concerned with evidence of the senses, holds his *Nicomachean Ethics* and gestures toward the earth. The two philosophers preside over mathematicians, philosophers, astronomers, and scientists, distributed across the picture plane. Various personages are divided into smaller groups, whom we see in perspective. The thinkers of antiquity reveal their identities by gestures, expressions, and characteristic actions. Ptolemy holds a terrestrial globe. Pythagoras writes in a book. At least some figures have the faces of Raphael's contemporaries: Plato, for instance, has the visage of Leonardo da Vinci. A seated Michelangelo represents a disconsolate Heraclitus, seemingly lost in thought and leaning on his elbow, which rests upon a stone block. Euclid, demonstrating a math problem with a compass, has the features of Bramante; his portrait "is so well done," reports Vasari, "that he seems no less himself than if he were alive" ("Raphael" 313).[2] If you look closely, you will see Raphael's name written in golden letters on the architect's collar. On the right, the painter includes a portrait of himself wearing a black velvet beret!

Three tall barrel-vaulted arches partially open to the sky and, receding into the distance, tower above the human figures. Statues of Apollo and Minerva in niches overlook the thinkers below. Some observers detect the influence of Bramante and the Basilica of Maxentius, finished by Constantine in the early 300s. We don't know exactly what Raphael intended this building to represent, but it looks more Roman than Greek and takes up fully half the painting. It's not clear, moreover, whether the painted figures occupy space within a structure or on a terrace outside. What we can say is that the setting of *The School of Athens*, by its size and design, reveals the painter's fascination with architecture and the effects it could achieve. In this instance, it imbues the figures below with grandeur. With some justice, Raphael has been called "the purest expression of the High Renaissance."[3]

Raphael's expertise was recognized when, upon the death of Bramante, he took charge of rebuilding St. Peter's. Later, only a couple of years before his own death, he was given an opportunity to create a sumptuous secular building. Cardinal Giulio de' Medici, the future Pope Clement VII, commissioned him to design a villa on the outskirts of Rome *c.* 1516. Raphael was fortunate in collaborating with Clement, who spent his early years in the Medici Palace, Florence, where he imbibed new styles of art and architecture. Located on the slopes of Monte Mario, the so-called Villa Madama (as it is known today) has been called a *villa suburbana*, meaning that it was located near an urban space and intended chiefly for recreation and entertaining rather than for agricultural production or habitation. It also served to welcome and accommodate visiting dignitaries before their formal entry into the city.

* * *

The villa's distinction was threefold. First, its sheer size exceeded by far that of any similar building in or near contemporary Rome. Second, the scope of the project was unprecedented, for Raphael sought to include an array of architectural features popular in antiquity. Third, the villa was adapted to its topography and thus reconceived the relationship of artistically crafted construction and natural setting. In effect, the villa reached out and incorporated its surroundings.

By inclination, Raphael was an antiquarian, something that Pope Leo X recognized when he named the painter/architect Superintendent of Roman Antiquities. When Raphael contemplated the design of a new villa, not surprisingly he looked to the ancients for inspiration. He studied the ruins of Hadrian's villa in Tivoli, just outside Rome. And he sought literary evidence, especially in the work of Pliny the Younger (*c.* CE 61–112), an ancient lawyer and magistrate, who in his letters described his Laurentine and Tuscan villas. He studied Vitruvius's work on architecture and the treatises of Leon Battista Alberti. On the basis of his research, Raphael proposed incorporating features that any ancient Roman would recognize. He said that the villa was meant to emulate those built in antiquity. In addition to a network of gardens on a series of terraces, for instance, he envisioned an outdoor amphitheater with semicircular seating in imitation of ancient structures. This was to have been built into the hillside and occupy the highest point of the estate. On a lower terrace, he planned a circular space surrounded by a colonnade. And he built a nymphaeum, a combination of spring or fountain and statuary evoking pastoral life, a place for rest and recreation. He also planned a hippodrome, an

oval-shaped course that ancient Romans used for chariot races, though here it would accommodate foliage rather than horses. (Pliny the Younger describes such a garden at his Tuscan villa, and the Emperor Hadrian built one at his villa in Tivoli.) Beyond the hippodrome was a grotto cut into the hill. Still lower on the estate, he planned stables to accommodate the horses needed for the pope's entourage. All of these features were situated along the hillside, but it's uncertain whether overall symmetry was Raphael's principal goal. A visitor strolling through the estate might not readily find a spot from which all the various features emerged as parts of a single design. Less than half of his plan, however, was completed, so we cannot be sure exactly how the estate would have looked when finished.

Raphael defied precedent by placing an unroofed and walled *cortile circolare*, or circular courtyard, at the center of his chief structure. Tall engaged columns are set into the wall at intervals and, between them, rectangular window bays, each flanked by smaller ionic columns. On opposite sides of the courtyard were rectangular blocks subdivided into compartments: on one wing, Summer rooms, and on the opposite, Winter quarters. Unlike most contemporary structures, this villa has its *piano nobile* on the ground floor, an unusual arrangement justified by its situation: the building is essentially married to the hillside. The most important surviving interior is the huge garden loggia, a great hall topped with a high dome supported by richly decorated arches, evocative of Constantine's Basilica. In keeping with the emphasis on size, the pilasters are colossal, that is, extending above one floor. Niches on the walls await sculpture. The loggia looks out on a garden seen through three arches that were originally open. In modern times, they have been glassed in. Walking through the rectangular garden, in effect an extension of the loggia, a visitor encounters a classical gateway topped with a pediment. Colossal statues made of stucco, executed by Baccio Bandinelli, guard entrance to another section of greenery.

* * *

What makes the estate especially innovative is its fusion of house and garden. The site required Raphael to ponder anew the relationship between structure and topography. He decided to capitalize on both rather than subordinate one to the other. Joining the interior and exterior, a triple-arched loggia offers views of the garden and the Tiber Valley. Terraces carved out of the hillside provide space for elaborate designs in foliage, the horticultural counterpart of decorated columns, pilasters, domes and walls within. Almost certainly a cross pergola

would occupy a rectangular area, with a pavilion at the center. Waterworks figure prominently in the form of fountains and pools. A staircase alongside the retaining wall of the garden nearest the villa leads down to a fish pond. Three semicircular recesses topped with half domes face the water. Niches within these chambers once held statuary. Records indicate that even more statuary was distributed throughout the garden; for instance, there were at least two images of Jupiter and images of the seated Muses as well. All this has vanished. What does survive at the center of the inner-garden wall is a marble, elephant-head fountain within a niche; the animal's trunk once spurted water into a Roman sarcophagus. Giovanni da Udine, responsible for much of the stucco work and some of the painting, made this ornament, basing it upon an ancient fountain discovered in the temple of Neptune. Alas, the original, which had been found on the Palatine Hill, is lost.

When Raphael settled in Rome, Italy had long occupied a special status in European gardens. As early as 1494, the French King Charles VIII, having invaded Naples to claim that kingdom for himself, found himself astonished by a garden he saw there—a combination of greenery, statuary, pavilions, and fountains. (Unfortunately, we don't know how the constituent parts were arranged.) Returning to France, Charles brought with him Pacello da Mercogliano, the designer of the garden he so admired. Thus began the gradual assimilation of Italian principles into northern European landscapes.

At the Villa Madama Raphael made a signal contribution, drawing from what he read in Leon Battista Alberti's treatise on architecture. Henceforth gardens would increasingly become extensions of architectural structures, not afterthoughts. Many of the principles that informed the creation of houses would guide the layout of gardens. They became works of art, employing the talents of sculptors, masons, stucco artisans, hydraulic engineers, and, of course, gardeners.

Had Raphael not suffered premature death in 1520, the villa would have become one of the glories of Rome, a locus of classical culture in the contemporary world. Sebastiano Serlio's book on architecture compliments the loggia there as "extraordinarily beautiful" (238). Believing Bramante's taste a little austere, Raphael seemed poised to introduce greater flair to his designs; we know, for instance, that he favored colored and veined marble for interiors. Because he died suddenly at the age of thirty-seven, however, he could not shepherd his plan to completion. The circular courtyard was left half-finished; the Winter wing never reached fruition. The gardens have mostly disappeared except for the *giardino segreto* (private garden), which was ordinarily restricted for use by the pope and his entourage.

After the architect's death, Giulio Romano and Antonio da Sangallo the Younger took over the project, which had remained unfinished and then partly destroyed. They squabbled over their responsibilities, and Giulio de' Medici, elected pope in 1523, assigned Bishop Mario Maffei, "a patron of architecture,"[4] to mediate and oversee the enterprise; he called both Giulio and Antonio "madmen." Work tapered off as money was diverted to fund the more urgent rebuilding of St. Peter's Basilica and the Belvedere Court at the Vatican. The May 6, 1527, Sack of Rome by Charles V's rogue troops proved calamitous: they set the unfinished villa ablaze. The unlucky Clement VII, whose father Giuliano had been assassinated in Florence's cathedral, is said to have watched in disbelief from his refuge at the Castel Sant'Angelo as imperial troops burned the villa and trashed the city, a story that may be apocryphal. What we can say is that the remains of the villa represent only a fragment of Raphael's vision. When the pope died in 1534, expectations for restoring and finishing the estate effectively ended, and it became increasingly dilapidated. Near the end of the nineteenth century, the estate was in parlous shape.

Fortunately, drawings by Antonio da Sangallo the Younger, who oversaw construction, offer some idea of what Raphael envisioned, and the 1519 draft of a letter bearing Raphael's name that found its way into the hands of Baldassare Castiglione describes at least roughly what he intended. He takes the reader on a walk through the property, explaining its principal features. So much of the original site has been lost (or never begun), however, that modern reconstructions of the villa and garden remain speculative. We can say with confidence that in addition to enjoying a garden loggia, visitors would stroll through a series of garden terraces. A ramped staircase (*cordonata* in Italian) led downward to levels carved out of the hillside and supported by retaining walls. The surface of an enclosed flat garden would have been subdivided into geometric units, called *compartimenti*. Judging from other sixteenth-century gardens, we surmise that there would have been a pavilion at the center of a tunnel-shaped cross-pergola, offering protection from the sun on warm days.

* * *

What remain today are most of the interior designs on the ceilings and walls of the extant building. Frescoes based on Ovid's *Metamorphoses* furnish much of the decoration. Something else, however, inspired Raphael. In 1495, a youth slipped through a soft spot in the ground and found himself in a frescoed room filled with

rubble. This turned out to be part of Nero's *Domus Aurea*, or Golden House, the largest and most sumptuous palace in the world, occupying 300 acres; work had begun *c.* CE 65. The site featured a 120-feet gilded bronze statue of Nero himself. Its immense size perhaps led to coining the word "Colosseum" for the nearby amphitheater. (The historian Suetonius reported that, upon finishing the house, Nero said, "At last I can begin to live like a human being.") Because the decorated room found by accident was subterranean, the word *grottesche*, which derives from the word *grotta*, meaning cave, was applied to the artwork. As an adjective in English, this term is rendered not very satisfactorily as "grotesque." Such spaces had nothing to do with naturally formed caverns. Instead, the word designates complex interior decoration made of paint and stucco in ancient buildings found underground. The rubble that filled the chambers of the Golden House was deposited there to bury the memory of the demented Nero and to support the Baths of Trajan, built on top. The discovery of the Golden House served as an inspiration to Raphael. The artist had himself lowered into the underground chambers by rope to see what the ancients had created. Perhaps it's just a coincidence, but Raphael seems to have been drawn to the architecture of Nero's era.

The wall and ceiling painting that he and his contemporaries discovered consists of fantastic creatures, human figures, foliage, masks, animals and ribbons—all loosely connected. Perhaps because they adhered to no rules, they struck contemporaries as eccentric, the very antithesis of what we call "realistic." But Raphael found grotesques fascinating. He experimented with such ornamentation in his paintings at the Vatican, and he planned to make extensive use of it in the villa. After his death, Giulio Romano, before departing for Mantua, and Baldassare Peruzzi painted the frescoes. There may be no finer expression of the grotesque style than the villa's, and it would provide a model for future artists. Vitruvius had no use for the grotesque, which he thought untethered to architectural rules and therefore unsatisfactory. Despite this opposition, Romano and Peruzzi, like other architects of their time, thought for themselves and departed from precedent when they deemed it appropriate.

Ownership of the villa changed hands several times. Margarita of Austria, daughter of Emperor Charles V, acquired it when she married Alessandro de' Medici, Duke of Florence, in 1536. Through her second marriage, Margarita became the duchess of Parma. She was known as "Madama," hence the name by which the site has come to be known. (Sometimes it is called the Villa Medici, in honor of Cardinal Giulio de' Medici, who first conceived of the estate.) Today the government owns what remains. The villa now accommodates such official functions as entertaining heads of state. Public access is severely restricted. I have never been able to visit the site.

NOTES

1 "Mount Parnassus, the mythical home of Apollo to which he brought the nine Muses, was generally conflated with their former home on Mount Helicon." Claudia Lazzaro, *The Italian Renaissance Garden* (New Haven and London: Yale University Press, 1990), 132.

2 Giorgio Vasari, *The Lives of the Artists*, trans. Julia Conaway Bondanella and Peter Bondanella, Oxford World's Classics (1991; repr. Oxford: Oxford University Press, 2008).

3 R. A. Scotti, *Basilica, The Splendor and the Scandal: Building St. Peter's* (New York: Viking, 2006), 95.

4 Ingrid D. Rowland, *The Culture of the High Renaissance: Ancients and Moderns in Sixteenth-Century Rome* (Cambridge: Cambridge University Press, 1998), 21.

CHAPTER 12

FARNESE PALACE, ROME

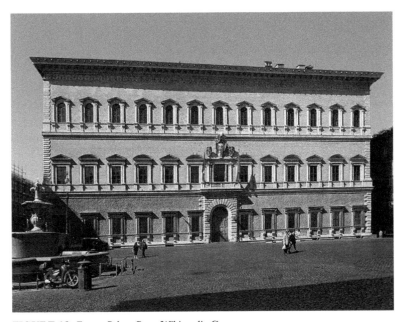

FIGURE 12 *Farnese Palace, Rome.* Wikimedia Commons.

Alessandro Farnese, who became Pope Paul III, sought a residence for his family. A student of humanistic study and an enthusiast of new learning, Farnese hired Antonio Sangallo to create a grand structure that would prove to be the largest secular building in Rome, one that expressed its intellectual debt to classical Rome.

Born in 1486 under the proverbial lucky star, Alessandro Farnese came from a wealthy, aristocratic family. He spent time at the court of Lorenzo de' Medici, a site of humanistic study, where young men absorbed the new learning. He enjoyed rapid success as a prelate, achieving the rank of cardinal at twenty-five

and becoming pope in 1534. As Paul III, he would prove to be a patron of the arts and a supporter of the Vatican Library. And he would indulge his taste for ancient artifacts: he raided the Baths of Caracalla for statuary.

Before he became pontiff, Farnese sought a home befitting his prominence and providing a residence for his two sons. He began by rebuilding a structure on the site of what would one day become his palace. (It's now the French embassy.) To this end, he hired Bramante's most talented assistant, Antonio da Sangallo the Younger, trained by his uncles Giuliano and Antonio the Elder. Construction began in 1517. When Farnese was elected pope many years later, he sought to expand vastly the scale of the edifice. Sangallo, accordingly, reconceived the structure, transforming it into something much grander. In order to create a large piazza to show off the palace, the pope demolished two blocks of houses and shops.

* * *

Upon my arrival, I felt uneasy. I did not immediately like what I saw: a three-story structure with dark stone on the ground floor, and yellow brick above. My feeling surprised me because I have admired almost every Renaissance structure I've encountered in my travels. Staring at the façade, I said to myself: something is not quite right. The longer I lingered, the more puzzled I became. Initially, I couldn't figure out what bothered me. What I immediately sensed, however, was that the building didn't look approachable. Admittedly, a palace meant to impress the observer with the occupant's prosperity and power need not engage the viewer. But this structure had a distinctly impersonal look. It looked like an office building in Renaissance garb. The huge size doesn't help. When completed, the palace was the largest secular building in Rome: 185 feet wide and ninety feet high. A freestanding rectangle, it is meant to be unique.

Like other palaces, this one has three stories. The façade seems larger than it otherwise might because the architect chose not to employ columns or pilasters to divide the façade vertically. A horizontal pattern prevails. Though thin stringcourses separate the levels, brick covers them, creating a monolithic look. Contributing to the impersonality of the building is a change made when the pope decided that he wanted a larger cornice than the one Sangallo had proposed. A competition was held and Michelangelo won. He took over the project upon Sangallo's death in 1546 and built the imposing top section of the entablature. In order to prevent it from dominating the façade, Michelangelo increased the height of the top floor by ten feet. Even with this change, however, the cornice casts a deep shadow at certain times of the day, making the building appear slightly top-heavy.

A phalanx of windows, all resting on supporting stones forming a bracket dominates the facade. It looks as though the architect sought to introduce variety by using a different kind of window on each level. Plain lintels top the rectangular windows on the ground floor, while windows on the second and third floors are more elaborate. Framed by slender engaged columns with a pediment above and projecting from the wall, they are called aedicules or tabernacles.

The cavalcade of windows combined with the size of the façade enforces a principle of repetition that causes the palace to look massive. Symmetry, a form of discipline, can offer reassurance. Without the relief that complementary vertical elements could have supplied, however, the sheer number of windows, in strict rows, feels slightly oppressive. The palace wants me to feel a sense of awe. I'm being invited to give assent to something on account of sheer size. But the dimensions work against the intended effect. More rigid than elegant, the immense wall flirts with monotony. I can easily imagine platoons of secretaries, accountants and other functionaries laboring behind those windows, eagerly awaiting the end of the working day. Their palace lacks a pulse.

Michelangelo must have realized that the monolith he inherited was not entirely satisfactory. So he enlarged the entrance with rusticated white stone around the doorway on the ground floor, supplying a focus of visual interest. He embellished Sangallo's wide central window above the entry, framing it with four recessed columns. He also enlarged the papal coat of arms above, and he added a small, balustraded balcony projecting from the wall. To complete the transformation, the architect employed rusticated quoins of the kind used in military architecture. These white rectangular stones, contrasting with the brick wall, appear at the ends of the façade in a staggered pattern alternating long and short; they grow smaller with each floor above. Because they resemble the same kind of stone that Michelangelo used on the new entrance, they help unify the overall design and give the walls a finished appearance. Even with the later architect's changes, however, the façade still casts a severe look on the piazza before it and on those of us standing there.

Michelangelo planned a bridge over the Tiber to link this palace to the Villa Farnesina, which belonged to the same family; its first arch is all that remains. The architect, besieged by other commissions, did not live to see the palace completed. Vignola succeeded Michelangelo in 1550. Giacomo della Porta finished the wall facing the river.

With a sense of relief, I walked through a barrel-vaulted passageway, with Doric columns inspired by the façade of the Theater of Marcellus in ancient Rome, and found myself in a *cortile*, ninety feet square. This much-admired courtyard belongs to Sangallo and provides one of the chief reasons to visit this site. Here we find

variations of the repertoire of windows and pediments displayed on the façade, and they follow the customary pattern of classical Orders—Doric, Ionic, then Corinthian. The lowest level of the courtyard consists of a loggia made of Roman arches supported by Doric piers and half columns, which, in turn, support an entablature of classical metopes and triglyphs.

When he took over construction, Michelangelo left this floor intact. But on the second, where Sangallo had created an open arcade, his successor filled the arches with masonry. Between the Ionic columns, he added pairs of tall, slim windows topped with triangular pediments. And on the entablature above he added a frieze of festoons. Michelangelo's third level consists mainly of a solid wall with narrow Corinthian pilasters and windows, topped with segmented pediments. In keeping with raising the height of the building's third floor, Michelangelo raised the height of the courtyard's third story so that it's taller than Sangallo's floors below.

* * *

The Farnese palace speaks much the same architectural vocabulary on view elsewhere in Renaissance buildings—hence its allegiance to the principles of symmetry, uniformity, and regularity. The overall effect here, however, is slightly cumbersome. The monumental façade seeks to make a virtue of austerity. The two fountains in the piazza plundered from the Baths of Caracalla, fail to soften the prospect.

What we do not see on the exterior of the palace, apart from the pope's coat of arms, is any indication that this property belonged to the leader of the Christian Church. As pontiff, his religious credentials were beyond reproach. Yet in virtually every respect, the Palazzo Farnese looks like a secular building. And religious imagery is conspicuous by its absence from the palace interior. His descendant Cardinal Odoardo Farnese commissioned Annibale Carracci to paint the walls and ceilings *c.* 1595–98. His work, consisting of a veritable cornucopia of mythological figures, bespeaks a fierce energy. The High Renaissance ideal of magnificence manifests itself everywhere. In one gallery we see *The Triumph of Bacchus and Ariadne*, his chariot drawn by tigers, hers by goats. On this huge barrel-vaulted ceiling, the gods, surrounded by nymphs, satyrs, and maenads, stare confidently at the viewer. Ancient myth never found a more comfortable setting. Paul III and his descendants could not have harbored doubts about constructing and decorating the family home out of forms originating in the pagan world. In this respect, he reveals himself as a sophisticated prelate, secure in his religious beliefs and unthreatened by the materials of classical antiquity.

CHAPTER 13

THE CASINO OF PIUS IV, ROME

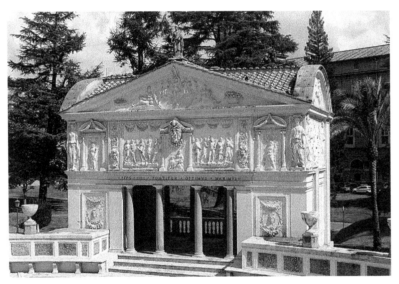

FIGURE 13 *Loggetta of the Casino of Pius IV, Rome.* Wikimedia Commons.

Situated on the grounds of the Vatican, the casino, or little house, was conceived as a refuge. It is decorated by an array of exterior sculptures and a display of frescoed paintings inside. Providing inspiration for the program of decoration is the mythology of ancient Rome.

In 1558, the elderly Pope Paul IV initiated a plan for a shelter in the woods near St. Peter's. He sought a respite from the parade of visitors with their incessant politicking at the Vatican, whose name derives from the Latin *vati*, designating the soothsayers of pagan Rome. The unpopular pontiff, who introduced the notorious *Index of Forbidden Books*, had no use for the classical past; he had ancient statues removed from the Villa Giulia and countenanced the banishment of such statuary elsewhere. Paul, who has been called "fanatically religious,"[1] did

not live to see the completion of his refuge, and the project might have ended at his death the next year. But his successor, Pius IV, decided to press forward. For guidance, the new pope turned to Pirro Ligorio, steeped in antique culture. He was an indefatigable collector of ancient coins and a classical archaeologist in charge of excavations at Hadrian's villa in Tivoli, as well as chief architect of the Vatican Palace. Ligorio, who apparently had not previously designed a building, finished the Casino, or summerhouse, by 1562. Not intended to serve as a formal residence, it is sometimes known as Villa Pia in honor of Pope Pius.

Situated on a hillside in a *bosco* (woods), the Casino of Pius IV was inspired by a villa at Pliny the Younger's ancient estate. Although it was originally planned as a one-story structure, a second was added later. Directly in front lies an oval courtyard (like Pliny's) surrounded by a low wall, and a fountain at the center.[2] Facing the villa and a little lower on the steep slope is the much smaller Loggetta, intended for accommodation. On opposite sides of the elliptical courtyard, free-standing, pedimented gateways provide access. Not until the visitor enters the oval space between the two buildings can the opposite façades of the casino and loggetta be seen in their entirety.

The ensemble today differs from its original appearance. When Pius V became pope in 1566, he stripped sculpture from the site. A frugal Dominican monk, he saw nothing worthy in ancient statuary. He said that "it did not become the successor of Peter to have such idols in his house." And so he gave twenty-six sculptures to the Grand Duke of Tuscany. During his reign, Pius achieved an ignominious trifecta: he deplored "pagan" art, opposed religious reform, and made anti-Semitism his official policy. He also provided an unfortunate precedent for later "refurbishments." Four satyrs in the shape of Pan on the ground level of the loggia were removed in the nineteenth century. Dull pilaster strips replaced the half-man, half-goat figures. Caryatids were also banished. Fortunately, elaborate frescoes, most of them biblical, remain in the interiors. According to Vasari, they originated with Pius IV. Chief among the painters was Marcantonio da Mula, appointed Vatican librarian in 1565.

* * *

Viewing the Casino after seeing the earlier palaces of Florence, I immediately noticed a difference. I saw neither the elaborate stone or brickwork that differentiates the levels of earlier buildings like the Palazzo Medici nor the gradations of capitals incised in the façade of the Palazzo Rucellai. Instead, I was confronted with what looks like three horizontal bands, each of which presents the most extraordinarily detailed decoration in the form of statuary,

plaques, reliefs and festoons. (The high vaulting of the Casino's second level makes it look from the outside as though there are three floors.) The eye of the beholder is nearly overwhelmed by the stucco reliefs, the building's most distinctive feature. When the Casino reached completion, nothing like it existed in Rome.

Ligorio, who began his career as a painter of house façades, all of which have vanished, was chiefly responsible for the decoration as well as the architecture. As a student of mathematics, he seems to have conceived the overall design as a series of variations on the number three. The loggia on the ground floor, defined by Doric columns, has three openings in the oval courtyard. When our eyes move to the second story, we see three large compartments defined by pilasters decorated with fruit-bearing branches, acanthus leaves and vines. The central compartment is itself divided into three. The top level has a central compartment of three windows.

To understand Ligorio's purpose, we must consider the middle level. Rectangular plaques within frames on the left and right hold images inspired by classical mythology. In itself, this was not uncommon. After all, mythology was the cultural currency of the Renaissance. Most people would, for example, readily identify Venus with romantic love, Mars with war, Diana with virginity, and so forth. Painters, sculptors and poets used such figures as a kind of shorthand.

What particularly marks Ligorio's handling of myth, however, is its arcane nature. For example, within a plaque, we see an oval with Pius IV's coat of arms, which includes the papal tiara and the keys to the kingdom granted to Peter. On either side are winged angels who project from the wall and seem about to fly off. So far, clear enough. More mysterious are two standing figures in a large arched panel to the left. These are labeled *Aegle* and *Solis*, a small winged putto between them. *Aegle* bears a shield decorated with a winged Medusa head resting upon a plinth. *Apollo* bears a lyre that rests upon another plinth. A surviving drawing in Ligorio's hand identifies the figures as *Haegle* and *Apollinis* (Apollo), but there's a problem. How many viewers could identify Aegle, consort of Apollo and mother of his daughters? There's another difficulty too. Both Ligorio's preliminary drawing and his stucco version of Apollo here, a male god, look somewhat feminine.[3] How may this be explained? Ligorio must have known that in Hellenistic times Apollo could be conceived as androgynous. But how many of his contemporaries knew this? There's yet another anomaly as well. To the right of the papal coat of arms, a rectangle surmounts an arch. Within it stand three winged sisters labeled Eirene, Dike and Eunomia. Sometimes identified as the daughters of Zeus and Themis in Greek myth, they embody, respectively, peace, justice and good order. Only an expert on classical

culture, however, would likely recognize them. The decoration on the Loggetta facing the Casino is even more obscure.

How may we account for the visual choices? It's entirely possible that the pope himself or his advisors were responsible for some of them. But Ligorio, from the beginning of his career, had a fascination with Rome second to none. In fact, he took part in excavations of ancient sites and recorded them in his notebooks. While in Rome, moreover, he compiled an encyclopedia of artifacts produced in antiquity; he planned an illustrated work in fifty books. Later, in Ferrara, he wrote a new version of his encyclopedia in twenty-four books. Although both versions survive in the manuscript, neither found its way into print. Had they reached publication, the architect would be better known today. Nevertheless, they establish Ligorio's engagement with Roman culture and the extraordinary breadth of his knowledge. Daniele Barbaro, himself a student of antiquity and owner of a Palladian villa, wrote that Ligorio "is as learned as anyone who can be found, to whom is owed infinite and immortal thanks for the study of which he has made and makes regarding antique objects for the benefit of the world."[4]

Examining the stuccowork, I asked myself: What would the Casino's façade mean to a typical observer? The answer is very little if anything. So why did Ligorio deploy his erudition in this fashion, risking the puzzlement of beholders? Because he knew that the people of Rome would never see the Casino, tucked away in a woodland retreat within the grounds of the Vatican. Ordinary folk would therefore never have had occasion to scratch their heads in wonderment over the complex designs. Most people admitted to the precincts of the Casino were educated and cosmopolitan. In fact, they may well have felt complimented by the challenge to understand what they saw. Ligorio offered the cognoscenti not only the opportunity to appreciate his and his patron's learning but also to demonstrate *their own* acuity.

* * *

Solving visual puzzles was a favorite pursuit, which gained currency when the peripatetic traveler Cristoforo Buondelmonti found Horapollo's *Hieroglyphica* on Andros, an island in the Aegean Sea. The manuscript, which apparently originated in the fourth or fifth century, purported to explain the meaning of 189 Egyptian hieroglyphs by translating them into Greek. When Buondelmonti brought the book to Florence in 1419 and gave it to Poggio Bracciolini, it created a sensation, for the combination of symbols and text promised access to the secret visual language of ancient culture. Contemporaries did not realize,

however, that many of the figures and signs were not in fact Egyptian. Nor did they appreciate that what they deemed symbolic might be an indication of sounds, thus a form of writing. Nevertheless, inspired by Horapollo, they began to emulate what they saw and invent their own designs. Leon Battista Alberti, for example, chose a winged eye surrounded by a wreath as a personal symbol, with implications for God's omniscience, time's passage and the value of sight. *Hieroglyphica* was later translated into Latin for the benefit of those who knew no Greek, and Aldo Manuzio's printing of the book in 1505 ensured a still wider audience, inspiring writers and artists to contemplate hidden meanings in pictorial symbols. Ironically, though, contemporaries of Manuzio never did succeed in unlocking the secrets of Egyptian hieroglyphs. That would have to await the discovery of the Rosetta Stone.

In the Middle Ages heraldry, chiefly in the form of geometric shapes painted on shields, banners and lance flags, had become essential to the nobility, eager to proclaim their identity at ceremonies and state funerals. In warfare knights customarily bore shields with family crests, an asset amid the confusion of battle; the conjoined forces in the Crusades must have needed such markers. In the 1400s, heraldry became increasingly elaborate, partly in response to the discovery of Horapollo's book and partly to meet a demand for new designs. Aristocrats or their artisans customarily devised *imprese* (coats of arms) uniting symbolic pictures and brief mottoes. Tournaments, for example, virtually required such symbolism. In some instances, the designs captured the character of a particular person or the history of a family. Such identification could appear on surfaces anywhere, from armor to pennons, from stonework to dishware. Architecture too became a site for displaying heraldry; the gatehouses of great houses proclaimed the owner's identity through carved shields bearing coats of arms. Within houses floor tiles, mural decorations and stained glass accomplished much the same purpose. In each instance, the viewer was invited to appreciate the ingenuity of the connection between the visual and the verbal.

Such an alliance takes dramatic form in *Pericles*, in its day one of Shakespeare's most popular plays. There a group of knights seeking to impress a king's daughter parade before her at a tournament. The pages of the knights present their masters' shields to the princess. She, in turn, proceeds to describe the *imprese* painted on the shields and reads aloud the Latin mottoes; her father briefly interprets the symbolic pictures. Even if many of the spectators in London's Globe Theater were illiterate, they would presumably have watched and listened with fascination as a woman used her knowledge to enumerate succinctly each enigmatic design.

The same taste for elucidating the obscure expressed itself in emblems: tripartite artifacts combining symbolic designs, mottoes and explanatory poems. Typically designers gathered them together and issued them in collections. The first deviser was an Italian, Andrea Alciato, whose *Emblematum Liber* appeared in 1531. It went through more than 170 subsequent editions and generated a new fashion. Many hundreds of these books were published in various languages throughout Europe in the sixteenth and seventeenth centuries. Readers who purchased them could while away their evenings contemplating the intricacy of each design, appreciating the symbolism and absorbing the lessons inculcated. The emblems were predicated on the assumption that beneath the surfaces of life lie deeper meanings. Decoding the images offered pleasure to the intellectually sophisticated. The façade of Ligorio's Casino appealed to this habit of mind, as did the Camera delle Imprese in Giulio Romano's Palazzo Te.

Erwin Panofsky, a twentieth-century art historian, popularized the word "iconography" to describe symbolic images. The term comes from the Greek *eikonographia*, a combination of *eikon*, which means "image," and *graphein*, "to write." Panofsky used the term to designate the subject matter of art, as opposed to its conventional forms. Iconography presupposes that the surfaces we see around us conceal profound truths, which may be revealed by knowledge and ingenuity, and that these revelations point toward insights otherwise inaccessible. This assumption is the hallmark of a culture in which the visual reigns supreme.

Most visitors to the Vatican today never see what Ligorio created because, though fascinating, the Casino is ordinarily off-limits. The Vatican's office on the piazza in front of St. Peter's, however, offers a tour of the gardens. Part of the visit, in a small bus, offers little of interest. Do we really need to admire the pope's helicopter pad? Or the Vatican's radio station? The good news is this: all that's required for a reservation is some identification (passport, driver's license, or the like). The Casino in all its mysterious but lonely glory is the high point of the tour.

NOTES

1 Peter Partner, *Renaissance Rome, 1500–1559: A Portrait of a Society* (Berkeley and Los Angeles: University of California Press, 1976), 31.

2 Partner writes in *Renaissance Rome*, "The most original thing in Villa Pia is the oval marble-bottomed sunken basin which is its focal and unifying point" (177).

3 For Ligorio's drawing of Hegle and Apollo, see David R. Coffin, *Pirro Ligorio: The Renaissance Artist, Architect, and Antiquarian* (University Park: Pennsylvania State University Press, 2004), fig. 22.

4 Cited by Coffin, *Pirro Ligorio*, 18–19.

CHAPTER 14

PIAZZA DEL CAMPIDOGLIO, ROME

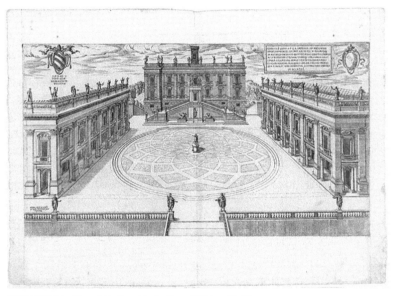

FIGURE 14 *Plan of the Campidoglio, Rome.* Wikimedia Commons.

Anticipating a visit to Rome by the Holy Roman Emperor, Pope Paul III decided that ancient Rome's political center needed refurbishing. Michelangelo was hired to reconfigure the summit of the Capitoline Hill, creating the first planned piazza in the city. At its center is a statue in bronze of the ancient emperor Marcus Aurelius.

Anticipating a visit to Rome by the Holy Roman Emperor Charles V, Pope Paul III in 1535 decided that the Piazza del Campidoglio, ancient Rome's political center and site of its most important temple, dedicated to Jupiter, should provide a suitable location for a royal welcome. In antiquity, the temple had become a repository of the Sibylline Books, recording divinely inspired

prophecy, oracles and Rome's destiny. Now, however, it urgently needed refurbishment. Like many other ancient buildings, the temple was raided for construction materials during the Middle Ages, and statues made of precious metals vanished. When political power shifted to the Vatican, the site of the papal court, Jupiter's temple was only a memory, a victim of neglect. Rome, moreover, continued to feel the effects of its sack by the imperial army in 1527 and then a great flood in 1530. Inhabited by goats and surrounded by mud, the Capitoline hill was reduced to squalor. Humiliated by the memory of Charles's onslaught, the pontiff called on Michelangelo to redesign a location suitable for civic events and to remind the world of the city's unique status. In short, Paul sought to impress visitors, whether the Holy Roman Emperor or some other potentate. Ironically, Charles never saw what Michelangelo constructed; he was greeted elsewhere, perhaps because the site of welcome was judged incomplete or even disreputable.[1]

The sculptor/artist/architect completely reconfigured the summit of the Capitoline Hill, the smallest of Rome's seven hills, creating the first planned piazza in the city. (The only comparable space in Rome is the piazza before the Farnese Palace.) In effect, Michelangelo fashioned a large outdoor courtyard bordered by three buildings and, on the fourth side, a *cordonata*, a ramped staircase leading downward off the hill; two figures, Castor and Pollux, usually identified as horse-tamers in Greece and Rome,[2] stand atop the ramp with their animals, guarding entry. And an entirely new structure had to be added to enclose the piazza, imposing a shape.

* * *

Opposite the top of the entry ramp stands the Senators' Palace (Palazzo dei Senatori), originally built in the twelfth century and providing administrative offices. Because the two existing buildings at the site were medieval, they needed to be refaced in keeping with developing expectations for architecture. Michelangelo devised the external double-ramped staircase leading to the principal floor, the *piano nobile*, which contains the reception rooms. To conceal the older building, he added a new façade, simplifying its appearance with tall pilasters. At ground level sits an ancient statue of Minerva, interpreted in Michelangelo's day as a personification of Rome. The ground-floor façade is rusticated, made of large stone blocks of pale travertine, a sedimentary stone, with deep joints. Tall pedimented windows mark the second level. A row of smaller square windows stretches across the top floor; these were the work of Giacomo della Porta, who took over the project after Michelangelo's death in

1564 and completed it about 1600 with the help of Girolamo Rainaldi. The roofline features a prominent cornice and balustrade. In the evocation of ancient practice, statues rise above the stone railing. Behind the building stands a bell tower struck by lightning in 1577 and rebuilt by Martino Lunghi in 1583, though not to Michelangelo's design.

Beginning in 1561 the architect also transformed the façade of the Conservators' Palace (Palazzo dei Conservatori), which dated from the early 1400s. The Conservators were magistrates who administered the city together with the Senate. The unusually large ground-floor bays have horizontal rather than round tops; Ionic columns support them. Windows on the floor above are each framed by an aedicule, which looks like the façade of a small temple with two columns supporting a pediment; the triangular pediment above the wide central window is flanked by segmental pediments above windows on both sides. Eight Corinthian pilasters, on high pedestals, rise two stories and seem to support the entablature and heavy cornice and balustrade. This feature marks the first use of the colossal, or giant, Order in a secular building. The repetition of the Order on the three structures connects them visually. With these pilasters, Michelangelo also fashioned an illusion, for the massive masonry atop the building is actually supported by strong piers hidden behind the tall, thin pilasters that lend unity to the assemblage. The ground-floor loggia, with Ionic (rather than the customary Doric) columns, opens onto the piazza in order to facilitate the movement of the people and provide shops for merchants. Giacomo della Porta completed the reconstruction following Michelangelo's death.

Directly opposite the Conservators' Palace stands the New Palace, also known as the Palazzo Capitolino or Palazzo Nuovo, begun from scratch in 1603. Strictly speaking, this structure was not really necessary for any institutional purpose. Although it became a home for Rome's guilds, it has no justification of the kind enjoyed by the other two buildings on the site. By its construction, however, the architect created a (mostly) enclosed piazza, ensuring a larger coherence to the space. Not until 1660 was this building finished.

One palace mirrors the other, in keeping with Michelangelo's belief that the corresponding parts of a plan must be identical, just as one hand is obliged to resemble the other in a human body. And so we find the same kind of colossal pilasters, openings onto the piazza flanked by columns, windows with columns on either side and topped with elaborate pediments on the second floor. Similarly, in both palaces, we find scallop shells within those pediments over the windows, symbolizing baptism, pilgrimage and rebirth. New Palace

represents the final phase of Michelangelo's project, completed long after his death by della Porta and Rainaldi.

* * *

The piazza is awkwardly shaped—it's a trapezoid, one end narrowing toward the entry ramp. This was the result of chance: the medieval Senators' and Conservators' Palaces were not aligned at right angles. And so Michelangelo decided to situate his new structure so that it preserved the same relationship to the Senators' building as the extant Conservators' Palace. (The narrow end of the trapezoid leads to the ramp.) And he devised an elongated ellipse that would create a visual focus for the piazza. Although Michelangelo's original plan for the pavement had to wait until 1940 to take shape, he designed for it a twelve-pointed star (or sunburst). The intricate lines of the surrounding stone radiate from the center. This geometric form may evoke the signs of the zodiac, the twelve apostles or the hours. Although the pavement was not actually installed in the architect's lifetime, Étienne Dupérac's etchings (1567–68) preserve Michelangelo's original plan. For centuries, visitors saw a plain oval divided into eight segments like those of an orange.

In 1538, the pope requested that a gilded equestrian figure be moved from St. John Lateran, the seat of Rome's bishop and thus the cathedral of Rome, to the center of the Campidoglio. (To preserve it from weathering, the authorities have moved the restored original into the Palazzo dei Conservatori; today a replica stands outside.) Although Michelangelo was apparently less than enthusiastic—I wonder if he might have envisioned a statue of his own making in that spot—he acceded to the pope's wishes, designed a plinth set on a concave space, and located the statue within an oval, a shape rarely employed previously though it helped counter the trapezoidal shape of the piazza. The design of the pavement has the effect of causing the figure to seem larger and higher than it actually is. In antiquity, the statue must have been stunning. The rider looked as if he was made of gold.

Pope Paul may not have known the true identity of the figure on horseback. Some people thought it was Constantine, who initiated the building of St. Peter's Basilica. He was the Emperor who split the Roman world in two, naming the eastern capital after himself, and making the city formerly called Byzantium the empire's capital. The horse's rider seems to gaze toward the Vatican. Actually, the rider, cast *c.* CE 176, is the emperor/philosopher Marcus Aurelius, attired in a military tunic, his right hand extended. The mistaken association with Constantine had prevented religious fanatics from destroying the bronze

sculpture in the Middle Ages when remnants of pagan antiquity were often melted down. Within the courtyard of the Conservators' Palace, a visitor can see, ironically, marble fragments (head, hands, and foot) of a colossal statue of Constantine dating from the fourth century and discovered in 1487 at the Basilica of Maxentius, CE 307–12.

Upon my first visit to the site, near the end of July, the temperature reached the mid-90s Fahrenheit, and it was frightfully humid. The pavement of the piazza seemed to magnify the sun's scalding force. Looking for some relief, I walked over to the base of the Senators' Palace, where colossal river gods— Nile and Tiber (formerly the Tigris of Mesopotamia)—hold horns of plenty, a reference to Rome's glorious past. (They had been discovered amid ruins at the Baths of Constantine.) In front of each was a small fountain. My journal reads, "I put my hand in and, to my surprise, the water was ice cold. It felt so soothing and I was so hot that I could cheerfully have jumped in and spent the rest of the day there." In my discomfort later that afternoon I could not resist a tourist trap: I found myself drinking cold beer out of a glass boot.

* * *

When visiting the Campidoglio, you are likely to find an empty piazza and only a few tourists milling about. Of course, no pageantry of the kind intended for the Emperor is on view today. In this sense, our experience of the place is incomplete, for we know that spectacle was an essential feature of Renaissance Italy. Every court proclaimed its status on special occasions. Coronation processions, royal entries into cities, receptions of ambassadors, religious festivals, aristocratic weddings, funerals, jousts and tournaments required the conspicuous display of costumes, banners, flags and, sometimes, horse-drawn floats. Paintings of ceremonies from the sixteenth century suggest that no expense was spared. Stunning displays of fireworks and colorfully attired troops affirmed power, prestige and pride. Renaissance culture valued conspicuous pomp. Our experience of the Campidoglio today, then, is quite different from what Pope Paul and Michelangelo intended. It is as though we enter a theater to see a play and find the stage deserted.

I suppose it's always unwise to generalize about a society, now more than ever. As many other visitors do, however, I feel that Italians have a special genius for visual display. Here's what I found on my first trip to Rome. I visited the sprawling Baths of Caracalla built *c.* CE 211–16 and now mostly a ruin, though in its prime 1600 bathers enjoyed the waters. While exploring, I noticed that a temporary stage had been set up. Venturing backstage I discovered stores of

props and sumptuous costumes. Learning that Verdi's *Aida* was to be performed that evening, I bought a ticket. Although I'm not an aficionado of opera, I was in for a treat. I arrived early for a performance that began at 9:00 p.m. when the heat of the July day had lifted. The open-air theater was filled with thousands of people, and the production was all that I expected and more—expansive, histrionic, and colorful. Everything seemed larger than life. In my journal, I wrote: "I've never seen such spectacle. At one point a chariot was drawn onstage by four magnificent white stallions." Weary but exhilarated, I arrived back at my hotel at 2:00 in the morning. I knew I was unlikely ever to see such visual splendor anywhere else in Europe.

NOTES

1 The historian Edward Gibbon said that the idea for his masterpiece, *The Decline and Fall of the Roman Empire*, occurred to him while he rested among the remnants of Rome: "as I sat musing amidst the ruins of the Capitol, while the bare-footed fryars were singing Vespers in the temple of Jupiter, that the idea of writing the decline and fall of the City first started to my mind." See Margaret R. Scherer, *Marvels of Ancient Rome*, ed. Charles Rufus Morey (New York and London: Phaidon, 1955), 43.

2 James Ackerman, in *The Architecture of Michelangelo* (Chicago: University of Chicago Press, 1986), offers a different account of the horsemen's identity: "the twins had not been identified as Dioscures in the mid sixteenth century, but were believed to be paired portraits of Alexander the Great carved in competition by Pheidias and Praxitiles" (164).

ST. PETER'S BASILICA, VATICAN CITY

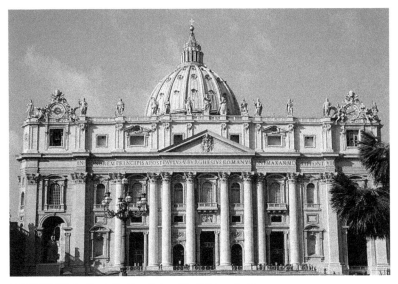

FIGURE 15 *St. Peter's Basilica, Vatican City.* Wikimedia Commons.

The story of its construction is bewilderingly complicated, for the reconstruction of the original church took place over an extended period and involved a legion of architects. What we can say is that the architects were, to a large extent, influenced by the design of classical temples. The façade, for example, is a copy of an ancient temple front.

The story of St. Peter's, which began as a basilica during the reign of Emperor Constantine, is bewilderingly complicated, for the reconstruction of the dilapidated church took place over an extended period. Various popes voiced opinions about the building that marked the saint's burial place and adjoined the administrative center of the Christian Church. Pontiffs employed a great many

architects, each with his own point of view. Arguments over design led to friction among the planners. Vatican bureaucrats meddled more or less constantly. The final contour of the building thus represents an amalgam of disparate ideas by competing personalities. No single architect can claim credit. As a result, tracing the path of reconstruction is anything but straightforward. The saga demonstrates how deeply felt were the issues facing architects in the 1500s.

Constantine the Great began constructing the original St. Peter's—the first Christian basilica, honoring Rome's first bishop—*c.* CE 319. Marking the site of the apostle's tomb, it consisted of a rectangular central hall with two slender (lean-to) rectangles, called aisles, flanking the space on both sides and divided by rows of columns. The hall culminated in an apse, a recess containing an altar. A lateral transept between the apse and nave permitted gatherings of the faithful near the saint's shrine. This was "the first basilica to be built in the shape of a cross."[1] In the Middle Ages, such transepts became an increasingly prominent feature of church design, underscoring its cruciform nature. Consecrated on November 18, 326, the Christian basilica reached completion *c.* 349.

When Tommaso Parentucelli became Pope Nicholas V in 1447, he sought to enlarge the basilica that had stood for 1100 years. A man of discriminating taste who had lived in Florence and had become a friend of Cosimo de' Medici, the pontiff was a scholar with a special interest in architecture; he was also an avid reader who relished ancient texts then being rediscovered. He knew that the basilica had deteriorated, especially during those years when the papacy had moved from Rome to Avignon (1309–77).[2] Not satisfied merely to shore up a building in parlous condition, Nicholas wanted something grander and large enough to accommodate the 50,000 pilgrims who visited Rome each year. He also sought a structure that projected his own notion of papal power. To accomplish his goals, he directed Bernardo Rossellino to begin drafting plans for a new and larger basilica. Old St. Peter's would be substantially replaced. The anticipated length of the new church was 640 feet, exceeding by far the original 400.

Rebuilding the ancient edifice began modestly. The project did not proceed very far, however. Pope Nicholas died only three years later and so did the project's momentum. Misgivings arose about dismantling the church that had seen the crowning of Charlemagne as the first Holy Roman Emperor and the consecration of 184 popes. St. Peter's also housed the tombs of countless saints. Many Christians shrank from the prospect of disturbing them. And then there was the issue of destroying centuries of artistry in the extant church. Wholesale reconstruction would entail wholesale demolition. Even Donato Bramante became a target of doubters. Vasari wrote: "It is said that he was so eager to

see this structure making progress, that he pulled down many beautiful things in S. Pietro, such as tombs of Popes, paintings, and mosaics."[3]

For the next fifty years, progress remained in abeyance as papal revenue was diverted to reclaiming Constantinople, conquered by the Muslims in 1453. Other issues inhibiting progress remain obscure, but almost certainly the enormous cost of the contemplated project lurked in the background. The technical challenges of transforming St. Peter's were also daunting and probably not fully understood at first. The alluvial soil beneath the basilica, considered inadequate to support heavy masonry, proved a continuing source of frustration. Old St. Peter's had been built, in part, on a marshy plain. By the early 1500s, the whole structure had become derelict. A rumor, possibly spurious, circulated that a pack of wolves had settled in the old church.

Shortly after Donato Bramante arrived in Rome, Giuliano della Rovere became pontiff and chose a name identified with power in the ancient city—Julius. Almost immediately this scion of the Medici family decided that rebuilding the crumbling St. Peter's was urgent. In fact, he was content to scrap the original as well as the plan suggested earlier by Rossellino. A man of formidable energy, Julius II wanted an edifice that would confer on him the stature he felt he deserved; he planned to have his grandiose tomb situated in the church. Imagining himself heir to the Roman emperors, he sought an opulence that would rival theirs. Pope Julius had the good fortune to have at hand the most able architect in Italy—the builder of the Tempietto. The combination of Bramante's brilliance and the pope's ambition promised the successful overhaul of Christendom's most important church.

The center of spirituality for Christians, the Vatican was simultaneously a hotbed of rivalry, politics, and manipulation. Architects were not exempt. The commission Bramante won had been sought by others, but he was selected, probably because his grand design best fit the pope's expectations.

* * *

As Bramante saw it, nothing less than a complete reimagining of the church would suffice for the citadel of Christianity. He wanted to convert St. Peter's Basilica into a central-plan church with a dome at the center. To accomplish his purpose, Bramante, like Brunelleschi before him, set out to investigate systematically the secrets of ancient architecture. He came to admire the vaults, pilasters and domes of imperial Rome. For models, Bramante looked to the enormous Baths of Caracalla and Diocletian, and to the Basilica of Maxentius in the Forum; these structures suggested majesty, a quality that Julius prized. The

pope approved the proposal in 1505 "because it showed 'the finest judgment, the best intelligence, and the greatest invention'."[4]

For lack of evidence, we cannot say precisely how his design would have looked had it been carried out. If Bramante made a wooden model, it has perished. But half of a blueprint survives in the Uffizi Gallery, Florence, possibly indicating what the architect envisioned: a colossal Greek cross within a square, each arm covered by a barrel vault and culminating in a semicircular apse containing a chapel. This design represented, of course, much more than a restoration of the original basilica. Bramante proposed radically changing both the size and the shape of the extant church so that it was worthy of ancient Rome. One side of a medal by Cristoforo Foppa, known as Caradosso, struck in 1506, shows a new exterior, which bears some resemblance to the ancient Pantheon. Bramante is said to have pledged, "I shall place the Pantheon on top of the Basilica of Maxentius." If we assume that the plan represented in Caradosso's medal was to be symmetrical, then eight subsidiary domes would be added to the principal dome.

The foundation stone of Bramante's church was set on April 18, 1506, and construction began on four huge piers to support the dome. For want of time, his plan never reached fruition. Only a small portion of the new church took shape in the next ten years. The architect who sought to create the most ambitious church in Christendom did not live to advance the project very far, and for years construction stalled.

A major cause of delay was the death of both architects and pontiffs. Julius II died in February 1513, and Bramante in April 1514. Fortunately, Raphael was at hand to energize the interrupted work. He was Bramante's choice of successor, and Pope Leo X honored the architect's wish. The pontiff also designated the aged Fra Giovanni Giocondo, a brilliant engineer, and Giuliano da Sangallo to collaborate with the maestro. The pope knew that Raphael had achieved renown as a painter, not an architect, and so it made sense to assign men with a track record as builders to assist him. But Fra Giovanni died in 1515, Giuliano da Sangallo in 1516, and Raphael in 1520 at the age of thirty-seven. (Pope Leo wept when he heard the news of Raphael's demise.) Leo himself died in 1521, after depleting the Vatican's treasury. No wonder work proceeded by fits and starts. The death of architects brought about a fusillade of changes, blunting sustained progress. By the time of Leo's death, the project was "in such an inchoate state that the next generation found it hard to determine precisely what the original intentions had been."[5] Delays occasioned a joke: when Bramante arrived at the gates of heaven, St. Peter announced: no admission till the Basilica was finished.

What the sequence of appointments and deaths demonstrates is the shocking lack of continuity that marked the project from its very beginnings. To make matters worse, work all but shut down at times. For example, the short-lived papacy of Adrian VI (1522–23) saw no progress whatever. Vasari said that he "took no delight in pictures, sculptures, or in any other good thing."[6] Adrian possessed neither the skill nor the temperament needed to advance the work at St. Peter's.

When the cultured Clement VII succeeded Adrian, it seemed that an opportunity for real progress had arrived at last. He appointed as chief architect the capable Antonio da Sangallo the Younger, nephew of Giuliano da Sangallo and Antonio da Sangallo the Elder. Antonio would be assisted by Baldassare Peruzzi. Despite this array of talent, international politics blocked progress. The new pope proved politically inept, seeking without much success to balance competing European factions. Timid by temperament, he had a habit of switching allegiances, brokering a treaty with Charles V, while secretly signing an alliance with Francis, the French king who despised the Holy Roman Emperor. Treated with duplicity, Charles knew he could never trust Clement: "I shall go into Italy and revenge myself on those who have injured me, especially on that poltroon [coward] the pope."[7] The Emperor then assembled a force of German and Spanish mercenaries, led by Charles, Duke of Bourbon, renowned for military expertise. They crossed the Alps and headed for Rome. Had the papal treasury not been depleted, Pope Clement might conceivably have avoided catastrophe by buying off the imperial army. His fecklessness, however, doomed any reconciliation. At dawn on May 6, 1527, thirty thousand soldiers took advantage of heavy fog and scaled the city walls, sacking and burning Christendom's capital.[8] Although he may have believed that the jaws of death had rubber teeth, the confident Bourbon, named Constable of France for battlefield exploits, was slain in the initial attack. The sculptor and goldsmith Benvenuto Cellini claimed to have shot him with an arquebus, a long gun, ancestor of the rifle.

The loss left the imperial army leaderless. The hungry, angry, unpaid marauders murdered thousands, raped nuns, desecrated churches, and looted everything they could carry. Entire libraries were reduced to ashes. Stained glass was smashed and the lead frames were used for bullets. In effect, the troops received their pay in plunder. The corpse of Julius II, who had made the rebuilding of St. Peter's his priority, was wrenched from its grave and stripped of garb and jewels. The carnage continued for months; cruelty reigned. Luigi Guicciardini, who would become commissioner of Florence in 1536–37, reported that "All the sacraments of the modern Church were scorned and

vilified as if the city had been captured by Turks or Moors or some other barbarous and infidel enemy."[9] Two-thirds of the population was gone by the time the ravages ended. Famine followed the massacre, and plague fell upon the survivors. The city that had numbered a million residents in the time of Augustus had shriveled to perhaps 20,000. Not for a thousand years had Rome suffered such devastation.

The trauma brought work at St. Peter's to an abrupt halt. The pope's treasury was empty, and the city was stripped of its wealth. Clement did not authorize resumption of work at St. Peter's till 1531. By then the momentum of the project had petered out yet again.

The difficulties were enormous. Some of the finest architects and artisans had left Rome never to return. The skilled labor force was depleted. Rome's psyche still suffered from the unprecedented destruction of 1527. Upon his election, Paul III in 1534 sought to revive the neglected plan, reappointing Sangallo the Younger chief architect; he, in turn, produced a huge and expensive wooden model of the church he envisioned, showing what seems like an uneasy fusion of a Greek and a Latin cross. The model, which took seven years to make, struck some observers as an extravagant mess.

The overriding issue was the shape of the reconstructed building. Most innovative architects probably saw virtue in a central plan, for it evoked the circle, the most perfect of forms. What's more, a *martyrium* in ancient times, marking the burial place of a Christian martyr, was usually built to a central plan. Peter's tomb would lie directly beneath the center of the dome. This is what Bramante wanted and what Pope Julius approved.

Although Raphael was Bramante's choice as successor, he and his collaborators (Fra Giovanni and Giuliano da Sangallo) opted for the more traditional Latin cross: a long nave, side aisles, and transepts. Raphael apparently had no objection to the cruciform plan; after all, it was enshrined by tradition for a thousand years. But the issue refused to go away. Antonio da Sangallo the Younger, for example, sought a return to Bramante's Greek cross.

What was most needed was someone with the drive and clout to corral men with large egos, achieve a consensus about the overall plan, and harness their talents to finish the work. After Antonio da Sangallo the Younger died unexpectedly in 1546, Michelangelo Buonarroti became chief architect. Some observers may have found this an odd choice since his métier was sculpture and he was best known for his paintings, especially the ceiling of the Sistine Chapel and *The Last Judgment*. The aged painter and sculptor, who suffered from an array of medical problems, could muster little enthusiasm. But Pope Paul

III insisted. So on January 1, 1547, Michelangelo was commissioned to take charge of the most important architectural enterprise of his time. He knew how formidable were the challenges. He did not want to tangle with the *fabbrica di San Pietro*, which oversaw new efforts at the Vatican. Distrusting both meddlesome bureaucrats and the papacy as well, he wisely insisted on a free hand and even offered to work without pay.

He labored for seventeen years to complete the church, though younger architects sometimes questioned his judgment. If Michelangelo had not been installed when he was, the structure might have become even more of a mélange than it is. But at least he succeeded in creating a sense of purpose and establishing a viable direction, though his scheme "was not definitively formulated at the outset but evolved gradually in the course of seventeen years of construction."[10] He died in 1564, leaving his work unfinished.

What exactly had Michelangelo accomplished? He eliminated the corner towers that Bramante earlier envisioned and did away with his predecessor's minor domes over chapels below. Both features offended Michelangelo's imperative to simplify wherever possible. He saw merit in Bramante's earlier ground plan and complained that Sangallo the Younger had compromised it in 1539 when he redesigned the project. Sangallo's model, with its tall bell towers and vertical emphasis, was too reminiscent of outmoded design and too ostentatious. Vasari commented on Michelangelo's judgment: "with all its projections, spires, and excessive details and ornaments, it possessed much more of the German [Gothic] workmanship than the good ancient method or the pleasing and beautiful modern style" (466).[11] Furthermore, Sangallo's plan, wrote Michelangelo, "has no light of its own, and so many dark lurking places above and below that they afford opportunity for innumerable rascalities, such as the hiding of exiles [bandits?], the coining of base money, the raping of nuns [...]."[12]

Streamlining a proposal that he considered mangled since Bramante's death, Michelangelo refused to accept Raphael's preference for a Latin cross. This return to an earlier vision of the basilica delighted Vasari, who wrote that Michelangelo had reconceived the structure, "sweeping away the countless opinions and superfluous expenses." Indeed he "has brought it to such beauty and perfection as not one of those others ever thought of, which all comes from his judgment and power of design."[13]

Michelangelo sought a Greek cross, though simpler and somewhat smaller in scale than Bramante's. He conceived the entrance as occupying one apse of the central plan; in other words, the edifice would have the shape of a diamond. This would require the construction of a huge façade (now 375 feet), much

wider than high (167 feet). Giant Corinthian columns and pilasters connect the first and second stories. The center features colossal pilasters and a triangular pediment. In other words, it represents a synthesis evoking an ancient Roman temple front.

Bickering over the shape of the building did not end with Michelangelo's death. A succession of architects continued to revisit the work in progress. Pirro Ligorio became chief architect after Michelangelo's demise, and Pius IV ordered him to honor his predecessor's design. But something very peculiar happened in August 1565. The architect was secretly arrested and charged with stealing from the pope. Through the intervention of Cardinal Alessandro Farnese, Ligorio was released. Apparently, however, Pius lost trust in Ligorio, perhaps because of the recent charges against him or perhaps because the architect sought changes in Michelangelo's plan. When Pius V assumed the papacy in 1566, Ligorio was a papal architect no longer, and he left Rome bitter at the treatment he had received. Giacomo Barozzi, known as Vignola, succeeded him in 1567, and in 1574, Giacomo della Porta took over as chief architect, modifying further what he inherited and designing a new façade overlooking the Piazza San Pietro.

Carlo Maderno, appointed by Sixtus V and inspired by Michelangelo's precedent, later completed the façade (1607–12) that now greets visitors. Unfortunately, its height blocks a clear view of the dome from the piazza, as contemporaries complained. Ironically, you can see the dome from virtually everywhere in Rome—except from the piazza directly in front of the church.

Progress remained ragged as architects continued to argue over whether St. Peter's should have the shape of a Greek or a Latin cross and as money became reliably available. Although the central plan had its champions, a longitudinal shape had the advantage of better accommodating the crush of pilgrims who came to Rome. Fra Giocondo, who published a large format edition of Vitruvius's work (with 140 woodcut illustrations) in 1511, favored the traditional Latin form, and, as we have seen, Raphael also had proposed an elongated nave with flanking aisles. After his death, Baldassare Peruzzi sought to reinstate the Greek cross. During Paul's reign, however, Carlo Maderno in 1607 insisted on a Latin cross and extended the nave by 200 feet. It now measures 613 feet.

How was the shape of St. Peter's decided? The central plan suffered from liabilities. There was no easy way to observe the hierarchical distinction of celebrant, choir and laity, the customary arrangement for worship. There was uncertainty about where to place the altar: situating the faithful on both sides of the altar (or even on four sides) would be unfamiliar. A central plan offered less space to accommodate the congregation and no easy way to handle the long processions that were part of religious observance. The clergy would need to

adjust their liturgical practices to new spaces. And where would side altars find a place? At the onset of the Counter-Reformation marked by the Council of Trent, antagonism developed toward centralized structures because their origins lay in antiquity and were therefore considered progeny of a pagan past. In its insistence on traditional customs of worship, the Council put the kibosh on such churches. Paul V finally settled the issue in 1606 when he declared a Greek cross impractical. Maderno's design of a long nave and wide façade had won.

* * *

Despite the continual shuffling of plans at St. Peter's, architects agreed on one issue: the need for a dome. But what kind? Like everything else connected with St. Peter's, the topic occasioned debate. Bramante preferred a shallow hemisphere with a single shell, sometimes called a dish dome. It would be made of concrete, measure 142 feet in diameter, and rest upon a colonnaded drum that would direct the eye upward. Antonio da Sangallo the Younger favored a somewhat more exuberant design. And in 1547, the newly appointed Michelangelo sought a double dome (two brick shells) like that of the Duomo in Florence, though he preferred a vault with sixteen ribs (instead of the [visible] eight in Brunelleschi's earlier design). These, in turn, would rest on pairs of Corinthian columns below. He built a model of the dome in 1558–61, envisioning a hemisphere within and a slightly pointed shape on the exterior. It would have a huge circumference—600 feet. Giacomo della Porta, however, appointed chief architect by Sixtus V in 1574, had his own ideas. Although he admired Michelangelo's rounded interior and double dome, della Porta preferred steeper contours for the outer shell. So he both heightened the dome and moved its shape closer to Brunelleschi's in Florence. The largest dome in Italy, St. Peter's measures 452 feet from the pavement to the top of the cross. The elevated profile, ten feet taller than the Florentine dome, argued della Porta, would be more visible from a distance and better distribute the weight of the masonry. Sixtus acquiesced in the changes. In 1588–90, together with the engineering genius Domenico Fontana, della Porta vaulted the dome we see today. The lantern was finished three years later. Elected pope in 1623, Urban VIII consecrated St. Peter's on November 18, 1626, thirteen hundred years after Constantine presided over the construction of the original basilica.

* * *

Many pilgrims experience something like ecstasy when they enter St. Peter's. My wife wept when she first stepped inside. The profusion of decoration in the form of paintings, mosaics, statuary, tombs, bronze doors, colored stone and

the like inspires awe. Devout visitors identify the basilica's size and shape with divinity. But for some of us, the opulence of the interior seems overwhelming. Michelangelo himself fretted that the building would in time become cluttered with embellishments. He was right to feel apprehensive.

When Urban VIII became pope, he chose Gianlorenzo Bernini as chief architect. The challenge of Martin Luther and other reformers remained insistent, and the Church needed somehow to respond. Bernini did so by adopting a style that came to be called Baroque. The word originated among fishermen to describe a misshapen pearl. Although initially used in deprecating fashion, it came to describe the art, sculpture and architecture powered by the Counter-Reformation. The new style was intended to deflect the faithful from Luther's appeal and recapture the allegiance of wavering Christians. Bernini did not invent the style but it achieved its most extravagant form in his hands. With the help of Francesco Borromini, Bernini supervised the final decoration of St. Peter's and in the process removed much of Michelangelo's interior design. Energetic grandeur was the route to accomplish the goals of a Church under siege. The resulting florid style has always left me cold, perhaps because it tries too hard to make me feel something. It's hyperbole on steroids.

There is simply too much to see. The eye does not know where to rest. In this sense, the personal experience of St. Peter's can be off-putting. Admittedly, architectural space can be employed to good effect. But here in Rome, the titanic arches and vaulted ceilings dwarf the people who gather beneath them.

Luther had argued that the size of a building and the spirituality it means to support have no necessary connection. Had he lived to see St. Peter's finished, he would have said that it cancels an atmosphere conducive to bonding with divinity. Fifty thousand worshipers can find a place at one time in the basilica. But how easy is it to connect with the divine when surrounded by a multitude of visual and auditory distractions? What bothers me most about St. Peter's is the scale: it's simply not human. I'd rather be standing in the Old Sacristy of San Lorenzo, Florence, or Santa Maria della Consolazione in Todi, where I wouldn't feel quite so intimidated and where I have experienced a greater sense of exhilaration.

NOTES

1 Suzanne Boorsch, "The Building of the Vatican: The Papacy and Architecture," *The Metropolitan Museum of Art Bulletin* 40, no. 3 (Winter 1982/83): 5.

2 This period is known as the Babylonian Captivity, a term having its origins in Jewish history when Judeans were captives in Babylon, the empire that had defeated them in battle.

3 "Life of Bramante," in *Lives of the Most Eminent Painters, Sculptors, and Artists*, trans. Gaston DuC. De Vere, 10 vols. (London: Philip Lee Warner for the Medici Society, 1912-14), 4:145.

4 R. A. Scotti, *Basilica, The Splendor and the Scandal: Building St. Peter's* (New York: Viking, 2006), 47.

5 James Ackerman, *The Architecture of Michelangelo* (Chicago: University of Chicago Press, 1986), 30.

6 Cited by Scotti, *Basilica*, 156–57.

7 Cited by Judith Hook, *The Sack of Rome, 1527* (London: Macmillan, 1972), 43.

8 Ironically, despite the debacle, Pope Clement would later crown Charles Holy Roman Emperor (in Bologna).

9 Luigi Guicciardini, *The Sack of Rome*, trans. James H. McGregor (New York: Italica Press, 1993), 115.

10 Ackerman, *The Architecture of Michelangelo*, 320.

11 Giorgio Vasari, *The Lives of the Artists*, trans. Julia Conaway Bondanella and Peter Bondanella, Oxford World's Classics (1991; repr. Oxford: Oxford University Press, 2008).

12 Cited by Boorsch, *The Building of the Vatican*, 12.

13 "Life of Bramante," in *Lives*, trans. De Vere, 145.

CHAPTER 16

FARNESE PALACE, CAPRAROLA

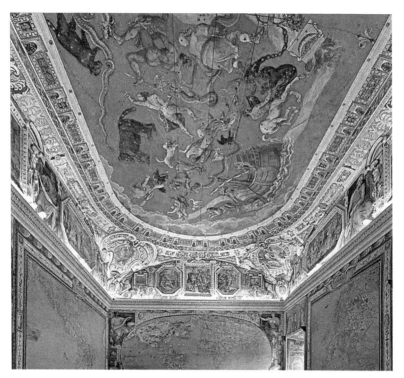

FIGURE 16 *Constellation ceiling, Farnese Palace, Caprarola.* Wikimedia Commons.

When Vignola began working for the Farnese family, he was charged with the task of converting a traditional fortress into a comfortable, if formidable, palace. The building has the shape of a pentagon with three large stories. An unusual round courtyard occupies the center of the building—the first in the history of the Renaissance. The rooms are filled with frescoes executed by some of the finest painters working in Europe. Extensive gardens complement the sumptuous interiors.

Giacomo Barozzi, called Vignola, enjoyed an exceptionally varied career. He studied in Bologna, then traveled to Rome, where he contemplated preparing an updated version of Vitruvius. He also worked at the French palace of Fontainebleau for a year and a half. Returning to his homeland, he found a patron in Pope Julius III, for whom he designed the Villa Giulia. A builder of churches, he was responsible for the Gesù in Rome, home of the Jesuits, a religious order founded by Ignatius Loyola in 1540. Vignola contributed to the rebuilding of St. Peter's. Somehow he found time to write his *Rule of the Five Orders of Architecture* (1562), which codified the columns in Roman buildings and represented them with detailed illustrations.

Upon the pope's death in 1555, Vignola began working for the Farnese family. In 1559, Cardinal Alessandro II Farnese, disappointed not to be selected pope and out of favor with Julius III, took up residence at the site of an unfinished castle in the small town of Caprarola, near Viterbo, about fifty miles north of Rome; the cardinal's grandfather had begun the building. Antonio da Sangallo the Younger and Baldassare Peruzzi in the 1530s were responsible for the design—a five-sided structure inspired by the shape of multisided fortresses. Around 1556, Vignola began plans to finish the abandoned building, turning it into a comfortable, if formidable, residence. Neither a country house like Palladio's in the Veneto nor an urban palazzo, Vignola's design is unique. By the time of his death in 1573, the transformation was largely complete.

I was intrigued by what I had read: that the edifice began life as a castle but subsequently shed its more forbidding features. Even after completion, the structure has a severe look. How successful, then, was the transformation? I had read of an impressive garden at the site, but as I approached, I saw no sign of one. Was Caprarola more friendly than the exterior initially suggested?

* * *

Unlike the entranceway to many Italian palaces, the main street is straight, largely because Vignola sought a dignified approach to the Cardinal's new residence. Arriving at the building situated atop a steep hill, I came upon a pair of semicircular ramps. The shallow steps culminate in a broad trapezoidal piazza, which served as a parade ground for the Cardinal's horses and guards. A double staircase in a zig-zag design leads to the entrance. The massive structure measures about 150 feet wide on each side, evoking a military origin. Although sometimes called the Villa Caprarola, it deserves to be termed a palace on account of its size and splendor. Situated at the summit of a fairly small town,

the dominating Farnese edifice announces the family's power and wealth. (This palace is not to be confused with the Palazzo Farnese in Rome.)

The five sides of the pentagon are mostly identical except for the large rusticated entrance facing the piazza and set apart by a drawbridge. Where two façades meet, an enormous cube-shaped bastion projects from the base of the walls for defensive purposes; the original architects were mindful of the catastrophic Sack of Rome. This multisided design allowed for raking fire against attackers and for defense against artillery. Vignola reduced the height of the corner bastions to minimize the impression of a fortress and to accentuate the visibility of the *piano nobile*. On the walls, Vignola reinforced the angles with quoins, horizontal white stones in a staggered pattern alternating long and short.

Although three tall stories rise from the ground, I learned that there are actually five floors. The lowest is relatively plain, with three pedimented windows on either side of the entrance. Looking upward, my eye was drawn to a loggia of five Ionic arches on the *piano nobile*; these were originally open but later faced with glass. The room behind them, double the height of the other floors, is named for Hercules, associated with the heroic virtues depicted in frescoes by Federico Zuccari. Here in the largest chamber of the palace, the Cardinal took his meals in summer and surveyed the town below. A stucco design resembling a grotto at one end of the room depicts a city and forest, below them a river. The inspiration was a legend that Hercules drew his club from the ground, and a spring appeared that created nearby Lake Vico. The two levels of the top floor, providing accommodations for staff, are linked by their exterior of Composite pilasters.

Vignola's basic concept combines a polygon and a circle. An unusual round courtyard occupies the center of the pentangular building. The palace "has the distinction of containing within its core the first completely finished circular courtyard in the history of architecture."[1] The Romans of antiquity had not anticipated such a feature. The first level has a rusticated colonnade set off by piers; the level above is made of smooth stone, with a matching row of arches separated by pairs of engaged Ionic columns. A balustrade tops each level. Five spiral staircases around the *cortile* connect the floors. The yard opens to the sky, a welcome contrast to the palazzo's formidable exterior. So picturesque is the courtyard that in 2016, it served as a location for *The Medici*, an Italian TV series shown on Netflix in the United States. The 2003 film *Luther*, starring Joseph Fiennes in the title role, also used the courtyard as well as the great staircase next to it. Now owned by the state, the central building and gardens are open to visitors, accompanied by an Italian-speaking guide.

A domed circular chapel occupies one corner of the pentagon. Another corner contains the most impressive of the spiral staircases. Supported by thirty pairs of Doric columns, this one has become known as the "Royal Stairs." Antonio Tempesta covered the barrel vault with illusionistic frescoes. In the second edition of his *Lives of the Artists* (1568), Vasari singled out the staircase for praise. According to one story, when Cardinal Alessandro first saw its richly painted walls and vaulting, he grasped the architect's hand and called him "a second Vitruvius."

My journal records an impression: "The staircase is the grandest I have ever seen, for every inch of the wall and ceiling is covered with splendid painting." What Vignola accomplished would not have been possible, of course, without the enthusiasm of the Cardinal, who paid the bills and must have thought that a medieval fortress was no longer necessary for security. Clearly, he found no discrepancy between his role as a high-ranking prelate and an aficionado of pagan culture.

The *piano nobile* consists of fourteen principal rooms, each adorned with frescoes. (This was the only floor open to view both times I visited.) In some chambers, landscape paintings predominate. Others portray narratives from classical mythology. While construction was proceeding, Taddeo Zuccaro and his younger brother Federico were already at work on the interior. Many other artists supplemented their efforts, and one of my favorite rooms is the Sala del Mappamondo, where huge topographical maps of the world adorn the walls. The most splendid painting here occupies a large oval vault decorated with constellations of the Ptolemaic system against a deep blue background.[2] The sky map was painted by Raffaellino da Reggio, Giovanni de' Vecchi, and Giovanni Antonio Vanosino da Varese in the mid-1570s. Lest the modern observer be puzzled by such a painting in the home of a church prelate, it's useful to recall that astronomers at the time viewed astrology as a natural science, not fanciful speculation. The same subject extends in a series of paintings between the ceiling above and the maps below: there we see twelve constellations of the zodiac. There is nothing overtly Christian about the subject. Although the sky map "has elements of religion, it is not obviously religious."[3]

With its architectural shape and profusion of paintings, Caprarola represents an epitome of Renaissance design. Contemporaries voiced their admiration. When he visited the palace, for example, the French essayist Michel de Montaigne spoke with enthusiasm: "I have seen none in Italy that may be compared with it." He especially admired the magnificent sky map, which he called "wonderful": "on its vaulted ceiling [...] you see the celestial sphere, with all the constellations."[4] I too was astonished by the design and the intensity

of color. In my journal I recorded this: "What the ceiling has going for it is a marvelous fluidity. There's no sense of stasis; the constellations seem almost to be in motion. With the exception of the Sistine Chapel, this is the finest ceiling fresco I've seen in Italy."

Paint seemingly covers every square inch of the palace interiors. The sheer profusion of color is staggering; it must have taken crews of painters years to accomplish it. Paradoxically, despite the extent of the paintings and their various subjects, the final result is coherent. Plaster and painted frames border the frescoes, and the arrangement of ceiling paintings in particular follows a symmetrical pattern. My journal entry records my response, "When the palace was painted and furnished, it must have been one of the great buildings in Europe." The furnishings are, of course, long gone: most of the oil paintings and books and objets d'art were removed to Naples in the eighteenth century.

* * *

Unlike other villas that emphasize gardens by locating them on the approach to a building, Vignola's walled gardens at Caprarola are hidden away at the rear of the palace. Apartments on two sides of the *piano nobile* provide access. Separated from the palace by a trench and drawbridge, the gardens are cut into the hillside: one a western winter garden, the other a northern summer garden. Because they extend from façades at different angles, the two walled spaces are not parallel. Seen from above, they resemble the top of the letter Y. A fresco at the nearby Villa Lante shows the so-called summer garden divided into quadrants, each subdivided into nine squares with a circle at the center. Flowers, including marigolds, hyacinths, violets, and lilies, once filled the geometric sections. Three fountains decorated this garden. The winter garden was originally divided into somewhat larger squares, subdivided into triangles. A pergola divided this garden in half. Montaigne was particularly taken with the Grotto of the Rain, "which, spraying water artfully into a little lake, gives the appearance to the eye and the ear of the most natural rainfall."[5] The Grotto, complete with stalactites carved out of rock, still exists beneath the garden, though in a decayed state. Originally, six stucco satyrs occupied the space and evoked the potential wildness of nature resistant to claims of reason.

Both gardens were alike in containing a series of patterned compartments filled with herbs and flowers. Beyond the formal gardens, however, lies a *bosco* thickly planted with greenery. For this purpose, Alessandro purchased four hundred fir trees in 1584. This "upper garden," located on a slope, was created sometime after the gardens that extend from the palace façades; it was

designed by Giacomo del Duca in the 1580s. Walking up a hillside, I came upon a clearing with a scalloped pool representing the Mask of the Senses: water issues from the eyes, ears, nose, and mouth of the visage, a reminder that the world of the senses is associated with pagan antiquity.[6] Just above is a water chain—*catena d'acqua*—made of linked dolphins; a ramped staircase flanks both sides. Statues of two giant river gods holding cornucopias recline on either side of a vase fountain. (A scene in Guy Ritchie's 2015 film *The Man from U.N.C.L.E.* was shot in this section of the garden. So were several scenes in Carlo Carlei's 2013 *Romeo & Juliet*, with Hailee Steinfeld.) Continuing on, I arrived at a summerhouse, the Palazzina del Piacere, designed by del Duca and completed by Girolamo Rainaldi. It consists of a small building, set into the hillside, with a two-story loggia and a triple arcade on both levels facing the palace below, providing relief from the sun on warm days, a place to rest after traversing the garden, and a setting suitable for dining *al fresco*. Originally, the parapet on three sides of the little garden was decorated with large finial spheres, as depicted in the fresco at Bagnaia. In the 1620s, these were replaced by male satyr-herms with baskets on their heads, and *canephori*, female figures with urns. Each of the twenty-eight statues is unique. Separate from the immediate precincts of the villa below, this space has been called a *giardino segreto*, a private section inspired by medieval enclosures. The little garden once contained fifty-five fruit trees in vases. Beyond the palazzina lies a still higher terrace, set off by a retaining wall and a circular fountain at the center surrounded by an octagonal mosaic.

The garden is perhaps the most innovative aspect of the estate: "Caprarola's significance in the history of landscape design lies in the creation of the Barchetto, a secluded retreat with a *casino* and herm-guarded *giardino segreto* approached by a quarter-mile-long path leading through the woods from the summer garden next to the palace."[7] This area created an atmosphere conducive to meditation and conversation. With the exception of invited guests and a few servants, no one was likely to intrude. Quietude might be accompanied by music and birdsong. The cares of the world must have seemed remote, allowing thoughtful discourse to flourish. The realm of opinion welcomed all who arrived with an open mind. Philosophy was no less important than the views. "As [Marsilio] Ficino was fond of remarking [...] what is cultivated in villa life is the soul as well as the fields."[8]

No visit to Caprarola would be complete without a survey of the gardens adjoining the palace. Aristocratic gardens like this one ordinarily contained topiary, shrubs shaped by clipping to resemble animals, people, pyramids,

and other architectural forms. From Pliny and Vitruvius, we learn that the ornamental fashioning of plants was a standard fixture of antique gardens. And Leon Battista Alberti once wrote that "circles, semicircles, and other geometric shapes that are favored in the plans of buildings can be modeled out of laurel, citrus, and juniper when their branches are bent back and intertwined" (9:300),[9] thereby adding to the visitor's delight. The highest of the terraces behind the palazzina once had a variety of such topiaries, which took the shape of peacocks, lilies of myrtle, and cherry laurel. Though once commonplace, such features seldom survive, for they strain the resources of gardeners and the pockets of owners. I looked in vain for topiary here. The taste for planting in geometric shapes, however, extended the enthusiasm for mathematics manifest virtually everywhere in the palace's architecture: the semicircular ramps leading to the parade ground, the pentagonal exterior, the circular courtyard, the symmetrical zig-zag stairways leading to the entrance, and the spiral staircases. In its day, the palace garden almost immediately attracted praise. When Montaigne visited Caprarola in 1580, he wrote of the palace, "I have seen none in Italy that may be compared with it." He was particularly impressed by the parterre, with its geometrical partitions and, in the center, "a high pyramid which spouts water in many different ways." He also singled out "a grotto, which spraying water artfully into a little lake, gives the appearance to the eye and ear of the most natural rainfall."[10]

At Caprarola today the visitor sees tall, thick manicured hedges dominating both of the walled gardens next to the palace. Unfortunately, they give little sense of how this area looked in its prime. Box, a slowly growing evergreen with small leaves, was often used for borders, though it was by no means the universal choice of Italian gardeners. Privet, rosemary, lavender, juniper, myrtle, and sage were popular too as a means for demarcations. Gardeners kept the boundaries low for a practical reason: to prevent them from obscuring the lilies, hyacinths, narcissus and other flowers within each compartment. The flowering plants and herbs, with their array of colors, have left no trace. In the twentieth century, blooms were sacrificed to overgrown edging, easier to care for. The paths originally separating sections and allowing visitors to enjoy the plantings closeup have largely disappeared. Also missing are the fountains and statues of mythological figures later removed to other estates. Collectively, these features imbued Caprarola's gardens with charm while simultaneously evoking the ancient world. Stripped of those distinctive elements, the gardens now exhibit only a rough semblance of what Alessandro Farnese once saw during his evening stroll.

NOTES

1 Loren Partridge, "The Farnese Circular Courtyard at Caprarola: God, Geopolitics, Genealogy, and Gender," *The Art Bulletin* 83, no. 2 (June 2001): 259–93.

2 "In traditional astrology there are only seven planets ruling twelve signs (Mars—Aries and Scorpio; Venus—Taurus and Libra; Mercury—Gemini and Virgo; Moon—Cancer; Sun—Leo; Jupiter—Sagittarius and Pisces; Saturn—Capricorn and Aquarius." Frederick Hartt, *History of Italian Renaissance Art*, 3rd ed. (New York: Harry N. Abrams, 1987), 60.

3 Mary Quinlan-McGrath, "Caprarola's Sala della Cosmografia," *Renaissance Quarterly* 50, no. 4 (Winter 1997): 1045–1100.

4 *Travel Journal*, in *The Complete Works of Montaigne*, trans. Donald M. Frame (Stanford, CA: Stanford University Press, 1957), 1026.

5 Montaigne, *Travel Journal*, 1027.

6 See Leonard Barkan, *The Gods Made Flesh: Metamorphosis and the Pursuit of Paganism* (New Haven and London: Yale University Press, 1986), 171.

7 Elizabeth Barlow Rogers, *Landscape Design: A Cultural and Architectural History* (New York: Harry N. Abrams, 2001), 181.

8 Terry Comito, "The Humanist Garden," in *The Architecture of Western Gardens*, ed. Monique Mosser and Georges Teyssot (Cambridge, MA: MIT Press, 1991), 37.

9 Leon Battista Alberti, *On the Art of Building in Ten Books*, trans. Joseph Rykwert, Neil Leach, and Robert Tavernor (1988; repr. Cambridge, MA, and London: MIT Press, 1997).

10 Montaigne, *Travel Journal*, 1026–27.

PART III

THE NORTH

CHAPTER 17

SANT'ANDREA, MANTUA

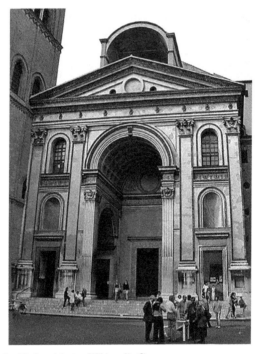

FIGURE 17 *Sant'Andrea, Mantua.* Wikimedia Commons.

The magnate of Mantua sought to create a pilgrimage church containing vials of Christ's blood collected at the Crucifixion. As many as 10,000 pilgrims would visit Mantua each year. The church, designed by Alberti, has an ingenious façade: it combines a Roman triumphal arch with a Roman temple front. In this way, a Christian church preserves the materials of pagan culture.

Almost nothing is known for certain about St. Andrew except that he was Christ's first apostle and the brother of Peter. He practiced his ministry near the Black Sea and was eventually martyred. The New Testament does not connect him with Mantua. But stories that arose in the Middle Ages may be stitched together to form a narrative involving an Italian city he probably never visited. According to legend, Longinus, a Roman centurion who pierced Christ's side with a lance at his crucifixion, collected two vials of blood from Mount Golgotha and in CE 37 took them to Mantua for safekeeping. When martyred, Longinus was buried there along with the relics. They were disinterred in 803 and buried yet again (for protection) when Mantua was threatened with attack. According to one story, St. Andrew in 1048 appeared to a beggar and showed him the hiding place of the blood. Following discovery, the vials were preserved in a Benedictine community named for the apostle. Because they were stored beneath the pavement of a church, however, almost no one ever saw them. Ironically, the vessels that provided the raison d'être for the abbey were virtually inaccessible.

Despite doubts arising over the authenticity of the blood, Francesco I Gonzaga, magnate of Mantua, saw an opportunity. In 1401, he directed that the vials be displayed every year on Ascension Day when the dried blood would liquefy. The growing number of visitors would eventually require a new and much larger church at the site. As many as 10,000 pilgrims would visit Mantua to see them. Although misgivings persisted, Francesco della Rovere, who would later become Pope Sixtus IV, assured the faithful that the blood was genuine. Whatever private reservations people may have harbored, the decision of Francesco's grandson, Ludovico II Gonzaga, to replace the decaying medieval abbey *c.* 1470 ensured that pilgrims could be accommodated. And they would arrive with cash in their pockets.

Ludovico, a student of architecture, had a threefold agenda: to extol his island city, celebrate himself and his piety, and provide a space large enough to accommodate multitudes eager to view the sacred relics. The Benedictine abbot opposed the demolition of his little church, but when he died, Ludovico pounced. He received from Antonio Manetti (Brunelleschi's biographer) a design for a new edifice and sent it to Leon Battista Alberti for his opinion. Alberti, in turn, offered his own proposal to replace the abbey. Ludovico wrote back, inviting the aging architect to visit Mantua. The two men apparently felt a strong kinship, for not long after their meeting work on the new church began.

The prospect of raising a new structure, begun in 1472, must have delighted Alberti, who wrote, "No aspect of building requires more ingenuity, care, industry, and diligence than the establishment and ornament of the temple

[church]. I need not mention that a well-maintained and well-adorned temple is obviously the greatest and most important ornament of a city; for the gods surely take up their abode in the temple" (7:194).[1] In keeping with his allegiance to ancient Rome, Alberti routinely used the word *temple* for *church* and preferred the locution *gods* to *God*.

* * *

Today, the building stands before us mute. If it had a voice, it might say something like this: *Don't just hurry inside. Take a long look and think about what you see. Although the face I present to the world contains elements of other churches, they are arranged in a strikingly new way. My façade takes the form of a giant Roman temple front, familiar to denizens of classical culture. Superimposed upon it is a huge triumphal arch of the kind Romans erected to honor victorious generals. Such an arch was not a feature of classical temples. Here it suggests not mere military success but a symbolic victory over Death. By fusing two entirely different forms, the architect creates a satisfying amalgam that draws upon religious, civic, and military culture. Temple front and triumphal arch do not cancel each other. Instead, they are integrated in such a way as to provide a synthesis. What you behold, then, is inventive and original. And, remarkably, the conflation of pagan materials serves the Christian God.*

A curious feature accompanies the motifs of arch and temple: a large arched canopy nicknamed *ombrellone* (umbrella) and sometimes called a "vaulted hood."[2] It rises high above the pediment of Sant'Andrea and extends outward from the church wall. It has the effect of diminishing sunlight entering the interior, and because Alberti believed that churches should be dimly lit, this assumption may account for the oddity: "The awe that is naturally generated by darkness encourages a sense of veneration in the mind" (7:223). An equally plausible explanation, however, involves the existing Romanesque bell tower immediately beside the church. Since the tower could not be moved, Alberti created a façade of lower height and shorter width than the church behind it, thereby allowing for a larger interior than could be justified by the façade. The "ombrellone" helps disguise the disparity between the façade and the church proper. And its curvature echoes the triumphal arch below.

Everything about the façade bespeaks size; some visitors have even speculated that its magnitude was meant to evoke the Basilica of Maxentius in the Roman Forum. Dominating the vertical scheme are four colossal pilasters (rising through several stories), standing on pedestals and topped with Corinthian capitals. Fluted pilasters flank the entrance on both sides and support the semicircular arch. A broad entablature rises above the taller pilasters. A pediment housing a circle in the *tympanum* (the triangular feature) surmounts the design.

Instead of settling for a flat façade, Alberti created a deep portico in the form of a tall barrel vault within the arch. Smaller vaults intersect it on both sides. (Despite this display of stone, the visitor does not guess that Sant'Andrea is made almost entirely of brick, a cheap material manufactured next to the building.) Contributing to a sense of depth is the coffering of the portico's vault, divided into individual sunken panels and decorated with rosettes, creating a three-dimensional effect. All of this makes for an exceptionally spacious porch, which Alberti surely knew characterized ancient temples.

Before I entered the church, I lingered under the arch, for I wanted to understand what made this construction feel so different from Alberti's other work. Neither the Tempio Malatestiano in Rimini nor Santa Maria Novella in Florence bears a strong resemblance. Here Alberti, in effect, was given a blank check to design from scratch what he wanted. In accord with his passion for ancient Rome, the architect does not announce that we are approaching the entrance to a religious building. Indeed, the triumphal arch was a secular, not religious, construction in antiquity. Other Italian churches may give prominence to such an arch, but none emphasizes the form with greater force than this. And the architect underscores that form by the way he repeats it in the interior. What Alberti had discovered was the primal power of the shapes he chose to dominate the façade. Nothing I saw there specifically evoked spirituality. Rather, the loggia affirms its own solidity and power. The ancients would surely have approved.

* * *

What awaited me inside was altogether different. Walking through the entrance, I experienced a sense of space expanding in all directions. Precisely because the façade is smaller in dimension than the church itself, the expansiveness is redoubled. Ludovico wanted nothing to interfere with pilgrims' sight of the sacred relics. Hence, in contrast to precedent, he mandated no side aisles with their columns. Instead, he created three barrel-vaulted chapels that branch off at right angles from the nave on both sides. Giant pilasters separate the chapels and support the huge barrel vault of the nave, the largest built since antiquity. Alberti anticipated no choir, only an apse at the end of the nave, a vaulted semicircular area. The architect apparently anticipated the addition of transepts to broaden the space even further, but they were not added till the eighteenth century. Alberti's dome, similarly, had not been constructed before his death. Filippo Juvarra later substituted his own plan.

Alberti's design represents a departure from traditional practice, which usually based churches on the shape of Roman basilicas, civic structures with

rectangular centers flanked by narrower rectangles. In a major break with the past, Alberti decided to replace that three-part design with one huge open area 330-feet long. Also contributing to the volume is the barrel-vaulted ceiling, made of brick, seventy-feet wide, and sixty-feet high, though for lack of money, the coffering was simply painted, not sculpted. Such vaults had a precedent in ancient Rome—for example, the Baths of Caracalla. Not on view, of course, are the vessels that ostensibly contain Christ's blood; most of the time they rest in the crypt for safekeeping.

Despite its dimensions, Alberti's interior is neither intimidating nor off-putting. As I looked upward, I found my mood brightening; I became more thoughtful and reflective. In fact, I felt a sense of awe. Where, I asked myself, had I experienced this previously? And then suddenly I knew. Alberti had taken a lesson from Gothic design. He was not using pointed arches, of course, or the other paraphernalia of the Middle Ages. But here was the counterpart of medieval cathedrals that seek to lift the spirit by directing the eye upward and prompting a sense of exhilaration. What makes Sant'Andrea different from its predecessors in centuries past is the way Alberti handled that space. It is not empty and does not disappear in pointed arches above. Instead, it is composed, contained and shaped by the barrel vaulting. The architect treats space as though it were one of his construction materials.

At the close of my visit, I wrote in my journal that the interior of Sant'Andrea was the most impressive I had yet seen: "On each day of my visit to Mantua, I returned to the church, and each time I did, I admired it more. What struck me when I first saw Sant'Andrea was the sheer volume of the interior and, even more important, the fact that the space felt coherent. The absence of aisles makes all the difference. The side chapels along the nave contribute to the sense of space because of their height and because their barrel vaulting echoes that of the nave itself. They contribute space to the center of the church rather than detracting from it."

Leon Battista Alberti was not a practicing architect as we usually understand the term. Essentially a planner and theorist, he saw no particular need to oversee work in progress, though he made several visits to supervise construction. He has even been called a "celebrity" architect. In Mantua, he had the good fortune to have at hand the Florentine mason Luca Fancelli, who had already supervised the construction of the Mantuan church of San Sebastiano, though he was reputed to be a scoundrel who stole building materials and forced laborers to work at the site of his home. Alberti preferred to spend most of his time in Rome rather than at building sites. He issued instructions to Fancelli by correspondence. In 1472 Alberti died, leaving most of the construction to his site manager.

NOTES

1 Leon Battista Alberti, *On the Art of Building in Ten Books*, trans. Joseph Rykwert, Neil Leach, and Robert Tavernor (1988; repr. Cambridge, MA, and London: MIT Press, 1997). Citations designate book and page numbers.
2 Samir Younés and Carroll William Westfall, *Architectural Type and Character* (New York: Routledge, 2022), 128.

PALAZZO TE, MANTUA

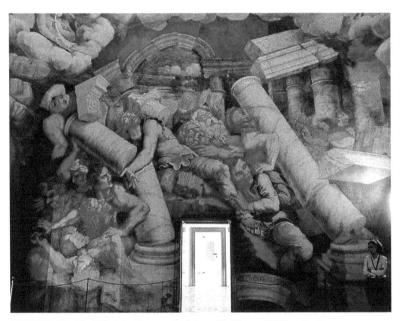

FIGURE 18 *The Fall of the Giants at the Palazzo Te, Mantua.* Wikimedia Commons.

Raphael's favorite student was Giulio Romano, who designed a great home for the Marquis of Mantua. Vasari reports that he wanted a place "where he could go and take refuge on occasion to have lunch or amuse himself at dinner." The palace has the form of a perfect square with a great garden attached on one side. The interiors feature a variety of frescoes most of which depict mythological subjects.

In 1524, Federico II Gonzaga, Marquis of Mantua, decided to build a summer house on the edge of the marshes that border his city. The site he chose was the Isola del Te, an island long used as a stud farm. Giorgio Vasari reports in *Lives of the Artists* that Federico wanted a place "where he could go and take refuge on occasion to have lunch or amuse himself at dinner" ("Romano" 366–67).[1] He also sought quarters for his mistress, the Contessa Isabella Boschetti, a married woman of spectacular beauty. To this end, he hired Raphael's protégé Giulio Romano, newly arrived from Rome, to design, oversee and decorate the project. When he saw what Giulio, architect and painter, was accomplishing, Federico expanded his original vision. In Giorgio Vasari's words, "This was the reason why the marquis later decided [...] to make the entire edifice into a grand palace" (367). Within ten years, the structure was virtually complete. In his book on the Italian Renaissance, Jacob Burckhardt called the palace "one of the most important buildings of the golden age."[2]

Symmetry characterizes the overall design: the palace has the form of a perfect square enclosing a courtyard of similar shape. Four entrances, across from one another, open onto the space, which Vasari likened to a piazza ("Romano" 367). Unlike the Palazzo Farnese in Rome or palaces built earlier in Florence, this one is only a little more than one story high; an upper mezzanine accommodates servants and storage. The waterlogged site discouraged a tall edifice. A strong horizontal line dominates the four external façades, their width four times their height. Because of the palace's dimensions, the *piano nobile* here occupies the ground floor, a highly unusual arrangement.

A curious paradox characterizes the palace. For a structure that contained a plethora of magnificent objets d'art, the façades seem mostly subdued. On the north wall, which now contains the chief entrance, a series of giant pilasters separates the windows. The rusticated wall has a sturdy and staid look. In fact, the architect has gone out of his way to present a bland face to the world. Nothing suggests grandeur; the building has been described as having "coarse, *rustica* features."[3] Nor do we find anything to excite visual interest. Neither a pediment nor an arch large enough to attract the eye focuses our view. Instead, we see three small, barrel-vaulted arches built into the wall, allowing entry. There is no portico. Giulio seems intent on diminishing our expectations.

His decision to minimize the entrance becomes apparent when we contrast it with another of the palace façades. Radically different from the main approach, the east front overlooks what must have been a large garden of geometrical precision. Three huge arches form a barrel-vaulted loggia that opens the palace to the visitor. The arcade, consisting of a double row of Doric columns, connects the interior courtyard with the outdoor garden. The triad echoes the triple

openings of the main entry but on a far grander scale. Scenes from the life of the biblical King David decorate the vault: "With images and reliefs of David, the *Loggia di Davide* refers, of course, to the well-worn theme of the divinely appointed ruler."[4] The huge neoclassical pediment present today was not built until 1774. It does not belong to Giulio's design.

The materials of the garden façade also contrast with those of the main entrance. What appears to be stone here is smooth, in contrast to the rougher surface of the main approach. In the absence of a suitable quarry nearby, Giulio used large building blocks with brick cores and covered them in stucco. In fact, most of the structure is made of brick disguised to look like stone, a classical technique.

What softens the look of this façade is the fish pond in front, evoking a moat separating building and greenery. The garden terminates in an *exedra*, a curved colonnade marking a division between garden and countryside; it was added by Nicolò Sebregondi *c.* 1650, perhaps to replace an earlier such structure by Giulio. To one side of the exedra, we find the *Casino della Grotta*, a suite of rooms arranged around a *giardino segreto*. This private garden contained an enclosed outdoor room offering a retreat where people could bathe and take their leisure. "Tranquil, intimate, embellished with statuettes, masks, and carvings in stucco, the secret garden was, by definition, an enchanting, secluded spot, reserved for solitary delights: a retreat from the strident affairs of the outside world and immune from the strain of court life."[5] Seashells and pebbles, as well as mosaics, decorate its walls. Frescoes on the ground floor feature grotesque designs, inspired by those in Nero's Golden House. On the second floor, a series of niches within rounded arches and separated by herms contains scenes from Aesop's *Fables*. The statuary that once filled the open space has, of course, vanished.

* * *

In the central courtyard of the palace, 145 feet on each side, the ingenuity largely absent from the main entrance startles us. The *cortile* must have struck contemporaries as unusual if not eccentric. Massive engaged columns supply vertical support rather than pilasters of the kind seen outside. Here the faux stones seem larger and more varied in size. Doric columns border irregular spaces, some much wider than others. Pediments loom over blind windows, their purpose obscure. Simple brackets attached to the wall support these triangular forms rather than the columns we should expect. Rusticated keystones that seem much too large push their way into the courtyard pediments. The walls vary in their surfaces, too. Smooth ashlar covers some areas while rougher stone covers

others. Broken plaster, called *spezzato*, adds yet another texture. Most remarkably, on two sides of the courtyard with a Doric frieze, some of the triglyphs seem to have slipped down, leaving blanks in their places, the adaptation of a classical motif. The metopes contain grotesque masks. (For the first time, these classical forms found their way into contemporary buildings.) Oddly, certain capitals atop columns seem unfinished as though the sculptor was called away from his task before the job was completed. Collectively, these features suggest that Giulio was abandoning the architectural principles that guided his predecessors. Some observers may find a parallel in the postmodern, a playful recombination of stylistic norms.

The term that best describes what we find at the Palazzo Te is Mannerism, a label coined in the seventeenth century by Roland Fréart de Chambray, who used it as a pejorative, signifying a decline from previous excellence. Notoriously difficult to define, the widely employed locution may have its origin in Giorgio Vasari's *maniera*, which has its root in the Italian word for "hand." Unfortunately, the biographer used the expression in different ways. Today the word is often translated as *manner* or *style* or *method*. Without historical context, this multiplicity does not tell us much. The "stylish style" apparently owes its origins to a sense that the major challenges confronting contemporary architects and painters had been largely resolved. Bramante, Leonardo, Raphael, and others having already achieved a kind of perfection, younger designers began to seek new ways to express their originality and virtuosity. In playfully defying the proportion and harmony of the Early and High Renaissance, for instance, architects came to prize ingenuity, instability, complexity and even asymmetry. Painters like Pontormo, Parmigianino, and Tintoretto used unfamiliar colors, pictured bodies in unnatural poses, and elongated the human form. They tilted toward artificiality rather than careful observation. Federico Zuccari later wrote a treatise insisting that artists might just as well portray what they saw in their imaginations as what they found in nature. Highly idiosyncratic, Mannerism, associated with the 1520s, 1530s, and later, displayed the virtuosity of architect and artist; it found a home in courtly culture, which welcomed elegance and refinement.

Decoration throughout the Palazzo Te was sumptuous, taking the form of tapestries, rich fabrics, statuary, furniture, clocks, mosaics, plasterwork, marble fireplaces, bronze doors and a host of decorative objects in glass, metal and majolica. All of these materials ensured both personal comfort and an apt setting for entertaining. The Emperor Charles V, grandson of Spain's Ferdinand and Isabella, was a guest in 1530 and 1532. His praise of what he saw at the palace enhanced Giulio's reputation throughout Italy. A century

later, however, catastrophe struck. In July 1630, Austrian troops sacked the palace, along with the city of Mantua. Virtually everything of value was stolen; after three days the palace had been picked clean. Aside from wood ceilings, fireplaces, decorated pavements, and some painted stuccowork, almost nothing survived of the original splendor. The frescoes, however, remain largely intact and still magnificent. Produced over a period of ten years by Giulio and his workshop, they are the chief reason to visit this site. Virtually all of them celebrate the ancient world, a realm of pagan gods, classical narratives, dragons and putti. In 1542, Pietro Aretino wrote of his friend, "The world cannot reproduce either the invention or the grace with which you handle a pair of dividers or a brush. And what could be said of Apelles and Vitruvius also applies to buildings and paintings that you have made and designed in this city, as you have embellished it, and glorified it by the spirit of your antique modern and modern antique ideas."[6]

* * *

The Sala dei Cavalli (Hall of the Horses), the largest room in the palace, served for entertaining, banquets, and dancing. The lower walls, now empty, were originally covered with leather panels featuring gold and silver decorations; the leatherwork was probably destroyed for its precious materials. Instead of contemporary portraits or celebrated ancient heroes, six full-size pictures of the Duke's favorite horses—some with their names inscribed—dominate the room. These images, probably made by Giulio himself, evoke the property's use as a stud farm; landscapes and towns, in the distance, provide a visual context. Vasari reports that the animals were painted with such skill "that they appear to be alive" ("Romano" 367), something we can still appreciate. Alongside the animals, framed by painted pilasters, illusionistic niches contain images of the ancient gods. Above the horses, copper bas-reliefs display classical scenes, including six of Hercules' Labors.

On its vaulted ceiling, the *Salara di Amore e Psiche* dramatizes a story told by the classical author Apuleius in his *Metamorphoses,* also known as *The Golden Ass.* It seems that Psyche was so attractive that men neglected to worship Venus. So the envious goddess sent Cupid to make Psyche fall desperately in love with a debased and degraded man. But the plan went awry when, instead, Cupid fell in love with her. She was transported to his palace, where every night they made love. Warned never to see his face and learn his true identity, she observed the stricture, knowing that mortals cannot survive the sight of a deity. Goaded by her sisters, however, she lit a lamp one night and discovered his beauty. When a

drop of burning oil fell upon him, he awoke and fled. To win him back, Psyche had to undergo a series of trials imposed by Venus. Octagonal panels on the upper walls and ceiling represent the story. The lovers were finally reunited when Jupiter intervened and conferred upon Psyche the status of goddess.

When I stepped into this banqueting hall, I found myself astonished by the dynamism and lush artistry of the paintings. The spirit of Dionysus presides here. A festival of erotica covers the walls, most of it depicted by Benedetto da Pescia and Rinaldo Mantovano, though Giulio retouched their efforts. Included are Mars and Venus bathing and preparing for a feast; Mars discovering Venus and Adonis together and chasing him out of her pavilion; the tomb of Adonis, lover of Venus; Cupid and Psyche lying nude on a daybed; Mercury preparing a banquet while Psyche bathes. Two large ceiling panels simulating tapestries depict the *Council of the Gods* and the *Wedding Banquet of the Gods*; exuberant figures animate both paintings, which seem hung from the vault. This pictorial program may have been inspired, in part, by Francesco Colonna's *Hypnerotomachia Poliphili* (written 1467?, printed 1499), an immensely popular and richly illustrated book describing a journey through a series of gardens to the isle of Venus/Cythera, which itself takes the form of a great garden. Federico planned to place a statue of Venus in the middle of this room.

Inspired by Ovid's *Metamorphoses* and assisted by Mantovano, Giulio painted the windowless *Sala dei Giganti* (Hall of the Giants), thirty-six feet square, in one continuous view from floor to ceiling. Unlike other ceilings in the palace, this vaulted structure is not divided into geometrical sections. A single design fills the entire room. Jupiter, surrounded by the other Olympian deities, violently repels the Giants/Titans, who have sought to build a mountain, invade heaven, and topple the gods. We see, in Vasari's words, "Jove annihilating the giants with his thunderbolts" (370). Classical columns buckle; arches collapse below. As the palace of the rebels crumbles, their faces register terror. Vasari records that a fireplace in the room, now lost, when lit made it seem as though the Giants were about to be overcome by flames.

Theatrical illusion dominates the ceiling. Because every inch of the room above the floor contains color, because there are no visible corners, and because the vault depicts a circular temple in perspective, the overhead painting seems on the verge of turning into a dome. On my first visit, a feeling of claustrophobia soon overcame me, and I instinctively looked for an exit. No escape awaits the Giants. Some topple into the sea, others crushed by falling rock. Their entire world seems unhinged. My journal entry records an initial reaction: "This is a tour de force, which dazzles and provokes by exaggeration and violence. This may be the single most stunning room I have ever seen. It's also a little creepy."

As I left, I reflected that I couldn't live comfortably with paintings that disturb as much as they please, no matter how powerful.

The fresco, probably painted *c.* 1527–1528, may express Giulio's shock at the Sack of Rome, though he did not witness it first-hand. Given his experience of Italian city-states in more or less constant conflict, however, he acutely sensed the frailty of even the most brilliant creations, memorably expressed by Prospero in Shakespeare's *The Tempest*: "The cloud-capped towers, the gorgeous palaces, / The solemn temples, the great globe itself, / Yea, all which it inherit, shall dissolve, / And like this unsubstantial pageant faded, / Leave not a rack behind." In Romano's Hall of Giants, even the gods themselves, looking disconcerted and fearful, project vulnerability.

Vasari, in the 1568 revision of his *Lives*, was mightily impressed: "let no one ever imagine seeing a work from the brush that is more horrible or frightening or more realistic than this one" (372). The key word is "realistic"—an attribute that connoisseurs especially admired about Giulio Romano. It was this aspect of his work that led Shakespeare to mention him in *The Winter's Tale*, where a statue is said to be so accurately rendered that it looks as if it was made "by that rare Italian master, Julio Romano." In all of his plays, this is the only time Shakespeare mentioned an artist of the Italian Renaissance.

NOTES

1 Giorgio Vasari, *The Lives of the Artists*, trans. Julia Conaway Bondanella and Peter Bondanella, Oxford World's Classics (1991; repr. Oxford: Oxford University Press, 2008).
2 Cited by Egon Verheyen, *The Palazzo Te in Mantua: Images of Love and Politics* (Baltimore: The Johns Hopkins University Press, 1977), 2.
3 Kurt W. Forster and Richard J. Tuttle, "The Palazzo del Te," *Journal of the Society of Architectural Historians* 30, no. 4 (1971): 267.
4 Forster and Tuttle, "The Palazzo del Te," 279.
5 Gian Maria Erbesato, *Guide to Palazzo Te* (Florence: SCALA, 1987), 50.
6 Cited by Ugo Bazzotti, *Palazzo Te: Giulio Romano's Masterwork in Mantua*, trans. Grace Crerar-Bromelow (London: Thames and Hudson, 2013), 17. The photos in this book, taken by Grazia Sgrilli and Ghigo Roli, are the finest ever published of the palace.

CHAPTER 19

SABBIONETA AND THE IDEAL CITY

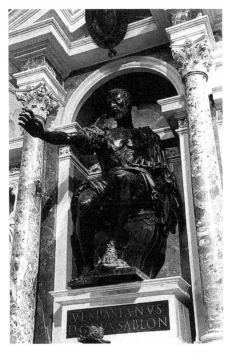

FIGURE 19 *Statue of Vespasiano Gonzaga, Sabbioneta.* Wikimedia Commons.

Vespasiano Gonzaga was a professional soldier with deep pockets. He decided to use his money to create the equivalent of an ancient Roman city. This was a formidable enterprise, but it was largely successful, though what he created is unknown to most Americans. It includes a town hall, an art gallery, a central-plan church, a mint, a synagogue, and a broad piazza. In its totality, Sabbioneta demonstrates the desire to embrace and perpetuate classical culture.

After the fall of ancient Rome, the gridwork that defined European cities gradually disappeared. As a result, few streets in the Middle Ages ran straight. And when a building by, say, Brunelleschi or Alberti was constructed, it was likely to be surrounded by a hodgepodge of extant structures bearing few marks of the dawning age. Terrain rather than logic might dictate the shape of a city. The urban setting became an issue as new kinds of architecture appeared next to the old. In the best of all possible worlds, a city should provide a framework within which innovation may thrive. Achieving this goal entails a thoughtful understanding of how buildings respond to one another. Contemplating this problem in the 1400s, people began to realize that structures needed to be situated so that their design could be appreciated, something difficult to accomplish when cheek-by-jowl with edifices that had come to be judged obsolete. Architects began to extrapolate from the shape of new buildings and to consider what an ideal city might look like.

Although Vitruvius discussed the siting of a city, paying particular attention to prevailing winds, he did not treat the concept of urban space in the systematic way that Renaissance architects did. Leon Battista Alberti described what he imagined as an ideal urban setting. This early town-planner advocated a rigorous geometric arrangement, the antithesis of medieval towns with their higgledy-piggledy layout. He wrote, "The principal ornament to any city lies in the siting, layout, composition, and arrangement of its roads, squares, and individual works: each must be properly planned and distributed according to use, importance, and convenience. For without order there can be nothing commodious, graceful, or noble" (7:191).[1] In short, the ideal city must exhibit a thoroughgoing unity. In practice, this took the form of concentric circles and radiating streets. Unfortunately, the original edition of Alberti's book contained no illustrations. By contrast, Pietro Cataneo's *Four Books of Architecture* a century later (1554) was richly illustrated. A mathematician and military engineer, Cataneo proposed the shape of a twelve-pointed star. Such polygonal perimeters became popular not only because they emulated a central-plan structure but also because, if walled, they offered better protection from a besieging army; the stellar shape helped resist high explosives hurled by artillery.

* * *

Antonio Averlino, who adopted the Greek name Filarete (lover of virtue), developed "the first fully planned ideal city of the Renaissance" in his treatise, probably written in the 1450s and 1460s though not published.[2] Calling his

imagined city Sforzinda after his patron Francesco Sforza, Duke of Milan, Filarete sought to banish the Gothic style, which he thought barbarous. He sought inspiration from ancient principles, especially reliance on geometry and symmetry. His overall design resembles an eight-pointed star, the shape of two intersecting quadrangles. A diagram shows the walls inscribed within a circle, representing a circular moat. Three interconnected piazzas form the core, which accommodates the palace, cathedral, and market. Streets radiate outward toward the city gates, a plan that differs from the ancient Roman grid. Improbably, every other street consists of a canal for the transport of cargo. The city's most peculiar feature is the House of Virtue and Vice, ten stories high: a brothel occupies the ground floor, an Academy of Learning on the top. Although Filarete's manuscript, written in Italian, circulated widely and contained the author's own drawings, it was not actually printed until 1890 (and then only in part), so it did not achieve the influence he must have intended. Although the design has been called the first modern, utopian city, Giorgio Vasari had little use for the book.

Realizing an intellectual scheme for a new city required money and power. Both became available when in 1458 Aeneas Silvius Piccolomini assumed the papacy. Like his predecessor Nicholas V, Pius II combined two special interests—books and architecture. His devotion to the written word resulted in doubling the size of the Vatican Library. Upon his elevation, he decided to transform his medieval hometown into a model urban space. In February 1459, he made a trip to his birthplace, Corsignano, near Siena. Alberti accompanied him. From this visit came a resolution to completely refashion the village. New principles of design would inform its religious, civic, and secular center. The scheme called for a new cathedral made of travertine, a light-colored limestone, and dominated by the shape of a classical temple front; three tall arches, all the same height and evocative of Roman triumphal arches, stretch upward for two stories on the façade and support a huge pediment. The papal coat of arms occupies the tympanum; it is the only Christian symbol visible on the exterior, apart from a little cross at the top. Also constructed in the years 1459–1464 were a two-story Palazzo Comunale (Town Hall), with a spacious loggia opening onto the principal piazza, and the Palazzo Vescovile (Bishop's Palace), a cubical block. The most impressive of the new buildings was the Palazzo Piccolomini (family palace), a sizable, freestanding building, which closely resembles the Palazzo Rucellai in Florence. (It's not clear which of the two was designed first.) The most interesting feature, on the side opposite the façade, is a triple loggia, one story above another. This configuration offers views of the walled garden below and distant mountains.

Although Alberti must have had a major say in the layout of the town, the pope selected Rossellino as site manager. Together pope and architect created the first ideal urban center to take shape in stone and mortar rather than in ink and paper. All of their buildings converge on a trapezoidal piazza, perhaps chosen to underscore the centrality of the church; the layout anticipates Michelangelo's Piazza del Campidoglio in Rome. Unfortunately, the piazza looks somewhat small, given the imposing size of the buildings that face it. They would seem more attractive if not quite so closely juxtaposed.

Within five years, the pope saw forty structures built or rebuilt in his reimagined birthplace, which has the distinction of being the first planned city of the Renaissance to take physical form. Pius renamed it Pienza (city of Pius) after himself. Following his death in 1464, however, the town slipped back into its former obscurity. Today about 2,500 residents remain. The decline occurred quickly. Only two months after Pius died, his nephews, inheriting the property, complained that their uncle's palace "was done at very great cost without any usefulness." They had no desire to sustain the building and its upkeep. A half-century ago, however, the film director Franco Zeffirelli used the Palazzo Piccolomini for the Capulet scenes in *Romeo and Juliet*.

Pienza may best be described as a cross between idealism and whimsy. Although the pope made several visits to the town during reconstruction, his responsibilities in Rome absorbed his time and attention. To make an ideal urban space out of an unprepossessing village required someone with both vision and determination to sustain the project. A much more effective effort to create a substantial town (not just a village) would be realized elsewhere. But nearly a century would elapse before it took shape.

* * *

Sabbioneta, in north-central Italy, represents a more thoroughgoing, systematic and successful attempt to design a city that would evoke classical antiquity by its architecture, sculpture and painting.[3] Combining these features, Vespasiano Gonzaga Colonna sought to create consistency of design and thereby to achieve a milieu not experienced for a thousand years. "Sabbioneta is probably the most complete and best preserved example of 16th century urbanism in Italy."[4] Remarkably, his bold venture remains substantially unchanged.

The small city lies about twenty miles southwest of Mantua and occupies an unremarkable, flat stretch of countryside. Its location in the Po Valley has encouraged neglect and attracts few visitors. Guidebooks give it brief mention or none at all. My 1023-page guide to Italy calls the site "an odd little place,"

not the kind of recommendation likely to attract tourists. Yet it offers an unrivaled opportunity to experience Renaissance culture available nowhere else. Sophisticated in conception and impressive in scale, Sabbioneta invites us to enter the mind of a sixteenth-century idealist.

In 1547, when he was scarcely fifteen, Vespasiano visited the remote settlement, part of ancestral lands belonging to his branch of the Mantuan family. He discovered a farming community, a medieval fortress (*rocca* in Italian), a monastery, and a marshland, a breeding ground for malaria. Where others may have seen a dreary hamlet in the middle of nowhere, Vespasiano recognized possibilities. Seeing things invisible to others, he imagined an urban development not realized since antiquity, a *città ideale*. Had he been an artist, he would have looked upon the unprepossessing site as though it were a blank canvas. His contemporaries must have thought the endeavor to construct a city from the ground up improbable, if not wacky. Nevertheless, he was single-minded and would, in time, have the deep pockets to realize his dream. In a sign of his purpose, Vespasiano razed most of the existing buildings, and, in the mid-1550s, began to transform concept into reality. By 1558, he called Sabbioneta a *città*. What he created has rested in a state of suspended animation for centuries.

Like the ancient emperor of the same name, Vespasiano first achieved success in the field of battle. This *condottiere*'s personal emblem was a winged thunderbolt. Contemporaries celebrated his courage. The Hapsburg Emperor Rudolf II recognized his martial prowess by naming him duke in 1577. His painted wooden statue in the ducal palace, perhaps carved by Venetian artisans, presents him on horseback and wearing a full suit of armor, evoking campaigns in service of the Holy Roman Emperor. His experience of siege warfare led to expertise in the field of military engineering, which he would put to use in Sabbioneta. Service to the Spanish crown, however, necessitated long absences from the work in progress, deflecting him from finishing his project. He had to appoint deputies to carry out his plans. Military service also separated him from his wife, whom he had married in secret at eighteen. In recompense for his loyalty, long employment and service on the battlefield, Spain's Philip II in 1585 awarded him the Order of the Golden Fleece, named for Jason and his Argonauts, who seized the artifact from the people of Colchis, on the Black Sea. Archaeologists, in their excavation of Vespasiano's tomb, discovered the pendant of a golden ram worn around his neck, a symbol of both his title and his fascination with pagan antiquity. On his deathbed, he requested that the pendant be brought to him.

When he undertook his new enterprise, he had assistance from Giovanni Pietro Bottaccio, a military engineer who served as site manager. Domenico

Giunti, a professional architect, may have helped as well; Domenico had earlier helped plan the nearby town of Guastalla. We know that Sabbioneta's founder consulted him, but it's impossible to estimate his contribution. Vespasiano himself applied what he knew as a military commander. That is, he envisioned his new city in the form of a seven-pointed star with wedge-shaped defenses called star-bastions. Invented by the Italians, these were fortifications in the shape of giant arrow tips. Each provided multiple angles of raking fire against aggressors and helped defend against artillery, as did huge embankments. "The bastion's triangular head, all faces of which could be protected by defensive fire, was attached to the fortress walls ('curtains') by short wall sections, the so-called 'flanks.' At these flanks, batteries were stationed that could sweep the outsides of the curtains with a cross-fire so intense as to make any attack upon them suicidal, even after they had been successfully breached by siege cannon."[5] Vespasiano raised a fortress (no longer extant), installed cannonry, and built a moat. Enormous brick walls still outline the city's perimeter, ensuring safety from marauders as well as from flooding of the nearby river Po, the longest in Italy. (The city's name means "sandy.") The fortifications create a sense that something momentous awaits inside. Something does.

Where did Vespasiano find inspiration for his project? Filarete (writing *c.* 1460s) and Francesco di Giorgio Martini (*c.* 1482–1495) both had imagined what an ideal city might look like. Although neither of their books reached print, they circulated in manuscript. Vespasiano had available Alberti's work on architecture as well, published a century earlier. And Vespasiano had at hand his own personal copy of Vitruvius, which he carried with him on military expeditions. In the absence of other evidence, we may conclude that most of the credit for Sabbioneta belongs to Vespasiano.

Once beyond the massive entry gate, the visitor confronts a rectilinear configuration of handsome though not exceptional buildings, mostly of two or three stories. Of special interest are the Ducal Palace, Garden Palace, Gallery of the Ancients, Theater, and central-plan church. Located at the head of the major piazza, Vespasiano's palace announces classical precedent (it's now the town hall). An open loggia occupies the ground floor. Alternating triangular and segmented pediments (with a curved upper edge) dominate second-floor windows. A decorated cornice tops the façade. The architectural vocabulary of ancient Rome typifies the building and, indeed, virtually all of Sabbioneta, except for the belvedere atop the palace. The interior has lost most of its original decoration; much of the wood paneling is gone and so are the tapestries. But many of the ceilings are intact, one of them covered in gold leaf.

The gridwork of streets, however, has a non-Roman peculiarity: that grid "is subtly distorted: instead of a straight street running east-west from gate to gate, we find ourselves baffled, once inside, by the choice of turning right or left to reach the main street."[6] What seems a puzzling departure from ancient practice can be explained as a defensive strategy. Should attackers gain entry to the city, "Alberti had advised in his treatise on architecture written a century earlier that, while great and powerful cities should have wide, straight streets, it is prudent in small towns or colonial foundations to have streets which twist and turn, to baffle the enemy."[7] As a lifelong warrior, Vespasiano would have seen the value of deception in frustrating the foe.

An open loggia made of red bricks arranged in semicircular arches supports the city's most imposing structure: the Corridor Grande, christened Gallery of the Ancients by Vespasiano's friend Ottavio Farnese. One of the longest such rooms in Italy, it was specifically conceived as a space to exhibit ancient sculpture; it contained busts of emperors and heroes, as well as figures from classical mythology. (With the removal of 170 sculptures in the eighteenth century, the Gallery became an empty shell.) Walking into this and other buildings, we enter the re-creation of an antique world. The good news is that extensive frescoes still adorn walls and ceilings. My journal records this: "The painted wood ceilings are among the most intricate and impressive I've ever encountered." At one end of the Gallery, which has been called "the first freestanding gallery to show works of art,"[8] trompe l'oeil painting presents what looks like five Doric columns on both sides, leading to a pedimented doorway topped by Vespasiano's coat of arms. These columns take the form of paint, not stone.

Wall paintings in the Gallery itself depict ancient scenes. I recall seeing chariot races in the Circus Maximus, mythical figures such as Aeneas, reputed founder of Rome, and his lover Dido, queen of Carthage. Others are drawn from the panoply of mythology as well. (Residing at Sabbioneta in 1587, Alessandro and Giovanni Alberti created some of the designs.) Ceiling frescoes in the Garden Palace include the wooden horse that allowed Greek soldiers to enter Troy and destroy the city; the satyr Marsyas who challenged Apollo in a musical contest and was flayed for his pride; and Arachne, who challenged Minerva as a weaver and was transformed into a spider. All of this artistry required a platoon of painters. The best known was Bernardino Campi, a teacher of Sofonisba Anguissola, one of the most talented woman painters of the Renaissance. The accomplished Sofonisba may be responsible for the unsigned portrait of Vespasiano, now in the civic museum of Como, though the painting has also been attributed to Antonio Moro and Francesco de' Rossi.[9]

The city offers a guided tour twice a day, the only way for visitors to access the principal buildings, all of which are well worth seeing. There have been losses. The Hall of Mirrors, for instance, has lost every one of its Venetian mirrors. Marble floors in the Chamber of Myths were detached and moved elsewhere. Portions of frescoes have deteriorated as plaster fell from the walls. On one of my visits, I watched as conservators painstakingly restored magnificent frescoes in the Gallery of the Ancients. In the adjacent Garden Palace, however, Vespasiano's private residence, a window had been left open on a windy day. Every time the shutters blew closed, I saw bits of fresco falling off the wall. No one took any notice. Renovation and loss vie for supremacy in Italy.

<p align="center">* * *</p>

How did Vespasiano develop his fascination with antiquity? From a young age, he read widely and thoughtfully. After his father's death and his mother's remarriage, his aunt Giulia Gonzaga sent him to the kingdom of Naples and Sicily. There the Spanish Alfonso of Aragon had become king in 1443. Fortunately, Alfonso was a patron of the arts, a collector of ancient coins, a commissioner of bronze medals, and the owner of a library filled with Roman books.[10] He created a courtly atmosphere conducive to embracing ancient culture. And he "sought to outdo all others in his patronage of men of letters."[11] Vespasiano had the advantage of excellent instruction there. He learned Spanish and German, Latin and Greek; he was tutored in mathematics. And because Naples was a dominion of Spain, Vespasiano found a future serving as a page to Duke Philip, son of Charles V. At Philip's court Vespasiano absorbed the skills requisite for an aristocrat and became politically savvy. He raided the libraries belonging to men of letters, immersing himself in Rome's culture. On his tomb's bronze statue, one of his hands rests upon a book, a symbol of intellectual pursuits and associated with the goddess Minerva.

Vespasiano believed that emulating the Romans of old would foster the accomplishments of the citizenry in the present. In an effort to extend the kind of cultural amenities available in, say, Urbino, the enlightened Vespasiano established an Academy of the Humanities. He recruited musicians, started a botanical garden, collected statuary, invited a theatrical company to perform and sponsored folk dancers.

To mark the center of the city, Vespasiano erected an ancient column in the chief piazza. His father had transported it from Rome after the 1527 Sack. Atop stands a marble statue of Minerva, the Roman counterpart of the Greek Pallas Athena and identified with wisdom and artistry. (Vespasiano's mint produced

coins bearing her image.) He must have considered his choice carefully. Sabbioneta would become known as the "little Athens."[12]

The story of Sabbioneta cannot be confined to bricks and mortar, paint and plaster. Vespasiano's project was fueled by a powerful conviction. Ideally, all aspects of urban life should be interconnected. If accomplished, serendipity would follow. One sphere of activity would complement another. In Vespasiano's hands ideal city and material city became one and the same.

As the guiding spirit of this unique location, Vespasiano implemented policies that bespoke social responsibility. He cautioned lawyers not to overcharge the poor. He founded a school to teach Latin and Greek. He opened a hospital. He established two libraries, one personal and one public. He welcomed Jews, who established a printing press in 1551 to publish books in Hebrew—and he did this while the Inquisition threatened independent thought. In Rome and Venice, Jewish Scripture, especially the Talmud, was burned by order of the pope. In Sabbioneta, by contrast, a synagogue serving the Jewish population thrived; its nineteenth-century replacement survives. Vespasiano invited merchants and craftsmen to practice their trades. The social milieu he envisioned bore little resemblance to that of the late Middle Ages when conventional images of sin, temptation and punishment predominated. Now the populace could take comfort in a world increasingly secular and prosperous. His policies, he believed, fostered both knowledge and good character. Life and learning were intimately connected in his mind. He imagined a dynamic relationship between the people and the physical place they inhabited. His concept of "Rome revived" found expression in personal activities as well: he wrote poetry, attracted intellectuals to his court, enjoyed discussions of philosophy, and collected paintings by Giulio Romano, who built the nearby Palazzo Te in Mantua. To stroll through Vespasiano's buildings is to step into another world, one shaped by history. Not history as a compilation of bric-a-brac, but a world in which the inhabitants have seemingly stepped away and to which they will return.

If Sabbioneta has an odd vibe, it's because there are so few residents in evidence even during the summer. On both of my visits, I saw only a handful of people. It is as though a neutron bomb had exploded nearby, eliminating the population but preserving the buildings. Anyone looking for street life or even a meal will likely be disappointed. The sole business with an open door was a shop selling tobacco and newspapers. Vespasiano's city, however, gained modest notice when it appeared in Bernardo Bertolucci's 1970 film, *The Spider's Stratagem*.

After my tour I strolled about, trying to get a sense of what Vespasiano's contemporaries might have felt. I expected to find people shopping for dinner;

I hoped to see children or at least hear their voices. But an eerie silence enveloped the streets. Despite Sabbioneta's website claim of 4,000 residents, I was reminded of paintings by Giorgio de Chirico, the surrealist known for his empty cityscapes. James Madge ventures a guess that the city numbered no more than 7,000 people in its prime.[13]

* * *

The time capsule of Vespasiano's ideal city helps us appreciate the impulse to reject the medieval past and replace it with a model finding inspiration in classical Rome. His tomb enshrines his alignment with antiquity. The duke's remains rest in the church of the Incoronata, once the family chapel. The octagonal structure represents the Renaissance adoption of the ancient central-plan temple/church, previously implemented in Mantua (San Sebastiano), Prato (Santa Maria delle Carceri), and Todi (Santa Maria della Consolazione). Leone Leoni's 1588 sculpture of Vespasiano rests here, where it forms the centerpiece of an elaborate marble monument. Flanked by personifications of Justice and Fortitude, the seated bronze statue of Vespasiano, with a patinated black finish, stretches out his right arm with an air of authority, perhaps a reminiscence of the equestrian figure in Rome's Campidoglio.[14] If any evidence were needed of the duke's allegiance to ancient forebears, his attire provides it. Evoking statues of Marcus Aurelius and Trajan, he wears the garb of a Roman emperor prepared for combat.

Above all, the duke sought to achieve what Italians call *antichità*— "ancientness." Sabbioneta represents much more than the exhibition of recently excavated statues or columns. The enterprise constituted a wholesale effort to create a template for the future by assimilating materials pioneered in the past. In so doing, Vespasiano believed that society at large would surely profit. The rationality deployed in his city's plan, including a modified grid, would provide a model for human behavior. The harmony of the urban space would foster bonds within the populace. The virtues praised by the Romans would find a counterpart in the present. And the arts on display everywhere would shape contemporary sensibilities. Artistry, not religious dogma alone, would exercise a moral effect. We do not find a church at the center of Sabbioneta, a mostly secular endeavor. The principal church lurks behind the Ducal Palace.

A painted counterpart of Sabbioneta exists in Urbino's palace. There we see an imaginary city, evidence that architects and painters were beginning to think about ideal cityscapes. The identity of the artist remains uncertain; the

work has been attributed at one time or another to Luciano Laurana, Piero della Francesca, Leon Battista Alberti, and Giuliano da Sangallo. (Variations of this painting may be seen in Baltimore and Berlin.) Circles, squares, rectangles, and triangles dominate the composition. A paved piazza occupies the center. The buildings nearest the viewer display the symmetry and regularity we should expect. On the left, for instance, we see a three-story building, with a ground floor featuring a loggia, the columns topped by capitals. On the second-level pilasters with Corinthian capitals flank rectangular openings in the wall. And the top floor features smaller columns with decorated capitals and windows; a loggia overlooks the piazza below. In the center of this piazza is a perfectly round two-story temple surrounded by a colonnade of Corinthian capitals; it occupies the very center of the city. This building, with a tall first story and a shorter second, is topped with a conical cupola and a crystal orb, a tiny cross above, the only Christian symbol visible. With this single exception, the envisioned city looks exclusively secular. The painter must have felt that such a design would foster good government and social responsibility.

This and other similar pictures present an urban setting that never actually existed except in the minds of artists, architects and writers. The treatment of space finds its inspiration in the impulse to reform. The possibility of perfection colors all such embodiments. With some justice, the word "utopian" has been applied both to the painting in Urbino and to Vespasiano's city. *Utopia* was, of course, the title of Sir Thomas More's book (1516) describing an imaginary society with a superior legal, political and social system. The anonymous painting and the plan of Sabbioneta belong to an intellectual world, composed, orderly and static. Evoking an ideal, they extol reason. Clean lines and clean streets characterize both. What the painter and the architect provide are paradigms. But the oxygen seems to have emptied from those cityscapes. They lack exuberance, humor and energy. How, then, may painting and city be brought to life? Just add people.

NOTES

1 Leon Battista Alberti, *On the Art of Building in Ten Books*, trans. Joseph Rykwert, Neil Leach, and Robert Tavernor (1988; repr. Cambridge, MA, and London: MIT Press, 1997). Citations designate book and page numbers.

2 See Helen Rosenau, *The Ideal City: Its Architectural Evolution in Europe* (London and New York: Methuen, 1983), 46.

3 The major works about Vespasiano Gonzaga's city are those by James Madge, *Sabbioneta, Cryptic City* (London: Bibliotheque McLean, 2011), and by James Cowan, *Hamlet's Ghost: Vespasiano Gonzaga and His Ideal City* (Newcastle upon Tyne, UK:

Cambridge Scholars Publishing, 2015). For the finest photos of Sabbioneta ever taken (by Arrigo Giovanni), see Giancarlo Malacarne's *L'anima di un uomo / The Soul of a Man* [bilingual edition] (Verona: Promoprint, 1994).

4 Kurt W. Forster, "From 'Rocca' to 'Civitas': Urban Planning at Sabbioneta," *FMR: The Magazine of Franco Maria Ricci* 30 (January/February 1988): 99.

5 Horst de la Croix, "The Literature on Fortification in Renaissance Italy," *Technology and Culture* 4, no. 1 (Winter 1963): 31.

6 Caroline Elam, "Sabbioneta," *AA Files: Annals of the Architectural Association School of Architecture* 18 (Autumn 1989): 27.

7 Elam, "Sabbioneta," 27.

8 Alastair Laing, "The Ideal City Preserved: Sabbioneta, Northern Italy," *Country Life* 177, no. 4575 (April 25, 1985): 1120.

9 The painting is reproduced by Umberto Maffezzoli, *Sabbioneta: A Tourist Guide to the City*, 2nd ed. (Bologna: Il Bulino, edizioni d'arte, 1992), 68.

10 Alfonso's most important architectural project was the triumphal arch at the entrance to Castel Nuovo, Naples, designed by Francesco Laurana, Pietro da Milano, and others. Although Alfonso was Spanish by birth and upbringing, the arch embodies Italianate style.

11 Stephen J. Campbell and Michael Wayne Cole, *Italian Renaissance Art* (New York: Thames and Hudson, 2012), 183.

12 "Ireneo Affò was the first to coin in 1780 the felicitous description of Sabbioneta as 'The little Athens' by which it is still known today." See Maffezzoli, *Sabbioneta*, 9.

13 Madge, *Sabbioneta, Cryptic City*, 21.

14 See Maffezzoli, *Sabbioneta*, 24–25.

CHAPTER 20

THE TEMPIO MALATESTIANO, RIMINI

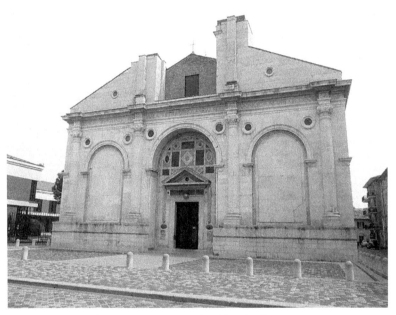

FIGURE 20 *The Tempio Malatestiano, Rimini.* Wikimedia Commons.

The professional soldier who ran the city of Rimini wanted to make his medieval church look like it belonged to the emerging Renaissance. He hired Alberti to devise a plan. The architect decided to wrap the entire church in a covering of white stone that would conform to new expectations of how a building should look.

153

When I travel on the continent, I usually reserve rooms before I leave home. I was led to this practice by an experience in Rome. Arriving very late at my hotel on the outskirts of the city, I approached the front desk and gave my name. The clerk looked in his register and informed me that I had no reservation. I knew I was in trouble, for night had fallen, and there were no other hotels in the vicinity. The chances of finding a room elsewhere at that hour were remote. Fortunately, I had taken the precaution of making a copy of my reservation. I reached into my luggage and produced it. This led to my being assigned the most luxurious hotel room I've ever seen. Italians call it an *appartamento*, a suite of rooms.

Contemplating a visit to Rimini, I took my usual precautions. I wrote to a hotel to secure a room, and driving into the city, quickly found my destination. But walking through the front entrance, I saw only carpenters and sawdust. The hotel was being extensively refurbished. I didn't panic, for I knew there must be plenty of other possibilities in this town on the Adriatic coast. I quickly found a large hotel, where every car in the parking lot had German plates. Once settled there, I was ready to explore the city. Incidentally, when I returned home many weeks later, I discovered that the hotel had indeed responded to my original request and reported that it would be closed. The letter, however, came by "surface mail."

What drew me to Rimini was the photo of a church designed by Alberti. I was intrigued by the site and knew I had to make a visit. The Lord of Rimini in the 1440s was Sigismondo Malatesta, a formidable *condottiere*, a soldier for hire. When he decided to modernize the Gothic church of San Francesco *c.* 1450 and convert it into a testament to his glory, he asked Leon Battista Alberti to devise a plan. The architect's makeover of the thirteenth-century church became far more extensive than his earlier treatment of Santa Maria Novella in Florence. He decided that the medieval brick edifice should be encased entirely in a shell of stone, some of it confiscated from other churches, including my favorite, the magnificent Basilica of St. Apollinaris in Classe, near Ravenna. A curious irony of the Renaissance was its willingness to plunder ancient Roman works and even other Christian buildings for their material. Quarries supplied what was not immediately available. White marble came from Carrara, and red from Verona.

Standing before the new façade of the Franciscan church, I was immediately struck by its unfinished state. Three arches dominate the lower half of the wall. The upper façade, never completed, has the beginning of what would have been an additional (larger) central arch. The design was inspired by Rimini's triumphal arch of Augustus, built by the Romans in 27 BCE; it survives nearby. Here a Renaissance architect deployed the ancient arch as the centerpiece of his new design.

The arches are separated by engaged columns, all of which rest on pedestals. These supports, however, are ornamental, not structural. Like Vitruvius, Alberti believed that columns were important to the artistry of buildings. He wrote, "There is nothing to be found in the art of building that deserves more care and expense or ought to be more graceful, than the column" (1:25).[1] And so he gave such ornaments pride of place here. Each is fluted and has a Composite capital, combining the volute of the Ionic form with the leaves of the Corinthian. This type of mixed capital had not been used since antiquity. It is Alberti's own variation on the Order as realized in ancient Rome. (Vitruvius had not mentioned it.) The tondi across the façade and above the arches were inspired by those on the nearby Augustan arch. Although originally meant to be filled with marble, they are empty today. The combination of three large arches across the width of the façade and the beginning of a fourth arch in the center provides a simple and unified design. Alberti once wrote, "Extravagance I detest" (9:298). Instead, he sought "anything that combines ingenuity with grace and wit."

The deep central arch at ground level contains a classically ornamented doorway topped with a pediment. An unusual decoration appears within the tympanum of the central arch immediately above: a group of geometric shapes (oval, rectangular, and diamond) executed in colored marble and porphyry (associated with imperial status). These blocks were apparently plundered from ancient monuments in nearby Ravenna and reflect the delight in color favored by Byzantine culture, across the Adriatic.

By refashioning the church, Malatesta meant to create an extravagant monument for himself. His is the only name inscribed on the exterior. He intended that his own sarcophagus be placed in one of the large niches on the façade and the body of his longtime mistress, Isotta degli Atti (later his third wife), in the other; Malatesta had fallen in love with her when she was fourteen. Their remains now reside in chapels within the church, where their entwined initials S and I adorn the interior. Malatesta hired Piero della Francesca, known for his skill with frescoes, to visit Rimini and paint his portrait in profile, kneeling piously before his patron Saint Sigismund. The figures, however, appear not in a church but in a palace; elegant hunting dogs lie at Malatesta's feet.

Isotta's tomb within the church rests, as Sigismondo's does, upon two elephants, carved from black marble. Malatesta's heraldic beast was a trumpeting elephant, and there are many such images in San Francisco. They recall the campaigns of Hannibal, the formidable Carthaginian warrior who in antiquity invaded Spain and then set his sights on Rome. His army, accompanied by elephants, crossed the Pyrenees, moved through southern Gaul, and crossed the Alps from the north in an effort to seize the Roman capital. The more important

significance of the elephants, however, was symbolic. In the Renaissance, elephants, known for their prodigious memories, drew Fame's chariot, and Malatesta's goal was to ensure that his reputation endured. The inscribed dedication of the church records that Malatesta "left a memorial worthy of fame and full of piety."

Along the exterior sides of the church, a series of arches rests on piers, a design possibly adopted from ancient aqueducts. Small (empty) tondi appear between the arches. Standing in front of an arch, I could see the medieval windows with their tracery (frames holding stained glass) behind the new shell. Each of the seven arches on either side was intended to accommodate the sarcophagus of a scholar or poet who belonged to Sigismondo's court. Although he had won his reputation as a fierce *condottiere*, achieving impressive victories in battle, he surrounded himself with thinkers and writers, meaning to foster lasting renown as an enlightened patron of the arts.

In addition to the triumphal arch on the upper façade, Alberti's original plan for the church called for a barrel-vaulted ceiling and a dome made of twelve segments, which would have rested upon a multisided tambour (drum). Neither was built. Alberti decided that the medieval walls weren't strong enough to support a vault of brick or stone. And he saw the advantage of a wooden roof in providing good acoustics.

In any event, Sigismondo's power was effectively broken in 1460, leaving the project unfinished. But Matteo de' Pasti, who oversaw construction, had made a commemorative medal, probably based on a wooden model of Alberti's design. (Such medals had a round shape and served as mementoes of significant occasions.) It shows a monumental dome supported by ribs, stretching from one exterior wall to the other, and towering high over the church. The hemispheric dome, made of wood to lighten the load on walls below, would have become the largest in Italy erected since antiquity, with the exception of the Duomo in Florence. Years later, the form of the church provided the model for a cake, designed for a wedding in the Malatesta family; it was made of sugar.

* * *

Alberti's new façade fails to announce the Christian character of the building. Nor does the aisleless interior. Frescoes by Giotto, the fourteenth-century artist celebrated by Vasari for his religious paintings, became a casualty of reconstruction; though initially preserved, they were later whitewashed. Most of the new decoration lacks any obvious connection to spirituality, though winged cherubs appear on the façade's frieze. Instead, I saw images of Roman planetary

deities with their zodiac signs—Jupiter, Diana, Minerva, Venus, Mercury, Mars, and Apollo—as well as the Muses and classical Sibyls (prophetesses in ancient Rome) by the Florentine sculptor Agostino di Duccio, whose genius found expression in what Italians call *schiacciato*, a very shallow kind of relief. Such a program struck me as the logical extension of a single-minded desire: namely, to recapture the look of ancient Rome, which did not legitimize Christianity until Constantine's Edict of Milan in 313, "the first explicit declaration of religious freedom in the ancient world."[2] (We don't know whether the Emperor himself became a believing Christian or whether his decision represented a political compromise, or perhaps even a concession to his mother Helena, a Christian convert.) Significantly, Alberti preferred the word "temple" to "church,"[3] and so San Francesco in Rimini has come to be known as the Tempio Malatestiano.

Pope Pius II considered Sigismondo "the worst scoundrel, the disgrace of Italy, and the infamy of our times." Already appalled by stories of notorious behavior in Rimini, including rumors of Malatesta's murder of three wives, the indignant pontiff saw in the Tempio nothing less than an attack on Christianity itself. What must have particularly irritated him was the status of the church, the site of this city's cathedral. A Gothic structure based on designs sanctioned by a millennium of tradition had, in effect, disappeared. The aesthetics of pagan Rome now informed both the outside and inside of a medieval church. Pius would not forgive the offense. He called Malatesta's monument to himself "so full of pagan images that it seems like a temple for the worshippers of demons, and not for Christians."[4] The pope must have been particularly miffed by the Roman deities. The pontiff had earlier excommunicated Malatesta as a slave to avarice and lust: "He committed adultery with many women whose children he had held at baptism, and murdered their husbands."[5] Now Pius performed what has been called a reverse canonization. In a 1462 ceremony in three public squares—St. Peter's Basilica, the Campidoglio, and the Campo dei Fiori (field of flowers, a marketplace used for executions)—he burned life-size effigies of Rimini's master and officially consigned his soul to hell: "By edict of the pope he shall be enrolled in the company of Hell as comrade of the devils and the damned."[6]

NOTES

1 Leon Battista Alberti, *On the Art of Building in Ten Books*, trans. Joseph Rykwert, Neil Leach, and Robert Tavernor (1988; repr. Cambridge, MA, and London: MIT Press, 1997).
2 Herbert J. Muller, *Freedom in the Ancient World* (1961; repr. New York: Bantam Books, 1964), 333.

3 Alberti was not alone in his preference for ancient terminology. Ingrid D. Rowland, in *The Culture of the High Renaissance: Ancients and Moderns in Sixteenth-Century Rome* (Cambridge: Cambridge University Press, 1998), observes that "devoted purists, from the early fifteenth century onward, resorted to ancient terms [...]. The Church and all its trappings fell victim to the humanists' linguistic purge, with particularly curious results: church buildings became temples [...]" (199).

4 Cited by Ludwig H. Heydenreich, *Architecture in Italy, 1400–1500*, rev. Paul Davies (New Haven and London: Yale University Press, 1996), 37.

5 The address of Pope Pius II to his cardinals, in Edward Hollis, *The Secret Lives of Buildings* (London: Portobello Books, 2009), 174.

6 Cited by Mary Hollingsworth, *Princes of the Renaissance* (New York: Pegasus Books, 2021), 89.

CHAPTER 21

THE DUCAL PALACE, URBINO

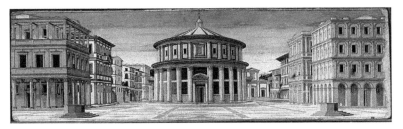

FIGURE 21 *Painting of an ideal city, Ducal Palace, Urbino.* Wikimedia Commons.

Probably the most elegant of Renaissance palaces, it belonged to a professional warrior who surrounded himself with intellectuals and artists. He wanted to be celebrated as a man of letters and a patron of the arts. So he hired Francesco di Giorgio Martini and Luciano Laurana to transform a medieval castle into a series of splendid rooms, showcasing the workmanship of his artisans—and his own good taste.

Federico da Montefeltro made his fortune as a mercenary fighting for Venice, Naples and Florence, among other city-states. He seized control of Urbino in 1444 upon the assassination of his half-brother. Unusually for a professional warrior, he went on to establish a career as a patron of the arts. He surrounded himself with intellectuals and artists and assembled a huge personal library, his collection numbering more than a thousand manuscripts in Latin, Greek, Hebrew and Italian. He preferred handwritten to printed materials, which lacked the rich ornament of pages produced by scribes. He hired experts wielding quills and ink to add even more manuscripts, and he bound codices in red velvet, a mark of status. The library was second in size only to that of the Vatican, where his manuscripts reside today. Federico has been called "a man of exquisite refinement."

Federico and his deceased wife, Battista Sforza, became the subject of a famous *diptych* (a double panel usually hinged) by Piero della Francesca. Both husband and wife appear in profile, a popular style inspired by classical coins. The blonde Battista, attired in black, faces right; Federico, attired in red velvet, left. (When the portraits were painted, Battista had already died, which becomes evident when you see her up-close at the Uffizi Gallery, Florence; her face has the unmistakable pallor of death.) Federico had a specific reason to favor this artistic format. Because he left his visor open at a youthful tournament, he lost an eye and suffered a shattered nose. His most famous portrait, attributed either to the Flemish Joos van Ghent or to the Spaniard Pedro Berruguete, shows the seated duke in full armor with a scarlet robe. His young son Guidobaldo, bearing the ducal scepter symbolizing family succession, stands by his side; this is the (seventh) child to whom his beloved second wife gave birth before dying at the age of twenty-six. Above, on a shelf, rests ceremonial headgear decorated with pearls, possibly sent to him by the Sultan of Constantinople. Federico's helmet sits on the floor. On his left leg, he wears the Order of the Garter, granted by England's King Edward IV. And because he belonged to the prestigious Order of the Ermine, awarded by King Ferrante of Naples, pelts of that creature adorn his attire. (Ermines were said to prefer death lest their fur be besmirched; symbolically, they became identified with purity.) In his hands, Federico holds a huge manuscript as if to demonstrate his scholarly character and devotion to the written word.

The ducal palace at Urbino, which began as a medieval stronghold, is nestled in the Apennine Mountains of central Italy, an hour's drive from the Adriatic coast. Although it looks daunting because of its sheer size, what it eventually became was less an impregnable fortress than a site celebrating the artistry of the new age. Baldassare Castiglione set *The Book of the Courtier*, a series of imaginary dialogues written *c.* 1508–1518, at Urbino's court, which he called "a city in the form of a palace." (The name Urbino literally means "little city.") Might the conversations and stories presented by this author have found their inspiration in discussions sponsored by Federico's successor, his son Guidobaldo?

Federico's personal qualities matched his military acumen. He often walked the streets of Urbino without any guard, greeting the populace. His librarian reported that "His subjects loved him so for the kindness he showed them that when he went through Urbino they would kneel and say, 'God keep you, my lord'." He was a gracious host to those who visited, loyal to those who employed him on military expeditions, and generous to his enemies. He kept taxes low. At home, Federico liked to hear books read aloud at meals, especially Livy's history

in its original Latin. His treatment of his wife was enlightened: "Battista not only enjoyed a humanist education but was also entrusted with the government of Urbino (along with the power to sign treaties) in periods when her husband was absent."[1] He attended Mass each day.

With a special interest in architecture, Federico hired Luciano Laurana, originally from Dalmatia, to remake the medieval castle in the 1450s. Trained in Venice, Luciano had previously worked in Naples and Pesaro, where he served the Sforza family. We cannot say exactly how much of the palace belongs to him. In 1468, Federico referred to him as architect-in-chief. Giorgio Vasari, however, ascribes the work to Francesco di Giorgio Martini, who wrote an architectural treatise in the 1480s; though unpublished, it circulated widely. Apparently, Luciano left Urbino in 1472, and Francesco took over, completing ten years later what his predecessor had begun. Leon Battista Alberti almost certainly advised Federico as well, for in the 1460s Federico and Alberti struck up a friendship, and the architect dedicated his treatise on architecture to Federico.

* * *

Situated in the center of the city, the palace faces the cathedral and the Piazza Duca Federico. Unfortunately, the façade is unfinished, and some windows are blocked off. Many small openings in the masonry, intended for scaffolding, serve no purpose now. It looked to me as though a giant machine had punched holes in the wall. The asymmetrical façade has a lower rusticated level with several entrances and, above, rectangular windows flanked by pilasters. Abandoned well before completion, it struck me as having no coherence at all. A more impressive façade looks out on a tree-covered ravine nearby. Two cylindrical brick towers stand on either side of a multi-story wall, a series of arched loggias linking them. Each of the narrow towers, with a conical top, has six square windows, one above another; spiral staircases within allow for easy passage.

The central courtyard, the single most memorable feature of the palace (and a chief reason for visiting), radiates elegance. Luciano Laurana probably designed its first level, Francesco di Giorgio Martini the second. The large rectangle has a classical arcade on all four sides forming an open loggia. Thanks to its proportions and handling of space, this is the most splendid Renaissance courtyard I have seen. The materials of brick and pale stone add to its appeal. Arches on the ground floor rest upon slender Composite columns, with circular forms in the spandrels. The L-shaped piers in the corners of the ground floor were a novel feature. Above the arches an entablature with an inscription in classical Roman lettering celebrates Federico. Windows on the

second-floor perch directly over the arches below, an arrangement possibly inspired by Brunelleschi's Foundling Hospital in Florence. Pilasters separate the rectangular windows and continue the vertical line of the columns on the first level. Another Latin inscription tops this floor. (A mezzanine with smaller square windows and yet another level above it were sixteenth-century additions and almost spoil what Luciano and Francesco created.) Because the space is expansively proportioned and only two stories high, in contrast to the tall but smaller courtyards of Florentine residences, this one seems to invite the sky into the palace, thereby creating a remarkable feeling of spaciousness and light.

Perhaps not coincidentally the painting of an ideal city survives at the palace. Extraordinarily wide, it was made in the last quarter of the fifteenth century and depicts an urban space where buildings conform to ancient precedent. Classical columns or pilasters support each of the three-story structures. The symmetry is thoroughgoing, including the marble pavement laid out in geometric shapes and the gridwork of the streets. Everything we see conforms to the principles of perspective formulated in the early-to-mid 1400s. At the center stands a circular structure, with a colonnade of Corinthian columns on the tall ground floor and another on the shorter floor above. A conical roof rests on top. This painting has been attributed to a number of artists, including Luciano Laurana, Piero della Francesca, Francesco di Giorgio Martini, and Pietro Perugino. Whoever was responsible, the painter had clearly absorbed the rules of perspective outlined by Alberti's treatise on painting, completed *c.* 1435. If Alberti had seen this rendering of an ideal city, he would have approved. And Federico himself believed that good architecture found its basis in geometry and arithmetic.

The chief attractions of the ducal palace lie within. My journal entry reads, "I marveled at the sheer diversity of motifs that cover the fireplaces, doorways, and moldings, and wooden panels on doors: putti, dolphins, shells, armor, books, faces, and foliage. And, diverse as it is, everything seems cohesive. As one walks from room to room, there's no sense of dissonance." We know that in 1476, Federico commissioned eleven tapestries from Jean Grenier of Tournai. They pictured not medieval legends but the story of Troy, the subject of Homer's *Iliad*. Italians, like their ancient forebears, liked to imagine that contemporary Romans traced their origins to Aeneas, who fled Troy in flames, according to Virgil's *Aeneid*, and, after a tryst with Queen Dido in Carthage, eventually went on to settle Rome. By installing the tapestries, Federico suggested a parallel between himself and Aeneas, between Urbino and ancient Rome.

The duke is said to have spent more than 50,000 ducats on furnishings, though the sumptuous objets d'art and Flemish tapestries that Federico purchased, winning the praise of contemporaries, have disappeared. They were looted by the wily Cesare Borgia, who betrayed Federico's son Guidobaldo, and in June 1502, invaded the defenseless city. The young duke, lacking his father's sagacity, had decided not to fortify Urbino. Pillage on a grand scale ensued. A train of 180 mules carted away Borgia's booty— jewels, statuary, silver, art, embroidery and much of the duke's manuscript collection. Today, the only paintings decorating the empty chambers belong to The National Gallery of the Marches (frontier territory). The small wooden theater at Urbino must have been decorated, probably with paint and statuary, but no trace of it remains.

Federico's *studiolo*, or private study, completed in 1476 is both the smallest and the most acclaimed room in the palace, intended for contemplation and reading. Intarsia—marquetry made of colored wood inlay, fitted to a flat surface—makes this interior extraordinary. The new art form may have been inspired by illusionistic wall paintings in antiquity or by written accounts of such paintings. Here, Benedetto da Maiano, assisted by his brother Giuliano, assembled thinly cut pieces of wood—oak, pear, walnut, and others—into geometric shapes so that they represent familiar three-dimensional objects. Vasari called such artistry *legni tinti* (tinted woods). Beneath a gilded, coffered ceiling, Federico's hideaway provides an exercise in trompe l'oeil design, the walls covered with what look like latticed cupboards, their shutters casually left open. Within are astronomical apparatus, musical instruments, stacks of books, a sword and mace, an astrolabe and a lute. Also on display are more common sights: a caged parakeet, a squirrel cracking a nut and a fruit basket. An illusionistic landscape, demonstrating a command of perspective, appears beyond a portico. Americans need not, however, travel to Urbino to appreciate this kind of intarsia. You will find a similar *studiolo*, built for Federico at the ducal palace in nearby Gubbio, installed at the Metropolitan Museum of Art, New York.

Completing the secluded room were twenty-eight portraits by Joos van Ghent and Pedro Berruguete on the upper walls in two tiers. Half of the original paintings now reside in the Louvre, some replaced by photographs here. The figures depicted were chiefly writers and philosophers of Greece and Rome, including Homer, Plato, Aristotle, Euclid, Ptolemy, Cicero, Virgil, Seneca, and Boethius. Others represent Jewish and Christian traditions, including Moses, David, Solomon, Augustine, Albertus Magnus, St. Thomas Aquinas, Basil (Johannes) Bessarion and Pius II, along with Dante and Petrarch.

As a Christian fascinated by ancient Rome, Federico epitomized the temper of the time. His dual focus informs a pair of adjoining chapels, built around 1474 and located directly beneath the *studiolo*. The tunnel-vaulted Cappella del Perdono (Chapel of Forgiveness) was intended for Christian worship and meditation. Behind a portal decorated with finely carved stone is a two-story, barrel-vaulted chamber with a niche at one end containing an altar. Columns on either side support a semicircular arch. A stone plaque depicting the Virgin and Child rested beneath the altar on one of my visits, though I have seen photos of the plaque installed above the altar. Rectangular panels of richly colored marble decorate the walls on both levels as well as the floor. An elaborately carved decorative strip with winged animals in pairs, carved by Ambrogio Barocci, divides the two. The entablature at the top of the wall consists of polychrome disks, large alternating with small. Winged angel heads decorate the ceiling, apt for a room that once contained sacred relics. In view of its size, the intimate chapel must have been designed for only a few worshipers.

The compact chapel next door, the Tempietto delle Muse, has a coffered vault adorned with stylized flowers. Columns probably once supported an arch, as in the Christian chapel, and beneath it an altar. According to a contemporary, Giovanni Santi (father of Leonardo da Vinci) and Timoteo Viti painted nine classical Muses, some of them now in Florence. We don't know how the wooden panels were arranged on the walls, now regrettably bare. Whatever additional decoration once existed must have been as splendid as other artifacts in the palace. All of it has vanished. Ordinary tiles, for instance, have replaced the original marble floor. Despite their vandalized state, the two juxtaposed chapels represent the chief enterprise of the Italian Renaissance: the effort to reconcile Christian and classical cultures.

* * *

Who destroyed the Chapel of the Muses and why? It may have been looters intent on grabbing valuable materials to sell elsewhere, or soldiers from Cesare Borgia's army bent on mindless pillage. What motivated the marauders is unknown. Even the clergy were known to spoil what they found. In 1632, Cardinal Antonio Barberini ordered painted panels sawn from their supports in the Muses' chapel and, in damaged condition, sent to the pope as a gift.

Standing in the empty chamber, I felt a powerful impulse to experience what Federico, possessed of limitless money and access to the finest artisans, had paid for. The empty chapels were once frequented by people of religious faith and

affection for antiquity. I wanted an answer to this question: What did they see and feel? I recalled what Vasari said about Brunelleschi—he was so steeped in the culture of ancient Rome that he could imagine how the city looked before its fall. How I envied such power of imagination. Looking at the despoiled room, I was intrigued. How were the various materials of the Muses' chapel arranged? Did a particular motif dominate? Were there parallels between the two adjoining chapels? If so, what form did they take?

What we know is that Federico, warrior general turned visionary for the arts, was thoroughly at home with the ancient past, as were most intellectuals and artists. The decoration in his palace leaves no doubt. The doors to the Throne Room, for example, feature classical buildings, represented in perspective. The upper panels represent Apollo, the god of inspiration playing a musical instrument, and Minerva, the goddess of wisdom holding her lance and shield. Not everyone, however, shared Federico's enthusiasm for pre-Christian culture. There were always some, especially clerics, who looked askance at survivals of a society that crucified Christ. For someone focused on affirming divine design, the celebration of ancient Rome could have seemed an irrelevance if not a distraction. We should notice, however, that Apollo and Minerva stand before seashells with potentially Christian applications: those shells may represent baptism, pilgrimage and rebirth.

Disapproval may have fueled the desecration of Federico's chapel. But if Christians were genuinely fortified by faith and hope (two of the three theological virtues depicted in the marquetry of the *studiolo*), why, we may ask, would they have felt so threatened by classical antiquity that they needed to expunge its remnants after a millennium? Were they completely incapable of discriminating between aesthetic brilliance and religious belief?

It's difficult to know the answer, for Christianity has always been, like America's Democratic Party, a big tent. Seeking to reach a largely illiterate populace, the early Church made use of representational art, for it conveyed biblical narrative and teaching in forms that virtually everyone could understand. People who might not be able to read could recognize a frescoed story or symbol. During the Gothic era, people could "read" messages in stained glass windows as well. But from its beginnings, Christianity demonstrated a penchant for iconoclasm, and its first targets were images of Roman gods, newly identified with demonic powers. Nervous about the portrayal of the human body, early Christians determined to eviscerate Roman sculpture and so ancient deities were shorn of their genitalia. Some classical figures (e.g., Mithras) were defiled because they were thought somehow in competition with Jesus. The Christian convert and polemicist Tertullian (*c.* CE 200)

summed up the opinion of doubters when he asked, "What has Athens to do with Jerusalem?" This hostility led to the wholesale destruction of classical artifacts.

Perhaps we should acknowledge that all along Christians have been of two minds about artistic representation. For a millennium and a half, it made vivid the teachings of Christ for an illiterate populace. With the Reformation, however, purists interpreted the Second Commandment as forbidding pictures of the deity: "Thou shalt not make unto thee any graven image, or any likeness of anything that is in heaven above, or that is in the earth beneath, or that is in the water under the earth" (Exod. 20:4).[2] Martin Luther believed that sculpture, art, and architecture could confuse the faithful who might fail to see the difference between material image and spiritual reality. He argued that Christians should read their Bible instead of admiring costly artifacts. For zealots, the physical representation of God, angels, and saints amounted to idolatry. Because of the reformers' withering opposition, the alliance of pagan and Christian came under threat.

NOTES

1 Robin Kirkpatrick, *The European Renaissance, 1400–1600* (London: Longman, 2002), 46.
2 *The Holy Bible: King James Version* (Cleveland and New York: Meridian Books, n.d.).

CHAPTER 22

SANTA MARIA DELLA CONSOLAZIONE, TODI

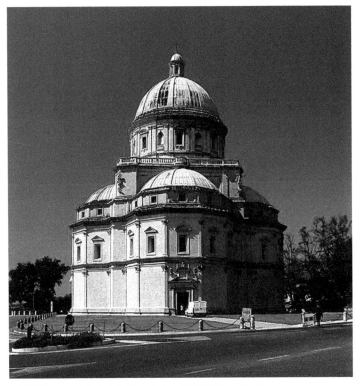

FIGURE 22 *Santa Maria della Consolazione, Todi.* Wikimedia Commons.

This is the apotheosis of the central-plan church, that is, a building with four equal arms that can be encompassed within a circle. It is an exercise in symmetry. Four apses join the central block of space; they are polygonal, inside and out. Half domes rise above the apses, echoing the curves of the central dome at the top.

Architects of the 1400s came to believe that the circle was the form most appropriate to the perfection of God and the shape of the universe. God himself, the Bible teaches, is a geometrician: "When he prepared the heavens, I was there: when he set a compass upon the face of the depth [...]" (Proverbs 8:27). A compass, consisting of two legs connected at one end by a pivot, allows for drawing a perfect circle, and its metaphoric use expresses God's shaping intelligence. In the words of Leon Battista Alberti, "It is obvious from all that is fashioned, produced, or created under her influence, that Nature delights primarily in the circle. Need I mention the earth, the stars, the animals, their nests, and so on, all of which she has made circular?" (7:196).[1] The architect Vitruvius, moreover, had declared the circle one of two perfect shapes.

In symbolic terms, a structure that can be encompassed within a circle represents the ideal configuration. Andrea Palladio said, "To maintain decorum in the shapes of our temples, we too, who have no false gods, should choose the most perfect and excellent one [shape]; and because the round form would be just that, as it alone amongst all the plans is simple, uniform, equal, strong, and capacious, let us build temples round" (4:216).[2] Ancient Roman buildings did indeed occasionally have a central plan, and Renaissance thinkers imagined that a circular scheme, together with a dome, was a standard feature of ancient temples: witness the Pantheon in Rome. Some early Christian churches emulated that model as well (e.g., Santa Costanza, named for the Emperor Constantine's daughter, and Santo Stefano Rotondo, both in Rome). But the template largely disappeared in the Romanesque and Gothic eras. And so when architects began to base churches on the form of circles, squares, or octagons, they were rediscovering a form sanctioned by antiquity. They saw in such shapes an expression of divinity. And the perfection of form was meant to foster the spirituality of the faithful.

What must have encouraged architects of the 1400s to experiment with central-plan churches was the precedent of Rome's Pantheon, dedicated in 25 BCE and, after calamitous fires, completely rebuilt by Hadrian in CE 118– 128. (The modest Emperor inscribed his predecessor's name on the façade.) Perfectly simple in design, the ancient temple may be described simply as a cylinder with a concrete dome originally topped with gilded bronze tiles, and entered through a colonnaded portico. Sixteen Egyptian granite columns, forty-six-feet high, resting on bases of white marble and surmounted by marble Corinthian capitals, support the pediment. The use of tuff, a porous volcanic stone, lightened the weight of the masonry as did the elaborate coffering. The forty-foot-high bronze doors, originally covered with gold, provide entry to the spectacular interior.

The proportions are flawless. In their design, the builders adopted a formula called the *golden section* or *rectangle*—a length-to-width ratio of 1.61803 on the façade. In the sixth century BCE, the Greeks had identified this ratio as especially pleasing to the eye and adopted it when building the façade of the Parthenon in Athens. Later, the Romans deployed it on the façade of their greatest temple. Leonardo da Vinci and others would revive it in the Renaissance. In fact, Leonardo was tutored by the finest mathematician of the time, Luca Pacioli, when he drafted *On Divine Proportion* (written 1498; published 1509), which discussed the golden section (or ratio) and credited it to God's inspiration.

The Pantheon, devoted to "all the gods," survived the Middle Ages by its conversion into a Christian church dedicated to Mary and the Martyrs in 609, though the temple lost some of its original features, including statues of the seven planetary gods. Even in antiquity both the Pantheon and Rome generally were treated as potential loot. Palladio records that the Byzantine Emperor he mistakenly called Constantine III (actually Constans II), visiting Rome in 663, plundered gilded bronze roof tiles from the Pantheon "along with all the bronze and marble statues that were in Rome. He did more damage in the seven days that he was here than the barbarians had done in 258 years."[3] In the 1630s, Pope Urban VIII directed that tons of bronze girders be stripped from the substructure of the Pantheon's porch roof. Melted down, the forty-feet long bronze beams ingloriously furnished raw material for cannonry at Castel Sant'Angelo, originally Hadrian's mausoleum, then a papal fortress.[4] Much of the Pantheon's marble and stucco facing the walls was also lost. Although various saints replaced Roman deities, the structure resembles no Christian church I have seen.

On my visit, I pondered what the Pantheon must have meant for Brunelleschi and Alberti's contemporaries. My journal entry reads: "It seems to me that anyone in the 1400s, emerging from the labyrinthine streets of Rome and coming upon the ancient temple must have recognized that the civilization that produced the Pantheon was sophisticated and accomplished and therefore worth emulating. And it is a triumph of engineering: the dome is huge—142-feet high, the largest dome till modern times." Sebastiano Serlio, in his book on architecture, wrote, "Of all the ancient buildings that can be seen in Rome, in my estimation the Pantheon, as a single body, is actually the most beautiful, most complete and best conceived" (99).[5] The original contents made the temple even more astonishing than it is today. Palladio reported, "Among the most famous things that one reads were in the temple an ivory statue of Minerva made by Pheidias and another of Venus, which had as an earring half that pearl which Cleopatra drank during a banquet to outdo Mark Antony's generosity" (4:285).

During a later visit to Italy, I wrote, "What impressed me about the Pantheon twenty years ago is what struck me again today: the illumination inside has a warm, welcoming dimension. The only source of light is the twenty-seven-foot opening in the dome's center. As the sun moves, you almost feel as though someone or something must be directing the beam of light. For many of us, this light has what can only be called a spiritual quality, complementing the aesthetic appeal of the dome." Has bare, coffered concrete ever possessed such a noble aspect? No photo can capture the feeling of serenity that overcomes visitors. What a contrast with medieval churches that are sometimes dark, cold and cluttered. No wonder Italian architects began experimenting with central-plan churches—structures with a simple geometric shape that could be encompassed within a circle.

* * *

Not surprisingly it was Brunelleschi, the most innovative architect of the early Renaissance, who pioneered the new kind of architecture with his 1434 plan for a monastic chapel. Replacing an existing structure in Florence and perhaps inspired by the so-called Temple of Minerva Medica in Rome, he designed Santa Maria degli Angeli, the "first perfect central-plan structure of the Renaissance."[6] Eight pillars supported it, and eight wide chapels between them radiated outward from the central octagonal space. (Christians associate the number eight with the Resurrection, for Christ rose from the dead eight days after his entry into Jerusalem. The number, then, came to represent regeneration and immortality.) Six chapels were devoted to the apostles (two in each), another dedicated to the Virgin Mary, and the eighth used for an entrance. This is the way Antonio Manetti, Brunelleschi's biographer, describes the chapel: "This temple was built with sixteen outer sides and eight inner sides and with eight sides above the chapels as well."[7] Alas, the money for Alberti's project ran out after only three years, and the chapel was never completed to plan.

Much later Ludovico Gonzaga of Mantua, inspired by a dream, commissioned Leon Battista Alberti to design the church of San Sebastiano, named for a Roman soldier martyred by Emperor Diocletian and later identified as a protector from the plague. Begun c. 1460, this was the first church shaped like a Greek cross—that is, a central square or circle with four equal arms. As it exists today, the façade evokes the form of a Roman temple front, minus the columns. The expanse of flat, undecorated walls is off-putting. Because Alberti believed that churches should stand apart from their surroundings, a long flight of steps leads up to the entrance; the staircase was, however, not constructed till the modern era. A series of tall pilasters supports the entablature. Unfortunately,

Ludovico died in 1478, and money for construction became scarce. The church was never completed. The planned dome, for example, was replaced by a groined vault. And Mantua's high water table constantly threatened the walls. In the twentieth century, moreover, San Sebastiano became a war memorial, further obscuring the original design. None of us can know exactly what Alberti intended, for the church has been substantially (and I think badly) reconfigured. Even the architect's contemporaries didn't know what to make of what they saw. Cardinal Francesco Gonzaga, son of Ludovico, said, "I could not tell whether he meant it to look like a church, a mosque or a synagogue."[8] Nevertheless, later architects, including Giuliano da Sangallo, his nephew Antonio da Sangallo the Younger, and Pirro Ligorio, were sufficiently intrigued by what they heard that they visited Mantua in order to sketch San Sebastiano. At the city's tourist office, I asked whether Alberti's church was open to the public. The answer was no. In fact, the fellow on duty had never entered the building, though photos exist.

Perhaps the first church to realize a central plan and to have retained much of its original appearance was Santa Maria delle Carceri (*c.* 1485–1506) in Prato, built to enshrine an image of Mary said to work miracles. Apparently a child reported seeing tears in the eyes of Mary, pictured in a shrine near the town's prison (*carcere* in Italian). Hence the name of this church. Designed by Giuliano da Sangallo, the building takes the form of a Greek cross. Because the arms are short, the eye of the visitor is drawn upward toward the twelve-sided "parasol" dome, which sits on a cylindrical drum, a new feature that became popular in the Renaissance. A Roman temple front was planned for the exterior end of each arm. Green marble strips set off the white marble of the outside walls. Much of the stonework, however, was never finished. In fact, only one of the arms was substantially decorated with marble. Inside, the dome, washed in light, seems to hover in the air. A blue and white terracotta frieze marks the division between lower and upper levels.

* * *

Santa Maria della Consolazione (Holy Mary of the Consolation), begun around 1509, stands outside the hilltop city of Todi in central Italy. Here, a design arranged around a center achieved its apotheosis. "Nowhere was the ideal of the centralized plan as Alberti had first defined it realized in a purer form than in this church."[9] The siting of the edifice must, in part, have resulted from lack of an available area in the dense urban space. Land was available just outside Todi, however, and this proved a huge asset. Ideally, a Renaissance church needs space to breathe, and this church profits from its relative isolation, alone on a hillside.

Central-plan churches are invariably freestanding. No other nearby structures detract from the design. You can easily walk around this building in Todi as though you were looking at a large, free-standing sculpture. This pilgrimage site asks to be seen and enjoyed in the round; and it offers a breathtaking view of the countryside stretched out below. Because of its location, I could look down upon the building—something usually impossible within the precincts of a city. From this vantage point, I better appreciated the relationship of parts to the whole.

We are not sure who designed the church. Historians have speculated that it was Cola da Caprarola, who seems to have been in charge of construction but is not otherwise known as an architect. Some suggest that the church may have been designed by Alberti, but his name fails to appear in any document associated with the building. Whoever designed it, the church is an exercise in symmetry. At the center, we find cubic space surmounted by a drum, the cylindrical wall that became increasingly popular after 1500. In turn, the drum sits on a square platform bordered by a small balustrade. In concept railings are, of course, meant to prevent people from falling off. Here, though, visual appearance rather than safety dictates the feature. From the outside, the platform and balustrade create a demarcation between the church below and the drum and dome above, like the one on Bramante's much smaller Tempietto. Giuliano da Sangallo, incidentally, helped popularize balustrades, which became a popular feature of Renaissance design. Urn-shaped balusters, the vertical elements in a balustrade, were unknown to the Romans.

Within the dome, a dove represents the Holy Spirit, which evokes the miracle of Pentecost—the descent of the Spirit upon the twelve apostles, who take the form of statues here within niches behind the altars. Four apses join the central block. Three are polygonal, inside and out. The fourth, containing the painted image with miraculous properties found outside the city, is semicircular. In 1508, a laborer reported that he recovered his impaired sight by touching the painting. Such miracles, associated with the Virgin Mary, provided the impetus for most central-plan churches.

Half domes rise above the apses, echoing the curves of the central dome at the top. Wonderfully compact and unified, the church represents a virtually perfect model of central planning. And, as it happens, it manifests Alberti's ideal—an interior and exterior that correspond. I felt inspired as I left. Like so many spectacular sites I have encountered in Italy, however, this one attracted few visitors. Although the city itself was crowded with weekend shoppers on a summer day, I was alone in the building.

In the later 1400s, not only architects but artists as well began to find increasingly appealing the combination of central plan and dome. In his

notebooks, for example, Leonardo da Vinci recorded images of numerous central-plan churches, none of which ever achieved physical form. These sketches were probably made in the 1480s or 1490s when he worked in Milan.

Painters too were attracted to central-plan structures especially when they sought to evoke the biblical era, particularly the reign of Solomon, identified with wisdom and seen as a prefiguration of the papacy. Pietro Perugino's *Marriage of the Virgin, c.* 1500, meant to represent the Temple of Solomon destroyed by the Romans, depicts the building topped by a dome part of which is missing because of the semicircular top of the painting. Images of the Arch of Constantine balance the composition on either side. Raphael's treatment of the subject, *c.* 1504, also depicts the Temple, seen in the background. Featuring sixteen sides and a dome, it occupies fully half the picture plane.

As the earlier Renaissance evolved into the High Renaissance, the dome would become ever more prominent, in contrast to the Middle Ages when it was rare. Most central-plan buildings are comparatively small. But architects would have an opportunity to realize their vision on a grand scale when they began to renovate St. Peter's Basilica in Rome.

NOTES

1 Leon Battista Alberti, *On the Art of Building in Ten Books*, trans. Joseph Rykwert, Neil Leach, and Robert Tavernor (1988; repr. Cambridge, MA, and London: MIT Press, 1997). Citations designate book and page numbers.

2 *Andrea Palladio: The Four Books on Architecture*, trans. Robert Tavernor and Richard Schofield (Cambridge, MA: MIT Press, 1997). Citations designate book and page numbers.

3 *Palladio's Rome: A Translation of Andrea Palladio's Two Guidebooks to Rome*, trans. Vaughan Hart and Peter Hicks (New Haven and London: Yale University Press, 2006), 78.

4 The Castle of the Angel contained a hidden passageway linked to the Vatican, allowing popes to elude their enemies. Pope Clement VII used this route to escape imperial forces in 1527, though he became a virtual prisoner in the redoubt.

5 Sebastiano Serlio, *On Architecture*, trans. Vaughan Hart and Peter Hicks, 2 vols. (New Haven and London: Yale University Press, 1996). Citations designate page numbers in the first volume.

6 Marvin Trachtenberg and Isabelle Hyman, *Architecture from Prehistory to Post-Modernism: The Western Tradition* (New York: Harry N. Abrams, 1986), 282.

7 Antonio Manetti, *The Life of Brunelleschi*, ed. Howard Saalman, trans. Catherine Enggass (University Park: Pennsylvania State University Press, 1970), 102.

8 Cited by Jerry Brotton, *The Renaissance Bazaar: From the Silk Road to Michelangelo* (Oxford: Oxford University Press, 2002), 148.

9 Wolfgang Lotz, *Architecture in Italy, 1500–1600*, rev. Deborah Howard, trans. Mary Hottinger (New Haven and London: Yale University Press, 1995), 39.

CHAPTER 23

SANTA MARIA PRESSO SAN SATIRO, MILAN

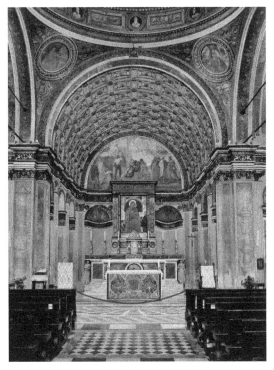

FIGURE 23 *Trompe l'oeil chapel, Santa Maria presso San Satiro, Milan.* Wikimedia Commons.

Two buildings share one site: the chapel of San Satiro and the much larger church of Santa Maria. What makes the larger structure especially notable is a faux chapel: that is, a choir less than three feet deep, needed to ensure the appearance of symmetry where the arms of the church meet. Designed by Donato Bramante, it is a triumph of trompe l'oeil illusion.

Because I have a fairly good sense of direction, I don't fret about driving into European cities new to me. I look for the spire of a cathedral to orient myself, and, beforehand, I take the precaution of studying a map. Milan proved to be a different story. The sheer size of the city defeated me, and the streets seemed to change their names every few blocks. A couple of times I stopped my car and inquired about the way to my hotel. I could tell by pedestrians' facial expressions that I was asking the unanswerable. After interminable driving, I found myself on a one-way street near the cathedral. Frazzled, I inched forward in traffic. Then a well-dressed gentleman walking on the pavement next to my car began speaking to me in Italian. As soon as he realized that I was an English speaker, he switched languages. When I told him that I was lost, he volunteered to join me in my car and direct me to the hotel. I instantly accepted his offer. He told me that when he sees someone in distress, he seeks to help. I sure needed it. As we drove, I learned that he had been a prisoner of war in America, that he had a background in education, and that he had personally known Ezra Pound and Archibald MacLeish. This was by far the most sophisticated fellow I have met on my journeys. Before long he directed me to stop. There was my hotel straight ahead. I said to him: How can I ever thank you for your astonishing generosity? He thought for a moment and said, "Niente." And he was gone. This experience taught me a valuable lesson: Just when you think all is lost, you may meet your guardian angel. I had a feeling that I was going to love Milan.

* * *

In this huge, industrial city two buildings share one site: the small chapel of San Satiro and the much larger church of Santa Maria. San Satiro was built *c.* 876 to honor Saint Satirus, brother of Saint Ambrose, patron saint of the city. The adjoining church of Santa Maria, which dates chiefly from the 1470s and 1480s, accommodates a painting of Mary and Child said to have miraculous properties: when stabbed, it issued blood. Because the two structures are conjoined, the complex is known as Santa Maria presso San Satiro, the word *presso* meaning "near."

 The story of Santa Maria is largely conjectural. In the late 1470s, the authorities apparently wanted a church that would, in effect, become an extension of a very small Carolingian chapel. This plan resulted initially in the creation of a long, rectangular structure that corresponds to the transepts and crossing of the present building. Around 1480, the authorities decided to expand what existed, fashioning a conventionally cruciform church. A barrel-vaulted nave with semicircular arches and aisles was added, as well as a sacristy.

It's not clear who planned the expansion, but it's likely that Donato Bramante was involved. Born near Urbino, he was trained at the court of Federico da Montefeltro by Piero della Francesca, a painter who pioneered the art of linear perspective. Bramante eventually found a home in Milan under the protection of Ludovico Maria Sforza, whose father gave him the nickname "Mauro," probably because of his dark eyes, hair, and complexion. He came to be known as "Il Moro," the Moor. A warrior whose name means "strength," Sforza became Duke upon the assassination of his brother, seizing control of Milan in 1494. Bramante's sojourn at his court coincided with the arrival of Leonardo da Vinci, whom Lorenzo the Magnificent had recommended to Sforza. Leonardo, who arrived around 1482 and spent eighteen years in the city, painted his *Last Supper* in the nearby refectory of a Dominican monastery. When I visited, (new) restorers of the painting were halfway through their work. Amazingly, this dining hall was almost completely destroyed by an RAF bomb in 1943. Only the wall paintings at opposite ends of the room survived.

Leonardo and Bramante were close in age and knew one another well. Sharing an enthusiasm for architecture, they were both attracted to central-plan churches. In his first such design, Bramante made a cube-shaped space at the meeting of the transepts, surmounted by a hemispheric dome resting on pendentives, which feature images of the Evangelists. The center of the church, then, in principle bears some resemblance to Brunelleschi's Pazzi Chapel in Florence, though on a grander scale.

Because Bramante sought to create a central-plan church, he needed space for the four arms branching out from the crossing; one of these would eventually turn into the nave bordered by massive pillars. Two arms would constitute the barrel-vaulted transepts on either side of the crossing. And opposite the nave, he anticipated an arm identical to those in the transepts. In other words, he sought what would be at its core a Greek plan. But he was stymied by the site. The fourth arm of the cross could not be built because next to the church lay a busy thoroughfare. The church would therefore need the shape of a T rather than that of a Greek or Latin cross. This presented a formidable challenge to an architect determined to create a compact symmetrical design. The problem had no apparent solution. What Bramante came up with was sheer genius.

He fashioned an illusion by creating a false choir less than three feet deep, yet it appears to be the same size as the two transepts. Standing in the nave with the altar straight ahead, we see a semicircular arch and, behind it, seven foreshortened rows of coffers in what resembles a barrel vault, continuing the shape of the nave. The "choir arm" culminates in a *lunette*, a semicircular painting on a wall; below are shell-topped niches. Between them, a large

architectural frame holds the image of Mary with miraculous powers. Arches on either side of the choir seem to branch off into subsidiary chapels. The ensemble creates a thoroughly convincing illusion of three-dimensional space, made possible by cleverly painted stucco on a flat wall. And its designer combined the skills of an architect, painter and sculptor. Only when I stood in a transept and looked toward the choir did the deception become apparent. What initially looks like real space when seen straight on is revealed as virtual space when viewed at an angle. Bramante's achievement transcends mere cleverness. He sought to preserve what he regarded as essential visual symmetry. Without the faux choir, the church would have looked odd to contemporaries because of its true shape, a T.

On the day I visited San Satiro, I registered my astonishment, writing in my journal: "Even when I stood before the apse, I could scarcely believe that I was looking at an illusion. The treatment of space is unlike anything I have ever seen. Space here, whether rendered in paint, stucco, or stone, is subordinated to architectural need. I suspect that I shall remember this work by Bramante long after I have forgotten other churches I've seen on my journey."

The architect's trompe l'oeil ingenuity would not have been possible had he not so thoroughly assimilated the achievements of his predecessors. That is, his visual illusionism could not have succeeded without the system of linear perspective discovered by Brunelleschi, described in Alberti's treatise on painting, adopted by Ghiberti in his panels for the second set of Baptistery doors, and practiced by innumerable painters, including Masaccio, whose frescoed representation of *The Trinity* (*c.* 1425) in Santa Maria Novella was among the first to employ perspective convincingly and thus enhance a sense of realism. Here in Milan, the perspective familiar to painters expresses itself in plastic forms like plaster and stucco. In fact, no more remarkable application of linear perspective to architecture exists in fifteenth-century Italy than the church of Santa Maria.

Although today aesthetics and math occupy different realms, the major achievements of Renaissance architecture and painting would not have been possible without the invention of mathematically accurate linear perspective, a system that logically and exactly rendered three-dimensional objects on a two-dimensional surface. This entailed a system of precise measurement as well as an understanding of how objects relate to one another in space. Without this knowledge, Bramante could not have created the illusionistic "choir arm" at Santa Maria presso San Satiro.

Bramante also restored the ninth-century San Satiro, originally a private chapel in the shape of a quatrefoil (a four-lobed or leaf-shaped curve), with three

small apses and an entrance on the fourth side. While preserving the essential design of this central-plan structure, Bramante converted the external wall into a cylinder with niches framed by pilasters. The architect transformed the next level into a Greek-style cross and deployed small gables at right angles, recalling the shape of the medieval chapel. An octagonal lantern tops the whole. Next to the chapel stands the original Romanesque bell tower.

The dense decoration of Santa Maria exceeds that of most earlier churches, for the Milanese preferred a more florid style than, say, Florentines did. Here, for example, the coffered dome has around its interior base a number of tondi, bearing terracotta figures of the prophets that project from the wall as well as several concentric rings of painted adornment. Elaborately bordered oval frames contain images of the Evangelists in the pendentives. The Corinthian pilasters supporting the arches and the dome above are richly carved.

When the French invaded Italy in 1499 to support their claims to Milan, the Sforza dynasty fell, and its cluster of architects and painters dispersed. Bramante needed to find another patron and decided that Rome offered the best prospect. In this, he was surely right, for what Florence had been to the Early Renaissance, Rome would become in the High Renaissance. Shortly after arriving there, Bramante designed the Tempietto, regarded by most contemporaries as a virtually perfect building. Sebastiano Serlio summed up his accomplishment: "Bramante was the discoverer and the light of worthy and true architecture, which from the ancients until his lifetime during the pontificate of Julius II had lain buried."[1]

NOTE

1 Sebastiano Serlio, *On Architecture*, trans. Vaughan Hart and Peter Hicks, 2 vols. (New Haven and London: Yale University Press, 1996). 1: 281.

CHAPTER 24

VILLA BARBARO, MASER

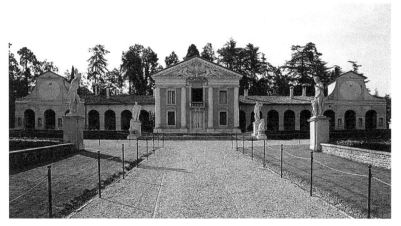

FIGURE 24 *Villa Barbaro, Maser.* Wikimedia Commons.

This villa is quite simply the most impressive home created in the Italian Renaissance. Marc'Antonio and Daniele Barbaro, gentleman farmers from an aristocratic background, commissioned the villa from Palladio. The façade emulates the shape of a Roman temple front; on both sides of the residential block are service wings which take the form of arcaded loggias. The brothers Barbaro also commissioned Veronese to paint the interior rooms, some of this artist's greatest work.

The Villa Barbaro is quite simply the most impressive home created in the Italian Renaissance. Located in Maser, a remote village of the Veneto, the region of the mainland dominated by Venice, it capitalized on the need for a great maritime city to find a source of agricultural produce and wealth, especially as the ascendancy of Islam jeopardized commerce with the eastern Mediterranean and as Europe's attention began a shift to the Americas. Venice, of course, was not only a collection of relatively small islands but also an empire, with trading

connections nearly everywhere. Its shipyard was the largest in Europe. Ever since the fall of Constantinople in 1453 to Sultan Suleiman the Magnificent, who ruled the Ottoman Empire, Venetian trade routes had become increasingly precarious. Prices for dyes, spices, incense, gems and much else began to climb. Vasco da Gama's successful voyage to India via the southern coast of Africa in 1497–1498, moreover, displaced Venice's unique role as chief entry into Europe. Accordingly, aristocratic families in the city began to invest in property far from the sea. Venice, a city of 150,000 people, controlled extensive territory on the mainland and beyond. Supported by new legislation, rural estates became not only comfortable residences but also working farms. Celebrating their wealth and sophistication, owners displayed their names on the façades of new homes, like this one, designed by Andrea Palladio.[1]

Situated near the base of a wooded hillside, the center of the Villa Barbaro consists of a two-story residential block that projects from the service wings, which take the form of arcaded loggias called *barchesse*, extending on both sides. These, in turn, lend dignity to the stables, workplaces, granaries, equipment, and warehouses of an agricultural enterprise located on the ground floor. The elongated arcade, perfectly symmetrical, rises at both ends to form what looks like the outline of a Roman temple front (minus the columns) and conceals a dovecote behind it. These shapes help visually balance the mass of the central living unit. Giant sundials with astrological symbols adorn the pavilions.

Marc'Antonio and Daniele Barbaro, gentlemen farmers from an aristocratic background, commissioned the villa from Palladio around 1556. The brothers were both learned and sophisticated. Marc'Antonio, a statesman and Procurator of Venice served as ambassador to France and, later, diplomat at the Ottoman court; he was also an amateur sculptor. Daniele, the older brother, was ambassador to the court of England's King Edward VI in 1549–1551, prelate, and scholar. Having met Palladio in 1550, Daniele became his patron. The architect later assisted him by providing illustrations for his richly annotated translation of Vitruvius into Italian (1556).

* * *

The two-story residence, which protrudes in front of the villa's wings, thereby assuring interior light from three directions, takes the form of a temple front. Instead of a portico like that at the Villa Rotonda, four colossal Ionic half-columns, modeled on those of the Temple of Fortuna Virilis in Rome, support the pediment above. The figures in the tympanum symbolize the Venetian state (marine deities riding sea creatures and carrying off water nymphs), the Barbaro

family (a two-headed imperial eagle bearing a coat of arms made of a red circle on a white field) and the papacy (a triple tiara). The names of both brothers appear prominently beneath the tympanum. The exterior, in pristine condition, has a warm yellow color, a contrast with the white engaged columns of the central block.

The upper floor contains the family's principal rooms and offers broad views of the agricultural land stretching out below. Like other Palladian villas, this one seems not to have been surrounded by elaborate gardens and waterworks; Maser's remote location obviated the need for much entertaining. In compensation, the home's opposite side offers an array of attractions. Because the house is built into a hillside, the *piano nobile* opens directly onto a courtyard in the rear. A spring in the hill above supplies water serving the needs of a kitchen, gardens, orchards, and even a drinking trough for horses on the road that passes by the estate. Behind the villa, a semicircular nymphaeum of the kind found in both ancient and contemporary Roman villas complements the classicism of the front façade. Palladio himself in his *Four Books* expressed his admiration for the nymphaeum "with an abundance of stucco and painted ornament" (2:129),[2] though he did not specify the designer.

The combination of the pool (doubling as a fish pond), garden, and statuary provides an ideal place for relaxation.[3] The only Palladian villa with such a feature, it may have been designed either by the Barbaro brothers themselves or by Alessandro Vittoria, perhaps the greatest Venetian sculptor of the late sixteenth century, who also made the deities in the front garden and, probably, the carving in the tympanum. Atop the nymphaeum stands Diana, water issuing from her breasts. Beneath her is a grotto, entered through a tall arch with a pond in front. Five Roman deities occupy niches on each side of the richly stuccoed hemicycle (curved wall). Bearded male figures evoking the Titan Atlas support the entablature over the niches below, as do two younger versions called *atlantes*. Marc'Antonio Barbaro may have selected the mythological personages to be represented, and this amateur sculptor himself could have had a hand in fashioning the statuary. Beneath each statue, an Italian inscription identifies the figure.

The Barbaro brothers, seeking an interior to match the excellence of the exterior, commissioned Paolo Veronese to paint the walls and ceilings of the living quarters. Born in Verona, the painter arrived in Venice around 1553 and quickly established his reputation. By 1562, he had painted five rooms in the central pavilion at Maser with illusionistic frescoes, including scenes of country life and ancient ruins. He brought the outside inside by his landscapes. The size of these paintings is virtually identical to that of the window openings, fostering

the impression that we are actually looking at foliage and architecture rather than paint. One panel depicts the Villa Barbaro itself.

On the ceilings mythological scenes predominate. In the principal room, for example, a single fresco depicts the gods, seasons, and elements. Paintings of the Muses, with musical instruments in their hands, appear in illusory wall niches. What makes the paintings especially appealing is the scale of the rooms. Some buildings seek to impress by sheer size, frescoes covering huge walls, and overwhelming the visitor with aspirations of grandeur. But there's something displeasing about domestic space that dwarfs the people within it. Here, by contrast, the dimension of the rooms creates a sense of intimacy.

Some of Veronese's designs have a specifically Christian meaning. For example, in the *Stanza del Cane,* we see the Holy Family presented by the personification of History. And in the *Stanza della Lucerna,* Faith, Hope and Charity extol the imperative to help the needy. At the same time, Veronese balances Christian values with pagan: for example, the Three Theological Virtues rest upon the Four Cardinal Virtues: Prudence, Fortitude, Justice and Temperance.

Veronese also fashioned a bravura display of trompe l'oeil painting. The walls and ceilings counterfeit architectural features found everywhere in the Renaissance: arches, pediments, cornices, columns and capitals. Even more impressive are the life-size figures. Behind a painted balustrade near the ceiling of the *Salon of Olympus,* we see Marc'Antonio's wife Giustiniana, attired in a blue satin dress and bedecked with a pearl necklace and gold jewelry; in her right hand, she holds red roses. Her youngest son Alvise and an aged nurse, along with a puppy and parrot, keep her company. Standing between white spiral columns, they look down on us as we admire the fresco above. The opposite wall portrays Giustiniana's older sons, Almorò reading a book and Francisco with his hunting dog; between them is a chained monkey. Elsewhere, framed in a false entryway, a huntsman, with a horn hanging from his belt and accompanied by his dog, looks directly at us. Might this be a youthful version of Marc'Antonio? A little girl in a green dress peeks through another illusionistic doorway; her expression lights up the room. As in so many of the villa's frescoes, the operative word is charm. Oddly, Palladio never acknowledged Veronese's contributions, though it's difficult to think of a painter and an architect whose work was so well matched. Perhaps the architect felt that the paintings by their splendor detracted from his overall design. By contrast, Veronese made a sensitive portrait of Alessandro Vittoria, sculptor of statuary at the villa. This oil painting resides at New York's Metropolitan Museum of Art.

* * *

Twenty years after the house was completed Marc'Antonio Barbaro asked Palladio to design a chapel for the estate. The Tempietto, or little temple, is the only central-plan church Palladio ever designed. Construction began in 1580, the year of his death. The church has the façade of a Roman temple, a large portico, a hemispheric dome, and two little bell turrets rising behind the porch. The exterior of the temple front and dome echoes the design of Rome's Pantheon, though on a much-reduced scale. Marc'Antonio's name appears beneath the tympanum. The interior is circular, with three apses of identical size for chapels; the fourth provides the entrance. Stucco decoration, attributed to Alessandro Vittoria and a little ornate for Palladio's taste, adorns the walls, which contain deep niches for statuary. Above the main altar stands a tall arch with Corinthian columns on both sides. No painting adorns the bright white walls. Palladio died at Maser, probably while planning the chapel, modest in size but splendid in effect. His diminutive church perfectly complements the sublime villa.

Superlatives cannot do justice to the Villa Barbaro. If a building can possess charisma, this villa has it aplenty. As I departed, I found myself exhilarated by what I had just experienced but simultaneously baffled by my own ignorance. I had only recently learned about the villa from a brochure in Vicenza's tourist office. I asked myself, "How is it that until a week ago I had never heard of Maser?" In the shop, I sought more information but found none. When I inquired, the clerk said dismissively, "finito." No guidebooks, no photos, no postcards, no nothing.

NOTES

1 The most comprehensive study of Villa Barbaro is that by Denis Ribouillault, *The Villa Barbaro at Maser: Science, Philosophy, and the Family in Venetian Renaissance Art* (Turnhout, Belgium: Harvey Miller, 2023).

2 *Andrea Palladio: The Four Books on Architecture*, trans. Robert Tavernor and Richard Schofield (Cambridge, MA: MIT Press, 1997). Citations represent book and page numbers.

3 See Carolyn Kolb and Melissa Beck, "The Sculptures on the Nymphaeum Hemicycle of the Villa Barbaro at Maser," *Artibus et Historiae* 18, no. 35 (1997): 15–33, 35–40.

PART IV

VENICE AND ENVIRONS

CHAPTER 25

THE BASILICA, VICENZA

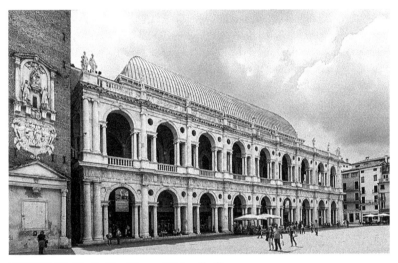

FIGURE 25 *The Basilica, Vicenza.* Wikimedia Commons.

Andrea Palladio's career may be summed up by his comment, "Vitruvius is my master, Rome is my mistress, and architecture is my life." His first great project was a replacement for the decaying town hall in Vicenza. He wrapped the half-destroyed medieval survival within a framework of classical piers and columns, creating a two-story loggia. This double-decker arrangement concealed the medieval hall with a panache of contemporary design.

"Vitruvius is my master, Rome is my mistress, and architecture is my life." Attributed to Andrea di Pietro, this remark, sums up the essential qualities of his career. Born in 1508, he began his working life as an apprentice stonemason. Count Gian Giorgio Trissino, author, linguist and diplomat, recognizing Andrea's extraordinary gifts when hired to renovate the nobleman's villa, took the young artisan under his wing and gave him a new name, "Palladio," derived

from the Greek deity Pallas Athena, goddess of wisdom and protectress of artisans.[1] Together Trissino and Palladio traveled from Vicenza, which belonged to the Venetian Republic, to Rome in 1541. There they investigated antique ruins and viewed the finest contemporary structures. Palladio could now see at first hand the application of Vitruvian principles in ancient structures. In fact, he called Vitruvius "my master and guide" (1:5). Later he would compile the first handbook to classical buildings in the city, *The Antiquities of Rome* (1554). What he saw on this and subsequent journeys informed the rest of his life.

Andrea Palladio's first public commission was Vicenza's two-story municipal building originally created in the late Middle Ages and known in Italian as the *Palazzo della Ragione* (Palace of Law). The medieval structure had mostly collapsed in 1496. The extensive renovation, begun in 1549, established his reputation, though the building was not actually completed until long after his death. It was Palladio himself who applied the name "basilica" because it had been used as a law court, as had similar ancient structures. Here civic policy was framed and commerce conducted. Vicenza's council met on the upper level, an enormous hall measuring 170 by 70 feet. The building has the singular advantage of its site: the center of the city's largest piazza.

Other architects had submitted proposals for the town hall. For example, the authorities invited Giulio Romano, already celebrated for having completed the Palazzo Te in Mantua, to visit Vicenza and propose a design. He suggested a colonnade, strengthened by stone piers, around the decrepit building. Jacopo Sansovino, Sebastiano Serlio, and Michele Sanmicheli all visited Vicenza to submit plans. Palladio's bid, approved in 1549, won the competition.

* * *

The task Palladio undertook was challenging: rehabilitate two crumbling late Gothic structures damaged in fires while employing the most sophisticated expectations of the day. He accomplished this by wrapping the extant buildings within a framework of classical piers and columns, creating a two-story loggia with an open arcade at ground level. His double-decker arrangement surrounded the medieval structure (with its Gothic arches and roof) while simultaneously providing the panache of contemporary design. In this his only edifice made entirely of white stone, Palladio designed a frame replacing the earlier Gothic loggia that had collapsed; the original core remained largely intact.

The first story combines piers and engaged Tuscan columns to create a wide loggia evoking Sansovino's library in Venice. Tall columns flank each bay, and within the bay, a pair of freestanding half-columns support a semicircular

arch. What makes this design distinctive are the (much narrower) rectangular compartments on either side of the arched space. Ancient Romans had used such a tripartite design in their bathhouses. A Serlian motif, it would become known as "Palladian" thanks to this building.

The genius of Palladio's design lies in his decision to create bays of varying width so as to create an impression of uniformity out of what had been an irregular rectangle. He managed to conceal the irregular widths of the existing bays. On both stories horizontal rows of empty circles appear in the spandrels between the arches and the large engaged columns; they support the illusion of symmetry and echo the round shape of windows in the medieval building.

Above the ground floor, we find an entablature decorated with a frieze of metopes and triglyphs, similar to those in Sansovino's Venetian library and finding their inspiration in ancient Rome. Ionic columns top this level. Little ornamentation distracts the eye of the visitor. At the roofline, balustrade, statuary, and finials (small pinnacles) continue the vertical lines of the columns below. The medieval keel roof, which resembles an overturned ship, was rebuilt after the Second World War and towers over the structure like an enormous tent. The overall design completely dominates Vicenza's central piazza, conveying elegance.

In his *Four Books on Architecture* (1570), Palladio, with characteristic self-assurance, traced his debt to Roman architecture when discussing his Basilica in Vicenza: "I have included the designs of this one alone because the porticoes around it were devised by me and because I have no doubt at all that this building can be compared to antique structures and included amongst the greatest and most beautiful buildings built since antiquity, both for its size and its ornaments, as well as because of its materials" (3:203).[2] At the same time, we need to acknowledge that the ancients never created anything precisely like Palladio's in Vicenza. In other words, the architect was not merely duplicating something he had seen elsewhere. Rather, he was adapting what he knew of Roman buildings. Like an alchemist, he transformed the past into something new and unique.

NOTES

1 "Palladio" was also the name of a figure in a poem by Trissino; his epic describes "Palladio" as driving the Goths from Italy.

2 *Andrea Palladio: The Four Books on Architecture*, trans. Robert Tavernor and Richard Schofield (Cambridge, MA: MIT Press, 1997). Citations represent book and page numbers.

CHAPTER 26

VILLA ROTONDA, VICENZA

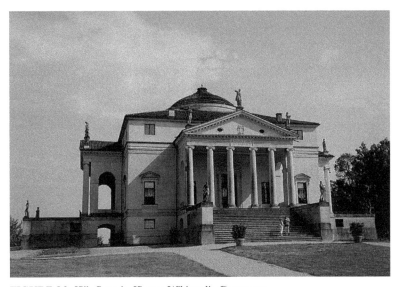

FIGURE 26 *Villa Rotonda, Vicenza.* Wikimedia Commons.

This home by Palladio is Italy's most famous residence. It consists of a square block built of brick and covered with stucco. It has the shape of a Greek cross. Four identical porticoes lead inward along barrel-vaulted corridors to a round, central hall. A temple front, at the top of a tall flight of stairs, appears on all four sides. Probably no building of the Italian Renaissance prizes an exacting symmetry as fully as this one.

Built in the 1560s for Paolo Almerico, who enjoyed a distinguished career as papal envoy and then retired to Vicenza, Palladio's villa goes by various names, including Villa Almerico after the original owner, Villa Capra after the family who purchased it in 1591, and Villa Rotonda, a nickname owing to its round central hall and dome. Unlike most of Palladio's other private structures in the

countryside, this one was not intended to function as an agricultural property. Instead, Almerico's estate provided a site for entertaining, especially on summer evenings. Situated atop a gentle hill on the outskirts of Vicenza and ideally suited to capture the evening breeze, the elegant villa takes advantage of views in all directions. Palladio likened the surrounding hills to "a vast theater" (2:94).[1]

The architect had probably never seen Roman homes from antiquity, for they did not generally survive the demise of the ancient world. As we know from the ruins at Pompei, buried under volcanic ash, substantial urban homes, which commonly turned a blank wall to the street, opened inward onto an atrium or peristyle, an open court surrounded by columns. In contrast, Palladio extrapolated from what he knew best and most admired—namely, the appearance of ancient temples.

* * *

The classicism of Villa Rotonda strikes us immediately. A square block built of brick and covered with stucco, it has the shape of a Greek cross. Four identical pedimented porticoes lead inward along barrel-vaulted corridors to a round, central hall. A temple front, at the top of a wide, tall flight of stairs, appears on all four sides. The succession of steps and the entablature create strong horizontal lines. These, in turn, are balanced by the vertical shape of six Ionic columns supporting triangular pediments above. Freestanding statues adorn the rooflines and extend the vertical emphasis. Palladio wanted nothing to distract from the symmetry and simplicity of his design.

Two basic forms, circle and square, account for the villa's shape. In effect, it is a cube, with the identical projection of a porch on all four sides. Probably no building of the Italian Renaissance prizes an exacting symmetry as fully as Palladio's. Self-contained and compact, the Villa allows you to make a circuit around it in five minutes, enjoying the repetition of its stately façades. Isolated by its site atop a hill and by the absence of nearby buildings, the Villa Rotonda asks to be appreciated in the round. The entire ensemble, including external staircases, can be inscribed within a circle. It conforms to a central plan par excellence.

Palladio sought panoramic views from the villa as well as attractive prospects of the villa from the exterior. In his *Four Books on Architecture* (1570), he wrote, "The site is as pleasant and delightful that one could find because it is on top of a small hill which is easy to ascend; on one side it is bathed by the Bacchiglione, a navigable river, and on the other is surrounded by other pleasant hills which resemble a vast theater and are completely cultivated and abound with wonderful

fruits, and excellent vines; so, because it enjoys the most beautiful vistas on every side, some of which are restricted, others more extensive, and yet others which end at the horizon, loggias have been built on all the four sides" (2:94). In the *terrafirma* (region on the mainland controlled by Venice), the siting of a structure became all-important. Architecture and nature converged to harmonious effect.

Palladio's surviving designs for the villa reveal that he wanted a hemispheric dome rising atop a drum and an *oculus* (skylight). To capture rainwater, the architect set a perforated grill on the floor directly beneath the opening; it has the face of a smiling faun, grape leaves adorning his hair. Most unfortunately, Palladio died before the villa was finished. Vincenzo Scamozzi, his assistant, completing the construction, changed its design for the worse. The dome he fashioned has a much less attractive low saucer shape. Spoiling Palladio's original plan, Scamozzi added a lantern, covering the opening to the sky. This has had the baleful result of diminishing light in the central rotonda below, thus hindering our enjoyment of the paintings there.

Alessandro and Giovanni Battista Maganza painted the elaborate frescoes on the dome interior. Their work presents a combination of classical and Christian virtues, including Temperance, Chastity, Justice, Fame, Prudence, and Faith. A wall of the *salone*, a room with a vaulted ceiling, below includes frescoes of Olympian gods, including Jupiter brandishing his thunderbolt, Mercury with his caduceus, Apollo with his lyre, Mars with sword and shield, Diana with her hunting hound, and Venus accompanied by Cupid. Louis Dorigny, a Frenchman who found a home in Italy, made the paintings of gods who had become personifications.

By the time the villa was completed, the classical heritage had been so fully acknowledged and absorbed that most cosmopolitan visitors would probably have found little dissonance between images of Christian virtues and those of ancient deities. Even during the Middle Ages, the classical gods had never disappeared; they were evoked and portrayed in the arts. Their names were assigned to the planets and thus became a part of astrological projections. Writers even managed to come up with Christian interpretations of mythological stories, and so the ancient narratives were viewed as relevant to the present as well as the past. Clearly, the prelate responsible for the villa could not have had any misgivings about commingling classical and Christian.

* * *

The Villa Rotonda, the architect's last domestic structure, has become his most famous. In addition to its aesthetic appeal, it marks an innovation in architecture,

for it gave a private structure a stature not previously enjoyed. In Palladio's hands, a secular building found its model in the dome and central plan of temples and churches. He could not use classical villas as models because they existed only in literary accounts of Pliny the Younger's estates. Vitruvius gave scant attention to private homes. So far as we know, the Romans reserved the pedimented temple front chiefly for religious structures. The archaeology of ancient Pompei suggests that Roman residences typically turned a plain face to the street. Leon Battista Alberti disapproved of large pediments in private homes; such a practice violated his sense of decorum. It was Palladio who made this motif central to his domestic creations. He believed, with good reason, that it created a sense of grandeur.

Having explored the painted walls and ceilings of the villa, I strolled onto a portico before leaving and looked outward. This stance must surely have been what Palladio intended for visitors four hundred years ago. It was a gloriously sunny day in late spring. If someone had handed me a glass of wine and a tasty morsel, I would have declared the experience incomparable. Even without such treats, I experienced something that intrigued me.

For someone who has not yet visited Vicenza, the most important thing to understand about the Villa Rotonda is that it commands the surrounding countryside, dominating all that the eye sees in every direction. The villa, though possessing neither tower, nor wall, nor moat, nor armament, exudes a quiet sense of power. Although merely a visitor, I felt that the building was inviting me to exult in the vantage point it offered. Without realizing it, I became an extension of the building. Looking at the distant hills, I found myself implicitly sharing the confidence of the architect who designed the edifice. Standing on that portico and surveying the horizon, I felt invested with quiet assurance. I thought: Who could stand here and not feel that the human eye and mind are at the very center of things in this world? Who would deny that humankind can achieve whatever it chooses to accomplish?

NOTE

1 *Andrea Palladio: The Four Books on Architecture*, trans. Robert Tavernor and Richard Schofield (Cambridge, MA: MIT Press, 1997). Citations designate book and page numbers.

CHAPTER 27

OLYMPIC THEATER, VICENZA

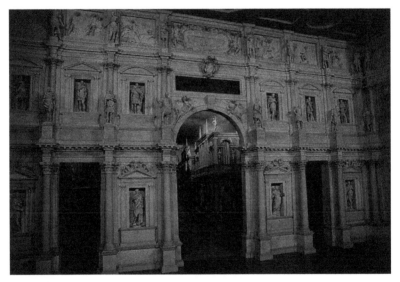

FIGURE 27 *Olympic Theater, Vicenza.* Wikimedia Commons.

The oldest surviving Renaissance theater was designed by Andrea Palladio. It is a showcase of ancient Roman architectural and sculptural features. The pièce de resistance is the stage wall three stories high and filled with statues wearing ancient robes and armor. The three entries onto the stage present perspectives of street scenes, generating a sense of realism in the setting.

Because theatergoing was an integral part of ancient culture, most Roman cities, including colonial London, had sites for outdoor productions. Playgoing in Rome had always been popular; Pompey's theater could hold 17,000 people. Even today all over the Mediterranean theatrical structures survive in varying states of preservation. It was inevitable that Italians, intent on recapturing the civilization of antiquity, would seek to create their own theaters. In 1555,

197

a group of sophisticates founded the Accademia Olimpica in Vicenza to "exalt those of its citizens who love *virtù*." Palladio was among the founding members—mathematicians, painters, sculptors, and musicians—who sought to promote the arts and humanistic enterprise in general. To further its purpose, the Academy assembled a library, acquired a collection of musical instruments, and obtained classical sculptures. It sponsored concerts, poetry readings, and theatrical productions.

An early performance under the Academy's auspices was Giangiorgio Trissino's *Sofonisba*, an Italian-language tragedy emulating classic precedent, in 1562; it's "based on Livy's account of a Carthaginian princess who drinks poison rather than fall into Roman hands."[1] Vicenza's town hall, a Gothic structure later called the Basilica after refurbishment, served as a temporary venue. The stage sets built for the occasion were so striking that they became famous. In time, Academy members decided that a permanent theater was desirable and found an unlikely site in what remained of an "old roofed prison"; this venue would obviate the need to construct a wholly new building; the financial savings would be considerable. The Academy turned to Andrea Palladio, the most respected architect in Vicenza and already an acclaimed set designer. He had designed his first stage set in 1557 for Terence's *Andria*, an ancient Roman comedy. In 1565, he designed a temporary theater for the Carnival in Venice.

No city in Italy, of course, had the money to recreate an outdoor theater made of stone like those of antiquity. Palladio's would be largely wooden and constructed within the shell of a dilapidated structure. His is the earliest permanent indoor theater of the Renaissance to survive. The advantages of the site were that it provided protection from inclement weather and ensured good acoustics. And it would not require an elaborate stage set to be disassembled following production and placed in storage. Instead, it would stand ready for any theatrical need with a minimum of preparation. This in itself might encourage playwrights to ply their trade (as they did in Shakespeare's England) since they had a specific venue at hand. Construction began on February 28, 1580, and Palladio's Teatro Olimpico opened on March 3, 1585, during the Carnival; perhaps a thousand spectators were present. The production was a suitably ancient drama—Sophocles' *Oedipus Rex*.

The elite theatergoers were astonished by what they saw at the first performance. A letter by Filippo Pigafetta, commenting on the performance of the play, brims with enthusiasm, describing the moment the curtain was lowered: "The curtain stretched in front of the stage fell in the blink of an eye. Here one can hardly express in words, or even imagine, the great delight and boundless pleasure that overtook the spectators […]."[2] What especially

delighted this playgoer was the deployment of classical forms: "[The theater] is pleasing generally to all owing to its beauty of proportion and exquisite measure of one thing with another; and then all together they may convey to the eye of the ignorant onlooker an incredible charm, created out of friezes, architraves, cornices, festoons, columns, with very fine capitals and bases, made out of stucco in bas-relief […]." The language points to the continuity of a prevailing style. That is, in addition to "beauty of proportion and exquisite measure," Palladio deployed the same architectural features seen in numerous other public buildings. Cornices, columns, capitals and so forth were adaptable to almost any requirement.

The single most impressive feature of Palladio's theater was (and remains) the richly decorated *scenae frons*, or scenic façade, which stretches across the stage measuring eighty-two feet and rises in three stories. By its color the wall surface suggests marble. Detached Corinthian columns dominate the ground floor, and situated between them are aedicules, niches framed by columns or pilasters and topped with pediments. Within each one stands a figure in Roman attire. Pigafetta's letter explains that he saw "perhaps eighty statues […] of stucco, worked by fine craftsmen, representing [likenesses of] the Academicians." Each member was obliged to provide at his own cost a statue of himself. The prominence of individuals on the wall face depended on their financial contribution to the project. Their age or calling dictated their attire. Younger men appear in battle dress while many of the elderly wear what look like legal robes. Most of them gesture while observing the action onstage below. Engaged columns and fluted pilasters adorn the second story, not so tall as the first, and with similar though smaller aedicules; some free-standing statues rest on projecting pedestals. The spectacular quality of the stage wall explains the theater's use for a scene in Lasse Hallström's 2005 film *Casanova*.

An attic story, with reduced height, depicts in high relief the labors of Hercules, patron of the Accademia; in place of columns, additional figures appear between scenes of the hero's triumphs, separated by pilasters. In creating the triple-level scenae frons, Palladio sought to emulate classical precedent, though the walls behind stages at surviving ancient theaters had almost entirely vanished and were therefore of little help as models. (Incidentally, the most complete classical stage wall I have seen is located in Orange, France: it measures 338 feet wide by 118 feet high. The original decoration, however, has disappeared.) Palladio had to rely on his own imagination, informed by knowledge both of ancient architecture and contemporary adaptations. At the very top of the stage wall, we see a classical hippodrome decorated with the words *Hoc Opus*, and *Hic Labor Est*. The final three words, once covered

in plaster, have been revealed in restoration. They represent the motto of the academy, which originated in Virgil's *Aeneid* and means, "This is the task, this is the labor." The words were earlier used in the first Olympic games under the auspices of the Academy (1558).

To supply visual interest, Palladio could have chosen *periaktoi*, the painted panels that were rapidly switched in ancient theaters; with three to six sides, they provided a sense of locale. Vitruvius described them as "triangular pieces of machinery which revolve, each having three decorated faces."[3] Similarly, Alberti called them "rotating machinery [...] capable of presenting at an instant a painted backdrop" (8:273).[4] Court performances in the sixteenth century still employed this ancient practice.[5]

Palladio chose a different strategy, creating three principal openings in the stage façade. At the center, he built a large triumphal arch; painted backdrops of a city would fill this and the two rectangular openings on the left and right. What exists today represents the work of Vincenzo Scamozzi. When hired to finish the theater after Palladio's death, he used visual recession behind all three entries onto the stage: that is, colorful illusionistic scenes that retreat into the distance. The central opening within the arch actually contains three street scenes constructed of wood, plaster, stretched canvas and paint, one perpendicular to the stage wall and the other two on the diagonal. Each presents a Roman street from a deep perspective. The additional openings on either side of the arch offer single scenes. The number of views, with their portrayals of palaces, churches, and statuary, is five. All converge on vanishing points behind simulated archways and sky. The advantage of the various entrances is that no matter where a playgoer sat in the audience, he or she had the illusion of deep space—a three-dimensional streetscape.

When I visited, the resident guide asked a stagehand to walk to the end of one of Scamozzi's streets so that we could better appreciate the illusion. There are other (smaller) openings in the "wings," or short side-façades, at right angles to the scenae frons. A grand total of seven entrances, then, provide access to the stage. None of these is an acting space. Instead, each supplies a *mise en scène* for the dramatic action—in the case of Sophocles' drama, the streets of Thebes. When the theatrical curtain dropped to uncover the stage wall, the effect must have been absolutely splendid even before a single word was spoken.

Constructing the street scenes would have been impossible without an understanding of linear perspective. In the theatrical world, the architect Sebastiano Serlio had become renowned for creating illusionistic backdrops for temporary stages; illustrations of tragedy, comedy, and satyr plays are represented in his treatise, "in effect a practical handbook of stagecraft."[6] He wrote,

"Of the many man-made things which give a great pleasure to the eye and satisfaction to the heart when looked at, the uncovering of a scene set on stage is (in my opinion) one of the best. There you can see in a small space, created with the art of perspective, splendid palaces, huge temples, multifarious buildings both near and far off, spacious piazzas graced with divers edifices, long, straight streets crossed by other roads, triumphal arches, exceedingly high columns, pyramids, obelisks and thousands of other beautiful things" (83).[7] Pigafetta, in his account of *Oedipus Rex* at its inaugural performance, singled out this feature: "The perspective inside is […] admirable and very well understood and viewed by five principal parts, or entrances, that make seven quarters of the city of Thebes, which it represents with a display of beautiful buildings and palaces and temples and altars in the ancient manner, of very fine architecture of solid timber, so as to last forever […]." No longer would a simple painted flat suffice. The art of scenography, now in three dimensions, had reached a new level of sophistication. Scamozzi's completion of Palladio's theater accomplished the marriage of ancient theatrical practice with scenery prizing perspective.

The visual splendor of the inaugural production extended to the actors as well. According to Pigafetta, "The number of costumes was perhaps 80. The number of persons performing in the tragedy is 9, all with double parts, so there is no lack." The doubling of parts required different costumes for each character to avoid confusion. "The performers," he continues, "were most excellent and decked out with refinement and splendor, according to the circumstances of each one." Two in particular stood out: "that is the king and the queen, dressed magnificently in gold cloth." No expense was spared.

What made Palladio's wood and stucco theater visually stunning was not only the scenae frons and the actors' costumes but also the profusion of statuary situated above and behind the seating area. These figures are located within niches on a curved Corinthian peristyle; later, additional figures were added above a balustrade atop the columns. (Palladio's image stands in the middle.) Vitruvius provided the impetus: he had described classical theaters as featuring just such a design. And Alberti also reported ancient practice: "to allow the voice to flow freely to the top of the theater without obstruction, they set out the steps so that their outer edges all align. On the very top of the steps they added a portico, a particularly useful device, facing […] toward the central area of the theater; the front of the portico remained open, but the colonnade was completely walled along the back" (8:273).

In some respects, Palladio's theater diverged from ancient practice. We know that he had studied the remains of Roman theaters on his travels, but he could not duplicate exactly what he had seen, for his theater needed to fit

into an existing building. This stricture required compromise. For example, the available space was insufficient to create the true semicircular seating of antiquity. Instead, Palladio had to adopt an elliptical shape (a half oval) within which he built thirteen tiers of stepped seats—the *cavea*—where most spectators sat. Dignitaries occupied seats within the level semicircular area closest to the stage—the *orchestra*. A fresco in the theater shows a 1585 performance in progress, honoring a visit by Japanese ambassadors in July.[8] The seated figures, in their secular and religious attire, represent the power brokers of Vicenza along with distinguished guests. Because of space constraints, the stage itself needed to be fairly shallow compared to its width. Nevertheless, the actors in classical garb, together with the statuary of Vicentines similarly attired and the shapes and detail inspired by ancient architecture, must have evoked a classical cachet, even though *Oedipus Rex* was spoken in Italian rather than Greek or Latin.

* * *

The success of the inaugural performance depended, in part, on sound, both instrumental and vocal. Vitruvius provided the impetus: he had described classical theaters as featuring a curved Corinthian peristyle attached to the back wall of the theater. It fostered audibility, as did the coffered ceiling over the stage. Alberti also reported the ancient practice: "to allow the voice to flow freely to the top of the theater without obstruction, they set out the steps so that their outer edges all align. On the very top of the steps they added a portico, a particularly useful device, facing [...] toward the central area of the theater; the front of the portico remained open, but the colonnade was completely walled along the back" (8:273). Alberti explained how this worked: "on the very top of the steps [tiered seating] they added a portico, a particularly useful device"; "they set the colonnading upon a perimeter wall; this served to contain the expanding spheres of the voice, which the denser air within the portico had cushioned and reinforced rather than reflected in full" (8:273).

We know that playgoers of *Oedipus Rex* heard "music of the choruses" as well as "a far-off music, a harmony of voices and different instruments." Music was performed "offstage at the beginning of the first act before and after the curtain fell, and at the end of each act, the music was designed to further the meaning of the play rather than to accompany traditional intermedi that contrasted with the action of the drama."[9]

When I visited, the resident guide described the acoustics as "perfect." He added that any possible echo is muffled when playgoers sit on cushions. As I

listened to the gentleman describe the theater's features, I detected a New York accent not unlike my own; he sounded a lot like my grandfather who spent his life in Manhattan. This didn't seem to make any sense so I gingerly asked if he would mind telling me where he had learned English. Rather sheepishly he said that he had served in the Italian army during World War II, was captured, and sent to a prisoner-of-war camp in northern New Jersey. There he was treated well and took on the intonations and body language of native New Yorkers who taught him English. I gave the guide a generous tip to thank him and propitiate the presiding deity of the theater.

Although indoor theaters normally require artificial light to illuminate the stage, Palladio's theater had windows that obviated their use. In fact, "no other theater is as intensely illuminated by natural light as is this one."[10] This eliminated the need for artificial lighting during most daytime performances. But Angelo Ingegneri, director of *Oedipus Rex*, specified that he needed additional lighting for performances at night; in fact, the initial production of *Oedipus* took place at 7:00 p.m. Therefore, the theater had to be "bright, lighting up all the scenery and arranged in such a manner that they neither impede the audience's vision nor cause discomfort or danger."[11] (Fire was always a threat and, in fact, had destroyed earlier indoor theaters.) We can only speculate about precisely how the stage was illuminated. Ingegneri, however, described at least in general terms the lighting in the first production: "a frieze suspended from above [...] full of small lamps lit with something that created a glittering effect that would be arranged in such a way that they would project their flickering light upon the actors."[12] Oil lamps were gradually replacing candles on Renaissance stages; metal brackets for the lamps are still on view at Palladio's theater.[13]

We may add to our knowledge by extrapolating from Sebastiano Serlio's treatment of lighting. He had much practical experience, having designed a temporary theater in the courtyard of the Palazzo da Porto as early as 1539. In his book on architecture, his chapter on perspective includes this information: "There should be a large number of torches hanging in front of the stage. You can also put some candelabra above the stage with torches above them and also above the candelabra put a bowl full of water with a little piece of camphor in it; when it burns it gives off a beautiful light and is aromatic" (92). The surprise in this account is the emphasis on *colored* light. Serlio, who explains how to achieve sky blue, emerald, or ruby colors, emphasizes the totality of their effect. The theater may be "adorned with infinite lamps—large, medium and small, depending on the type required—which are so skillfully arranged that they appear to be many dazzling jewels, as it were, diamonds, rubies,

sapphires, emeralds and the like" (83). Making illusionistic street scenes visible in the Olympic stage openings called for special care. Scamozzi arranged "with his characteristic precision oil-lights that so effectively threw into relief every building of his stage-set, that the amazed audience had the impression of seeing a city lit by the sun's rays."[14]

<p style="text-align:center">* * *</p>

Italy's precedent had a profound effect on Shakespeare's England and other northern countries through Inigo Jones, the foremost architect and set designer of his day. Between *c.* 1597 and 1603 he visited Denmark, Germany, and France. His itinerary then took him to Italy where he delighted in virtually everything he saw. Later he used this experience to design a new classical portico for St. Paul's, London's Gothic cathedral. The abrupt juxtaposition of Gothic and classical must have looked a little awkward at Paul's. What Jones created survives in engravings, but Old St. Paul's was completely destroyed by the Great Fire of London in 1666. The classically inspired addition, however, announced a new direction of English architecture: "Elizabethans had dabbled in Italian architectural theory and form, but there was never a decisive move towards a unified theory of architecture, and certainly no unity of theory and practice based on Vitruvian or Italian Renaissance experience."[15] Beginning with Jones, Italy's engagement with classical architecture was assimilated in both England and northern Europe generally.

With a copy of Vitruvius in his luggage, Jones traveled to Italy a second time early in 1613, accompanying Thomas Howard, second Earl of Arundel, a wealthy art collector. (Jones's copy of Vitruvius with his annotations survives at Worcester College, Oxford.) In Vicenza, Jones "bought what seems to have been the entire stock drawings that had remained in Palladio's studio."[16] The experience of his actually seeing the architect's buildings and studying the drawings became a turning point in English architecture: "The year of Jones's return to England, 1615, may be counted as the beginning of English Palladianism."[17] Jones would employ Italian principles to design a variety of structures, including the Queen's House in Greenwich, Anne of Denmark's royal residence.

When the Banqueting House at Whitehall Palace burned to the ground in 1619, the authorities readily turned to Jones, Surveyor of the King's Works. From the outside, his design for a replacement looks like a two-story structure, supported by classical columns and pilasters, Ionic on the ground floor, Composite on the second. Actually, the building consists of a single large room

in the form of a double cube; Peter Paul Rubens painted the ceiling. The huge room functioned as an audience chamber for James I and a site for courtly entertainment. In this and his other structures, Jones applied principles that had guided Palladio. After the English Civil War, the unpopular King Charles I, son of James, would, ironically, be executed at his father's Banqueting House.

During his second trip to Italy, Jones assimilated everything he saw: "he sketched paintings by Raphael, Michelangelo, and Parmigianino as well as classical remains, made notes on the design of piazzas and on the church of San Pietro in Montorio [the Tempietto] by Bramante, in the form of a circular temple, which he says he 'observed often'."[18] In addition, Jones actually met Scamozzi, the architect who had finished the Olympic theater in Vicenza after Palladio's death and who designed Sabbioneta's theater. Jones visited the Medici court in Florence and saw at first-hand theatrical effects that Italians had pioneered for entertainment at court. He had an opportunity to exploit what he had seen when, during the reign of King James, he collaborated with the poet and dramatist Ben Jonson on entertainments called masques. Unlike drama at the Globe Theater, these performances combined song, dance, elaborate costumes, and painted scenery in the service of courtly compliment. No one in England had ever before seen such extravagant delights for the eye. More than 450 of Jones's drawings for costumes and sets are preserved in London.

By his work, this Englishman became the conduit for Italian designs fashioned by Palladio, himself indebted to Vitruvius. In fact, Jones became known as the British Vitruvius. The style pioneered by Jones and imitated throughout Europe and America is known today as "Palladian." Thanks to Jones, English architects moved away from the combination of Gothic and classical architecture that had characterized Elizabethan buildings. England became the first country in northern Europe to popularize Vitruvian/ Palladian principles.

NOTES

1 Vincent Cronin, *The Flowering of the Renaissance* (London: History Book Club, 1969), 107.
2 "Letter written by Filippo Pigafetta," in Fernando Rigon, *The Teatro Olimpico in Vicenza* (Milan: Electa, 1989), 75. In my following paragraphs here, all quotations from the letter have their source in Rigon's edition, pages 74–75. This translation is superior to that in A. M. Nagler's *Sources of Theatrical History* (New York: Theatre Annual, 1952), 81–86.

3 Cited by Richard and Helen Leacroft, *Theatre and Playhouse: An Illustrated Survey of Theatre Building from Ancient Greece to the Present Day* (London: Methuen, 1984), 26.

4 Leon Battista Alberti, *On the Art of Building in Ten Books*, trans. Joseph Rykwert, Neil Leach, and Robert Tavernor (1988; repr. Cambridge, MA, and London: MIT Press, 1997).

5 Oscar G. Brockett, Margaret Mitchell, and Linda Hardberger, *Making the Scene: A History of Stage Design and Technology in Europe and the United States* (San Antonio, TX: Tobin Theatre Arts Fund, 2010), 81–82.

6 Richard C. Beacham, *The Roman Theatre and Its Audience* (London: Routledge, 1991), 206. Beacham observes, however, that "Because no permanent theatres had yet been built, he assumed that a temporary stage would be erected in a rectangular hall, yet he imitated ancient practice by placing a semi-circular orchestra and auditorium within such a hall, even though this arrangement was not the best for appreciating the optical illusion of the perspective flats."

7 Sebastiano Serlio, *On Architecture*, trans. Vaughan Hart and Peter Hicks, 2 vols. (New Haven and London: Yale University Press, 1996). Citations designate page numbers in the first volume.

8 Rigon, *Teatro Olimpico*, reproduces the fresco (14).

9 Eugene J. Johnson, *Inventing the Opera House: Theater Architecture in Renaissance and Baroque Italy* (Cambridge: Cambridge University Press, 2018), 148.

10 Rigon, *Teatro Olimpico*, 76–77.

11 Remo Schiavo, *A Guide to the Olympic Theatre*, 3rd ed., trans. Patricia Anne Hill (Vicenza: Accademia Olimpica, 1987), 140.

12 Schiavo, *A Guide*, 140.

13 See the photo in Rigon, *Teatro Olimpico*, 54.

14 Schiavo, *A Guide*, 140.

15 Robert Tavernor, *Palladio and Palladianism* (London: Thames and Hudson, 1991), 115.

16 Douglas Lewis, *The Drawings of Andrea Palladio* (Washington, DC: International Exhibitions Foundation, 1981), 8.

17 Tavernor, *Palladio*, 125.

18 Peter Burke, *The European Renaissance: Centres and Peripheries* (Oxford: Blackwell, 1998), 113.

CHAPTER 28

TEATRO ALL'ANTICA, SABBIONETA

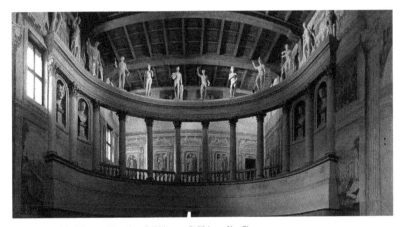

FIGURE 28 *Teatro all'antica, Sabbioneta*. Wikimedia Commons.

Vespasiano Gonzaga, as part of his recreation of an ancient city, commissioned a theater from Vincenzo Scamozzi. This is the second oldest theater dating from the Italian Renaissance and the only surviving court theater of its time. Its indebtedness to classical antiquity is apparent everywhere. Above and beyond the seating area, Corinthian columns support a curved colonnade, and the figures standing on top are the twelve Olympian deities. On both sides of the theater, we see classical portrait busts. And between the seats and the stage, large frescoes of ancient Rome decorate the walls.

On the eve of my departure for a sojourn in Italy, a colleague asked if I would be visiting Sabbioneta. I drew a blank. I had never heard the name and could not imagine why I should travel to such an obscure site. But during a visit to Mantua, I recalled my friend's query and learned at the tourist office that I was only a forty-five-minute drive away from the small city. Why not see what it had to offer? I took my friend's suggestion and discovered something wondrous.

Although it looks mostly deserted today, Sabbioneta represents Vespasiano Gonzaga's effort to create the modern counterpart of an ancient city, complete with a palace, theater, and central-plan temple/church. Drawing inspiration from classical motifs, Vespasiano, who bore the name of a Roman emperor, had a hand in designing the buildings, though he may have had the help of Domenico Giunti, painter and architect, who enlarged and fortified the nearby city of Guastalla. During Vespasiano's long absences on military expeditions, Giovan Pietro Bottaccio served as site manager. Created in the second half of the sixteenth century, the small city became known as "the little Athens."[1] We cannot say with certainty, however, who actually drew up the blueprints. We do know that Vespasiano had the good sense to hire Vincenzo Scamozzi to design the theater in May 1588.

His theater is not so large as Palladio's in Vicenza, for the population of the town was much smaller. Opening in February 1590, the *Teatro all'antica*, or theater in the ancient style, is the second oldest indoor theater surviving in Europe. Despite its status, the theater has been slow to reveal its story. We don't even know whether Vespasiano chose a name for it. No factual evidence supports the often repeated claim that he named Scamozzi's creation "The Olympic Theater." Contemporaries applied the word *Odeon*,[2] a Greek term designating an enclosed space for music or poetry.

Scamozzi, of course, completed the theater at Vicenza when Palladio died, and this connection seems to promise information about the new theater. Some observers have even claimed that Sabbioneta's theater "is obviously modelled on the Teatro Olimpico at Vicenza."[3] Actually, the two theaters are different in concept, shape, seating and decoration. Differences rather than similarities dominate. And Sabbioneta is virtually unique as a surviving courtly theater of the Renaissance.[4] Seldom included on tourist itineraries, it deserves to be better known and invites a number of questions: How does this theater manifest its builder's engagement with antiquity? What do we know about its appearance? And what can the theater tell us about staging?[5]

* * *

Vespasiano must have known all along that his ideal city would remain incomplete without a site for dramatic entertainment. He and his contemporaries understood that ancient Romans, like the Greeks before them, had regarded drama as essential to their culture. Leon Battista Alberti testified to the popularity of playgoing in antiquity, reporting that Rome "contained three large theaters [and] several amphitheaters" (8:269).[6] Yet the evidence about the structure

housing Vespasiano's theater remains equivocal. The building occupies the end of a city block. Nothing on the exterior reveals the presence of a theater inside. In fact, "at first glance, it is indistinguishable from a standard Renaissance palazzo—rusticated ground floor, paired Doric pilasters on the *piano nobile*, and so on."[7] Circular spaces above some second-floor windows may have held busts when the theater was new. But such sculpture appeared on all sorts of buildings and so would not necessarily mark this one as a theater. Like many other edifices of the era, Sabbioneta's may have featured exterior wall painting hinting at what lay within.[8] If it ever existed, no trace survives. A Latin inscription, *Roma quanta fuit ipsa ruina docet* (her very ruins teach us how great Rome was), quoted from a title page in Sebastiano Serlio's book on architecture (95), adorns the exterior. But the inscription does not specifically mention theaters. It could apply to almost any creation of Roman civilization.

On balance, I am inclined to believe that Scamozzi's theater found a place in a building that could have accommodated a variety of purposes and may not have first been envisioned as a playing space. Consider this oddity: the theater is much longer than it is wide—eighty-eight by thirty-seven feet. The proportions are unusual. The seating pattern, moreover, bears little similarity to Palladio's arrangement for playgoers at Vicenza, which Scamozzi helped finish. The oddest fact about this theater is simply that it had not been made earlier in the city's life. Not until 1588 did Vespasiano commission the structure, and by this time the palace, church, gallery, library, school and mint had all taken shape. So its existence appears almost an afterthought rather than an essential ingredient of the urban plan. Perhaps Vespasiano did not anticipate his approaching demise and so put off construction until other major projects were complete. Maybe the structure was pressed into service to accommodate a theater conceived, figuratively, at the last moment. The absence of ancient precedent may also have inhibited the impulse toward designing a new kind of theater. Although sixteenth-century builders relished the architecture of Rome, they found no surviving indoor theaters to emulate. Finally, it's entirely possible that Vespasiano was simply unable to find a designer who had the skill to fashion a place for performance that would match his expectations until his life neared its end.

Although Scamozzi's *Teatro all'antica* little resembles any surviving theater erected when the Roman Empire flourished, the allegiance of both Vespasiano and Scamozzi to the world of the ancients was unmistakable: they were kindred spirits. Above and behind the seating area, twelve Corinthian columns support a curved colonnade. (Vitruvius had described such linked columns in his book on architecture dedicated to Emperor Augustus.) The

figures standing on top call to mind the academicians whose life-size statues adorn the theater in Vicenza, but here they represent twelve Olympian deities. On both sides of the theater, two pairs of portrait busts occupy alcoves formed by the three classical columns nearest the stage: Cybele, earth mother and protector of cities, and Alexander the Great; the Roman Emperor Trajan and the Greek general Seleuco. Between the seating area and the stage, large frescoes of ancient Rome, framed by triumphal arches, decorate the walls: one depicts the Castel Sant'Angelo, designed as a mausoleum for the Emperor Hadrian; opposite is Michelangelo's (unfinished) Campidoglio, once Rome's political center on the Capitoline hill.

Scamozzi's decision not to use an elaborate scenae frons like Palladio's is the single biggest difference between their two theaters. Vespasiano's architect must have felt that the stage in a relatively small theater would be overwhelmed by such a bold design. We know that Scamozzi did not adopt multiple entries onto the stage like those at Vicenza, almost certainly because his stage was comparatively narrow. He planned an illusionistic set, however, made of wood, stucco and paint, not unlike those he had previously made for Vicenza's theater. It has disappeared. On my last visit, in place of a proper set, I saw the painting of a piazza seen through an arch.

On the back wall behind the colonnade and its statuary, we find additional evidence of ancient inspiration. Frescoes of five Roman emperors, including Vespasiano's namesake, contribute their prestige to the dramatic action below. What gives special charm to the interior is another artistic display: trompe l'oeil painting. High on the wall above the deep, raked stage, frescoes depict well-dressed men and women, along with musicians, looking down from behind a balustrade. On the opposite wall of the theater, behind the statues of Olympian gods, similar figures gesture to one another as they watch a performance. Their faces probably belonged to residents of the city. The frescoes bear an uncanny resemblance to those painted by Veronese at the Villa Barbaro in Maser, Palladio's villa in the Veneto. If not by Veronese, these paintings were likely made by someone in his circle or at least familiar with his work.

The rectangular space for the theater presented Scamozzi with a challenge that neither the ancient Romans nor Palladio faced. Seating could not have the form of a true semicircle (as in antiquity) or an ellipse (as at Vicenza). Instead, the architect chose a different form entirely: he made a horseshoe- (or bell-) shaped area for seated playgoers. Most of the audience in Sabbioneta occupied five curved and stepped benches; a surviving sketch in Scamozzi's hand shows the arrangement, which has been recreated today. (The Sam Wanamaker Playhouse, London, employs a somewhat similar, though far smaller, design in a

section of its ground floor.) Some spectators would necessarily sit at right (or left) angles to the stage. As a practical measure, the architect arranged the backs of seats to be raised slightly higher than the floor of the next higher level, ensuring that playgoers, who sat in tiers, would not have to contend with the feet of those above them. Scamozzi's surviving sketch at the Uffizi Gallery in Florence suggests that this interior, after modern restoration, looks much as it did four centuries ago. In fact, "the remarkably well-preserved interior gives us the best experience we will ever have of a renaissance court theater."[9]

We do not know, however, how the ceiling looked. The precedent of Vicenza suggests one possibility. The coffered space directly above the stage at Palladio's Olympic Theater was divided into fifteen geometric panels one of which depicted Hercules' choice between Virtue and Vice. A painting of wispy clouds and sky, executed in 1914, covers the seated portion of the theater today. Whether this represents a version of the original design is uncertain, though an interesting parallel existed on the contemporary Elizabethan stage. In the *English Wagner Book* of 1594, a sequel to the *English Faust Book*, the account of a theater hosting a performance of the Faust story, includes this detail: "Now above all was there the gay Clowdes [...] adorned with the heavenly firmament, and often spotted with golden teares which men call Stars."[10] Another parallel, also in London, appeared at the Whitehall Banqueting House in 1604: "Leonard ffrier Sergeant Painter [was paid] for laying upon Canvas in the Ceeling of the great Banqueting house cxxxij yards square of worke called the Cloudes in distemper [disorder] [...]."[11] Still, another parallel existed in the temporary theater erected on the Campidoglio when Giuliano and Lorenzo de' Medici received Roman citizenship: "This rectangular theatre was covered by a costly cloth representing the sky [...]."[12] Decades later Nicola Sabbattini would write his *Manual for Constructing Theatrical Scenes and Machines*, which includes instructions on covering a theatrical sky with clouds.[13]

If we cannot know with confidence the ceiling's design, we can at least speculate about Scamozzi's creation. Kurt W. Forster has suggested that the present wooden ceiling "may have been covered with stretched cloth in the manner of antique *velaria* [awnings] so as to enhance the sense of an outdoor space."[14] Perhaps we may extend this attractive suggestion. My hunch is that some sort of sky map appeared in Sabbioneta's theater, like that above the stage in London's reconstructed Globe (1997). Celestial globes, often made of metal or wood, were popular in Scamozzi's time and might be found in an aristocrat's study. Signs of the zodiac, based upon a configuration of stars, also appeared in countless woodcuts and engravings. And painters depicted sky maps on palace ceilings. Often these honored a dignitary. For example,

the Loggia di Galatea in Rome's Villa Chigi/Farnesina, built for Agostino Chigi, features two paintings by Baldassare Peruzzi, *The Constellation of Perseus with Fame* and *The Constellation of the Chariot*. The design complimented the owner of the palace, for, together, they delineated the position of the stars at Agostino's birth on December 1, 1466. The Sala del Mappamondo at Caprarola, which brilliantly depicts the signs of the zodiac on the ceiling, is one of the finest produced in the Renaissance. Although this map of the heavens by Giovanni Antonio Vanosino da Varese may not designate Alessandro Farnese's birth date, it may be interpreted in general terms as a sign of his career's political, ecclesiastical, and artistic importance.[15]

By the time Sabbioneta's theater was built, the representation of sky maps had become conventional. And if the ceiling at Scamozzi's theater was meant to glorify Vespasiano, the design may well have depicted a horoscopic chart. Although many hundreds of celestial maps were made during the Renaissance in one medium or another,[16] their popularity today may draw bemusement or even disdain since astrology is commonly viewed with skepticism, despite frequent appearances in our newspapers and magazines. Someone must be reading them! The line dividing astronomy and astrology, however, was hardly precise four hundred years ago. And many Christians had no compunction about consulting the firmament. After all, they construed the stars as a means whereby God implemented his plans for the world. Even the Vatican sanctioned astrology. Raphael's representation of Astronomy in the Stanza della Segnatura depicts the alignment of stars when Pope Julius II was born. And the Sala Bolognese, also in the Vatican, features a sky map painted by Giovanni Antonio Vanosino da Varese in 1575. The fresco presents the constellations as though we share God's view looking down rather than our terrestrial view looking up. As its name implies, this hall celebrates a pope from Bologna, Gregory XIII.

What made astrology suspect to some contemporaries, particularly Protestant reformers, was its prominence in pre-Christian societies that studied the stars for clues to the future. Martin Luther and his followers, moreover, worried that the concept of astral determinism would obscure the nature of Christian providence. But the issue was not clear-cut. Consider: Luther declared, "astrology is not a science because it has no principles or proofs. On the contrary, astrologers judge everything by the outcome and by individual cases and say, 'This happened once and twice, and therefore it will always happen so.' They base their judgment on the results that suit them and prudently don't talk about those that don't suit."[17] This same theologian, however, harbored the most profound sense of fatalism in spiritual matters, as

did his follower John Calvin. "It is amusing to observe that the most implacable opponents of astrology, with its often tacit fatalism, were precisely those who themselves preached predestination, albeit predestination of a different sort."[18] In short, Luther's understanding of God's foreknowledge had an unmistakable parallel with pagan fatalism, customarily represented in Greece and Rome by the Three Fates, who spun, measured, and cut the thread of life.

* * *

If the physical properties of Scamozzi's theater provided a challenge, they provided opportunities as well. Capitalizing on the theater's dimensions, Scamozzi could create a deep stage. This amplitude, in turn, exploited the sixteenth-century enthusiasm for illusionistic painting.[19] It's difficult to know how much Renaissance designers knew about the work of ancient painters, most of whose artistry had yet to be discovered. We do possess, however, literary evidence that Greek and Roman theaters used scenery. "The earliest mention of theatrical painting is found in Aristotle's *Poetics* [...] where he credits Sophocles with having introduced scene painting; *skenographia*, in the middle of the fifth century BCE. Having originated in a specifically theatrical context, the term came to be used in antiquity to refer to perspective painting in general."[20] Roman theaters too adopted the theatrical practice. Most surviving paintings and mosaics of drama in performance show actors in costume, sometimes playing musical instruments, sometimes armed with weaponry.[21] There's no evidence, however, that Roman stages sought to create the look of a believable location as is generally the case today. What the eyes of spectators saw was more likely suggestive than realistic.

For all their visual sophistication, Romans seem not to have achieved a knowledge of what we call one-point linear (or scientific) perspective, the kind discovered by Filippo Brunelleschi, carefully described in Leon Battista Alberti's book on painting, exemplified by Masaccio's painting of the Trinity in Santa Maria Novella, and displayed in the second set of Ghiberti's panels for the Florence baptistery. It was this knowledge that allowed Italian theatrical designers to pursue their interest in perspective scenery, which "provided a geometric system for the convincing representation of architectural and open-air settings."[22] "The first perspective settings were primarily backdrops—scenes painted onto a flat surface at the back of the performance space."[23] In their representation of space, Renaissance scenic designers were, of course, departing from the example of Vitruvius, whose book on architecture emphasizes the spoken word: "The whole emphasis of his account is on sound, on the voices of

the players, on how every word they speak must be audible, on the music of their voices to be emphasized and brought out into volumes of harmonious sound."[24]

In time, the representation of space became increasingly sophisticated. Baldassare Peruzzi, for example, contributed a complicated stage set for *La Calandria*, based on an ancient comedy by Plautus, adapted by Cardinal Bernardo Bibbiena, and staged on February 6, 1513, at Urbino's court. Baldassare Castiglione, author of *The Book of the Courtier*, produced the play and recorded his thoughts about the set, painted by Timoteo Viti and Girolamo Genga: "The scene was laid in a very fine city, with streets, palaces, churches, and towers, all in relief, and looking as if they were real, the effect being completed by admirable paintings in scientific perspective. Among other objects, there was an octagon temple in low relief, so well finished that, even if all the workmen in the duchy of Urbino had been employed, it seemed hardly possible to think that all this had been done in four months!"[25] When the play was performed the next year, this time at the Vatican for Pope Leo X, Baldassare Peruzzi created even more sophisticated scenery. Giorgio Vasari reported: "It is wonderful how, in the narrow space, he depicted his streets, palaces, and curious temples, loggias, and cornices, all made to make them appear to be what they represent. He also arranged the lights inside for the perspective, and all the other necessary things."[26]

Peruzzi's student Sebastiano Serlio designed an acclaimed set for a temporary theater in Vicenza in 1539, that is, well before the Teatro Olimpico or the Teatro all'antica was built. Serlio had seen his teacher's illusionistic work in the Palazzo Chigi/Farnesina, Rome, where a temporary theater was sometimes raised in the garden and where Peruzzi, on the *piano nobile*, had created the stunning illusion of a townscape seen from within the villa. Serlio's own example, in turn, had a powerful effect on Scamozzi, who may have written a (now lost) treatise on perspective *c.* 1575. Serlio's popular study of architecture captured the prevailing fashion and offered practical advice about construction. By the time his treatise was published, playwrights and audiences were "in the thrall [...] of pictorial illusion."[27] Mathematics and theatrical practice found one another when Scamozzi designed a three-dimensional townscape in Sabbioneta.

Despite their passion for the ancients, then, Palladio, Serlio, Scamozzi, and their contemporaries departed from antiquity's precedent. Serlio in particular stressed the aesthetic benefits resulting from the careful fashioning of scenery informed by perspective: it was able to accommodate a heterogeneous world. Describing intermezzi, those extravagant scenes enacted between the acts of an Italian court play, for example, Serlio wrote, "With this artifice [i.e.,

perspective], for some particular purpose a god can be seen descending from heaven, or some planets can be seen flying through the air. Then on stage come the various *intermezzi*, most richly decorated: costumes of various types, with outlandish dress both for the Moorish dancers and the musicians [...]. All these things are so satisfying to the eye and heart that it is hard to imagine any man-made material object that is more beautiful."[28] Nothing will seem out of place, for everything is subordinated to a particular way of seeing. The contrivance of perspective guarantees visual pleasure. Nor does this achievement represent merely the taste for an ocular trick. Rather, supporting it was a profound conviction—that "perspective lines represent the underlying or hidden order of natural forms and of man himself."[29]

* * *

To complement his new theater and show off its elegance, Vespasiano invited a company of *Commedia dell'arte* (improvised comedy) players from Ferrara to provide entertainment. During the Carnival festival of March 1590, this professional group performed a comedy on the new stage, as did three groups of amateur players (from Sabbioneta itself, as well as from nearby Bozzolo and Guastalla). Comedies or pastorals were ordinarily performed in the evenings. Most days of the Carnival had at least two performances.

Duke Vespasiano was so pleased by what he witnessed that he contemplated setting up a theatrical troupe in his new city. A document dated March 18, 1590, records that the duke directed an actor to visit Mantua and Ferrara to scout for talent and assemble a company that would be paid 400 scudi each year. In return, the actors would visit Sabbioneta for two months: twenty days during Carnival, twenty after Easter, and another twenty in September, after harvest. When in residence, the actors would bear Vespasiano's coat of arms, a sign of his sponsorship. And during their employment, the duke would, of course, provide room and board. At the end of their residency, they were at liberty to move on and seek employment elsewhere.

During performances Vespasiano himself and his family apparently sat above the other playgoers (on the peristyle level), occupying a position between the gods on the colonnade above and the courtiers on their benches below. This represented an innovation. As Eugene J. Johnson observes, "The duke and his party occupied the highest point. This arrangement appears to be a novelty in court theaters. Heretofore the ruler and the most important guests had occupied a conspicuous spot at the lowest level."[30] Perhaps the explanation lies in the use of perspective. Situated above, the duke had the best view of Scamozzi's

onstage illusion: a single-point perspective works best from one spot in the theater. (In contrast with Palladio's, this theater had only a single perspective view.) Metaphorically, the arrangement suggests a parallel with the world over which God presides, that is, hierarchically arranged and harmoniously disposed.

If theaters represent a culture's most deeply felt values, this one may be considered the crown jewel in Vespasiano's enterprise, despite its late construction in the community's history. Here the creator of an urban settlement based upon ancient principles and taste seated himself in a brilliant architect's theater, complete with a fashionable, illusionistic stage set. As warrior, humanist, courtier, and architect, the duke embodied a cultural ideal that flourished throughout Italy. Watching professional actors not previously seen in the municipality that he personally conceived and built must have filled him with satisfaction.

Unfortunately, his ill health short-circuited his plan for a residential company. Although the first performances at Sabbioneta took place in February 1590, Vespasiano died on February 27, 1591, and what Scamozzi had devised did not long survive as a working theater. The planned return of professional actors never happened. It fell victim to the demands of theatrical production. Drama, the most ephemeral of art forms, is no sooner realized onstage than vanished. For a troupe of actors to thrive, a regular infusion of money and talent is necessary in the form of actors, scripts, sets, props and costumes. All were in short supply after Vespasiano's illness and death. Without the duke's guiding spirit and generous spending, the population of his city dwindled. Despite having been married three times, he left no male heir, his sickly son Luigi having died at fourteen. Marguerita, Vespasiano's widow, departed, along with other aristocrats. Devoid of playgoers, Scamozzi's theater lost its raison d'être and was converted to an infirmary during a plague outbreak in 1629. The walls of the theater were whitewashed. Later, ignominiously, it became a granary and warehouse. In the 1920s, it assumed yet another form, this time as a cinema. (The transformations explain the loss of painted and sculptural decoration in the interior.) The original three-dimensional set fashioned by the architect was demolished in the eighteenth century.

Vespasiano would have been dismayed, though perhaps not entirely surprised, to witness Sabbioneta's future. The fortifications he built—moat, cannonry and ramparts—could not safeguard the city from relentless change. A downward slide, economic and cultural, was inevitable given the death of the city's founder, a declining population, the city's relative isolation and the failure to produce a surviving male heir. Moreover, the city never became a pilgrimage site, which would have drawn a steady supply of visitors.

Without courtly playgoers, how could the theater be sustained? No aristocrat stepped forward to support Sabbioneta with the enthusiasm of its founder, though the Emperor named Luigi Carafa, Vespasiano's son-in-law, the new duke. Both he and his wife Isabella (her father's heir) decided to leave the city, moving their artistic treasures to Naples soon after Vespasiano's death. Ironically, benign neglect had the effect of preserving much of Sabbioneta. If the city had continued to grow into a mercantile, civic and artistic haven, it would gradually have been modernized and "improved." What the duke had painstakingly built would have been destroyed.

NOTES

1 "Ireneo Attò was the first to coin in 1780 the felicitous description of Sabbioneta as 'The Little Athens' by which it is known today." See Umberto Maffezzoli, *Sabbioneta: A Tourist Guide to the City*, 2nd ed. (Bologna: Il Bulino, edizioni d'arte, 1992), 9.

2 Eugene J. Johnson, *Inventing the Opera House: Theater Architecture in Renaissance and Baroque Italy* (Cambridge: Cambridge University Press, 2010), 153.

3 Alastair Laing, "The Ideal City Preserved: Sabbioneta, Northern Italy," *Country Life* 177, no. 4575 (April 25, 1985), 1120.

4 The enormous theater at Parma, built for Duke Ranuccio I, bears little resemblance to those of Vicenza and Sabbioneta. This *Teatro Farnese*, constructed in 1619, was based on plans by Giovanni Battista Aleotti. Located within the ducal palace, it was largely destroyed by bombing in World War II. What exists today is a reconstruction.

5 Stanley V. Longman, in "A Renaissance Anomaly: A *Commedia dell'Arte* Troupe in Residence at the Court Theatre at Sabbioneta," *Theatre Symposium, Tuscaloosa*, 1, part 2

6 Leon Battista Alberti, *On the Art of Building in Ten Books*, trans. Joseph Rykwert, Neil Leach, and Robert Tavernor (1988; repr. Cambridge, MA, and London: MIT Press, 1997).

7 Caroline Elam, "Sabbioneta," *AA Files: Annals of the Architectural Association of Architecture* 18 (Autumn 1989): 29.

8 For example, the façade of the Palazzo del Consiglio, Pisa, which was "enlarged and redecorated 1596–1603 following earlier plans by Giorgio Vasari." See Stephen J. Campbell and Michael Wayne Cole, *A New History of Italian Renaissance Art* (London: Thames and Hudson, 2012), 617 (fig. 21.11).

9 Eugene Johnson, *Inventing the Opera House*, 157–58.

10 E. K. Chambers, *The Elizabethan Stage*, 4 vols. (1923; repr. Oxford: Clarendon Press, 1951), 3: 72.

11 Cited by John Ronayne, "*Totus Mundus Agit Histrionem*: The Interior Decorative Scheme of the Bankside Globe," in *Shakespeare's Globe Rebuilt*, ed. J. R. Mulryne and Margaret Shewring (Cambridge: Cambridge University Press, 1997), 121–46 (146, n55). The original canvas at the Banqueting House, destroyed by fire in 1619, was replaced with a plaster ceiling when the edifice was rebuilt.

12 Wolfgang Lotz, *Architecture in Italy, 1500-1600*, trans. Mary Hottinger (New Haven and London: Yale University Press, 1995), 46.

13 "Sabbattini on Theatrical Machinery," in *Sources of Theatrical History*, ed. A. M. Nagler (New York: Theatre Annual, 1952), 97–102.

14 "Stagecraft and Statecraft: The Architectural Integration of Public Life and Theatrical Spectacle in Scamozzi's Theater at Sabbioneta," *Oppositions: A Journal for Ideas and Criticism in Architecture* 9 (Summer 1977): 68.

15 Kristen Lippincott has extensively studied the ceilings of the Villa Chigi and Caprarola's palace. See "Two Astrological Ceilings Reconsidered: The *Sala di Galatea* in the Villa Farnesina and the *Sala del Mappamondo* at Caprarola," *Journal of the Warburg and Courtauld Institutes*, 53 (1990): 185–207. She calls the twelve depictions of the Mappamondo's ceiling "astro-mythological scenes" (201).

16 See Deborah J. Warner, *The Sky Explored: Celestial Cartography, 1500–1800* (New York: Alan R. Liss; Amsterdam: Theatrum Orbis Terrarum, 1979).

17 *Luther's Works*, ed. Jaroslav Pelikan and Helmut T. Lehmann, 55 vols. (St. Louis: Concordia Publishing House; Philadelphia: Fortress Press, 1955–86), 54: 173.

18 J. D. North, "The Reluctant Revolutionaries: Astronomy after Copernicus," in *The Universal Frame: Historical Essays in Astronomy, Natural Philosophy and Scientific Method* (London and Ronceverte, WV: Hambledon Press, 1989), 24.

19 Shakespeare's Globe theater did not, of course, customarily use painted scenery or three-dimensional sets like those of Serlio. For a Shakespeare connection, however, see Tom Rutter, "Shakespeare, Serlio, and Giulio Romano," *ELR* 49, no. 2 (Spring 2019): 248–72.

20 Richard C. Beacham, *The Roman Theatre and Its Audience* (London: Routledge, 1991), 64. W. Beare, however, in *The Roman Stage: A Short History of Latin Drama in the Time of the Republic* (Cambridge, MA: Harvard University Press, 1951), expresses skepticism about the extent of scenery in the Roman theater: "Reduced to the barest terms, the permanent scenery consisted of the plain wall at the back with its three doors, the two projecting wings with the side-entrances, the flat roof of the actors' house, and on the stage itself an altar" (172).

21 See Katherine M. D. Dunbabin, *Theater and Spectacle in the Art of the Roman Empire* (Ithaca and London: Cornell University Press, 2016).

22 H. W. Janson, *History of Art*, rev. Anthony F. Janson, 4th ed. (New York: Harry N. Abrams, 1991), 58.

23 Brockett et al., *Making the Scene*, 66.

24 Frances A. Yates, *Theatre of the World* (Chicago: University of Chicago Press, 1969), 118.

25 Cited by Julia Cartwright, *Baldassare Castiglione, the Perfect Courtier: His Life and Letters, 1478–1529*, 2 vols. (London: John Murray, 1908), 2: 337.

26 Nagler, *Sources*, 72.

27 Beacham, *The Roman Theater*, 206.

28 Sebastiano Serlio, *On Architecture*, trans. Vaughan Hart and Peter Hicks, 2 vols. (New Haven and London: Yale University Press, 1996), 1: 83.

29 Longman, "A Renaissance Anomaly," 60.

30 Eugene Johnson, *Inventing the Opera House*, 159.

CHAPTER 29

ST. MARK'S LIBRARY, VENICE

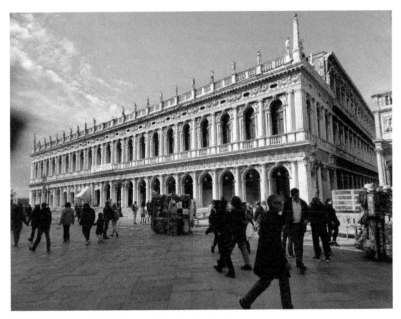

FIGURE 29 *St. Mark's Library, Venice.* Author's photo.

The doge of the Venetian Republic convinced Jacopo Sansovino to visit Venice and set up his architectural practice there. His most famous building is the library that, astonishingly, seems to lack walls. It is an illusion, of course, fashioned by a collection of piers and columns linked together, hiding the brick skeleton. The play of light and dark has a remarkable three-dimensional effect.

Libraries can have a forbidding look. In the nineteenth and twentieth centuries, their style was often neoclassical, with large columns, pediments, and imposing doors; sometimes they looked like banks. Upon entry, the visitor might be confronted by a person of formidable bearing. An unspoken code of conduct prevailed: no talking or eating or drinking or disruption of any kind lest something be damaged or someone disturbed. Older libraries may have the atmosphere of a church—or at least they did until our own era when every reader carries an electronic gadget. But the library in Venice, when built, had almost nothing in common with those in modern cities. It opened onto the busiest piazza in the city, a place crowded with shoppers, visitors, and vendors. On the Grand Canal a few paces away, gondolas awaited passengers as they do now. There has always been a festive air about this site. And in keeping with the restless foot traffic, the library opened itself to the populace by making the ground floor a loggia filled with shops. True, fruit sellers and other peddlers would scarcely be invited to inspect the manuscripts, but the street level seems to welcome everyone, like Michelangelo's Piazza del Campidoglio in Rome.

Formerly known as the Biblioteca Marciana—named for the Basilica of San Marco—the library was designed by Jacopo Sansovino, who fled to the city after the Sack of Rome in 1527 and never left. He had intended to move on to France but became a favorite of the influential Andrea Gritti (Doge of the Venetian Republic from 1523 to 1538), who convinced him to stay in Venice. In effect, Sansovino became city architect, undertaking the restoration of St. Mark's medieval cathedral by fortifying the domes, which were badly in need of shoring up. The library, begun in 1537, was meant to preserve Greek and Latin manuscripts bequeathed to Venice in 1468 by Cardinal Bessarion, titular Latin patriarch of Constantinople, who had come to Italy in 1438 for a conference; the Muslim capture of his city prevented his return home. His collection of 482 Greek and 264 Latin manuscripts, furnishing the nucleus of the new library, spent decades in crates before finally being deposited in 1558.

On the Piazzetta San Marco, which opens onto the Grand Canal, the library adjoins a medieval bell tower and faces the Gothic Doge's Palace. The site required a long, narrow building so as not to upstage the palace opposite. As a result, the structure is twenty-one bays long, three bays wide, and only two stories tall. This arrangement ensured a strong horizontal line. (Although the two buildings belong to different styles, they happily complement one another.) The ends of the library overlook the Grand Canal, on one side, and the Loggetta and bell tower, on the other. The tall column with a statue of St. Theodore, an Eastern martyr and first patron saint of the city, stands just a few steps away

and represents a characteristically Renaissance conflation—the torso carved in ancient Rome, the head in Greece. St. Mark began to displace Theodore when in 828 Venetian merchants literally stole the body of the Evangelist from Alexandria and brought it home.

Because the city rests upon sand, silt, mud, and clay, building in Venice is tricky at the best of times. In the absence of sturdy stone foundations, subsidence lurks as a potential danger. In December 1545, a vault in the upper story of the library collapsed, possibly because of problems with the supporting structure, though Sansovino blamed frost interfering with the settling of concrete. The architect probably wanted a vault because this form looks like a natural extension of the walls, whereas a flat ceiling represents merely the stopping place of those walls. As a result of the debacle, he was fined and thrown in jail briefly. He won his release through the intercession of powerful friends though he was required to repair the damage at his own expense. This time a beamed ceiling replaced the original. Two years later, officials restored his salary and allowed him to continue what he had started.

* * *

The massing of external columns and piers sets this library apart from most earlier Renaissance structures and frames the arches on the ground floor. Behind them is not the book collection itself but rather a broad porch. Today this loggia houses a sidewalk café and a small band playing popular tunes. From here, enjoying a morning coffee, you will have the best possible view of the Doge's palace. By the way, Italian coffee, like its Greek and Turkish counterparts, is a dark roast, very different from the weak and watery blend often found in America and called "blonde" by Starbucks.

Smooth Ionic columns on pedestals frame each bay of the library's second floor. Within are round arches supported by a pair of smaller freestanding, fluted colonnettes on each side, a characteristic feature of Sansovino's work. At the corners of the building on both levels, conjoined pilasters and engaged columns add a sense of majesty. Balconies overlook the Piazzetta, the space between the palace and the library. With these classical features, the architect moved decisively away from the Gothic and Byzantine past, long dominant in Venice.

The most daring and innovative feature of the building is the apparent absence of walls. Standing outside, we confront a collection of piers and columns linked together, hiding the brick skeleton. Because of this massing, because of the wide arches, and because the second-floor windows are deeply

set into the wall, the white stone imported from Istria (present-day Croatia) creates a dramatic contrast with sunless shadows. The play of light and dark has a remarkable three-dimensional effect. "It was his capacity to articulate facades in high relief that was perhaps Sansovino's most important contribution to Venetian architecture."[1]

The decoration is unusually elaborate, made possible by the high frieze atop each floor. A continuous band inspired by Greek and Roman precedent runs the entire length of the façade above the first-story arches, creating a strong horizontal line. Metopes alternate with triglyphs. Keystones alternating men's and lions' heads decorate the centers of the Doric arches. (The lion symbolizes both the city and St. Mark, the Evangelist traditionally identified with the animal, as was St. Jerome later.) A prominent cornice and balustrade rest upon this level. Above, fluted Ionic columns flank the arches. And just above the second floor, we find a richly decorated frieze: between small oval windows, putti bear garlands of fruit. A crowning balustrade surmounts the wall. At corners of the roof, tall obelisks stand on pedestals; the Roman practice of importing Egyptian stonework to their capital furnished the precedent. (Like pyramids, obelisks suggested allegiance to antiquity; the two words were often used interchangeably.) Between the obelisks, twenty-five freestanding statues of classical gods and heroes look down upon the Piazzetta. The statuary stands directly over the columns below, extending their vertical line. All such features belong to classical antiquity.

The second-floor *piano nobile* houses the sumptuous reading room, which occupies seven arches of the façade. The windows face east to catch the morning sun, an arrangement favored by Vitruvius. By placing this room well above ground level and by locating the book stacks here as well, the architect ensured that the manuscripts bequeathed by Cardinal Bessarion would not be threatened by high water in the Grand Canal. In 1556, a competition began for paintings to adorn the gilded ceiling, and Titian, along with Sansovino, determined the winners. In keeping with the expectations of the time, the seven painters selected were instructed to depict classical deities representing the virtues and the arts; ironically, this display was only a short walk from one of Christianity's greatest cathedrals. Paolo Veronese won the day and a gold chain with his painting of *Music* resting in the clouds. Altogether, three rows of circular designs with seven paintings each were installed on the coffered ceiling. In addition, rectangular paintings filled the spaces between the windows. At the entrance to the reading room, a vestibule provided the site of an elite school for young noblemen. On the ceiling there, Titian's octagonal painting

of *Wisdom* (*c.* 1560), a scroll in one hand, and a modern book in the other, sits atop the clouds.

Outside the library, you will not find any sign indicating direct access. At the end of the Piazza San Marco, however, opposite the cathedral, you will find the Correr Museum. One afternoon finding myself free for a couple of hours, I bought a ticket to see a collection of ancient statuary and Renaissance paintings there. At one point, I turned a corner on the second floor and, to my surprise, found myself in Sansovino's library, at liberty to enjoy Titian's *Wisdom* and all the ceiling paintings in the reading room. I know of no easier way to gain entry. So when you're in Venice, keep an eye out for the Correr Museum and prepare yourself for a treat.

* * *

It was no accident that Venetians should attach such importance to their library. Nor was this a cache of manuscripts only. A German, Johann von Speyer, along with his brother Wendelin brought printing to Venice in 1469. Charles VII of France sent Nicholas Jenson to Mainz in 1468 in order to explore the new invention. Impressed by what he saw in Germany, Jenson decided not to return home. Instead, he settled in Venice, where he set up a press and developed a new Roman-style font, still in use today. Although the city reluctantly surrendered its allegiance to the Gothic style, it embraced the new technology from the Rhineland with unmatched enthusiasm. "Venice was the first city in the world to feel the full impact of printing, and to experience the most important revolution in human communications between the development of letter symbols sometime in the fourth millennium before Christ and the emergence of electronic mass media in our own age."[2] At the turn of the century, Venice boasted 150 presses, many employing German workers. The printing industry burgeoned, producing books on a vast multitude of topics. Perhaps as many as half the books published in Italy in the 1500s were issued from this metropolis. It may not be a coincidence that Venetians were notably cool to the Church's *Index of Forbidden Books*: "The Roman Inquisition was admitted to the republic only on condition that Venetian laymen be included in all its deliberations."[3] Italians invented a new kind of type for the press. In place of the Gothic "black-letter," Poggio Bracciolini had adopted a script inspired by writing in the time of Charlemagne and characterized by rounded shapes.[4] Called Carolingian miniscule, it formed the basis of many fonts used today. In the form of "Roman" type, it replaced earlier forms that were less legible.

Aldo Manuzio, who opened his Venetian printing house in 1494 and adopted clear typefaces for his books, specialized in publishing classical Greek texts that had not previously been available to the reading public.[5] For example, he printed a five-volume edition of Aristotle in the original language, unencumbered by the commentary attached to his work in the medieval era. He also set a new standard for textual accuracy, attracting scholars of Greek to his home, including the Dutch man of letters Desiderius Erasmus, and conversed with them in the ancient language. Significantly, the scholarly Aldo's first publication was a Greek and Latin grammar. His development of a small format (and thus portable) book called the octavo, enhanced the affordability and dispersal of the printed word throughout Europe. For example, the Aldine press made available work by Erasmus, simultaneously a student of pagan Rome and Christian religion, who understood the potential of the press to open minds. A year before Luther launched the Reformation, Erasmus's edition of the New Testament in Greek was published (by Johann Froben in Basel), a turning point in printing history.

* * *

By locating St. Mark's Library at the very center of Venice, the authorities conferred upon it a status the Medici Library in Florence lacks. The Medici collection is stacked atop an already existing building. And although the interior is splendid, there's nothing remarkable about the exterior. By contrast, the library in Venice occupies one side of the city's main piazza, opposite the Doge's Palace and diagonally across from St. Mark's. Everyone who visits the Piazza San Marco becomes a witness to Sansovino's achievement.

The architect, who began his career in Rome restoring ancient statues for Pope Julius II, died in 1570 and did not live to see the building finished. Vincenzo Scamozzi completed the library in 1591, extending the building's length almost to the waterfront. Procurators used the added office space. Palladio, an admirer of the library, called it "perhaps the richest and most ornate building made since the ancients" (1:5).[6] Pietro Aretino, courtier, a man of letters and playwright, paid Sansovino the ultimate compliment: "You are the man who knows how to be Vitruvius." And the nineteenth-century art historian Jacob Burckhardt called the library "the most splendid work of secular architecture in modern Europe."[7]

In addition to his library, Sansovino also designed the adjoining mint, as well as the Loggetta, a gathering place for power brokers, next to the bell tower. Together these three structures completely changed the look of the city center. They created a consistency of design that Romans of antiquity would have

applauded. In fact, Andrea Palladio, who praised Venice as "the sole remaining exemplar of the grandeur and magnificence of the Romans," singled out Sansovino as "the celebrated sculptor and architect [who] first began to make known the fine style" (1:5). The nucleus created by this architect provided an impressive entry for visitors to the city's heart. Urban renewal had achieved unprecedented success.

NOTES

1 Deborah Howard, *The Architectural History of Venice*, revised and enlarged ed. (New Haven and London: Yale University Press, 2002), 177.

2 Martin Lowry, *The World of Aldus Manutius: Business and Scholarship in Renaissance Venice* (Ithaca, NY: Cornell University Press, 1979), 8.

3 Gary Wills, *Venice: Lion City, The Religion of Empire* (New York: Simon and Schuster, 2001), 343.

4 In *The Swerve: How the World Became Modern* (New York: W. W. Norton, 2011), Stephen Greenblatt writes, Poggio "was a superbly well-trained scribe, with exceptionally fine handwriting, great powers of concentration, and a high degree of accuracy" (32). Such skills, Greenblatt notes, began to decline with the invention of printing.

5 The printer was born Teobaldo Manuzio; his name has often been Latinized as Aldus Manutius.

6 *Andrea Palladio: The Four Books on Architecture*, trans. Robert Tavernor and Richard Schofield (Cambridge, MA: MIT Press, 1997). Citations designate book and page numbers.

7 Cited by Wolfgang Lotz, *Architecture in Italy, 1500-1600*, trans. Mary Hottinger (New Haven and London: Yale University Press, 1995), 85.

CHAPTER 30

GRIMANI PALACE, VENICE

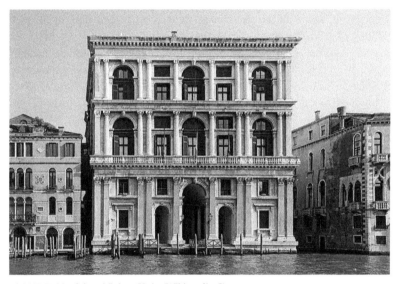

FIGURE 30 *Grimani Palace, Venice.* Wikimedia Commons.

Michele Sanmicheli designed this palace for one of the power brokers of Venice. Situated on the Grand Canal, it features giant pilasters, columns, and entablatures of the kind pioneered by the ancient Romans. We find a consistency of design rare in most other palaces of the time. Throughout the two upper levels, the windows are recessed behind arches and columns, which give the face of the building a three-dimensional aspect.

In addition to talent and training, Italian architects needed a willingness to travel. Commissions might come from anywhere, and those who made a living by designing buildings had to be prepared to move whenever the opportunity arose. Filarete traveled from Florence to Milan; Vignola from Rome to Caprarola; Luciano Laurana from Naples to Urbino; Giovanni Rucellai from

Florence to Pienza; Leonardo from Milan to Mantua and then to Venice. Even Michelangelo, renowned for his work in Rome, was summoned to Florence at the height of his career when the Medici family needed a façade for San Lorenzo as well as a new sacristy and library. Sometimes catastrophic events necessitated an abrupt change of locale. When the French seized Milan in 1499, Bramante departed for Rome. And when Spanish troops and German mercenaries devastated Rome in 1527, a wholesale departure of leading architects followed: Sansovino left for Venice, as did Serlio; Peruzzi for Siena; Michele Sanmicheli for Verona. Like a balloon deflated, the intelligentsia of Rome disappeared.

Sanmicheli's career was especially peripatetic. Born in Verona and sent to Rome at the age of fifteen for training, he took up an appointment as chief architect of Orvieto Cathedral in 1509 and stayed for eighteen years. Still later he worked for the papal states on his specialty—fortifications—which took him to innumerable towns and cities. He completed both ecclesiastical and military buildings in his hometown of Verona, among other assignments. Around 1530, he was hired to supervise the military architecture in Venice. Doge Andrea Gritti had convinced him that splendid opportunities awaited him in *La Serenissima*. Within two years, he became the most influential architect in the city. And while in the service of the Venetian Republic, he traveled extensively, including stints in Dalmatia, Corfu, Crete and Cyprus.

Unlike other Italian urban settlements, Venice had never been a Roman city in the manner of Florence, Milan and Bologna. Although Venice was situated near the mainland, its situation off the coast insulated it from developments on the boot of Italy. Venice, moreover, had a thriving commercial relationship with Constantinople, a locale with its own architectural and artistic traditions. The city on the north Adriatic therefore more slowly assimilated advances on *terrafirma* that found inspiration in classical Rome. The most innovative architects practicing their trade in Venice were not, in fact, natives; they came from other locations and brought their experience with them.

In 1556, Sanmicheli embarked on a prestigious project, a palazzo located on the Grand Canal. The property belonged to Girolamo Grimani, a procurator of Venice, one of the power brokers who ran the island state. When the architect arrived, he found his work cut out for him. Venice presented a multitude of challenges, including construction upon what had once been 118 islets and marshy shallows—land essentially reclaimed from the sea. Architects tackled the problem by driving timber piles into the mud, sand and silt. A row of horizontal logs was placed above, forming a basis for further construction.[1] Waterproof mortar and rubble filled the remaining spaces. (Renaissance

engineers rediscovered what the ancient Romans had invented: a concrete that would cure underwater.)

A much greater challenge was aesthetic. More than any other Italian city, Venice had been shaped by the legacy of Byzantium and the Eastern Empire. The Gothic spirit lingered longer here than in cities on the mainland. The single most imposing structure in Venice had been constructed in the Middle Ages: St. Mark's Cathedral. Originally built in 829 and rebuilt in 1063, it represents a composite of medieval origin: the façade draws inspiration from the Gothic; the bas relief looks Romanesque; the combination of domes and spires has antecedents in Byzantine design. The Doge's palace on the city's principal piazza also draws inspiration from the Gothic. It is not surprising, then, that when Sanmicheli arrived in Venice, he found homes of prosperous citizens featuring asymmetry in windows and balconies; pointed *ogee* arches (two opposing S curves that look like a boat keel); *biforate* windows (narrow and divided vertically); and stone *tracery* (holding stained glass panels) common in the Middle Ages. Strong vertical lines marked those homes, too, resulting from the need to exploit the available land. Buildings grew higher and were often topped with conical chimney pots, sometimes decorated. Venice remained a Gothic urban space well into the sixteenth century.

* * *

Sanmicheli's architecture differed from the design of palaces in Florence and other cities of the mainland, where the threat of lawlessness and incursion lurked. Venice was protected by its watery situation, especially the shallows of the lagoon, as well as by its substantial navy; 4,000 workers toiled in the shipyard. Sanmicheli's designs also differed from Palladio's achievement in the Veneto, whose villas typically occupied large estates. The Villa Barbaro and the Villa Rotonda, for example, were meant to be appreciated from afar before the visitor ever set foot inside. Substantial residences in Italian cities typically opened onto a piazza. By contrast homes and palaces in Venice were often situated along the Grand Canal, where gondolas tied up at the entrance and disgorged their passengers. The water of the lagoon lapped at the front steps.

Like Palladio, Sanmicheli had absorbed architectural practices developed in ancient Rome and revived in his day. (Antonio Sangallo the Younger trained him.) When he undertook the design of a palace for Girolamo Grimani, patron of art and architecture, he observed principles practiced by Bramante, Raphael, Sansovino, and Palladio, among others. The architect's ingenuity, however, chiefly found expression in the building's façade. The visitor sees only the

front rather than an entire building like the Medici Palace in Florence or Villa Rotonda in Vicenza.

Most substantial homes in Venice were not called palaces, as they are today. Instead, the more common word was *cà*, an abbreviation of the word for house, *casa*. And so you may visit, among others, the Cà d'Oro, Cà del Duca, and Cà Foscari. Only the *Palazzo Ducale* next to St. Mark's Cathedral retains the formal term. The home that Sanmicheli designed for the Grimani family, however, deserves to be called a palace on account of its size, opulence, and beauty.

At first glance, the Palazzo Grimani looks like a structure of three floors. Actually, each is subdivided in two vertically, an arrangement concealed by giant pilasters, columns, and entablatures. The palace, then, actually contains six floors. The façade of each level has five bays. In the middle, a triumphal arch frames the entrance. Much smaller arches flank it, creating a triple (Serlian) pattern. Supporting the entablature above the ground floor are tall grooved pilasters: one on either side of the chief entrance, two on the outer side of the smaller arches, and then, finally, two more at both ends. The assemblage of ten giant pilasters, topped with Corinthian capitals, creates a sense of massive solidity, appropriate for an architect who had made his reputation as a military engineer.

The *piano nobile*, with a continuous balustrade across its width, is not so tall as the ground floor. Some observers have suggested that Sanmicheli intended the second story to be higher but died while the work was ongoing. Giangiacomo de' Grigi took over, perhaps changing the original dimensions. Others have suggested that Sanmicheli planned a two-story structure all along. Most Venetian palaces on the Grand Canal, however, had three levels, not two. And the triple-decker façade compared favorably with other celebrated homes of that time and place. Deborah Howard has suggested that "as originally designed, the palace would have been even taller, but the height of the upper two storeys was reduced after Sanmicheli's death."[2]

The second and third floors are virtually identical, the middle and end bays characterized by Roman arches; a carved face looks out from the keystone of each. The intervening bays consist of rectangular compartments, each featuring windows. Fluted-engaged columns rather than pilasters divide the compartments, though a single-fluted pilaster stands at both ends of the upper floors. Corinthian capitals top all the columns, which are aligned vertically. The three stories have a consistency rare in other Venetian palaces. Throughout the two upper levels, the windows are recessed behind arches, pilasters, columns, and entablatures, which give the face of the building a three-dimensional aspect. A prominent cornice surmounts the façade.

An inexpensive vaporetto ride offers the best view of the palace; boats provide the watery equivalent of a bus, cheap and efficient. The visitor enjoying the prospect from the Grand Canal will be struck by the expanse of windows on the *piano nobile* and the floor above it. Their size would have impressed Sanmicheli's contemporaries, too. Such windows were desirable, even necessary because Venetian palaces did not normally have large interior courtyards permitting the illumination of rooms within. (The Palazzo Grimani has a courtyard toward the back, far from the Canal.) Rooms with exterior walls could be fitted with windows, but the densely packed buildings along the Canal did not allow for an expanse of windows along the sides of most palaces, which tended to be plain. The central galleries used for receptions and entertainment in long narrow rooms, therefore, depended on light entering from the façade.

What sets the Palazzo Grimani apart from most other such structures is the site itself, irregular in shape and more closely approximating a trapezoid than a rectangle; it narrows toward the back. One side (with a service entrance) borders the Rio di San Luca, a waterway intersecting the Grand Canal. The front of the property lies at an oblique angle to the building behind it. This arrangement accounts for the asymmetrical layout of the interior despite the symmetry of the façade. Behind it, we find a three-arched atrium framed by paired columns. Eminently practical, it provides an intermediary space between the Canal façade and the room that dominates the ground floor. The atrium helps disguise the fact that the central entrance is not aligned with the building behind it. That is, most of the palace is not perpendicular to the façade. As the Gothic style finally surrendered to new expectations, symmetry became more important than it had been since antiquity.

Because of his death in 1559, Sanmicheli did not live to see the completion of his palazzo. Giangiacomo de' Grigi continued work on the second story, and, after his death in 1572, Gian Antonio [Giovanni] Rusconi took over the project, finishing in 1575. And what did people think of the three architects' achievement? Sanmicheli's son, Francesco, admittedly not a disinterested observer, in 1581 wrote that four palaces on the Grand Canal—including the Grimani palace—were so brilliant that the ancient Roman master would approve: "These for the size of their circumference, for height, and for every other quality that is required by a harmonious edifice, were made in our times, and according to the doctrine of the ancient Vitruvius, from whose rules the best Architects are not permitted to depart."[3]

John Ruskin, the Victorian art critic who much preferred Gothic to Renaissance style, nevertheless conceded that Sanmicheli's Palazzo Grimani achieved greatness: "There is not an erring line, nor a mistaken proportion,

throughout its noble front; and the exceeding fineness of the chiselling gives an appearance of lightness to the vast blocks of stone out of whose perfect union that front is composed."[4] Like Ruskin, almost everyone who visits Venice falls under the city's spell. I know of no other urban location where wandering without a map offers so much to gratify the senses. Don't worry about getting lost. The city is not large, and a delight awaits around every turn. If you need help, you will find most locals kind.

You may, as I did, detect a whiff of decay, but it is balanced by the ceaseless endeavor to preserve the past. (Nicholas Roeg's *Don't Look Now*, my favorite film, is set in Venice, where the chief character played by Donald Sutherland restores church mosaics.) Whenever visiting this city on the lagoon, I have taken a childlike delight in the buildings, boats, water, and sky. The combination allows for an experience at once exciting and restful.

* * *

On the day I saw the Palazzo Grimani, I decided to cap off my experience with a drink at the café opposite the Doge's palace. I needed to relax and think about what I had seen. As the sun went down, I watched fellow Americans taking gondola rides, artists painting St. Mark's façade for tourists, and others sketching the likenesses of visitors, providing them with souvenirs. The merchandising epitomized the energy of a city that from practically its earliest days became a capital of commerce. And that, in turn, allowed Venice to thrive as a magnet for artists and architects. Surrendering to the panoply of light and color, I said to myself, this is glorious.

Enjoying the setting sun, I thought about the indispensable asset of Venice— its location. Surrounded by water, the city benefits hugely from the images reflected in its canals, and its fluid palette. Depending on the time of day and the configuration of clouds, these shapes alter markedly, water and light sometimes collaborating, sometimes not. As I relaxed in the piazza, I thought of the satirist Pietro Aretino, who came to this city in 1527, savored the atmospheric effects, and described to Titian the clouds he saw: "I was astonished at the various colors which they showed. Those near at hand burned with the flames of the sun's fire, while those in the distance had the dull glow of half-molten lead. Oh, with what clever strokes the paint brushes of nature gave perspective to the very air, withdrawing it skillfully from the palaces just as you, Titian, make it draw backward in your landscapes."[5]

Encompassed by the constantly changing gradations of light, generated by water in the canals and moisture in the air, Venetians developed a visual

sensitivity second to none. No wonder some of the most brilliantly colored paintings of the Renaissance originated here. Italians did not invent the medium of oil painting, which offered a richness and intensity of color and a painstaking realism denied both to frescoes made on damp plaster and to tempera painting (powdered pigments mixed with a binder like egg yolks and water and applied to panels or canvas; the word comes from the Latin term for "mix."). The problem of buildings literally sinking into the sea also made frescoes a liability, for their plaster always risked cracking. Giorgio Vasari credited the invention of oils to the Flemish master Jan van Eyck, who mixed linseed oil and the oil from nuts to achieve a mixture necessary to transfer pigment to a panel or canvas. Even though Vasari was mistaken, Bellini, Carpaccio, Giorgione, Veronese, Titian, Tintoretto, and other denizens of Venice developed a love of color that issued in oil paintings of stunning effect. In contrast to frescoes, individual paintings had a particular advantage: they could be painted slowly and carefully on canvas or wood. They could be altered as the need arose. And they were portable. Connoisseurs collected them to celebrate their families and to decorate their homes. The age of great portraiture had arrived.

If the nucleus of Renaissance creativity shifted from Florence to Rome with the French invasion of Milan and the subsequent arrival there of Bramante, it shifted again with the Sack of Rome. Venice offered physical and psychological distance from ruined Rome. The city on the Adriatic welcomed artists and architects from the rest of Italy. And it enjoyed political leadership that rewarded artistic brilliance rivaling that of the mainland. Sanmicheli, Sansovino, Serlio, and Palladio were all beneficiaries of the profound shift in cultural capital.

NOTES

1 See Giovanni Distefano, *How Was Venice Built?* rev. ed. (Venice: Supernova, 2023), 15–23.
2 Deborah Howard, *The Architectural History of Venice*, rev. ed. (New Haven and London: Yale University Press, 2002), 184.
3 Cited by Tracy E. Cooper, *Palladio's Venice: Architecture and Society in a Renaissance Republic* (New Haven and London: Yale University Press, 2005), 43.
4 *The Stones of Venice*, ed. J. G. Links (New York: Hill and Wang, 1960), 233.
5 "Sunset in Venice. To Titian," in *The Letters of Pietro Aretino*, ed. Thomas Caldecot Chubb (Hamden, CT: Archon Books, 1967), 196.

CHAPTER 31

IL REDENTORE, VENICE

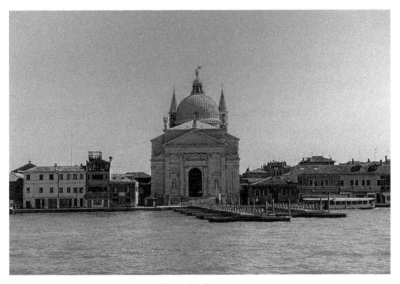

FIGURE 31 *Il Redentore, Venice.* Wikimedia Commons.

This is Andrea Palladio's most famous church, designed to celebrate the city's release from the plague. What marks the exterior is a series of pediments superimposed upon one another. Although the arrangement seems complicated, the repetition of triangular forms ensures coherence. Each pediment reinforces the pattern of the others. They have cumulative force.

Palladio's church, known formally as the Church of the Most Holy Redeemer, is usually called by its Italian name *Il Redentore*. The Venetian Senate commissioned the structure to commemorate the deliverance of the city from plague in 1575–1577, when nearly a third of the population died. The Senate stipulated that the Doge and members of the Senate, with the monks of San Marco, should visit the church on the third Sunday in July each year, offering thanks

to God for ending the epidemic. The Redentore, consecrated in 1592, became the destination of an annual procession, which crossed to Giudecca Island on a pontoon bridge. Construction of the church was completed in the unusually short span of fifteen years.

The site is particularly well chosen—in view of the Piazzetta San Marco. Meant to be seen from the water, the Redentore rises high from its base and towers over adjacent structures. From the front, the church seems compact; in fact, it looks much like a central-plan structure, which Palladio wanted to build. (His mentor Marc'Antonio Barbaro supported this preference.) But the Senate rejected his proposal. A rectangular plan was deemed the optimum arrangement for long processions that would culminate inside the building every summer.

* * *

A flight of fifteen steps leads from the quay up to the entrance, a pair of tall doors surmounted by a semicircular Roman arch and a small triangular pediment above it. The doorway, flanked by a single colossal pilaster and engaged column on either side topped with Composite capitals, has a spare look. Two niches with statues (Saints Peter and Francis) adorn the façade. Pure white Istrian stone intensifies the simplicity of design. (The main exterior of the church consists of red brick, a much cheaper material and a useful substitute for stone in a city lacking a quarry.)

A pediment many times larger than that above the doorway below tops the façade, but, like the small one beneath, it contains no image in the tympanum. The façade announces the overall pattern confronting the visitor: a series of overlapping pediments.[1] In addition to that of the temple front, there seems to be a second behind it, partially obscured, wider but not so high; the design is called a *broken pediment*. And perched above is yet another triangle, built at an angle as part of the roof sloping backward; this projection is known as "hipped." Finally, still another pediment, mostly hidden by the architectural forms in front of it, seems to belong to the principal wall of the church; it stretches across the entire width. In total, then, the façade consists of no fewer than five triangles.

Although this interlocking arrangement may sound impossibly complicated, the repetition of triangular forms ensures coherence. Each pediment reinforces the shape of the others. Together, they have cumulative force and render this façade more impressively unified than Palladio's earlier church on the Giudecca Canal, San Giorgio Maggiore. For that matter, the spectacular façade has a cohesiveness more nearly complete than that of Santa Maria Novella in Florence, Sant'Andrea in Mantua or St. Peter's Basilica in Rome.

* * *

Rising over the array of pediments, a high, hemispheric dome dominates the site. A lantern sits above and, finally, a statue of Christ the Redeemer, his right arm outstretched, his left holding the banner of the Resurrection. Two slender round towers, made chiefly of red brick, frame the white dome and extend the vertical line of the columns and pilasters on the façade below. Islamic architecture probably inspired them; Venice had a long history of commerce with Constantinople and Arabia. Many years earlier, moreover, Bramante had proposed towers for the new St. Peter's. Such towers were actually attached to the basilica early in the 1600s by Gianlorenzo Bernini, who constructed them on bases earlier made by Carlo Maderno, his predecessor as chief architect. This scheme would prove Bernini's greatest blunder. Inadequate foundations and underground water undermined them. They had to be dismantled. Antonio da Sangallo the Elder also planned four towers for his Greek-cross church of San Biagio (begun 1518, consecrated 1529), outside Montepulciano, though only one was built, leaving the ensemble unbalanced.

Resting atop a deep drum, Il Redentore's dome ensures a flood of light into the interior. The combination of white stone and whitewashed stucco redoubles the brightness. Palladio had strong feelings about this effect: "Of all the colors none is more suitable for temples than white, because purity of color and life would be supremely pleasing to God" (3:217). The interior capitals and entablature are pale gray, introducing a subtle contrast. In this respect, he differed from many contemporaries in the city who favored bright colors. Because Venetians were not as attracted to frescoes as their counterparts on the mainland (high humidity was not suited to painting on a wet plaster base), we don't find here the profusion of wall paintings typical in other Italian churches. No distraction prevents the eye from moving upward. Engaged columns and pilasters with Corinthian capitals seem to support a cornice all around the interior. Only abbreviated transepts appear on either side of the central crossing, and they are curved not rectangular. Side aisles are conspicuously absent. The interior consists of a wide nave beneath a barrel-vaulted ceiling. Three shallow chapels on either side of the central space admit plenty of light. (The windows, incidentally, were made on the nearby island of Murano, renowned for its glass manufacture and still open to tourists today.) No private memorials or graves obscure the public purpose of this votive church. Capuchin friars, whose residence occupied the site, pledged to look after the building. A reformed branch of the Franciscan order, they sought to restore the principles of their founder; they valued spare simplicity and minimal decoration. Although they were initially cool to Palladio's plan and complained of its "magnificence," Pope Gregory XIII thought otherwise,

perhaps because the church represented not just a particular religious order but the state of Venice itself. (In contrast to other churches, including Palladio's nearby San Giorgio, no organ was installed until modern times; the austere Capuchins had little interest in music.)

Beneath the dome lies the chancel, with the principal altar, focus of ceremony at the annual festival. The Doge, along with his council and other dignitaries, crowded into the space. On one side is the nave, on the other side, the area corresponding to the head of a Latin cross, reserved for the clergy and, in many churches, often set off with a rail or screen. There are, then, three distinct areas in the Redentore, each set off by steps. Although technically a cruciform church, the transepts are minimized, a concession to Palladio's enthusiasm for central-plan structures. And the four columns separating chancel from choir form a graceful curve, not a conventional straight line. Together they enclose the chief altar in a space on the verge of becoming a circle.

To allow congregants, a direct view of the priest at Mass, Palladio located the monks' space behind the altar. Because of its placement there, this spartan area is sometimes called a *retrochoir*. Monks customarily sang their office, and the term gradually evolved into its modern meaning, a group of singers. Locating the space in back of a semicircular colonnade on the far side of the altar, Palladio diminished the clergy's prominence.

Almost certainly Palladio was inspired by changes brought about by the Reformation and by the Church's strategy to deal with its challenge. The Council of Trent, which met intermittently over a period of eighteen years (from 1545 to 1563), mandated that nothing should separate the celebration of Mass from worshipers. By bringing the congregation close to the priest, the architect enhanced the individual's connection with the consecration of bread and wine and implicitly downplayed the intermediary of Church hierarchy. The high altar was also suitable for public display of an important relic, a fragment of the True Cross. Palladio's patron Daniele Barbaro, a member of the clergy, was a Venetian delegate to the Council of Trent, convened to address the challenge of the reformers, and the architect joined him there on at least one occasion. Palladio did not live to see Il Redentore finished; Antonio da Ponte completed it.

Although I much prefer the Redentore to Palladio's other nearby church, San Giorgio, there are two good reasons to take a vaporetto across the Grand Canal from the Piazzetta San Marco and visit the latter, situated at the end of Giudecca Island. First, this site sometimes sponsors spectacular exhibitions. One year, I happened upon a vast collection of Renaissance engravings based on Italian paintings. It was through the circulation of such prints that people

all over northern Europe were able to see reproductions of Italian art and architecture otherwise inaccessible to them. Second, San Giorgio has a tall bell tower equipped with an elevator. From the top, the visitor gains a spectacular overview of the entire city, perhaps the very best available. A word of caution, however: be careful not to visit the tower on the hour. When the bells sound, ears of nearby listeners will ring for days.

NOTE

1 There were classical precedents for this feature, including the Pantheon: "One pediment is on the portico, the other on the wall above and behind it" (Robert Tavernor, *Palladio and Palladianism* {London: Thames and Hudson, 1991], 65).

PART V

GARDENS

CHAPTER 32

VILLA D'ESTE GARDEN, TIVOLI

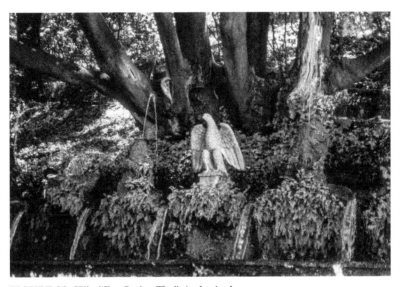

FIGURE 32 *Villa d'Este Garden, Tivoli.* Author's photo.

This is the grandest and most accomplished of Renaissance gardens in Europe. It was planned by Pirro Ligorio for the Cardinal of Ferrara. The plan depends almost entirely on stories drawn from ancient mythology. A colossal statue of Hercules once stood in the garden. Much of the sculpture has vanished, but what remains is an extraordinary collection of fountains in the form of reflecting pools, sprays, and cascades. More than 1600 feet of underground pipes distribute water that connects the various parts of the garden.

The Villa d'Este began life as a consolation prize. Its origins lay in the contested struggle for the papacy when Paul III died. Competing factions, each determined to elect its own candidate, brought about a stalemate. The conclave to choose a successor lasted ten weeks in 1549–1550; electors cast sixty-one ballots. Among the participants was Ippolito II d'Este, Cardinal of Ferrara, who from an early age was marked for success, becoming bishop of Milan at the age of ten and cardinal at thirty. Given his wealth and connections (he was the son of Lucrezia Borgia), he emerged a credible candidate for the Church's highest office but was judged inordinately ambitious. The cardinals eventually settled on a compromise, Giovanni Maria del Monte, who took the name Julius III. (He would create something of a scandal when he appointed to the College of Cardinals a handsome fifteen-year-old, who took charge of the pope's pet monkey.) Because of Ippolito's support, the new pope met with him and named him lifetime governor of Tivoli, a town twenty miles east of Rome and favorite summer retreat of popes. There he would build a princely residence and garden.

Although Ippolito's entry into Tivoli was accompanied by considerable pomp, what he discovered there was not initially promising. He deemed unsuitable the official residence assigned to him, the site of a former medieval monastery. It was not nearly large enough to accommodate his household. He wanted a substantial home befitting his status and providing room for entertaining guests. Accustomed to luxurious surroundings, he set out to recruit the finest artists and artisans. He had his choice of architects to transform the site into a splendid villa and design a complementary garden. To supervise the project, Ippolito selected the antiquary, architect and mapmaker Pirro Ligorio, already excavating the nearby villa of Emperor Hadrian. From about 1555 to nearly his death in 1583, the architect fashioned his masterpiece, the most spectacular surviving garden of the Renaissance. No previous gardens in Italy possessed the combination of features that found expression in Tivoli. Because ancient gardens had disappeared and few written accounts of them survived, there were scarce strictures to limit Ligorio's imagination. He conceived a garden larger in scale and more ingenious in concept than anything since the fall of Rome.

When I first visited Tivoli, camera in hand, I set about recording what I saw. Trying to capture the look of the abundant greenery, I found myself flummoxed. I simply could not get a photo of the foliage without encountering masonry in the form of staircases, fountains, ramps and terraces. Walking through the garden, I gradually realized that the greenery was not meant to be viewed in isolation. I expected flowers, grass, perhaps a stream, a stand of trees—in other words, a modern garden. What confronted me at the Villa d'Este was altogether

different. I had never experienced anything like this. My challenge was to figure out what I was looking at.

The villa itself is known chiefly for its frescoes. The walls are adorned with pictures of Greek philosophers, the story of Hippolytus, a synod of the classical gods, personifications of Wisdom, Charity and Patience, among others, and a host of mythological figures. Most paintings were made by Girolamo Muziano, some by Federico Zuccari. They contain only a few Christian subjects (e.g., the celestial crowning of Mary). Perhaps the most interesting fresco is Muziano's 1567 rendering of the estate, for it depicts Ligorio's garden when new.

<p align="center">* * *</p>

High walls surround the site, built onto a fairly steep hillside, measuring 148 feet from top to bottom. I began on the large terrace next to the villa and surveyed the garden stretched out below me. Looking downward, I found the design obscure. Moving through it, I needed to use zig-zag ramps and staircases to accommodate the steep grade; where they led was not always clear. Repeatedly having to make decisions about my direction, I finally recognized the overall scheme deriving from mythology: the choice of Hercules. According to Greek legend, the classical hero had to decide between the path of virtue and the path of pleasure. Here one route leads to the grotto of Diana, goddess of chastity, while the other leads to the grotto of Venus, goddess of romantic love. Choosing the former course, Hercules was able to seize the golden apples of the sun from the Garden of the Hesperides. The garden was protected by dragons identified with vigilance because they did not sleep. In the Fountain of the Dragon here, the four-headed creature rises from the center of an oval pool. Appropriately, the cardinal's coat of arms consists of golden apples, symbols of virtue held by an eagle, as well as the image of a dragon. A colossal statue of Hercules once stood in a niche behind the fountain.

What supports the connection between Greek hero and the Este estate? The cardinal's family liked to imagine Hercules, traditionally identified with heroic virtue, as their legendary ancestor. The garden, then, suggests a parallel between Greek hero and Italian clergyman. Flattery takes physical form.

Hovering behind this and other sixteenth-century gardens was the prospect of Arcadia, a mythical landscape celebrating a secluded, rustic world and its inhabitants, especially shepherds, who tended their flocks, sang, wrote poetry and lived in harmony with an idyllic setting. Neither ambition nor envy finds a place here. Predicated upon a concept of nature as a site where humankind finds not just beauty but also refuge, even a kind of therapy, Arcadia evoked

a lost realm, perhaps the Golden Age itself. And so a misty nostalgia clings to its representations, whether in poetry, drama or art. This secular world was conceived before the advent of Christianity. In fact, the pastoral mode seems to have originated with the poetry of Theocritus, who lived in Sicily when it was a Greek colony; the name Arcadia is itself a district of Greece. Romans embraced the concept: Virgil's *Georgics* has a practical emphasis, not only celebrating agriculture and animal husbandry, but also idealizing the life of shepherds: "Happy [...] is he who knows the rural gods, Pan and aged Silvanus and the sisterhood of the Nymphs."[1] Because it found its origins in classical culture, the Arcadian landscape typically featured images of the ancient gods, who represented natural powers. A pagan Eden, Arcadia was the home of Pan, depicted with the hooves and ears of a goat. He was associated with fertility; his name means "all." Woodland nymphs adopted him as a youth. Henceforth he kept company with satyrs, who had the lower bodies of goats, symbols of sexuality. All such woodland creatures represented primal energies.

Pirro Ligorio's fascination with antiquity expresses itself most obviously in the Rometta, or little Rome, a schematic re-creation of the classical city. Structures in this Fountain of Rome, made of brick covered with stucco, originally included miniature versions of the Pantheon, Colosseum, columns of Trajan and Marcus Aurelius, and triumphal arches. Sites were grouped so as to suggest the seven hills of Rome. Many parts, however, were lost in the nineteenth century when a retaining wall collapsed, and some of what remained was demolished. Still prominently situated here, however, is a stone vessel with an obelisk mast, representing Tiber Island, which has the shape of a boat; it was the site of a temple sacred to Aesculapius, Greek god of healing. Also prominent in the Rometta are statues of Romulus and Remus. According to legend, these twin sons of Mars and Rhea Silvia (descendant of Aeneas) were abandoned in the Tiber, washed up at the future site of Rome, and found by a wolf, who suckled them. They eventually became founders of the city. The helmeted figure of a seated woman, with short sword and scabbard on her lap and holding an upright spear, presides over the Rometta. This sculpture has been identified as personified Rome and as the goddess Minerva. A similar figure, with the same double identity, occupies a central place in Michelangelo's Campidoglio.

A leisurely stroll through the garden reveals the general scheme, a space divided in two by a central axis from top to bottom. Cross-axes at right angles intersect this demarcation at intervals. Walking downward from the villa, I encountered terraces, statuary, fish ponds, and fountain niches. Despite the complexity of design, the garden must have been substantially finished by

September 1578, when Pope Gregory XIII visited. Most, if not all, of the fountains worked. (The cardinal hired Tommaso Chiruchi and Orazio Olivieri to oversee the hydraulic engineering.) People exclaimed over the waterworks, which were even more extravagant than they are now. The French essayist Michel de Montaigne remarked on water flowing with great force into the reflecting pools, producing "a thick and continual rain falling into the pond." Jets of water originally shot up near the fishponds, creating a mist. In the 1580s, Montaigne observed that it produced "a rainbow so natural and vivid that it lacks nothing of the one we see in the sky."[2] Elsewhere inconspicuous controls allowed visitors to release a hidden spray and surprise the ladies. Italians call the devices *giochi d'acqua*. Such pranks passed for amusement in more innocent times.

To ensure a plentiful supply, Cardinal Ippolito diverted the course of the River Aniene, a tributary of the Tiber, and built a tunnel 3,200-feet long through the city; it was said to distribute 300 gallons per second.[3] More than 600 feet of underground pipes dispersed the water connecting various parts of the garden: it trickles from fountains, jets skyward, and cascades in a waterfall. Water takes sculptural form at the Villa d'Este, some of it channeled into rectangular ponds, which stretch across the main axis of the garden, compartments of water rather than foliage. These pools ensured a supply of fish as well as water fowl. The Avenue of the Hundred Fountains, which also runs along a cross axis for almost 300 feet, consists of a vast series of small fountains, each in triple formation, one above the other. Ornamenting the display are symbols of the Este family: eagles, obelisks, and boats. Overgrown ferns and moss now conceal what remain of the original ninety-one terracotta plaques depicting scenes from Ovid's *Metamorphoses*. Beneath them visages of beasts spout water. At either end of a trough below the fountains, enlarged mouths of what look like giant faces swallow the water.

Perhaps because of the cardinal's interest in music, the largest and most impressive of the garden's fountains is that of Nature, containing a water organ. The Frenchman Luc LeClerc designed this hydraulic device, completed by his nephew Claude Venard. Located within a small arched pavilion, it forms the site's centerpiece. The mechanical device worked by using water to force compressed air through pipes, producing sounds. Reportedly the fountain could play madrigals. During his visit in 1572, Pope Gregory XIII insisted on looking inside to see whether a musician was actually playing the music.

As well as pleasing the ear, the two-story fountain delights the eye by its extensive program of statuary and stuccowork, some of which was added during reconstruction in 1609–1615. Niches on the lower level contain freestanding

statues of Orpheus, who played a lyre so well that he could charm animals and trees, and Apollo, whose proficiency on stringed instruments (ancient kithara, Renaissance àern or violin) was legendary. On either side of them stand pairs of large male *herms* with arms folded; they seem to support the second story.

By its immense size in width and height, the Fountain of Nature dominates its section of the garden. An imposing masonry arch protects the machinery below that once produced sounds. And it concealed the source of water necessary for the various parts of the fountain to work. The upper level continues the program created on the lower. Instead of herms, we see four (much smaller) caryatids with spiral legs. Between each pair are plaques executed in stucco: one depicts Apollo's musical contest with Marsyas, the other, Orpheus entertaining wildlife. Just above the masonry arch, two figures of winged Victory (not part of the original fountain) rest. A giant corbel separates them, and a white eagle, marker of the Este clan, perches above. Not surprisingly, this particular fountain has generated imitations in other countries.

The same Este eagle tops the Fountain of the Owl, located on the opposite side of the garden and ensconced within a niche bordered by Ionic columns; they themselves are decorated with the golden apples of the Hesperides. Within the Owl fountain Luc LeClerc created twenty painted bronze birds that sang, thanks to piped water and air. When a large mechanical owl hooted, all the birds ceased their song. (Aviaries became a feature of such venues.)

Early visitors saw a somewhat different garden. In 1582, an intruder searching for tin he intended to sell vandalized the site. Then the villa was, in effect, abandoned in 1586 after the death of Cardinal Luigi d'Este, a nephew who had succeeded Ippolito. Agents of the d'Este family made off with numerous sculptures. Rome's Capitoline Museum preserves some of them. Neglect gradually dimmed the garden's attractions.

Beginning in 1605, Cardinal Alessandro d'Este, Dean of the College of Cardinals, took possession of the property and sought to restore what he found. In the years 1609–1615, the Cardinal altered the Fountain of Nature, repairing the water organ. Originally a statue of the multi-breasted Artemis of the Ephesians (Roman Diana) stood before the fountain, water issuing from her breasts. Referred to as Nature in villa documents, this personification wears a garment bearing images of young animals. The Flemish sculptor Gillis van den Vliete, working from a Roman original now in Naples, created the famous statue. The Cardinal moved it to a less conspicuous location, probably because he found her overt sexuality disturbing. She was replaced by an octagonal domed pavilion, designed by Gianlorenzo Bernini, which

now shelters the source of sound. (This fountain is today often referred to, inaccurately, as the fountain of the organ.)

The visitor's experience of the garden must have been quite different when it was new. The base of the hill furnished the original entrance; today visitors enter the garden from the terrace adjoining the villa. Three stepped ramps, arranged in parallel, allow ascent from the middle of the garden upward; the climb on the forested slope must have been difficult for many. As compensation each step on both sides of the ramps had a pedestal on either side; small jets of water flowed from the mouths of grotesque masks into little basins beside the next step down. The parade of fountains has become known as the Stairs of the Bubbling Fountains.

A fresco situated in the villa's *salotto*, or communal dining hall, depicts the newly planted trees and shrubs in evenly spaced, discrete rows, an ancient practice: on the upper section, close together; on lower sections, farther apart. The plantings have, of course, become denser as the garden matured. Such is the fate of gardens and their contents. Necessarily ephemeral, greenery changes from one day to another.

Components made by human hands are ever subject to alteration, too. Some of the garden's original features no longer exist. We know from an engraving made by Étienne du Pérac in 1573 that originally a pergola occupied the lowest section of the garden. A bird's-eye view shows two such tunnels meeting at right angles, forming a cross-pergola. At the center, a domed octagonal pavilion supplied both a shady retreat and privacy on summer days. The cross-pergola divided this section of the garden, planted with herbs, into four squares, each with its own little pavilion at the center. Cypress trees replaced the pergola by 1611. Also gone are the labyrinths that flank both sides of the pergola in du Pérac's engraving, each taking the form of a square. (An engraving is made with a burin pushed across a metal plate. A printing press, when inked, duplicates the original design on paper.)

An even greater loss are the ancient statues that once adorned the garden, some of them filched from Hadrian's nearby villa, some purchased in Rome. Montaigne particularly admired the statuary, which included four emperors who had built villas in the area: Caesar, Augustus, Trajan and Hadrian. At the center of the garden stood the colossal figure of Hercules, removed in the eighteenth century. Statues formerly at the Villa d'Este now adorn museums all over Europe. Still in place, however, is Pegasus, winged horse of classical mythology that, taking off from Mount Parnassus, caused the spring Hippocrene (literally, spring of horses) to issue from its hoofprints; this source of water became the fountain

of the Muses. Does the fountain suggest a likeness between Parnassus and the hill of Tivoli, where the cardinal surrounded himself with men of letters?

The Villa d'Este garden differs from today's counterparts in the assumption of its maker that it represents an extension of the house: the central axis of this garden aligns with the center of the villa above. Unlike Raphael's unfinished garden at the Villa Madama, Ligorio's, created about fifty years after the painter's death, has a design that clearly subordinates constituent parts to an overall plan. In other words, it is the horticultural equivalent of stage sets by Sebastiano Serlio, who specialized in three-dimensional perspectives. At their best, Renaissance gardens were not merely collections of plants. They were compositions, orchestrations.

* * *

Makers of Renaissance gardens were typically architects. What follows from this? If symmetry characterizes the house, then it must define the garden as well. If the house finds its basic forms in geometry, then so must the garden. If the design of the house proceeds from mathematical calculation, then so must the garden too. Behind and beneath its unruly appearances, the natural world, properly understood by architects, was based on mathematical precision. Numerical ratios and geometric figures revealed the essence of reality. We may not think of mathematics when we envision nature, but Renaissance planners, preoccupied with geometry, did. Seen from above, the entire Villa d'Este garden reveals itself as a series of contiguous squares.

In its combination of natural forms and those fashioned by workmen, the Villa d'Este garden embodies a favorite Renaissance topic: the relationship of nature and art. Ambiguity clings to such representations, for we may choose to see them either as rivals or allies. We may also imagine that relationship as neither competition nor collaboration but as an inherently unstable equilibrium, capable of tilting in one direction or the other depending on the skill and purpose of the designer. However we conceive of it, the Renaissance garden works its magic by a combination of greenery and masonry.[4]

Perhaps the most famous literary treatment of the topic appears in *The Winter's Tale* by Shakespeare, when two characters argue. Perdita, costumed as Flora, goddess of flowers, will not allow hybrids in her garden because they are impure, she thinks, tainted by the intervention of the gardener. The king challenges her, arguing that the art of the gardener improves the wild stock of plants, and so, he assures her, we need not assume a conflict between nature and art. Thanks to the gardener, they interact. The relationship between the two,

then, may be interpreted as symbiotic, a fruitful competition that evolves into profound reconciliation.

Because many of the smaller fountains at the Villa d'Este are now dry, a faint air of neglect makes itself felt. Many of the 500 fountains, powered by gravity, have not seen water in a very long time. Throughout Italy—and Europe generally—Renaissance gardens have suffered drastic change, obscuring their original design. Few survive intact. Fashion changes constantly, and in the mid-1600s, the precision of the Renaissance garden began to lose its appeal. John Milton's *Paradise Lost* registered the transformation in his description of Eden, where streams "fed / Flow'rs worthy of Paradise which not nice Art / In Beds and curious Knots, but Nature boon / Pour'd forth profuse on Hill and Dale and Plain" (IV.240–43).[5] "Nice" here means fussy, showy or fastidious. The term "knot gardens," widely used in England, designates the low-growing geometric designs long enjoyed on the Continent.

Changing taste has done more to ruin Renaissance gardens than all the civil unrest and warfare over the past four hundred years. In the name of "modernity," the features characterizing Tivoli were gradually sacrificed elsewhere to broad vistas and vast expanses of grass. Adapting to the times has had the effect of obliterating the excellence of the original without replacing it with anything nearly as impressive. Because many artifacts and gardens in Italy, including Tivoli's, suffered bomb damage during wartime, it seems astonishing that so much here has been preserved so well for so long. My journal entry reads: "The combination of over all design and the excellence of individual parts disarms criticism. It's all quite magnificent."

NOTES

1 Virgil, *Eclogues, Georgics, Aeneid I–VI*, trans. H. Rushton Fairclough, revised by G. P. Goold, Loeb Classical Library (1935; repr. Cambridge, MA, and London: Harvard University Press, 1999), 171.

2 *Travel Journal*, in *The Complete Works of Montaigne*, trans. Donald M. Frame (Stanford, CA: Stanford University Press, 1957), 963.

3 Judith Chatfield, *A Tour of Italian Gardens* (New York: Rizzoli, 1988), 198.

4 See "The *Paragone* of Art and Nature in the Renaissance and Later," in John Dixon Hunt, *A World of Gardens* (London: Reaktion Books, 2012), 113–29.

5 *Paradise Lost*, in *John Milton: Complete Poems and Major Prose*, ed. Merritt Y. Hughes (New York: Odyssey Press, 1957).

CHAPTER 33

VILLA LANTE GARDEN, BAGNAIA

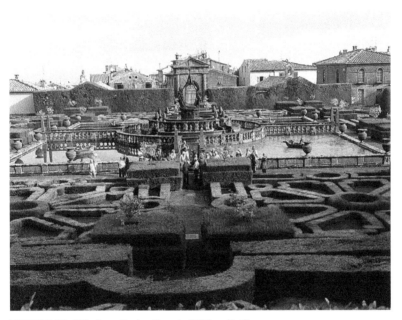

FIGURE 33 *Villa Lante Garden, Bagnaia.* Wikimedia Commons.

This is the gem of Renaissance gardens, laid out on a hillside belonging to a church prelate who had deep pockets. It consists of a series of fountains depicting the history of humankind from the Great Flood to the present day. The garden, divided into a series of geometrical forms, extolls the panoply of classical mythology.

Sixty miles north of Rome in the little town of Bagnaia lies the gem of Renaissance gardens. In 1568, Cardinal Gianfrancesco Gambara, bishop of Viterbo, decided to build a new summer residence in the countryside. Construction began soon afterward. Two identical cubic structures were planned for the lower section of the property. Called in Italian *casinos*, they would provide shelter for the cardinal and his staff. Eminently simple in form and situated on either side of the garden's central axis, they were made at different times. Although one was early constructed for Cardinal Gambara, its twin suffered a delay. Pope Gregory XIII, learning of the garden's extravagance, in 1579 canceled Gambara's stipend, awarded for so-called "poor cardinals." A visit in 1580 by Cardinal Carlo Borromeo resulted in another reproof for squandering money, leading Gambara to fund the restoration of a nearby hospital and church as recompense. Both pope and cardinal, perhaps inspired by reformers' complaints of the Church's profligate expenditures, disapproved of resources lavished on an estate intended for a handful of privileged prelates and aristocrats. Construction of the second pavilion had to wait until the dust settled. The garden acquired its present name when the Lante family acquired the estate in 1656. The Italian government now owns the site, which is open to visitors.

Giacomo Barozzi, known as Vignola, designed the garden. He had worked previously as chief architect of the nearby Villa Caprarola, and in 1568, Cardinal Alessandro Farnese gave permission for Gambara to use his services. Like the garden at the Villa d'Este, Vignola's occupies a fairly steep hillside. Because this garden is smaller and narrower, the visitor more easily grasps the layout, a series of balustraded terraces. The division into geometric units also resembles the plan at the Villa d'Este. Symmetry dominates the design, with circles and squares predominant. Even the trees and shrubs were originally planted in rows, as evidenced by Tarquinio Ligustri's 1596 engraving. But a narrative sequence more obviously informs the Villa Lante. Therefore, the best way to appreciate the property is to begin at the top of the hillside, rather than at the base, site of a handsome entrance.

* * *

At the highest point, I found two narrow pavilions with walls of round, smooth stones, the kind formed over time in rivers. The structures represent the homes of the Muses, situated on the twin peaks of Parnassus, according to myth. Both buildings have open loggias and central arches supported by Ionic columns. A visual pun informs the display, for a crayfish (crustacean resembling a lobster), the

centerpiece of the Cardinal's heraldic device, appears on each arch. The Italian word for this creature (which lives in water), *gambero*, evokes his family name, Gambara. Between pavilions water issues from a grotesque mask, marking the Grotto of the Deluge. An inundation followed the four ages of humankind, as recounted in Ovid's *Metamorphoses*: Gold, Silver, Bronze, and Lead. When Jove became appalled at society's corruption, he determined "to destroy the human race beneath the waves and to send down rain from every quarter of the sky." The god of the sea unleashed his watery destruction as well: "Neptune himself smites the earth with his trident."[1] Thanks to an ark he built on the advice of Prometheus, the virtuous Deucalion and his wife Pyrrha survived. According to Ovid, the twin-peaked mountain they arrived at was Parnassus. Humankind would be reborn there.

The Fountain of the Dolphins, the first of the garden's great structures, belongs to the god of the sea. It was originally housed within an octagonal pavilion that featured a pedimented central section, lower side arms (each topped with a small dome), and round arches over the entrances. Both Ligustri's 1596 engraving and Giovanni Guerra's 1604 sketch show the fountain as it originally appeared. Greenery once covered the pavilion. Unfortunately, that superstructure, probably made of wood and stucco, no longer exists. Also long gone is a branch of coral that found its origins in a watery home. "The appeal of coral was that it is both natural and hard, so that it can be carved and made into art."[2] The stone fountain itself survives, however. Water issued from mouths of paired dolphins as well as from lion heads. The sea creatures invite us to envision Neptune's underwater palace. Here water takes the form of a jet that originally topped the fountain; eight smaller jets send water into receptacles around the base.

Continuing down the slope, I came upon the *catena d'acqua*, that is, a water chain, a steep, stepped channel bordered by linked voadutes, or spiral scrolls, that have the effect of increasing the speed of the water and creating the illusion of waves. (This device resembles the water chain at nearby Caprarola.) Water issues from the head and claws of an elongated crayfish, at the top of the chain, an allusion to Cardinal Gambara's name, and exits at the bottom between giant crustacean legs. Here water has a shape, nature transformed by art.

At the Fountain of the River Gods, below a retaining wall and balustrade, the bearded Arno and Tiber, representing Florence and Rome, recline placidly above a wide, semicircular basin. Each giant deity pours water from an urn and holds a cornucopia, symbol of abundance. Appropriately, statues of Flora, goddess of flowers, and Pomona, goddess of fruit, stand in niches on either side of the fountain. With the assistance of water, these deities bring fertility to the

land. Also carved in marble are splay-tailed Sirens, hybrid creatures that reside in the sea. (The Starbucks coffeehouse chain uses a Siren as its logo.) On the terrace in front of the fountain stands the elongated Cardinal's Table made of stone. A channel in its center, situated along the garden's chief axis, contains water to cool bottles of wine for *al fresco* dining. Helena Attlee has suggested that the table may have triggered "thoughts of a polished marble basin that Pliny the Younger had in his classical garden and used during dinner parties to amuse his guests by serving *antipasti* in little boats on the water."[3]

A retaining wall, with a monumental staircase on both sides, defines the terrace below. Today colorful azaleas, hydrangeas, and rhododendrons complement the greenery, though they were unknown in Italy when the garden was new. Giant urns rest upon a balustrade atop the wall. Grottoes occupy space on either side of the fountain: one belongs to Neptune, the sea god; the other, to Venus, conceived from the genitals of Uranus and born at sea. The fountain consists of crescents on several levels; those near the top are concave; those farther down, convex. This combination probably originated in Donato Bramante's outdoor theater at the Vatican's Belvedere Court. Vignola's display has become known as the Fountain of the Lights, because little jets of water catch the sunlight filtering through the trees. A hundred and sixty jets seem to glow like candles in a chandelier.

Set into the hillside just below are the twin casinos, separated by a lawn and connected by diagonal paths. Neither building is especially interesting; the garden supplies the reason to visit this site. In a barrel-vaulted loggia on the 1578 casino, known as the Casino Gambara, however, frescoes depict topographical landscapes: the Villa d'Este in Tivoli, the Palazzo Farnese at Caprarola and the Villa Lante itself, as they originally appeared. Their presence celebrates Gambara's friendship with Ippolito d'Este and Alessandro Farnese, whose gardens rivaled this one.

The ground floors of the casinos open onto the lowest terrace of the garden. This final section, now known as the Fountain of the Moors, is flat, square and subdivided into sixteen smaller compartments; it's called a parterre (literally, "on the ground"), a French term designating a level space symmetrically divided into sections and planted with flowers, shrubs and fruit trees. Pliny the Younger records such an arrangement in Rome. Typically these designs accompanied contiguous villas. The twelve outermost compartments today feature carefully clipped box and yew. The swirls represent seventeenth-century design, very different from the more disciplined original. The four innermost units, bordered by masonry and balustrades, contain still pools of water. A small marble boat appears in

each. When these pools were first built, a trumpeter and two arquebusiers shooting volleys of water occupied the vessels, an allusion to the mock naval battles of antiquity known as *naumachia*. This portion of the garden contrasts most sharply with that atop the slope, where the mythical Four Ages of humankind succumbed to the flood. If we conceive of an opposition between the materials of nature and human ingenuity, art achieves its ascendancy here. To put this another way, plants are not in charge of this garden.

A fountain occupies an island where the central pools meet, and a circular basin of water rises above the compartments. The appearance of the fountain today contrasts markedly with its original form. According to Michel de Montaigne, who visited the garden in 1581, the fountain had "a high pyramid [obelisk] which spouts water in many different ways: one jet rises, another falls."[4] When Cardinal Alessandro Montalto, Gambara's successor, inherited the property in 1590, he initiated changes. He hired Carlo Maderno to sculpt four life-size nudes, whose color has led them to be called Moors though they are Caucasian. Made of travertine, a sedimentary rock, aged by climate and time, the figures are dark. The four men, accompanied by lions, hold aloft symbols of the Montalto family: a collage of mountains, pears and a stylized star that emits water.

The ancients imagined that a protective spirit, *genius loci*, presided over gardens. We may not subscribe to that notion today, but the term "spirit of the place" has come to suggest the special qualities of a garden. And how shall we describe that spirit here? Everything about the garden feels virtually perfect. The scale is neither too large nor too small. Simplicity characterizes both overall design and individual parts. Each level of the property has an appeal of its own, and, at the same time, belongs to a sequence of interconnected spaces. We trace a logical progression from the beginnings of civilization to the present. The setting ministers to the senses as well. Even on a warm day, the combination of shade and water offers delight. When stressed, I find it helps to imagine I've returned to this garden, surrounded by greenery and accompanied only by songbirds; originally an aviary occupied a place here. Today we can experience what Cardinal Gambara felt four hundred years ago—a respite from cares of the world.

If you seek more variety, you may enter what was originally a *barco*, or hunting ground, outside the garden walls. As early as 1514, a lodge was situated in this preserve. Strolling along the diagonal avenues through rows of trees, we come upon various fountains that seem haphazardly arranged; no gridwork defines this space. Perhaps this area is meant to represent "the desire for a wildwood, an evocation of the sacred grove in antiquity."[5] A variety of trees once filled

the park—oak, beech, fir, chestnut and cypress. Within the barco the sixteenth-century visitor would also have encountered a square maze no longer extant.

Just outside the garden wall and near the present (side) entrance to the garden proper stands the Fountain of Pegasus, carved by the Flemish-born sculptor Giambologna, who became a favorite of the Medici family. According to myth, the winged horse of classical mythology landed on Mount Parnassus, where his hooves struck a rock, the origin of the Hippocrene spring sacred to the Muses. Busts of those Muses, associated with artistic inspiration, rest upon scrolled brackets along the high, curved wall of the fountain (a hemicycle). Water issues from their mouths and descends into the oval pool below where Pegasus frolics. A dramatic jet of water rises directly in front of him. This entrance must have furnished convenient access to the garden for influential prelates and friends.

* * *

Much like the garden at the Villa d'Este, Bagnaia's epitome of Renaissance design achieves a harmony of nature and art. If you spend enough time here to absorb its atmosphere, you will experience a sense of pleasure. The Villa Lante garden casts a spell: friends converse, enjoy the views, and find relaxation. This success would not have been possible without the collaboration of gardeners, architects, sculptors, and hydrologists. Working together they provided a master class in transforming the most commonplace materials—plants, rocks, water—into something wondrous. The English critic Sacheverell Sitwell wrote that the garden is "a perfect work of art."[6] We might even call the garden a performance in stone and greenery. And unlike most Renaissance gardens, this ensemble, maintained for centuries, preserves the spirit of the original. If a collection of plantings can possess a sacred dimension, you will find it here.

When Montaigne visited the Villa Lante, he was astonished. He wrote in his journal, "if I know anything about it, this place easily takes the prize for the use and service of water." The display of fountains, he added, "seems not only to equal but to surpass [that of] both Pratolino [built by Francesco de' Medici] and [the Villa d'Este garden in] Tivoli."[7] Much of the credit goes to Tommaso Ghinucci, the hydrologist whom Vignola employed to supervise the waterworks. He was hired on the strength of the fountains he had designed for the Villa d'Este near Rome.

NOTES

1 *Ovid: Metamorphoses*, trans. Frank Justus Miller, Loeb Classical Library, 2 vols. (1916; repr. Cambridge, MA: Harvard University Press, 1966), 1: lines 260–61, 283.

2 Claudia Lazzaro-Bruno, "The Villa Lante at Bagnaia: An Allegory of Art and Nature," *The Art Bulletin* 59, no. 4 (December 1977): 553–60.

3 Helena Attlee, *Italian Gardens: A Cultural History* (London: Frances Lincoln Publishers, 2006), 71.

4 *Travel Journal*, in *The Complete Works of Montaigne*, trans. Donald M. Frame (Stanford, CA: Stanford University Press, 1957), 1026.

5 Elizabeth Barlow Rogers, *Landscape Design: A Cultural and Architectural History* (New York: Harry N. Abrams, 2001), 138.

6 Introduction to *Great Houses of Europe*, ed. Sitwell (1961; repr. London: Hamlyn, 1970), 11.

7 Montaigne, *Travel Journal*, 1026.

CHAPTER 34

SACRO BOSCO, BOMARZO

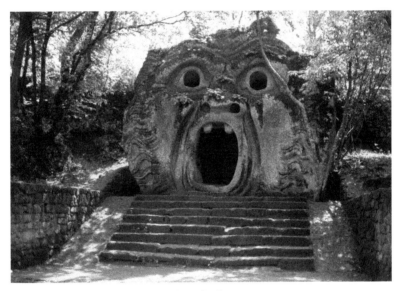

FIGURE 34 *Sacro Bosco, Bomarzo.* Wikimedia Commons.

Much of this garden is unusual if not inexplicable. The equilibrium and proportion of the High Renaissance have disappeared. "Classicism," as traditionally practiced, no longer has the authority it previously enjoyed. Obscurity takes its place. Symmetry goes missing. Surprise awaits at every turn. Perhaps the best way to explain the garden is to see it as an expression of Mannerism, a late stage of Renaissance design.

Only about eight miles from the Villa Lante lies a castle once owned by Pier Francesco Orsini, called Vicino, Duke of Bomarzo. As did other men of wealth and power, he considered gardens integral parts of his estate, known as the Villa Orsini. Because his residence was perched on a cliff, he situated the garden in

the spacious valley below, where outcroppings of volcanic rock furnished the
raw material for sculpture.

I was initially baffled by what I saw, and when I left, I remained puzzled.
Although Vicino had often visited the garden at nearby Bagnaia, none of the
principles that guided Vignola there or, for that matter, Ligorio in Tivoli, informs
Bomarzo. Created between 1552 and 1580, this park has little in common with
either of those properties. The terms "order" and "symmetry" have no purchase
here. And although some familiar mythological figures appear (Pegasus, Ceres,
Neptune), there seems no overall narrative scheme. It's safe to say that such a
garden had never previously been realized. How may we explain this innovation
at the sacred grove?

One possibility is that the Duke, an avid reader, had perused Francesco
Colonna's illustrated *Hypnerotomachia Poliphili*, printed by Aldo Manuzio
(1499), which proved both immensely popular and influential in the sixteenth
century. The enigmatic narrative, with 172 woodcut illustrations, sometimes
attributed to Benedetto Bordone, combines erotic longing with antiquarian
lore. It represents the fantastic dream vision of Poliphilo, who experiences a
multitude of adventures in pursuit of the beautiful Polia. With the help of
Cupid, the two meet and journey to the garden island of Cytherea, ruled by
Venus. On their way they encounter ruins of classical buildings and unusual
gardens, one made of glass, another of silk; yet another consists of a labyrinth,
a popular motif with origins in antiquity. They find giant statues of a horse, a
war elephant and a recumbent colossus; they pass obelisks, pyramids and the
triumphs of Jove. The gods and goddesses of the ancients make an appearance.
Colonna's book makes considerable use of Alberti's treatise on architecture,
with detailed accounts of classically-inspired buildings and monuments. Yet
it also contains seemingly unconnected vignettes such as Poliphilo's vision of
hell and his experience of visiting a cemetery alone. Ultimately, the story tells
of love unfulfilled. When Poliphilo awakes from his dream, Polia is nowhere
to be found. No one knows what the author intended, though some readers
view the work as informed by alchemical lore. Although the illustrations are
straightforward, the text remains opaque.

* * *

A tempietto with an octagonal dome stands out as Bomarzo's most conventional
structure. Tuscan columns support a high circular arch that dominates the
front; a large porch-like vestibule stands behind the façade. The entablature
bears Vicino's name in ancient Roman lettering. Built twenty years after the

garden was begun, the temple constitutes a mausoleum honoring his second wife, Giulia Farnese, whose emblem was the fleur-de-lis, which decorates the little temple.

Just about everything else we find is unusual, if not inexplicable. Randomness presides here. Scattered around the landscape in no particular order are an array of curious figures attributed to Simone Moschino. They include three-headed Cerberus, envisioned as sentry to the underworld by the ancients; a huge tortoise with a woman (Fame) standing on its back and blowing a trumpet; a winged dragon fighting off lion attackers; an elephant, bearing a howdah, crushing a Roman centurion; a colossal figure holding another upside down and tearing it apart; the head of a huge sea creature with gaping mouth and sharp teeth; a little theater built into a retaining wall; a nymphaeum made to look like an ancient ruin; two Sphinxes; a Siren with twin tails; and, finally, an enormous hell mouth—a monstrous face in the act of screaming. (Ironically, a picnic table is situated behind the intimidating visage.) Around the mouth we read, "Leave every care, you who enter here"—a reference to the inscription at the gates of Dante's hell: "Abandon hope all you who enter here." Elsewhere in the garden, a house made of stone seems to sink into a hillside, collapsing before our eyes. Violence and death haunt Bomarzo.

The lake and fountains that once graced the garden are long gone. And if a document ever existed describing what we see and explaining its rationale, that has vanished too. A few inscriptions, however, survive though most are now illegible because of lichen growing on the stone. They call the site a *sacro bosco* (sacred wood). Perhaps our best insight lies in these words: "You, who roam the world in search of sublime and fearful wonders, come hither and look upon terrible countenances, elephants, lions, bears, man-eaters and dragons." Another inscription insists that the garden "resembles itself and nothing else." Vicino's purpose would appear to have been singular: to surprise, appall and disquiet visitors. To walk through the garden is to experience an emotion somewhere between bewilderment and alarm. For this reason, the familiar features of a Renaissance garden have no assured place. Vicino intended to follow no one's lead, to strike out on his own, to upend expectations. Mystery surrounds this site. No one knows for certain who laid out the garden; it may have been Vicino himself. Nor does a consensus exist to explain what we behold. Upon Vicino's death in 1588, his family abandoned the garden. In the 1870s, the property changed hands and some repairs were made. By the time the surrealist painter Salvador Dalí visited in 1949, the venue was derelict, nearly forgotten. The University of Rome conducted research in the archives to retrieve information about its original

form. Not until the 1950s, however, was some restoration undertaken. Today the site remains largely a ruin, a victim of neglect. Advertisements call it "The Park of the Monsters."

* * *

A fruitful way of understanding the defiance of convention is to consider the garden an expression of the late Renaissance style called Mannerism, characterized by the sense of restlessness and disturbance manifest at Michelangelo's Medici Library, Florence, and Giulio Romano's Palazzo Te, Mantua. Originating in the High Renaissance, Mannerism was a sophisticated development registering not only artists' desire for novelty but also the trauma of contemporary life, religious, scientific and military.

The Protestant Reformation, with its challenge to existing beliefs and rituals, created unprecedented discord. Other sources of dismay included the catastrophic invasions of Italy by France in 1494 and 1499, as well as the 1527 Sack of Rome, which traumatized the populace. Internecine struggles between Italian city-states were endemic. Scientific discoveries undermined assumptions about the shape of the cosmos and the teachings of the Church, which condemned Galileo's challenge to orthodoxy. Through their research, Copernicus, Giordano Bruno, Tycho Brahe, Johannes Kepler, and Galileo reconceived Earth's place in the universe. Defying long-held assumptions, they repudiated the Ptolemaic system—the notion that Earth was the center of the universe, a belief propounded by Claudius Ptolemy, a Roman citizen of Egypt writing in Greek. The ancients found this notion congenial, and Aristotle was believed to have accepted it. In the Middle Ages, St. Thomas Aquinas sought to square Aristotle's philosophy with Church theology. Even Martin Luther was loath to challenge received belief about the cosmos: "Luther called Copernicus a fool because he held opinions contrary to the Bible."[1]

Christianity embraced the Ptolemaic system without a shred of scientific evidence. Those who disagreed with the conventional wisdom were charged with challenging Scripture. Ptolemy's theory had such a long pedigree that it became accepted as fact. Astronomers, however, reported that traditional—and unchallenged—assumptions about the cosmos were mistaken: planets revolved around the sun. No longer at the center of creation, humankind lost its pride of place. Inhabitants of the earth were at the center of nothing.

The inspirations of Mannerism, then, were not exclusively aesthetic. Architects and artists responded to a world characterized by political and cultural instability that undermined comforting beliefs. Gardens and their contents

manifested the new sensibility. "As mannerism developed, its boldest and most blatant manifestations were in the architecture of buildings and gardens."[2] At Bomarzo, the equilibrium and proportion of the High Renaissance disappeared. "Classicism," as traditionally practiced, no longer had the authority it previously enjoyed. Obscurity took its place. Symmetry went missing. Ingenuity assumed precedence, and surprise awaited at every turn. Exaggeration and even the grotesque found welcome. The guidance furnished by linear perspective had vanished. Squares or circles no longer defined space. In my journal, I wrote, "We find ourselves in a world inscrutable and a little sinister."

NOTES

1 Vincent Cronin, *The Flowering of the Renaissance* (London: History Book Club, 1969), 148.
2 Helena Attlee, *Italian Gardens: A Cultural History* (London: Frances Lincoln, 2006), 75.

CONCLUSION

Imagine that a long-lost relative has left you a sum of money. First surprised, then delighted, you decide to learn something about your benefactor and then make the most of your inheritance. This, in effect, describes what architects of the Italian Renaissance did when they rediscovered the heritage of classical Rome. Of course, everyone knew of the Roman Empire, at least in general terms. It once dominated Europe from the misty Lake District in northern England to the dusty deserts of Egypt. It had produced literature, philosophy, history, and science that were still being studied. Rome enjoyed a status no other civilization possessed. In its heyday, the capital city was celebrated by the poet Sextus Propertius, who imagined visitors arriving from every land after experiencing the wonders of the world. Nothing, says the poet, compares with the empire's capital city: "What are all these marvels / before the miracle of Rome? / What riches the earth bears, nature placed here."[1]

Renaissance architects, like their predecessors, knew the accounts of villas and temples in writings by Pliny and others. What was new was the desire not only to read about ancient architecture but also to locate the physical ruins of ancient Rome, excavate buildings covered with the accretions of centuries, measure their dimensions, and investigate their method of construction. Beginning with Brunelleschi in the early 1400s, architects pursued these efforts with unprecedented curiosity and intensity. Inspired by their newly acquired knowledge, they came to view architecture in the centuries following Rome's fall as symptomatic of a long falling off. Convinced that the time was ripe to reverse the decline and restore excellence, they replaced or adapted structures that Giorgio Vasari called "German" (Gothic), a synonym for the benighted, deplorable—and foreign. Filarete wrote with contempt, "I beg everyone to abandon modern [Gothic] usage. Do not let yourself be advised by masters who hold to such bad practice. Cursed be he who discovered it! I think that only barbaric people could have brought it into Italy" (1:102).[2]

What accounts for the pivot from medieval Gothic to classical Roman? A threefold conviction informed this change: 1. that classical civilization was aesthetically superior to medieval; 2. that the route to achieving beauty and power lay in principles practiced by the ancients; and 3. that such precepts had their origins in nature.

* * *

At least metaphorically the dimensions of classical culture expanded in the 1400s as the study of antiquity advanced. New knowledge confirmed the belief that the centuries following Rome's fall had witnessed a wholesale debacle. As the long-lost world of the Greeks and Romans began to take shape in the minds of intellectuals and designers, they assigned an honored place to pagan civilization. They were fascinated by the physical remains of Rome, and, the more steeped in Roman culture they became, the greater grew their nostalgia.

Appreciation of ancient culture had immediate implications for education, which became synonymous with rhetoric, dialectic, grammar, and philology, as well as the arts of close reading, letter writing, and argumentation. Together these activities generated a worldview that today we call *humanism*, a term implying intellectual attitudes common in antiquity, especially reliance upon empirical evidence, inductive reasoning, and the spirit of free inquiry. A secular enterprise, humanism (from the Italian *umanista*, a nickname for students in the liberal arts) was predicated on the recovery of ancient books and their cultural context, as well as an appreciation of their literary quality.[3] "Humanists drew their inspiration from the Greek and Roman past rather than their more immediate medieval heritage, and they looked to that remote past as a guide to their own conduct in the present."[4]

With the advent of humanism, investigating the provenance and editing the writing of antiquity became a profession of singular importance, for scribal errors had crept into manuscripts both religious and secular as they were copied, recopied, and suffered deterioration. The earliest manuscripts, consisting of papyrus made from reeds, were particularly fragile. The introduction of vellum (or parchment) offered a more durable surface. But because all of the writing on papyrus or vellum was made by hand, no two manuscripts were identical; each had its own idiosyncrasies.

New ways of thinking required new ways of writing. Latin was the language of educated men and women throughout Europe. As ancient Roman texts were discovered, scholars noticed with concern a disparity between the stylistic elegance of antiquity and the debased Latinity of their own time. And so they made a

conscious effort to emulate the style perfected in Rome. Cicero's prose became a model, and Petrarch led the way: he recounts that in childhood, while his chums read Aesop's *Fables*, he studied Cicero. As it happens, he would write most of his work in Latin. His followers ratified that choice by searching monastic libraries for previously unknown writings of Rome's greatest orator. Poggio Bracciolini found a number of such works in Switzerland, Germany, and France.[5]

The career of Lorenzo Valla demonstrated the practical value of closely studying language. Like other humanists, he was essentially a philologist. "As the name itself indicates, philologists were devotees (*philoi*) of the study of words (*logoi*)."[6] They were "people who had undergone the course of classical studies known in their own day as humane letters, *studia humanitatis*."[7] With his expertise, Valla challenged the so-called *Donation of Constantine*, a document that purported to grant Pope Sylvester (314–36) secular power. Through scrutiny of linguistic detail, historical anachronism, and simple logic, he established that Emperor Constantine could not possibly have written the edict.[8] It was, in fact, an eighth-century forgery concocted in the papal chancery. In 1440, Valla branded it a fake.

The printing press, devised in the 1450s by Gutenberg, his partner Johann Fust, and Peter Schöffer, Fust's son-in-law, allowed humanism to flourish everywhere. In fact, "the key humanist institution is the print shop."[9] Without the new technology, the study of ancient texts would never have developed so quickly. Nor would it have moved beyond a relatively small group of bibliophiles. Within a generation after the invention of the press, the intellectual landscape of Italy underwent a transformation impossible to imagine just a few decades earlier. A wide portal to antiquity had opened. The printing press became the single most important invention of the Renaissance, gunpowder a close second.

Pragmatism fueled humanism, which valued the study of grammar, rhetoric, poetry, moral philosophy, and history. By examining Roman rhetoric, for example, students would achieve eloquence. Ideally, young humanists would learn to write, speak, and act with elegance—what Italians call *sprezzatura*. They would excel at public address and have the power to persuade. Such pursuits prepared students for careers in the world taking shape. Their writing became more accessible than the philosophizing of the Middle Ages, captive to jargon and focused on issues with little practical import. Humanists believed that their work entailed responsibility to the wider society. Ideally, fledgling scholars had the capacity to change Italy for the better, whether as secretaries, magistrates, civic officials, teachers, notaries, lawyers, or even ambassadors. And laymen rather than clerics would fill most such roles. Individual judgment would take the place of religious certitude.

Humanism and spirituality were not mutually exclusive. But as this world beckoned more urgently, a new sensibility began to develop. At the outset of the Renaissance, Coluccio Salutati, chancellor of Florence between 1375 and 1406, argued for the value of secular life. To a friend, he wrote, "Do not believe [...] that to flee the crowd, to avoid the sight of attractive objects, to shut oneself in a cloister or to go off to a hermitage is the way of perfection." Instead, "If you provide for and serve and strive for your family and your sons, your relatives and your friends, and your state [...] you cannot fail to raise your heart to heavenly things and please God."[10] Although contemplation in seclusion may prove sublime, he argued, life in the wider world has its own claims, for it has the virtue of serving the community: "the active life that you flee is to be followed both as an exercise in virtue and because of the necessity of brotherly love."[11] Subsequently, "students of Salutati began to emphasize the uniqueness of every individual and to value self-awareness and, above all, self-assertion."[12]

Adopting humanist values in a Christian world, however, could be a fraught enterprise. A corollary of this new focus was a less celebratory view of Christianity. Niccolò Machiavelli, the acerbic, sharp-eyed political philosopher, took a dim view of changes wrought by followers of Christ. Contrasting the religion of the present with that of ancient Rome, he blamed Christian values for the fecklessness of his era: "Our religion has glorified humble and contemplative more than active men. It has then placed the highest good in humility, abjectness, and contempt of things human; the other [ancient Rome] placed it in greatness of spirit, strength of body, and all other things capable of making men very strong. And if our religion asks that you have strength in yourself, it wishes you to be capable more of suffering than of doing something strong. This mode of life thus seems to have rendered the world weak and given it in prey to criminal men [...]."[13] This passage, in *Discourses on Livy*, argues for the supremacy of the state and the centrality of secular life. "Contempt of things human" must give way to a celebration of accomplishment. Confidence should replace fear. Self-reliance must replace deference to authority.

For more than a thousand years, attaining salvation had been humankind's pre-eminent goal, to be achieved—prior to the Reformation—by good works, prayer, observation of ritual, and contemplation of divinity. Monasticism became the most important institution of the Middle Ages. In a spirit of renunciation, monks took vows of poverty, chastity, and obedience. As humanism gained adherents in fifteenth- and sixteenth-century Italy, however, the active life increasingly became the favored model. The English poet John Milton, a fierce Protestant, would later sum up this reorientation by saying in his pamphlet

Areopagitica, "I cannot praise a fugitive and *cloistered* virtue, unexercised and unbreathed, that never sallies out and sees her adversary, but slinks out of the race where that immortal garland is to be run for, not without dust and heat."[14]

Milton chose his words carefully: he knew that monasteries had cloisters, and covered walkways around a quadrangular courtyard open to the sky; there monks would read, pray, and meditate. For the most part, they lived in seclusion, literally walled off from the outside world. By contrast, the active life celebrated by Milton meant engagement with the here and now. Anticipating a future in heaven need no longer constitute the focus of this life; ambition need not be construed as a vice; achieving fame need not be an unworthy goal; religion need not trump the workings of civil society; exercising reason need not be confined to buttressing the teachings of the Church. What's more, members of the community were now expected to participate in, not shun, the hurly-burly of urban life. The piazza in every town became a site for robust discussion, argument, and debate.

Long before the Reformation, the prescient Leon Battista Alberti anticipated the new emphasis when he urged youth to develop their bodies as well as their minds: "I praise the practice of letting the young enjoy all the recreation they need. Their games should only be manly and honest."[15] And although he praised country life, he recognized the attraction of an urban setting: "In the city are the workshops of great dreams, for such are governments, constitutions, fame."[16] Of "this great world" Montaigne, in his essay on education, wrote, "I want it to be the book of my student."[17] The secular was neither to be feared as a source of temptation nor to be despised as irrelevant. Aesthetics gained prestige not enjoyed since antiquity. Inevitably the contemporaries of Brunelleschi, Bramante, and Michelangelo began to challenge assumptions long felt as facts.

While humanists won adherents in the intellectual realm, religious reform challenged their ideals. When Martin Luther posted his 95 Theses at Wittenberg, a town of only 2000 people, few Italians could have foreseen the implications of this act, which triggered a wholesale revolution in European culture. The movement capitalized on dissatisfaction with religious doctrine, the power of the clergy, and the Vatican's handling of money. Luther's followers had come to identify opulent churches with well-fed clergy who could seem indifferent to their plight. People came to associate ecclesiastical splendor with corruption. A sense of oppression, social, political, and economic, accumulated over time. Stories of nepotism (from the Italian word for "nephew"), simony (buying or selling Church offices), and greed among the clergy were rife. Political intrigue and debauchery became synonymous with the papacy. It was this underlying resentment that the reformers exploited so successfully. When an opportunity

arose to express their indignation, both the peasantry and the merchant class seized it. An orgy of destruction followed, taking a toll on religious art, especially in northern Europe.

* * *

Despite the turmoil, one issue had the capacity to unite humanists and reformers. Conceivably it might even have offered a starting point for some sort of rapprochement: namely, recognition that the Greek language, largely unknown in Western Europe, was indispensable to Christians. Italians were not entirely innocent of the language. As early as 1397 Coluccio Salutati invited Manolis Chrysoloras, from Constantinople, to instruct Florentines in learning Greek. Although he remained in Florence for only a few years, the Byzantine scholar cultivated knowledge of his language. His charismatic teaching, in turn, would lead to the refinement of extant manuscripts, and this made them attractive to publishers when printing arrived.

Erasmus of Rotterdam, called "the 'arch-humanist' of his day,"[18] was the adherent par excellence of classical Greek. For him, it was doubly important. In addition to fostering the agenda of humanism, the ancient language was the touchstone of Christianity. His view was pragmatic: even though only a small number of Europeans could read the language, the New Testament, written in Greek, held the blueprint for salvation. Most early Christians had in fact spoken Greek. But for a thousand years, people in the West depended on a Bible that was a flawed version of the original and thus unsatisfactory—a Latin translation ostensibly translated by Saint Jerome in the late fourth and early fifth centuries. But how much of the Latin text had actually been written by Jerome and how much by others who attempted to duplicate, sometimes imperfectly, what they inherited? Lorenzo Valla was "the first scholar to believe that Jerome had not actually translated the Vulgate New Testament but had issued an already existing translation under his own name."[19] The original manuscript had, of course, disappeared centuries earlier, and surviving copies were riddled with discrepancies and mistranslations. To remedy this handicap, Erasmus himself edited the Greek New Testament in 1516, along with his corrected version of Jerome's Latin text, known as the Vulgate. What Erasmus came to realize is that the Latin version existed in countless forms, some in conflict with others, some the result of faulty copying, others the result of misinterpretation. Scholars were now applying to the study of Scripture techniques they had developed to analyze secular literature.

Erasmus was inspired in part by his discovery of Lorenzo Valla's *Annotations on the New Testament* (dedicated to Pope Nicholas V),[20] but his work did not aspire

to improve the original Greek. By contrast, Erasmus insisted that Christians needed to understand the words of the Gospels as they had first been written. Some observers, however, felt uneasy about what readers might discover: namely, that the Bible in use for twelve hundred years was unreliable. Beginning in 1559 the Church nervously placed Erasmus's writings on the *Index of Forbidden Books*.

Readers and speakers of the Greek language, arriving in Italy from Constantinople after its fall to Islam in 1453, popularized a language that had largely gone into eclipse in the West, except at universities and aristocratic courts. Many books, of course, did not survive the conquest of the eastern capital, for the Ottoman Turks destroyed magnificent libraries there. Pius II said that the loss of Byzantium meant "the second death for Homer and for Plato too."[21] The catastrophe was, nevertheless, a boon to Western students of antiquity in this sense: the influx of Greek-speaking immigrants and the transfer of personal libraries to Venice allowed access to a dimension of classical culture little known in Italy, and Greece was the civilization most venerated by the ancient Romans. With the dispersal of manuscripts from the East, that culture took on a new immediacy.

Like Erasmus, Luther came to believe that the New Testament in Greek provided the indispensable path to salvation. Both the German theologian and the Dutch humanist believed that Christians needed to know Greek in order to understand Scripture aright. And Scripture needed to be available to everyone. Erasmus, in the introduction to his New Testament, wrote, "I wish that every woman would read the Gospels and the Epistles of Paul. And I wish these were translated into each and every language."[22] This concern was especially important to Luther, who wanted the Bible made available in the vernacular of every nation. Fear that the faithful might misinterpret what they read motivated resistance; only the priesthood, the Church maintained, could explain what Scripture meant. William Tyndale, influenced by Luther and working from the original languages of Hebrew and Greek, translated the Bible into English, the very best version ever made in his native tongue and the foundation of the King James version. He sought to convince authorities that access to the vernacular was no impediment to salvation; indeed, it was just the opposite. For his pains, Tyndale was arrested, jailed, and executed by strangulation.

To a considerable extent, Luther and Erasmus shared an intellectual affinity transcending national boundaries. Erasmus gave the study of the Bible a new philological emphasis that Luther applauded. The German monk, for his part, hoped the Dutch scholar would join his challenge to the Church. In his first surviving letter to Erasmus in 1519, Luther wrote, "who is there in whose heart Erasmus does not occupy a central place?"[23] Although he would engage in

intellectual combat with Erasmus over the issue of Church renewal and much else, the leader of reform recognized the merit of his opponent's insistence on knowledge of the language little known in the West. A humanist in scholarly method, Luther, building on Erasmus's research, would himself translate the Greek New Testament into German. At this moment the Renaissance and the Reformation clasped hands.

What made an actual alliance impossible was the reluctance of Erasmus to challenge the Church and the refusal of an intransigent Luther to compromise his demands. By temperament, the Dutchman was as cautious as his opponent was irascible. Although he visited Rome in 1509 and was appalled by much of what he witnessed there, his dismay did not issue in the frontal attack on corruption that an infuriated Luther made. Luther's opposition to the established Church, however, was not merely temperamental. He had a litany of complaints that Erasmus either did not share or was reluctant to voice. For Luther, the Bible was the only sure route to knowing God's will, not the teaching of priests, who were often ignorant of Scripture. He saw Church leaders as effete, captive to vanity and extravagance. He had little use for pomp or ceremony. He frowned on extolling miracles. Ritual, he worried, was being observed for the sake of ritual itself. Most importantly, he argued that God's grace, not good deeds, was essential to salvation. For a person to be "justified" (found worthy), faith alone was the key.

The issue of reform, which gained support rapidly, capitalized on an undercurrent of antagonism to the Church and the corruption it had long tolerated. What Luther found particularly abhorrent was the sale of indulgences, a medieval invention ostensibly meant to remit temporal penalties for sin and shorten a person's time in purgatory, where souls suffered before gaining admittance to heaven. When money grew short during the rebuilding of St. Peter's Basilica, Julius II revived the sale of indulgences to remedy the shortfall. Money sent from German-speaking countries to the Vatican had begun to decline as anger at papal taxes (for church buildings outside Italy and for legal work) rankled and as respect for papal authority diminished. Later the banker Agostino Chigi suggested to Leo X that he ramp up the sale of indulgences, previously employed on an occasional basis. The feckless Leo, known for extravagance, decided to shift sales into high gear. (He once said that, since God gave him the papacy, "let us enjoy it.") In December 1514, he appointed commissioners to administer the plan not only in Italy but also throughout Europe. This practice outraged Luther, who found that the doctrine of purgatory had no biblical warrant and who was appalled at the prospect of buying spiritual benefits with cash. What particularly riled the reformer was a

deal struck by Pope Leo and Albert of Hohenzollern, who, in effect, bought the archbishopric of Mainz. The pope gave Albert permission to sell indulgences as a way of retiring his debt. Half the money realized would go into his pocket, half to the Vatican. Johann Tetzel, a German Dominican, who arrived in Saxony during the spring of 1517, was reputed to have promoted the sale of indulgences by promising, "As soon as the coin in the coffer rings, / The soul into heaven springs." What purported to be a practice offering spiritual benefit came to look like a racket. On October 31, Luther posted his 95 Theses on the door of the castle church in Wittenberg, precipitating the Reformation.

Recognizing the threat posed by Luther, Pope Paul III belatedly convened the Council of Trent in 1545. The convocation, which would meet intermittently till 1563, initiated changes in policy that came to be known as the Counter-Reformation, an effort to affirm the pope's temporal and spiritual authority and to root out corruption. Nepotism, simony, and the sale of indulgences were deplored. None of this, however, was enough to satisfy Luther or his followers. What's more, the Church reaffirmed the cult of Mary, the intercession of saints, and the veneration of relics, which reformers rejected. Whereas Luther had argued that the Bible should be translated into the languages of native speakers, offering the faithful first-hand access to Scripture, the Church announced that the fourth-century Latin Bible was correct and authoritative. Whatever prospect had existed for a meeting of minds, no reconciliation would ensue.

* * *

Although its most important work was doctrinal, liturgical and pastoral, the effort at self-renewal initiated at Trent led to immense changes in the arts. Humanists had celebrated the beauty of the body, which was, after all, God's creation. In 1563, however, the Council backtracked on this issue. Nothing indecorous would henceforth be tolerated in art deployed for religious purposes. A papal official insisted that the nudes in Michelangelo's *Last Judgment* were scandalous. Pope Paul IV, who thought the figures "shameless," ordered Daniele da Volterra to paint over them. He would thereafter be dubbed "the pantaloon maker." In the future, religious art would need to observe propriety.

Classical mythology, likewise, became suspect, for it was, after all, the product of pagan culture and therefore not consistent with biblical teaching. Reformers now preferred images of Christ's Passion and other New Testament subjects. The application of ancient myth to Christian teaching, once commonplace, no longer seemed appropriate. Why, for example, depict the classical Charon, who carries damned souls to Hades across the river Styx, in Michelangelo's

Last Judgment? Artistic adherence to biblical narratives was preferable to the imaginings of artists. Religious art should appeal to the populace by drawing upon the simplicity of daily life rather than mythical creations.

The shape of ecclesiastical structures became an issue too. From the time of Brunelleschi, the central plan became the admired model. For a hundred years some of the most talented minds had sought to adopt the Greek cross. And, as we have seen, such a plan intermittently informed thinking about St. Peter's Basilica. Both architects and artists argued that religious buildings in the shape of circles, squares, and octagons were consistent with Christian belief. Such classical inspiration now became suspect. Cruciform churches, ubiquitous in the Middle Ages, were deemed superior to central-plan churches identified with a pre-Christian world.

Protestant attacks led the Church to turn inward and devour its own. The fate of Paolo Veronese, an acclaimed Venetian artist, epitomized the new rigidity. In 1573, he was hauled before the Inquisition to defend his *Last Supper*, commissioned by a Dominican monastery, where it had hung undisturbed for five years. Animated figures crowd a large canvas radiating energy. Christ and his apostles share space with German soldiers, richly dressed guests, various servants, turbaned Turks, a dwarf jester, a man with a nosebleed, and several animals, including a parrot, two dogs, and a cat—all depicted below three huge Roman arches supported by Corinthian columns. An expanse of blue sky and a classical cityscape fill the background. In the foreground, Christ celebrates the Passover feast. The inquisitors complained that this indecorous treatment obscured the event's central meaning: the institution of the Eucharist. Interrogated by the clergy, Paolo took refuge in the argument that artists paint images originating in their own imaginations, and Michelangelo's *Last Judgment* had provided a precedent. Although his examiners were skeptical, the witty Paolo dealt with the charge of heresy by cleverly changing the title of his painting to *The Feast in the House of Levi*, "the episode (Mark 2:13–22) where a wealthy man in the company of 'publicans and tax collectors' entertained Christ."[24] As the incident illustrates, even someone with this artist's credentials could be intimidated and threatened. Ancient Rome, the touchstone of culture, no longer represented an unalloyed value. Creativity now, more than ever before, was subject to limits imposed by enforcers of orthodoxy. Repression supplanted artistic spontaneity. Increasingly intolerant, traditional Christianity grew more narrow, self-righteous, and mean-spirited.

The Roman Church had long felt threatened by challenges to its teachings. Its instinctive response was to suppress them by any means deemed necessary. Even before Luther's 95 Theses, Pope Sixtus IV had named the fanatical

Dominican monk Tomás de Torquemada to lead the Spanish Inquisition, intended to root out any divergence from the Church's party line. His name became synonymous with cruelty. The fusion of pagan and Christian faltered. And with this sundering, Italian artists began to surrender their unique status in Europe.

Instead of capitulating to demands from the north, the Church doubled down and supported the development of a grandiloquent style intended to win back waverers by the expedient of visual splendor and emotional appeal. The swagger of Baroque spectacle would engage the senses of the faithful and overwhelm their doubts, while the Church confidently proclaimed the old verities. Pomp and size would replace the discipline of the Renaissance. Grandeur came to seem more attractive than simplicity, magnificence more welcome than symmetry, harmony, and restraint. A feeling of limitless energy began to infuse architecture and the other arts. A twofold challenge, then, overwhelmed the Renaissance: the forces of reform and the strategy of a Church and wider culture losing its bearings in a world increasingly uncertain, disturbed, and bewildered. After two hundred years, the Italy of Brunelleschi, Alberti, Bramante, Michelangelo, and Palladio approached its end.

NOTES

1 *The Poems of Sextus Propertius*, trans. J. P. McCulloch (Berkeley and Los Angeles: University of California Press, 1972), 192–93.

2 *Filarete's Treatise on Architecture*, trans. John R. Spencer, 2 vols. (New Haven and London: Yale University Press, 1965). Numbers within parentheses designate volume and page numbers.

3 "It was in [Leonardo] Bruni's time that the word *umanista* first came into use, and its subjects of study were listed as five: grammar, rhetoric, poetry, moral philosophy and history" (Paul Johnson, *The Renaissance* [London: Weidenfeld and Nicolson, 2000], 29). Bruni was chancellor and historian of Florence.

4 Ingrid D. Rowland, *The Culture of the High Renaissance: Ancients and Moderns in Sixteenth-Century Rome* (Cambridge: Cambridge University Press, 1998), 10–11.

5 Attending the Council of Constance (beginning in 1414), Poggio "searched industriously among the abbeys of South Germany. He there discovered six orations of Cicero, and the first complete Quintilian, that of St. Gallen, now at Zürich; in thirty-two days he is said to have copied the whole of it in a beautiful handwriting. He was able to make important additions to Silius Italicus, Manilius, Lucretius, Valerius Flaccus, Asconius Pedianus, Columella, Celsus, Aulus Gellius, Statius and others." See Jacob Burckhardt, *The Civilization of the Renaissance in Italy: An Essay*, trans. S. G. C. Middlemore [first published in 1878], 2nd ed, Landmarks in Art History (1945; repr. Oxford: Phaidon, 1981), 115. Burckhardt's study was first published in German with the title *Die Kultur der Renaissance in Italien* (1860).

6 Jill Kraye, "Philologists and Philosophers," in *The Cambridge Companion to Renaissance Humanism*, ed. Kraye (Cambridge: Cambridge University Press, 1996), 142.

7 Rowland, *The Culture of the High Renaissance*, 10.

8 See Meredith J. Gill, "Forgery, Faith and Divine Hierarchy after Lorenzo Valla," in *Rethinking the High Renaissance: The Culture of the Visual Arts in Early Sixteenth-Century Rome*, ed. Jill Burke (Burlington, VT: Ashgate, 2012), 245–62.

9 Tony Davies, *Humanism*, The New Critical Idiom (London and New York: Routledge, 1997), 76.

10 Cited by Margaret L. King, *The Renaissance in Europe* (London: Laurence King, 2003), 81.

11 Coluccio Salutati, "Letter to Peregrino Zambeccari," in *The Earthly Republic: Italian Humanists on Government and Society*, ed. Benjamin G. Kohl and Ronald G. Witt (Philadelphia:University of Pennsylvania Press, 1978), 111.

12 Maria S. Haynes, *The Italian Renaissance and Its Influence on Western Civilization*, 2nd ed. (Lanham, MD: University Press of America, 1993), 99.

13 Niccolò Machiavelli, *Discourses on Livy*, translated by Harvey C. Mansfield and Nathan Tarcov (Chicago and London: University of Chicago Press, 1996), 131.

14 *Areopagitica*, in *John Milton, Complete Poems and Major Prose*, ed. Merritt Y. Hughes (New York: Odyssey Press, 1957), 728.

15 Alberti, *The Family in Renaissance Florence: A Translation of Il Libri della Famiglia*, trans. Renée Neu Watkins (Columbia: University of South Carolina Press, 1969), 83.

16 Alberti, *The Family*, 194.

17 "Of the Education of Children," in *The Complete Works of Montaigne*, trans. Donald M. Frame (Stanford, CA: Stanford University Press, 1957), 116. Paul Johnson, in *The Renaissance*, calls Montaigne "the outstanding product of French humanism" (40).

18 Peter Burke, *The European Renaissance: Centres and Peripheries* (Oxford: Blackwell, 1998), 98.

19 Alastair Hamilton, "Humanists and the Bible," in *The Cambridge Companion to Renaissance Humanism*, ed. Jill Kraye (Cambridge: Cambridge University Press, 1996), 104.

20 "If Erasmus was the hero of the Spanish humanists, his own hero, insofar as he had one, was Valla. He wrote: 'In me you see the avenger of Valla's wrongs. I have undertaken to defend his scholarship, the most distinguished I know'" (Paul Johnson, *The Renaissance*, 48).

21 Cited by Charles L. Stinger, *The Renaissance in Rome* (Bloomington: Indiana University Press, 1985), 121.

22 Cited by E. Harris Harbison, *The Christian Scholar in the Age of the Reformation* (1956; repr. Grand Rapids, MI: William B. Eerdmans, 1983), 100.

23 *Luther's Works*, ed. Jaroslav Pelikan and Helmut T. Lehmann, 55 vols. (St. Louis: Concordia Publishing House; Philadelphia: Fortress Press, 1955-86), 6:281.

24 Stephen Campbell and Michael Wayne Cole, *Italian Renaissance Art* (New York: Thames and Hudson, 2012), 562. The authors suggest that Veronese may have sought to ridicule "the Counter-Reformation attempt to turn painting into an instrument of moral and doctrinal instruction" (562).

POSTSCRIPT

My enthusiasm for the Renaissance began in a Florentine church. Prior to my first Italian journey, I never asked myself what a church should look like. Why? Because I thought I already knew the answer. A church was two or three stories tall, made of stone, with a tower or spire, sculpture on the exterior, and windows of colored glass. How did I know this? Because virtually all the churches I had seen, at least in New York, shared these features.

When I visited Italy for the first time, I realized how limited my experience had been. In Florence, I beheld an entirely different kind of building—San Lorenzo, with its Old and New Sacristies—a structure completely at odds with what I expected. And I liked what I was seeing. Many years later when I read Giorgio Vasari's *Lives of the Artists*, I could understand his enthusiasm for the new architecture of the 1400s. Vasari reminds us that "in his lifetime the German [Gothic] style was venerated throughout Italy and practiced by older artisans, as is seen in countless buildings" ("Brunelleschi," 146),[1] and he observes that almost single-handedly Brunelleschi's imagination changed everything. Vasari describes the architect's achievement in terms that strike us as hyperbolic: his "genius was so lofty that it might well be said he had been sent to us by Heaven to give a new form to architecture which had been going astray for hundreds of years" (110).

What impressed me in Florence was what attracted Vasari's praise. Brunelleschi's churches were so different from the norm that they evoked emotions of surprise, delight, and even wonder. It's impossible now to recover fully the response of the architect's contemporaries, who mostly knew no mode but Gothic. Although Vasari was writing more than a hundred years after San Lorenzo was built, the biographer captures the continuing excitement generated by the new style.

Within just a few years Brunelleschi revolutionized the look of urban Italy. He brought this about by immersing himself in ancient culture, beginning with

his journey to Rome after losing the competition for the Baptistery doors. Vasari tells us that "his studies were so intense that his mind was capable of imagining how Rome once appeared even before the city fell into ruins" ("Brunelleschi," 118). This remark points to the great paradox of Renaissance architecture: practitioners at the cutting edge of new design fell under the spell of an ancient culture and never ceased mining it for ideas.

Leon Battista Alberti was likewise steeped in the world of classical Rome. Both he and Brunelleschi believed that the Gothic style had been a monstrous mistake and therefore needed to be replaced, the sooner the better. Both found inspiration in the same model: imperial Rome. This was not exactly a "new" style, since it had been perfected a millennium and a half earlier. But for people who knew only Gothic, the ancient forms looked novel. And Roman models possessed the cachet of a once-great civilization.

Alberti applied what he had learned about ancient practice when he built a new façade for Giovanni Rucellai's home in Florence. At the time most substantial estates resembled fortresses more than comfortable dwellings. To accomplish his goal, Alberti deployed what he knew. He began with a blank wall and incised vertical lines on it. These took the form of pilasters and were crowned with capitals corresponding to those of antiquity. I must previously have seen such forms in movies about ancient Rome and federal buildings in Washington, DC, but I never thought about their function. Here at Rucellai's home, they were eminently practical because they subdivided the wall into separate compartments, thus conferring a pattern and elegance on what otherwise would have been a plain surface.

As I looked at the Palazzo Rucellai, it struck me that I was seeing the antithesis of buildings at home. In downtown Tucson the exterior of the federal courthouse features blank walls; the interiors are equally nondescript. The only decorative element I recall is the oversized sculpture of an eagle mounted in a courtroom. Otherwise, plain, vast spaces rule this and other modern buildings. Painted surfaces are generally pale gray or beige. Clearly, modern taste finds an expanse of emptiness attractive. This is the antithesis of Renaissance practice, which was comfortable with decoration as long as it was subordinated to a coherent design. Architects found that design chiefly in the triumphal arch, the temple façade, and the barrel vault. In effect, these forms supplied a framework within which architects could deploy their expertise and ingenuity.

It's axiomatic that every building has a function. What distinguishes Renaissance structures is their capacity to fulfill a practical purpose while simultaneously offering delight. They serve the public and please the eye by adopting basic geometrical forms, exploited in new combinations. All along

what united Brunelleschi and his contemporaries was a common dedication to perfecting a style that would establish Italy as the avant-garde of architectural design. They were redefining the very concept of aesthetic excellence, which had been allowed to deteriorate (they believed) for a thousand years. In time this new approach would inspire the enthusiasm not only of Italy but also of the whole of Europe and beyond.

Although architects managed to realize this goal by recovering the splendor of the ancients, they were not merely imitating structures created when Roman civilization was thriving. Antiquarian exactitude was never their purpose. Admittedly, they employed the arches, pilasters, columns, capitals, and domes of the ancients. But they were heirs, not suppliants. And although virtually everyone paid tribute to the architect whose work survived Rome's fall, they felt free to depart from his example: "Vitruvius never encouraged the slavish adherence to ratio and proportion that became the rule of the Renaissance."[2] Churches, palaces, and civic buildings in the 1400s and 1500s almost never merely copied Roman structures. That's why the buildings of Italy look so diverse. They juxtapose classical forms in thoughtful variations. No two churches are identical; no two villas look the same. Instead, architects used what they discovered as starting points for contemporary construction. And so, for example, Palladio had never seen a building that looked like his Basilica in Vicenza. Nor had he seen a surviving Roman villa like the ones he built for wealthy clients in the Veneto. If his villas look Roman, it's because Palladio took as his model temple fronts and grafted them onto private residences. He and his fellow architects were endlessly imaginative. They taught themselves how to exploit what their ancient predecessors had originated and thereby serve the needs of contemporary society. This agenda elicited ingenuity at the very time that they were assimilating all they knew of the distant past.

They achieved their goals by emulating a style they called *all'antica*. Each architect, drawing upon the resources of antiquity, sought a unique way to deploy what he most admired. With a gift for synthesis, architects assimilated rather than merely imitated classical models. Palladio, steeped in the writings of Vitruvius and Alberti, may have included Bramante's Tempietto in his book on ancient architecture, as though it were the survival of a Roman temple. It is not, however, identical to anything produced during the reign of Emperor Augustus. In this sense, the Renaissance may as fruitfully be called a distillation and rejuvenation as a rebirth.

Despite their detailed knowledge of Roman buildings, Renaissance architects were never shackled by the past; their purpose was not to clone anything; they were endlessly inventive. Francesco di Giorgio Martini, who helped design the

Farnese Palace in Caprarola, summed up his profession's goal: "The older and more ancient things are, the more it seems necessary to innovate." Alberti, a devotee of classic forms, spotlights his own capacity for innovation: "I shall now refer to information that I have been able to gather myself about pavements, by careful and diligent inspection of the works of the ancients. And, I must confess, I have learned more on my own than I have from the author of any book" (3:89). Renaissance architects were not captive to Vitruvius either: "The Renaissance concept of symmetry was substantially different from Vitruvius's and much simplified. Whereas Vitruvius had regarded symmetry as the harmonious relationship of all the parts to one another and the whole—a perfectly calibrated proportional system—Alberti defined symmetry to mean the balance of parts identically arranged with reference to a central axis."[3]

* * *

Like a giant magnet, the Renaissance attracted ideas and motifs from the ancient world to satisfy the needs of the present. Architects saw their calling as re-inventing the look of buildings and cities. This transformation happened with remarkable speed, for, as they worked, they tried to top one another. Rivalry helped accelerate advances in their field. No one wanted to be left behind. Architects competed for commissions, and this too helped increase the rate of change. In search of work, they often had to travel from one locale to another, bringing their personal expertise and goals with them. They taught and learned from the architects with whom they collaborated. And they exulted in their accomplishments. In his book on architecture, Alberti wrote, "Is it not true perhaps to say that the whole of Italy is fired by a kind of rivalry in renewing the old? Great cities which in our childhood were built entirely of wood have suddenly been transformed into marble."

Innovation for its own sake, however, was not their chief goal. They had a practical, if ambitious, purpose—to change the way people lived. Humanists sought to enhance the well-being of the populace. The aesthetic environment, they believed, had reverberations throughout society, affecting everything from business transactions to moral judgment. An investment in architecture and art could produce models for aspiration and thus provide a new appreciation of humankind's power to chart its future. To study the past was to transform both the present and the future. The (anonymous) painting of an ideal city in Urbino's palace is predicated on the conviction that an urban environment could evoke the best selves of the population. Ideally, the configuration of stone and brick and plaster could modify and even transform the human condition;

it could bring about a civilizing effect. To cynics, this may sound like a pie-in-the-sky platitude, but it was precisely this confidence that inspired the idealistic Vespasiano Gonzaga to create Sabbioneta out of a stagnant backwater.

What motivated this need? I suggest that their understanding of human nature was critical. At the time when Brunelleschi, Alberti, and Bramante built churches, the teachings and rituals of Christianity pervaded nearly every aspect of life. Every child was baptized, had first communion, and was confirmed. A church was the setting for both marriage and funerals. Mass was a ritual observed by most people. The principles enunciated in the Gospels found expression in those buildings. The words of Scripture read aloud, especially passages extolling the value of mercy, and the panoply of art, with biblical narratives, affected all who attended a service. But principles alone did not then and do not now restrain people from succumbing to destructive impulses. The Pazzi saga is exemplary. When Florentines, appalled by the attack on the Medici brothers, sprang to take revenge, the carapace of religion broke open and revealed an ugly reality underneath. The human species has never lost its primal nature.

Architecture plays a part in counteracting weakness within, the tendency to succumb to self-destruction. Consider what the physical structure of a church offers. Attending a service has a spiritual dimension, without question. But a person's physical presence brings something else as well. Hearing Mass is, in part, a social occasion, an opportunity for fellowship. The experience of communal speech and common resolve affirm values shared when people represent their best selves. Where else is that likely to happen?

In their private lives, Italians (and other Europeans, of course) assumed all along that outward appearance and inherent character were connected. So, for instance, a nobleman, blessed with native good sense and corresponding education, would almost certainly possess the outward trappings belonging to his nature. Why should this same principle not apply to architecture? If inner merit manifests itself in an individual's presentation, so too does the moral significance and even the therapeutic power of buildings express themselves through their constituent forms. To stand before and then enter an edifice, to study its contours, admire its embellishment, breathe its atmosphere, and savor its design, brings psychic uplift. A building's visual sublimity possesses the capacity to ennoble the person who dwells within.

* * *

A personal reflection: What exactly was it about Italian structures that appealed to me? In contrast to the intricacy of Gothic buildings, those of Brunelleschi,

Alberti and their followers consisted of simple geometric forms ensuring an overall sense of proportion and continuity of style. This, in turn, produced a feeling of harmony. Architects communicated, moreover, a sense of what the Romans called *gravitas*—literally, *weight*; by extension, *consequence, importance*. Buildings with this quality possess an intrinsic dignity and authority. At the same time, they bespeak an indefinable energy, springing ultimately from the architect's ingenuity and informing the configuration of materials. If we look carefully at what the architects created, we can, at least in our imagination, feel their enthusiasm. In this sense Renaissance structures combine two qualities we might ordinarily consider antithetical—sobriety and vitality.

My childhood experience prepared me to enjoy what Vasari praised. As a boy, I was not allowed to play with guns. My parents worried that I might become a warmonger, and so they refused to give me what I most wanted: a Hopalong Cassidy pistol, with a belt and holster. Instead, I had to settle for a set of polished, wooden blocks that I could assemble and reassemble all day long. (I still have them.) My parents' decision disappointed me, but this early experience of arranging and rearranging shapes may have prepared me to appreciate the geometry of Italian structures. Maybe it's just a coincidence, but the only math I ever enjoyed was plane geometry. Algebra was a terrifying mystery that to this day withholds its secrets.

What, finally, have I gained from my travels in Italy? I came to understand that Roman principles of architecture were almost infinitely adaptable: they could be configured in countless ways. Today most of us have at least a rough sense of what imperial Rome may have looked like. Most of us have seen *Cleopatra, Spartacus, Gladiator*, and similar movies. But could any of us have imagined what Renaissance architects would do with those basic shapes that found their way onto film? Ancient Roman accomplishments did not *dictate* a new style in the 1400s. Instead, they furnished *inspiration*.

If an ancient architect came back to life and looked at the façade of Sant'Andrea in Mantua, he would likely be nonplussed to see, for example, the fusion of the triumphal arch and temple front. In much the same way, that architect would be astonished by Giulio Romano's Palazzo Te, or Vignola's Palazzo Farnese in Caprarola, or Pirro Ligorio's Casino for Pius IV in Rome. None of these buildings has an exact counterpart anywhere in antiquity. In short, what I came to realize is that in all likelihood each Renaissance building I encountered on my journeys was likely to be different from all the others. Architects were never bound by a single template.

When I returned from a trip to Italy, a friend asked me when I first felt the power of ancient Roman culture. I said, "Actually, that moment occurred

not in Italy but in southern France." My family was visiting Provence. We had heard about an aqueduct called the Pont du Gard and decided to check it out. I had seen photographs but was not prepared for the moment when I was close enough to walk up and put my hands on the stone. Built by the Romans *c.* CE 40–60 to bring water to a burgeoning colony known today as Nîmes, its name means "Bridge of the River Gard." (The city also contains a perfectly preserved Roman temple and an amphitheater still used for concerts and bullfighting.) The nearest source of water was sixteen miles away, and gravity moved the liquid; the aqueduct had a gradient of only twenty-two inches per mile. And it crossed a gorge 900 feet wide. The sheer size impressed me first. The construction has three levels: the highest and widest of the arches at the bottom, and the shortest at the uppermost level. From base to top, this massive bridge measures 160 feet and is said to be the tallest of surviving aqueducts.

I stood near the river bed and discovered gigantic stone blocks at the aqueduct's base; some are said to weigh six tons. They are so precisely carved that I could not fit a piece of paper between any two of them. I saw no sign of mortar, though it's used on the highest level, which contains the conduit for fresh water. I could scarcely believe what the Romans had conceived and built 2,000 years ago—and with only primitive tools. The precision of workmanship was breathtaking, and all construction was, of course, hand-made. Improbably the builders completed the aqueduct in a remote colonial settlement far from the Empire's capital. Such was Rome's reach.

NOTES

1 Giorgio Vasari, *The Lives of the Artists*, trans. Julia Conaway Bondanella and Peter Bondanella, Oxford World's Classics (1991; repr. Oxford: Oxford University Press, 2008).

2 R. A. Scotti, *Basilica, The Splendor and the Scandal: Building St. Peter's* (New York: Viking, 2006), 77.

3 Fil Hearn, *Ideas That Shaped Buildings* (Cambridge, MA: MIT Press, 2003), 84–85.

NOTES

Citations of Vitruvius are from *Ten Books on Architecture*, trans. Ingrid D. Rowland, ed. Rowland and Thomas Noble Howe (1999; repr. Cambridge: Cambridge University Press, 2001).

Citations of Alberti are from *On the Art of Building in Ten Books*, trans. of *De re aedificatoria*, by Joseph Rykwert, Neil Leach, and Robert Tavernor (1988; repr. Cambridge, MA, and London: MIT Press, 1997). Citations within parentheses designate book and page numbers.

Citations of Filarete are from *Filarete's Treatise on Architecture*, trans. John R. Spencer, 2 vols. (New Haven and London: Yale University Press, 1965). Citations within parentheses represent volume and page numbers.

Citations of Palladio are from *Andrea Palladio: The Four Books on Architecture*, trans. Robert Tavernor and Richard Schofield (Cambridge, MA: MIT Press, 1997). Citations within parentheses represent book and page numbers.

Citations of Serlio are from *Sebastiano Serlio: On Architecture*, trans. Vaughan Hart and Peter Hicks, 2 vols. (New Haven and London: Yale University Press, 1996). Citations within parentheses represent page numbers of the first volume in this two-volume set. Serlio's book was published in seven parts and different years.

Citations of Vasari are from *The Lives of the Artists*, trans. Julia Conaway Bondanella and Peter Bondanella, Oxford World's Classics (1991; repr. Oxford: Oxford University Press, 2008). Citations within parentheses designate the relevant minibiography, then the page number.

BIBLIOGRAPHY

Ackerman, James S. *Palladio*. London: Penguin, 1966.

———"The Planning of Renaissance Rome, 1450–1580," In *Rome in the Renaissance: The City and the Myth*, 3–18. Edited by P. A. Ramsay, Medieval & Renaissance Texts & Studies. Binghamton, NY: Center for Medieval & Early Renaissance Studies, 1982.

———*The Architecture of Michelangelo*. Chicago: University of Chicago Press, 1986.

Alberti, Leon Battista. *On the Art of Building in Ten Books*. Translated by Joseph Rykwert, Neil Leach, and Robert Tavernor. 1988; repr. Cambridge, MA, and London: MIT Press, 1997.

Apuleius, [Lucius]. *The Tale of Cupid and Psyche*. Translated by Joel C. Relihan. Indianapolis: Hackett, 2009.

Aston, Margaret, editor. *The Panorama of the Renaissance*. London: Thames and Hudson, 1996.

Atalay, Bulent, and Keith Wamsley. *Leonardo's Universe: The Renaissance World of Leonardo da Vinci*. Washington, DC: National Geographic Society, 2008.

Attlee, Helena. *Italian Gardens: A Cultural History*. London: Frances Lincoln, 2006.

Bartlett, Kenneth R. *The Civilization of the Italian Renaissance: A Sourcebook*. 2nd ed. Toronto: University of Toronto Press, 2011.

Battilotti, Donata. *The Villas of Palladio*. Translated by Richard Sadleir. Milan: Electa, 1990.

Battisti, Eugenio. *Brunelleschi: The Complete Work*. Translated by Robert Erich Wolf. London: Thames and Hudson, 1981.

Bazzotti, Ugo. *Palazzo Te: Giulio Romano's Masterwork in Mantua*. Translated by Grace Crerar-Bromelow. Photos by Grazia Sgrilli and Ghigo Roli. London: Thames and Hudson, 2013.

Beacham, Richard C. *The Roman Theatre and Its Audience*. London: Routledge, 1991.

Beare, William. *The Roman Stage: A Short History of Latin Drama in the Time of the Republic*. Cambridge, MA: Harvard University Press, 1951.

Becker, Marvin B. *Florence in Transition*. 2 vols. Baltimore, MD: The Johns Hopkins University Press, 1967.

Bellonci, Maria. "Sabbioneta: Vespasiano and His City." *FMR: The Magazine of Franco Maria Ricci*, no. 30 (January/February 1988): 82–98.

Boorsch, Suzanne. "The Building of the Vatican: The Papacy and Architecture." *The Metropolitan Museum of Art Bulletin* 40, no. 3 (Winter 1982/83): 1–64.

Brockett, Oscar G., Margaret Mitchell, and Linda Hardberger. *Making the Scene: A History of Stage Design and Technology in Europe and the United States*. San Antonio, TX: Tobin Theatre Arts Fund, 2010.

Brotton, Jerry. *The Renaissance Bazaar: From the Silk Road to Michelangelo*. Oxford: Oxford University Press, 2002.

Burckhardt, Jacob. *The Architecture of the Italian Renaissance*. Edited by Peter Murray. Translated by James Palmes. Chicago: University of Chicago Press, 1985.

Burke, Jill, ed. *Rethinking the High Renaissance: The Culture of the Visual Arts in Early Sixteenth-Century Rome*. Burlington, VT: Ashgate, 2012.

Burke, Peter. *The European Renaissance: Centres and Peripheries*. Oxford: Blackwell, 1998.

———*The Italian Renaissance: Culture and Society in Italy*. 2nd ed. rev. Cambridge, UK: Polity Press, 1999.

Campbell, Stephen, and Michael Wayne Cole. *Italian Renaissance Art*. New York: Thames and Hudson, 2012.

Cartwright, Julia. *Baldassare Castiglione, the Perfect Courtier: His Life and Letters, 1478–1529*. 2 vols. London: John Murray, 1908.

Castex, Jean. *Architecture of Italy*. Westport, CT: Greenwood, 2008.

Chambers, E. K. *The Elizabethan Stage*. 4 vols. 1923; repr. Oxford: Clarendon Press, 1951.

Chatfield, Judith. *A Tour of Italian Gardens*. New York: Rizzoli, 1988.

Cheney, Liana De Girolami, ed. *Readings in Italian Mannerism*. New York: Peter Lang, 1997.

Cocke, Richard. *Paolo Veronese: Piety and Display in an Age of Religious Reform*. Burlington, VT: Ashgate, 2001.

Coffin, David R. *The Villa d'Este at Tivoli*. Princeton, NJ: Princeton University Press, 1960.

———*The Villa in the Life of Renaissance Rome*. Princeton, NJ: Princeton University Press, 1979.

———*Pirro Ligorio: The Renaissance Artist, Architect, and Antiquarian*. University Park: Pennsylvania State University Press, 2004.

———*Magnificent Buildings, Splendid Gardens*. Edited by Vanessa Bezemer Sellers. Princeton, NJ: Princeton University Press, 2008.

Cole, Alison. *Italian Renaissance Courts: Art, Pleasure and Power*. London: Laurence King, 2016.

Colvin, Howard. "Herms, Terms and Caryatids in English Architecture." In *Essays in English Architectural History*, 95–135. New Haven and London: Yale University Press for The Paul Mellon Centre for Studies in British Art, 1999.

Comito, Terry. *The Idea of the Garden in the Renaissance*. New Brunswick, NJ: Rutgers University Press, 1978.

———"The Humanist Garden." In *The Architecture of Western Gardens: A Design History from the Renaissance to the Present Day*. Edited by Monique Mosser and Georges Teyssot, 37–45. Cambridge, MA: MIT Press, 1991.

Concina, Ennio. *A History of Venetian Architecture*. Translated by Judith Landry. Cambridge: Cambridge University Press, 1998.

Cooper, Tracy E. *Palladio's Venice: Architecture and Society in a Renaissance Republic*. New Haven and London: Yale University Press, 2005.

Cowan, James. *Hamlet's Ghost: Vespasiano Gonzaga and His Ideal City*. Newcastle upon Tyne, UK: Cambridge Scholars Publishing, 2015.

Cronin, Vincent. *The Florentine Renaissance*. New York: Dutton, 1967.

————*The Flowering of the Renaissance.* London: History Book Club, 1969.

Davies, Tony. *Humanism.* The New Critical Idiom. London and New York: Routledge, 1997.

Dernie, David. *The Villa d'Este at Tivoli.* London: Academy Editions, 1996.

Dewez, Guy. *Villa Madama: A Memoir Relating to Raphael's Project.* New York: Princeton Architectural Press, 1993.

Distefano, Giovanni. *How Was Venice Built?* Rev. ed. Venice: Supernova, 2023.

Dunbabin, Katherine M. D. *Theater and Spectacle in the Art of the Roman Empire.* Ithaca, NY, and London: Cornell University Press, 2016.

Eisenstein, Elizabeth L. *The Printing Press as an Agent of Change.* 2 vols. Cambridge: Cambridge University Press, 1979.

Elam, Caroline. "Sabbioneta." *AA Files: Annals of the Architectural Association School of Architecture* 18 (Autumn 1989): 25–29.

Elsner, Jaś. *Imperial Rome and Christian Triumph: The Art of the Roman Empire AD 100–450.* Oxford History of Art. Oxford: Oxford University Press, 1998.

Enge, Torsten Olaf, and Carl Friedrich Schröer. *Garden Architecture in Europe, 1450–1800.* Translated by Ailsa Mattaj. Cologne: Benedikt Taschen, 1990.

Erbesato, Gian Maria. *Guide to the Palazzo Te.* Florence: SCALA, 1987.

Fagiolo, Marcello. *Roman Gardens: Villas of the Countryside.* New York: Monacelli Press, 1997.

Filarete [Antonio Averlino]. *Filarete's Treatise on Architecture.* Translated by John R. Spencer. 2 vols. New Haven and London: Yale University Press, 1965.

Forster, Kurt W., and Richard J. Tuttle. "The Palazzo del Te." *Journal of the Society of Architectural Historians* 30, no. 4 (1971): 267–93.

————"Stagecraft and Statecraft: The Architectural Integration of Public Life and Theatrical Spectacle in Scamozzi's Theater at Sabbioneta." *Oppositions: A Journal for Ideas and Criticism in Architecture* 9 (Summer 1977): 63–87.

————"From Rocca to Civitas: Urban Planning at Sabbioneta." *FMR: The Magazine of Franco Maria Ricci,* no. 30 (January/February 1988): 99–120.

Frommel, Christoph Luitpold. *The Architecture of the Italian Renaissance.* Translated by Peter Spring. London: Thames and Hudson, 2007.

Furlotti, Barbara, and Guido Rebecchini. *The Art of Mantua: Power and Patronage in the Renaissance.* Translated by A. Lawrence Jenkens. Los Angeles: J. Paul Getty Museum, 2008.

Furnari, Michele. *Formal Design in Renaissance Architecture from Brunelleschi to Palladio.* New York: Rizzoli, 1995.

Gadol, Joan. *Leon Battista Alberti: Universal Man of the Early Renaissance.* Chicago and London: University of Chicago Press, 1969.

Giovannetti, Bruno, and Roberto Martucci. *Architect's Guide to Florence.* Translated by Michael Cunningham. Oxford: Butterworth-Heinemann, 1994.

Gordan, Phyllis Walter Goodhart. *Two Renaissance Book Hunters: The Letters of Poggius Bracciolini to Nicolaus de Niccolis.* New York and London: Columbia University Press, 1974.

Goy, Richard J. *Florence: The City and Its Architecture.* London: Phaidon, 2002.

————*Venice: An Architectural Guide.* New Haven and London: Yale University Press, 2010.

Greenblatt, Stephen. *The Swerve: How the World Became Modern.* New York: W. W. Norton, 2011.

Guicciardini, Luigi. *The Sack of Rome.* Translated by James H. McGregor. New York: Italica Press, 1993.

Hale, John R., ed. *A Concise Encyclopaedia of the Italian Renaissance.* New York and Toronto: Oxford University Press, 1981.

Harris, Cyril M., ed. *Illustrated Dictionary of Historic Architecture.* New York: Dover Publications, 1983.

Hart, Vaughan, and Peter Hicks, eds. *Paper Palaces: The Rise of the Renaissance Architectural Treatise.* New Haven and London: Yale University Press, 1998.

Haynes, Maria S. *The Italian Renaissance and Its Influence on Western Civilization.* 2nd ed. Lanham, MD: University Press of America, 1993.

Hearn, Fil. *Ideas That Shaped Buildings.* Cambridge, MA: MIT Press, 2003.

Heydenreich, Ludwig H. *Architecture in Italy, 1400–1500.* Revised by Paul Davies. Translated by Mary Hottinger. New Haven and London: Yale University Press, 1996.

Hollingsworth, Mary. *Princes of the Renaissance.* New York: Pegasus Books, 2021.

Hollis, Edward. *The Secret Lives of Buildings.* London: Portobello Books, 2009.

Holmes, George. *The Florentine Enlightenment, 1400–1450.* Oxford: Clarendon Press, 1992.

Hook, Judith. *The Sack of Rome, 1527.* London: Macmillan, 1972.

Howard, Deborah. *Jacopo Sansovino: Architecture and Patronage in Renaissance Venice.* New Haven and London: Yale University Press, 1975.

———*The Architectural History of Venice.* Revised and enlarged. New Haven and London: Yale University Press, 2002.

Hunt, John Dixon. *A World of Gardens.* London: Reaktion Books, 2012.

Huppert, Ann C. *Becoming an Architect in Renaissance Italy: Art, Science, and the Career of Baldassare Peruzzi.* New Haven and London: Yale University Press, 2015.

Jestaz, Bertrand. *Architecture of the Renaissance: From Brunelleschi to Palladio.* Translated by Caroline Beamish. New York: Harry N. Abrams, 1996.

Johnson, Eugene J. *Inventing the Opera House: Theater Architecture in Renaissance and Baroque Italy.* Cambridge: Cambridge University Press, 2010.

Johnson, Paul. *The Renaissance.* London: Weidenfeld and Nicolson, 2000.

King, Margaret L. *The Renaissance in Europe.* London: Laurence King, 2003.

———*Brunelleschi's Dome: How a Renaissance Genius Reinvented Architecture.* London: Chatto and Windus, 2000.

———*Leonardo and The Last Supper.* Toronto: Bond Street Books, 2012.

King, Ross. *The Bookseller of Florence: The Story of the Manuscripts That Illuminated the Renaissance.* New York: Atlantic Monthly Press, 2021.

Kirkpatrick, Robin. *The European Renaissance, 1400–1600.* London: Longman, 2002.

Kolb, Carolyn, and Melissa Beck. "The Sculptures on the Nymphaeum Hemicycle of the Villa Barbaro at Maser." *Artibus et Historiae* 18, no. 35 (1997): 15–33 + 35–40.

Kraye, Jill. "Philologists and Philosophers." In *The Cambridge Companion to Renaissance Humanism,* 142–60, Edited by Kraye. Cambridge: Cambridge University Press, 1996.

Laing, Alastair. "The Ideal City Preserved: Sabbioneta, Northern Italy." *Country Life* 177, no. 4575 (April 25, 1985): 1118–20.

Lauritzen, Peter (text), and Reinhart Wolf (photos). *Villas of the Veneto.* New York: Harry N. Abrams, 1988.

Lazzaro, Claudia. *The Italian Renaissance Garden.* New Haven and London: Yale University Press, 1990.

Lazzaro-Bruno, Claudia. "The Villa Lante at Bagnaia: An Allegory of Art and Nature." *The Art Bulletin* 59, no. 4 (December 1977): 553–60.

Lee, Alexander. *The Ugly Renaissance: Sex, Greed, Violence and Depravity in an Age of Beauty.* New York: Doubleday, 2013.

Levey, Michael. *High Renaissance.* Harmondsworth, UK: Penguin, 1975.

Lewis, Miles, ed. *Architectura: Elements of Architectural Style.* Lane Cove, Australia: Global Book Publishing, 2008.

Lippincott, Kristen. "Two Astrological Ceilings Reconsidered; The *Sala di Galatea* in the Villa Farnesina and the *Sala del Mappamondo* at Caprarola." *Journal of the Warburg and Courtauld Institutes* 53 (1990): 185–207.

Longman, Stanley V. "A Renaissance Anomaly: A Commedia dell'Arte Troupe in Residence at the Court Theatre at Sabbioneta." *Theatre Symposium, Tuscaloosa*, 1, part 2 (January 1, 1993): 57–65.

Lotz, Wolfgang. *Architecture in Italy, 1500–1600.* Revised by Deborah Howard. Translated by Mary Hottinger. New Haven and London: Yale University Press, 1995.

Lowry, Martin. *The World of Aldus Manutius: Business and Scholarship in Renaissance Venice.* Ithaca, NY: Cornell University Press, 1979.

Luchs, Alison. *The Mermaids of Venice: Fantastic Sea Creatures in Venetian Renaissance Art.* Turnhout, Belgium: Brepols, 2010.

Luther, Martin. *Luther's Works.* Edited by Jaroslav Pelikan and Helmut T. Lehmann. 55 vols. St. Louis: Concordia Publishing House; Philadelphia: Fortress Press, 1955–86.

MacDougall, Elisabeth Blair. *Fountains, Statues, and Flowers: Studies in Italian Gardens of the Sixteenth and Seventeenth Centuries.* Washington, DC: Dumbarton Oaks Research Library and Collection, 1994.

Machiavelli, Niccolò. *Discourses on Livy.* Translated by Harvey C. Mansfield and Nathan Tarcov. Chicago and London: University of Chicago Press, 1996.

Madge, James. *Sabbioneta, Cryptic City.* London: Bibliotheque McLean, 2011.

Maffezzoli, Umberto. *Sabbioneta: A Tourist Guide to the City.* 2nd ed. Bologna: Il Bulino, edizioni d'arte, 1992.

Manetti, Antonio di Tuccio. *The Life of Brunelleschi.* Edited by Howard Saalman. Translated by Catherine Enggass. University Park: Pennsylvania State University Press, 1970.

Markschies, Alexander. *Icons of Renaissance Architecture.* Munich: Prestel, 2003.

Miller, Keith. *St Peter's.* Cambridge, MA: Harvard University Press, 2007.

Milton, John. *Areopagitica.* In *John Milton: Complete Poems and Major Prose*, 716–49. Edited by Merritt Y. Hughes. New York: Odyssey Press, 1957.

Moffat, Alistair. *Tuscany: A History.* Edinburgh: Birlinn, 2009.

Montaigne, Michel de. *The Complete Works of Montaigne.* Translated by Donald M. Frame. Stanford, CA: Stanford University Press, 1957.

Morrow, Ann, and John Power. *Art for Travellers, Italy: The Essential Guide to Viewing Italian Renaissance Art.* New York: Interlink Books, 2004.

Muraro, Michelangelo. *Venetian Villas: The History and the Culture.* Photos by Paolo Marton. Translated by Peter Lauritzen, John Harper, and Stephen Sartarelli. New York: Rizzoli, 1986.

Nagler, Alois. M. *Sources of Theatrical History.* New York: Theatre Annual, 1952.

Ovid [Publius Ovidius Naso]. *Metamorphoses*. Translated by Frank Justus Miller. Loeb Classical Library. 2 vols. 1916; repr. Cambridge, MA: Harvard University Press, 1966.

Palladio, Andrea. *The Four Books on Architecture*. Translated by Robert Tavernor and Richard Schofield. Cambridge, MA: MIT University Press, 1997.

———*Palladio's Rome: A Translation of Andrea Palladio's Two Guidebooks to Rome*. Translated by Vaughan Hart and Peter Hicks. New Haven and London: Yale University Press, 2006.

Partner, Peter. *Renaissance Rome, 1500–1559: A Portrait of a Society*. Berkeley and Los Angeles: University of California Press, 1976.

Partridge, Loren. "The Farnese Circular Courtyard at Caprarola: God, Geopolitics, Genealogy, and Gender." *The Art Bulletin* 83, no. 2 (June 2001): 259–93.

Payne, Alina. *The Architectural Treatise in the Italian Renaissance*. Cambridge: Cambridge University Press, 1999.

Pearson, Caspar. *Leon Battista Alberti: The Chameleon's Eye*. London: Reaktion Books, 2022.

Quinlan-McGrath, Mary. "Caprarola's Sala della Cosmografia." *Renaissance Quarterly* 50, no. 4 (Winter 1997): 1045–1100.

Ribouillault, Denis. *The Villa Barbaro at Maser: Science, Philosophy, and the Family in Venetian Renaissance Art*. Turnhout, Belgium: Harvey Miller, 2023.

Rigon, Fernando. *The Teatro Olimpico in Vicenza*. Milan: Electa, 1989.

Rogers, Elizabeth Barlow. *Landscape Design: A Cultural and Architectural History*. New York: Harry N. Abrams, 2001.

Ronayne, John. "*Totus Mundus Agit Histrionem*: The Interior Decorative Scheme of the Bankside Globe." In *Shakespeare's Globe Rebuilt*, 121–46. Edited by J. R. Mulryne and Margaret Shewring. Cambridge: Cambridge University Press, 1997.

Rosenau, Helen. *The Ideal City: Its Architectural Evolution in Europe*. London and New York: Methuen, 1983.

Rowland, Ingrid D. *The Culture of the High Renaissance: Ancients and Moderns in Sixteenth-Century Rome*. Cambridge: Cambridge University Press, 1998.

Ruskin, John. *The Stones of Venice*. Edited by J. G. Links. New York: Hill and Wang, 1960.

Salvadori, Antonio. *Architect's Guide to Venice*. Translated by Brenda Balich. London: Butterworth Architecture, 1990.

Satkowski, Leon. *Giorgio Vasari: Architect and Courtier*. Princeton, NJ: Princeton University Press, 1993.

Scherer, Margaret R. *Marvels of Ancient Rome*. Edited by Charles Rufus Morey. New York and London: Phaidon, 1955.

Schiavo, Remo. *A Guide to the Olympic Theatre*. 3rd ed. Translated by Patricia Anne Hill. Vicenza: Accademia Olimpica, 1987.

Scotti, Rita A. *Basilica, The Splendor and the Scandal: Building St. Peter's*. New York: Penguin, 2006.

Serlio, Sebastiano. *On Architecture*. Translated by Vaughan Hart and Peter Hicks. 2 vols. New Haven and London: Yale University Press, 1996.

Servida, Sonia. *The Story of Renaissance Architecture*. Translated by Bridget Mason. Munich, London, and New York: Prestel, 2011.

Sitwell, Sacheverell, ed. *Great Houses of Europe*. 1961; repr. London: Hamlyn, 1970.

Smith, Graham. *The Casino of Pius IV*. Princeton, NJ: Princeton University Press, 1977.

Stinger, Charles L. *The Renaissance in Rome.* Bloomington: Indiana University Press, 1985.

Strathern, Paul. *Death in Florence: The Medici, Savonarola and the Battle for the Soul of the Renaissance City.* London: Jonathan Cape, 2011.

Tavernor, Robert. *Palladio and Palladianism.* London: Thames and Hudson, 1991.

———*On Alberti and the Art of Building.* New Haven and London: Yale University Press, 1998.

Testa, Judith. *An Art Lover's Guide to Florence.* DeKalb: Northern Illinois University Press, 2012.

Trachtenberg, Marvin. *Building-in-Time: From Giotto to Alberti and Modern Oblivion.* New Haven and London: Yale University Press, 2010.

Trinkaus, Charles. *In Our Image and Likeness: Humanity and Divinity in Italian Humanist Thought.* 2 vols. Chicago: University of Chicago Press, 1970.

Vasari, Giorgio. *The Lives of the Artists.* Translated by Julia Conaway Bondanella and Peter Bondanella. Oxford World's Classics. 1991; repr. Oxford: Oxford University Press, 2008.

Virgil [Publius Virgilius Maro]. *Eclogues, Georgics, Aeneid I-VI.* Translated by H. Rushton Fairclough. Revised by P. Goold. Loeb Classical Library. 1935; repr. Cambridge, MA: Harvard University Press, 1999.

Vitruvius [Marcus Vitruvius Pollio]. *Ten Books on Architecture.* Translated by Ingrid D. Rowland. Edited by Rowland and Thomas Noble Howe. 1999; repr. Cambridge: Cambridge University Press, 2001.

Walker, Paul Robert. *The Feud That Sparked the Renaissance: How Brunelleschi and Ghiberti Changed the Art World.* New York: William Morrow, 2002.

Warner, Deborah J. *The Sky Explored: Celestial Cartography, 1500–1800.* New York: Alan R. Liss; Amsterdam: Theatrum Orbis Terrarum, 1979.

Wilkinson, Tom. *Bricks & Mortals: Ten Great Buildings and the People They Made.* New York and London: Bloomsbury, 2014.

Wills, Gary. *Venice: Lion City, The Religion of Empire.* New York: Simon and Schuster, 2001.

Zamperini, Alessandra. *Paolo Veronese.* Translated by Grace Crerar-Bromelow. London: Thames and Hudson, 2014.

Zuffi, Stefano. *The Renaissance.* First published in Italy as *Il Rinascimento.* Hammersmith, UK: Collins, 2003.

INDEX